# CHUCK CLOSE

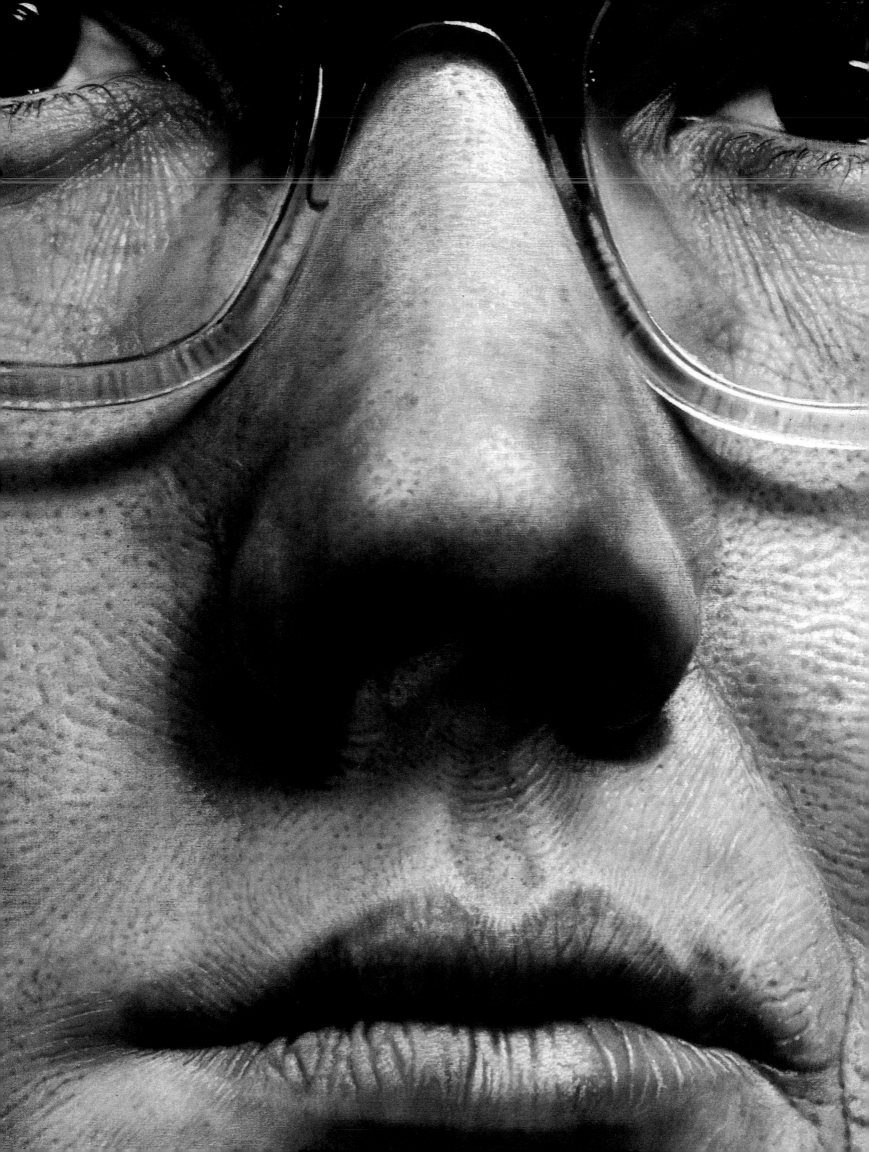

Robert Storr

With essays by Kirk Varnedoe and Deborah Wye

# CHUCK CLOSE

THE MUSEUM OF MODERN ART, NEW YORK

Distributed by Harry N. Abrams, Inc., New York

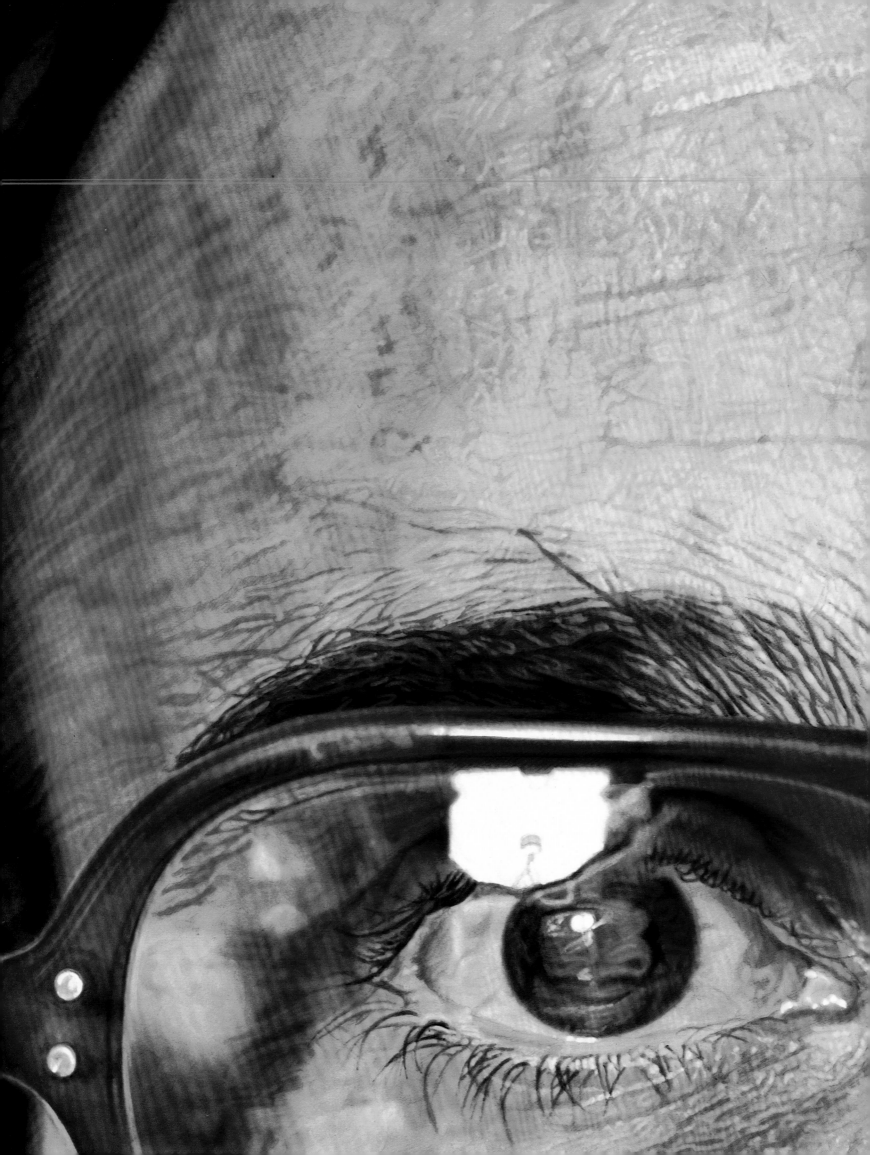

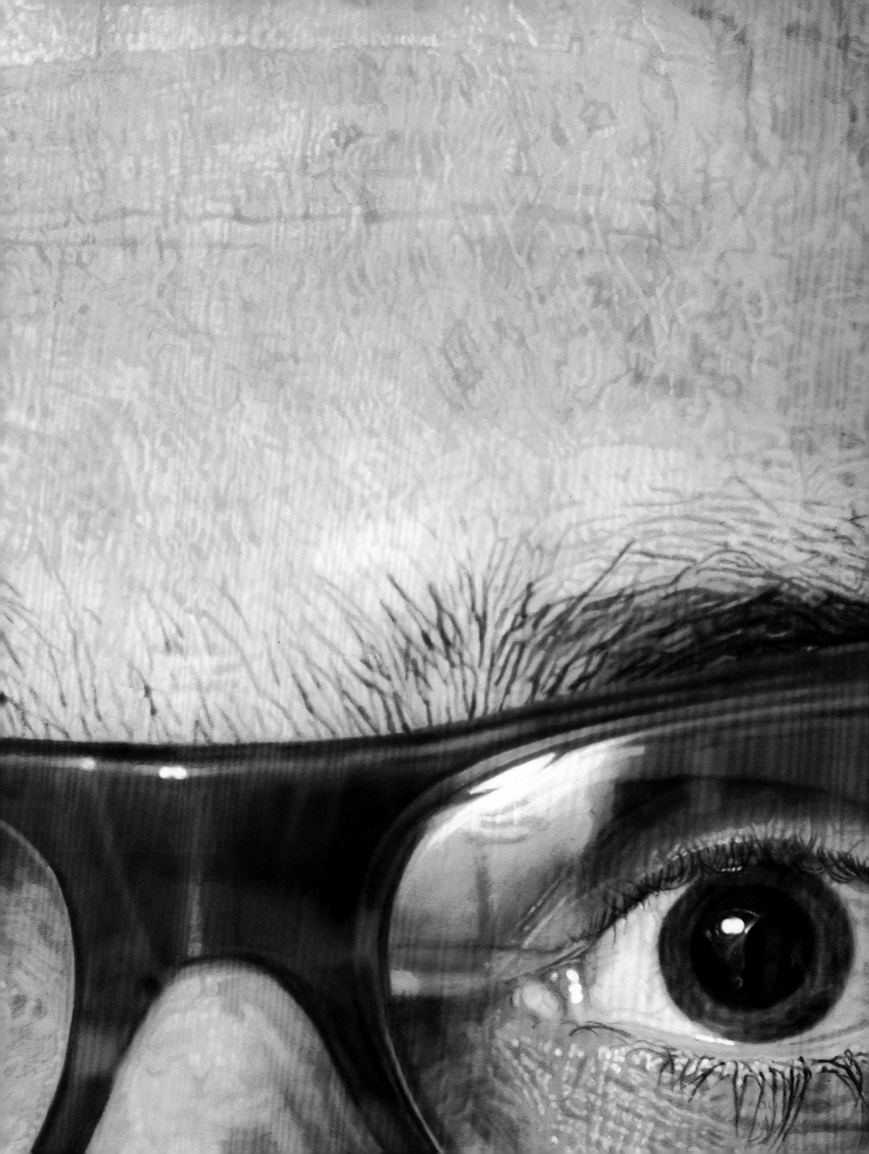

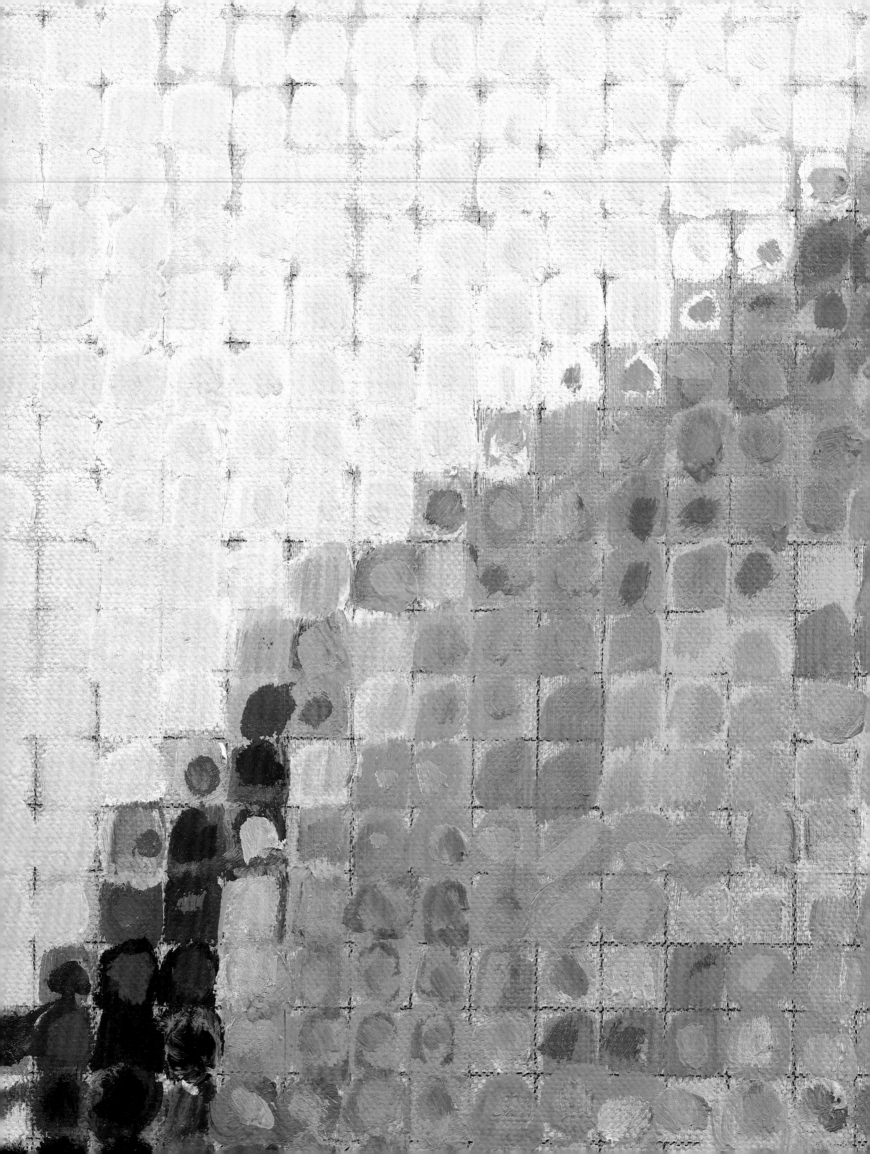

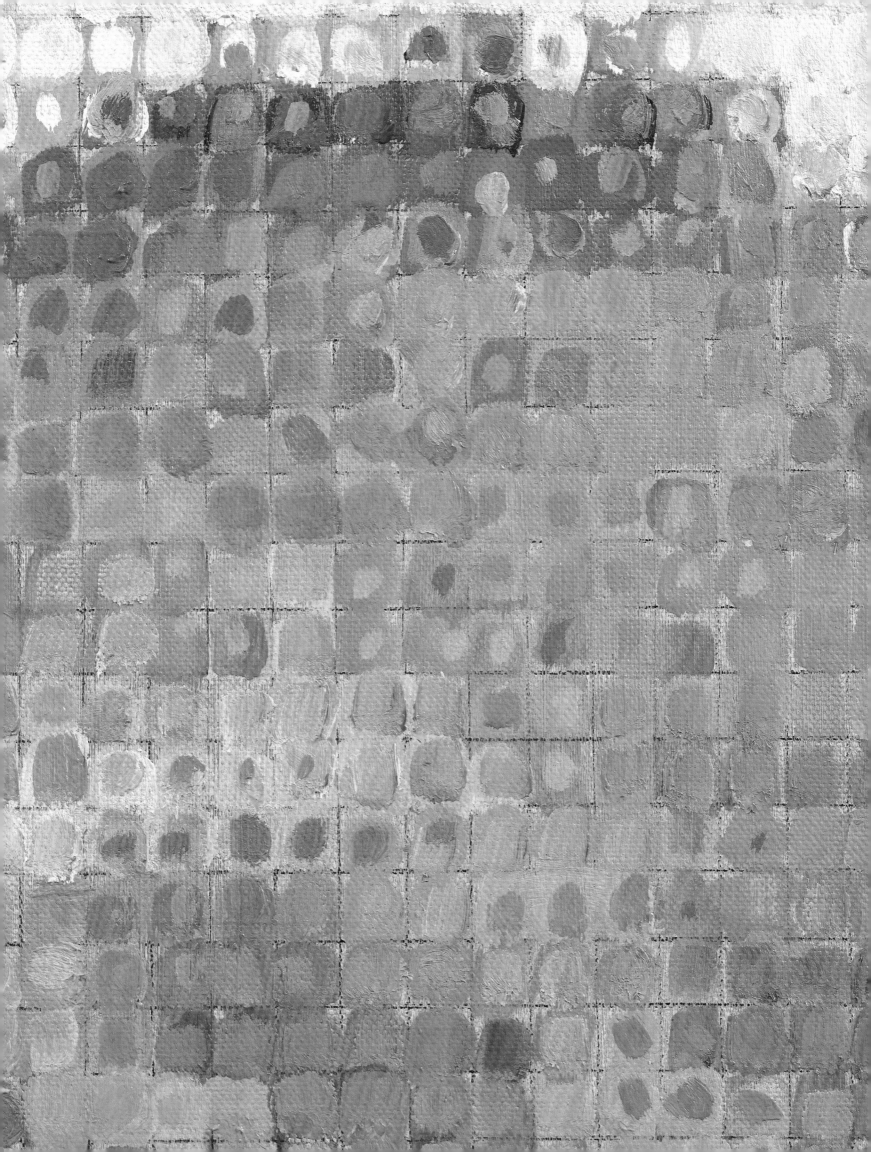

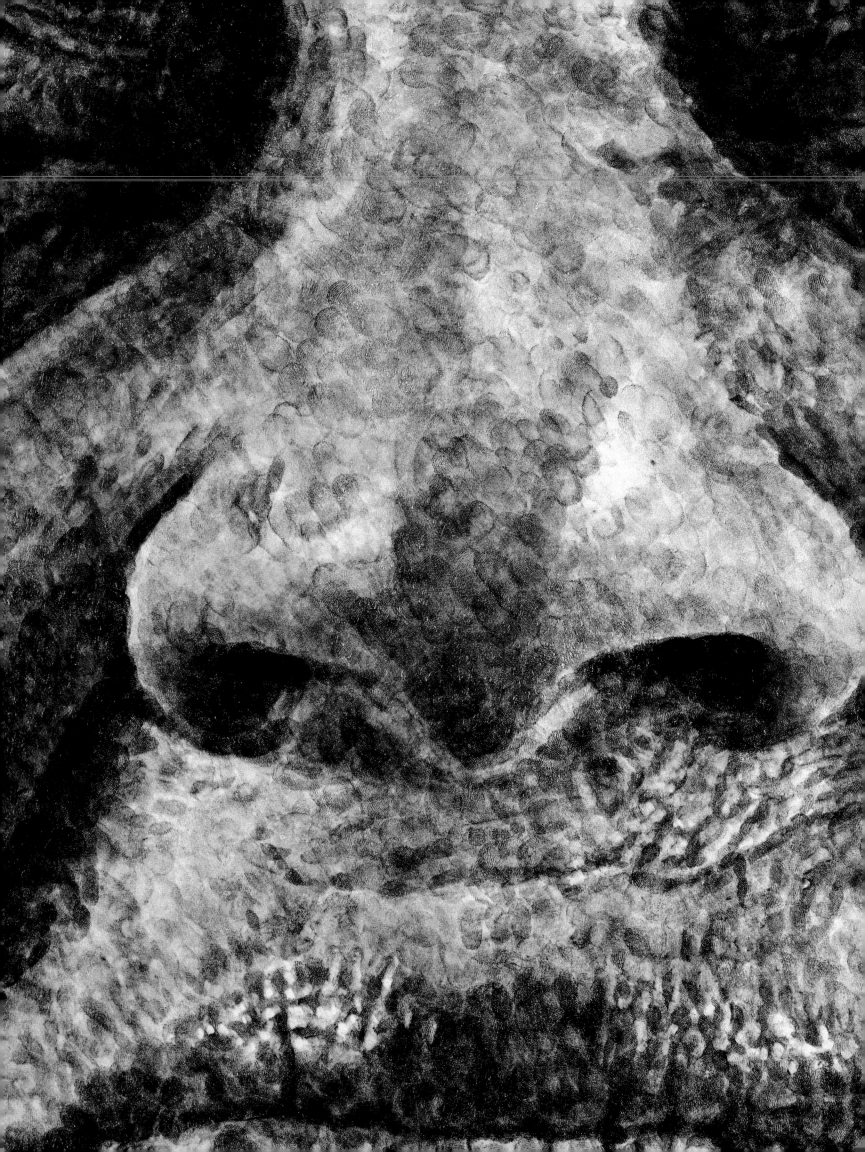

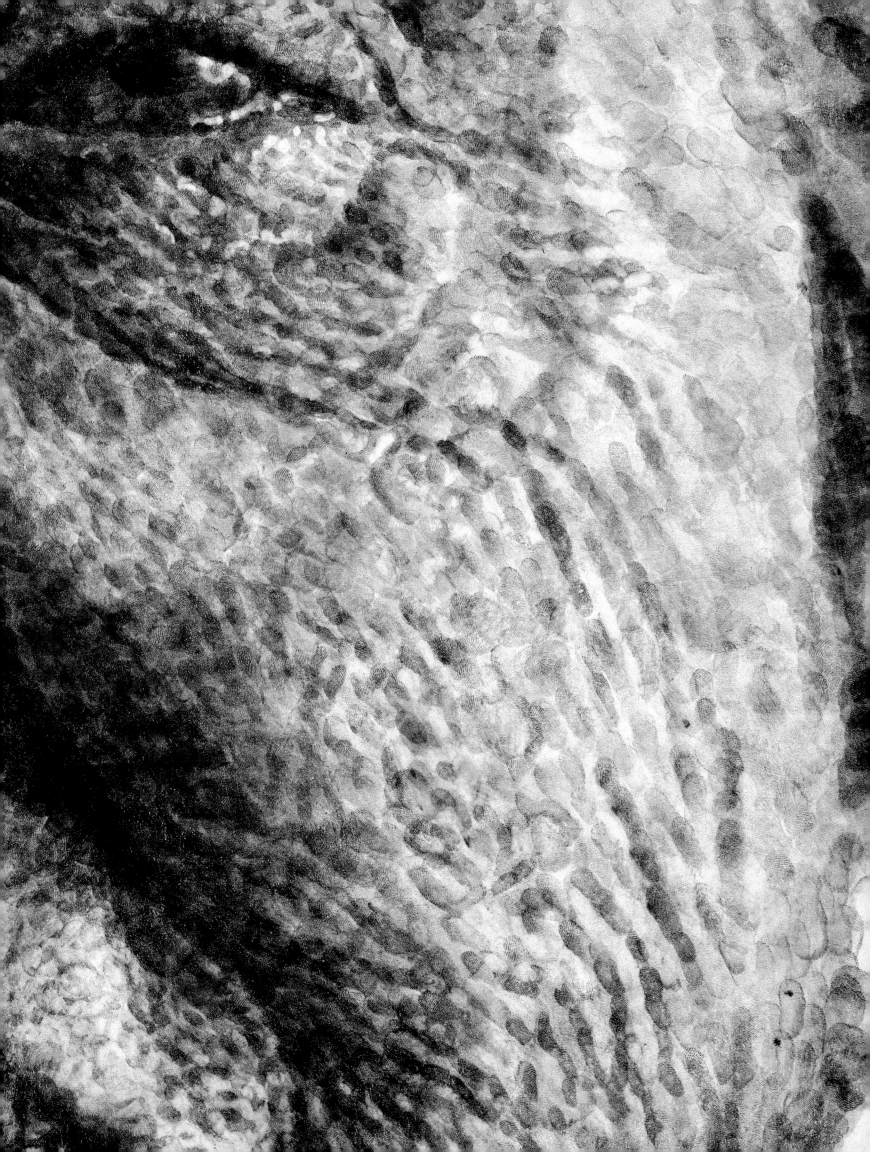

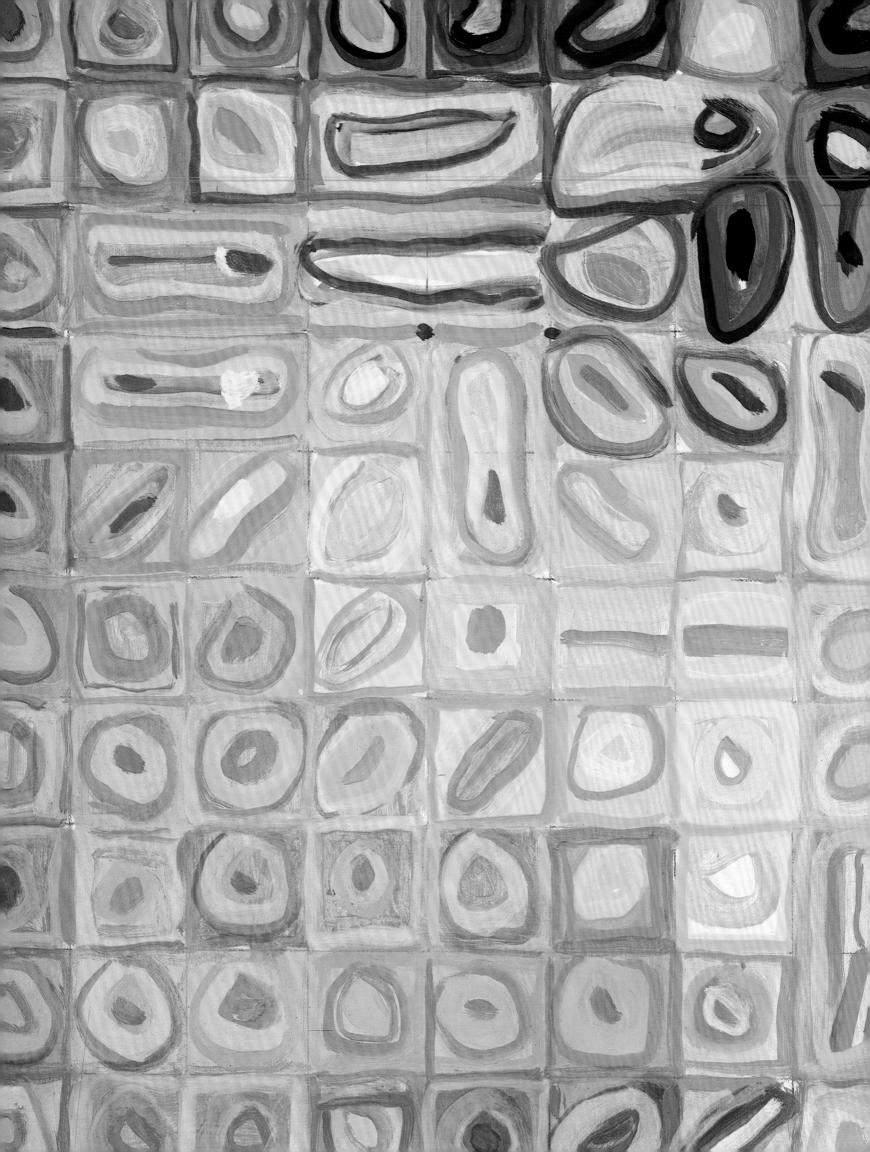

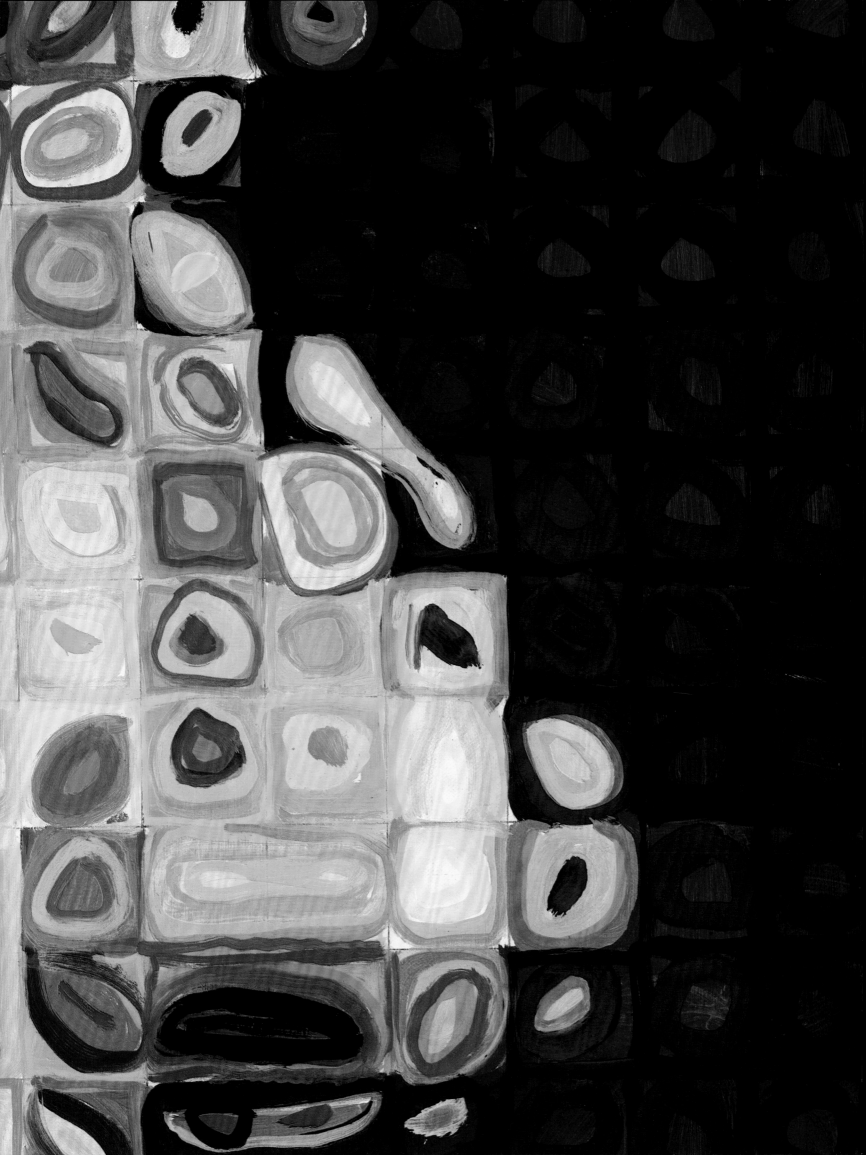

Published on the occasion of the exhibition "Chuck Close,"
organized by Robert Storr, Curator in the Department of Painting and
Sculpture at The Museum of Modern Art, New York,
February 26–May 26, 1998

The exhibition will travel to
the Museum of Contemporary Art, Chicago,
June 20–September 13, 1998;
Hirshhorn Museum and Sculpture Garden, Washington, D.C.,
October 15, 1998–January 10, 1999;
and to the Seattle Art Museum,
February–May 1999

This exhibition is made possible by Michael and Judy Ovitz,
and by a generous grant from Banana Republic.

Additional generous support is provided by
Jon and Mary Shirley.

Produced by the Department of Publications
The Museum of Modern Art, New York

Edited by Joanne Greenspun
Designed by Hahn Smith Design, Toronto, Canada
Production by Marc Sapir
Color separation by LS Graphic, Inc., New York /
Fotolito Gammacolor, Milan
Printed by LS Graphic, Inc., New York /
Grafica Comense, Como

Library of Congress Catalogue Card Number: 97-075612
ISBN  0-87070-066-9 (clothbound, The Museum of Modern Art /
Thames and Hudson)
ISBN  0-87070-067-7 (paperbound, The Museum of Modern Art)
ISBN 0-8109-6184-9 (clothbound, Harry N. Abrams, Inc.)

Published by The Museum of Modern Art
11 West 53 Street, New York, New York 10019

Clothbound edition distributed in the United States and Canada
by Harry N. Abrams, Inc., New York
Clothbound edition distributed outside the United States and Canada
by Thames and Hudson, Ltd., London

Cover: Chuck Close. *Big Self-Portrait*. 1967–68.
Acrylic on canvas, 107 ½ x 83 ½" (273.1 x 212.1 cm).
Walker Art Center, Minneapolis.
Art Center Acquisition Fund, 1969

Frontispiece: Chuck Close. *Keith* (detail). 1970.
Acrylic on canvas, 108 ¼ x 84" (275 x 213.4 cm).
The Saint Louis Art Museum.
Purchased with funds given by the Shoenberg Foundation, Inc.

Overleafs:
Chuck Close: *Mark* (detail). 1978–79.
Acrylic on canvas, 108 x 84" (274.3 x 213.4 cm).
Private collection, New York

Chuck Close: *Robert/104,072* (detail). 1973–74.
Acrylic and ink with pencil on canvas, 108 x 84" (274.3 x 213.4 cm).
The Museum of Modern Art, New York.
Gift of J. Frederic Byers III
and promised gift of an anonymous donor

Chuck Close. *Stanley* (detail). 1980.
Oil on canvas, 55 x 42" (139.7 x 106.7 cm).
Collection Mr. and Mrs. Charles Diker

Chuck Close. *Jud/Collage* (detail). 1982.
Pulp paper collage on canvas, 96 x 72" (243.8 x 182.9 cm).
Virginia Museum of Fine Arts, Richmond.
Gift of The Sydney and Frances Lewis Foundation

Chuck Close. *Fanny/Fingerpainting* (detail). 1985.
Oil-based ink on canvas, 102 x 84" (259.1 x 213.4 cm).
National Gallery of Art, Washington, D.C.
Gift of Lila Acheson Wallace Fund

Chuck Close. *Roy II* (detail). 1994.
Oil on canvas, 102 x 84" (259.1 x 213.4 cm).
Hirshhorn Museum and Sculpture Garden,
Smithsonian Institution, Washington, D.C.
Regents Collections Acquisition Program with matching funds
from the Joseph H. Hirshhorn Purchase Fund, 1995

pp. 102–103: Chuck Close. *Janet* (detail). 1992.
Oil on canvas, 100 x 84" (254 x 213.4 cm).
Albright-Knox Art Gallery, Buffalo, New York.
George B. and Jenny R. Mathews Fund, 1992

Printed in Italy

# CONTENTS

# FOREWORD

*Chuck Close* brings together forty-six paintings, six photographs, and thirty-eight drawings that trace thirty years of artistic creativity, from 1967 through 1997. Organized by Robert Storr, Curator in the Department of Painting and Sculpture at The Museum of Modern Art, the exhibition and the catalogue that accompanies it offer an in-depth study of Close's career to date.

Although Close's portraits or (as he sometimes prefers to call them) heads often seem straightforward and direct, they are, in fact, highly complex and nuanced images that reflect the artist's intense inquiry into the making of pictures. Each work poses for Close an intriguing set of problems that allows him to explore the possibilities of constructing a human visage through color and form in new and different ways. Close's work has always been distinguished by a kind of tough-minded commitment to push himself to ask the most difficult questions about his art, to avoid simple and easy solutions. At a time when many artists abandoned painting, he affirmed his interest in it. When figuration was thought to be passé, he determined to work almost exclusively with the figurative image.

Much of Close's work is inherently paradoxical. His subjects, for instance, are often intensely personal portraits of friends and family, yet they are approached with a detachment that borders on the impersonal. In the same way, each work is both a highly abstract composition of seemingly random strokes based on predetermined systems of composition developed by the artist and a finely rendered image held together by a tightly woven network of shapes and colors. As one's field of vision changes, so, too, does the work. What distinguishes all of Close's paintings, however, is their avoidance of any kind of internal hierarchical structure. No one part of any of his paintings, which are built up of carefully constructed grids, is made more important than another. As a result, the eye is forced repeatedly to scan each image looking for clues as to how to read it, and the viewer is drawn into an ever deeper engagement with the picture.

It is Close's singular ability to invest and reinvest his interest in painting with new meaning. From his early black-and-white works of the late 1960s—made up of densely compressed units where the trace of the artist's hand is tightly controlled—to his richly colored recent paintings with their bold open strokes, Close has constantly experimented with different ways of organizing the structure of his pictures. By varying the size and increment of the grids he uses to build up his images, he is able to alter dramatically the way each picture is realized. It is this constant sense of inquiry and engagement that makes each of his paintings such a remarkable event, and the trajectory of his remarkable career so compelling.

Although *Chuck Close* concentrates on the artist's paintings, photographs, and drawings, a companion show has been organized by Deborah Wye, Chief Curator of Prints and Illustrated Books, that focuses on his printmaking from 1972 to 1997. Together these exhibitions provide a unique opportunity to study and enjoy the work of one of America's most talented artists.

This project would not have been possible without the dedication and commitment of Mr. Storr who, in addition to organizing the exhibition, conducted an interview with Mr. Close for the catalogue. I am also deeply grateful to Kirk Varnedoe, Chief Curator in the Department of Painting and Sculpture, for his essay in the catalogue and for his support of the exhibition, and to the many other members of The Museum of Modern Art's staff who worked on this project.

No undertaking of this scope would be possible without the generosity of numerous sponsors. I am particularly grateful to Michael and Judy Ovitz, to Jon and Mary Shirley, and to Banana Republic, and in particular its chairman, Don Fisher, and his wife, Doris—all avid collectors of Mr. Close's work as well as great friends of The Museum of Modern Art. Finally, I want to thank as well the many public and private lenders to this project who have allowed us to borrow their works and to share them with the public. Their generosity is deeply appreciated.

Glenn D. Lowry, Director

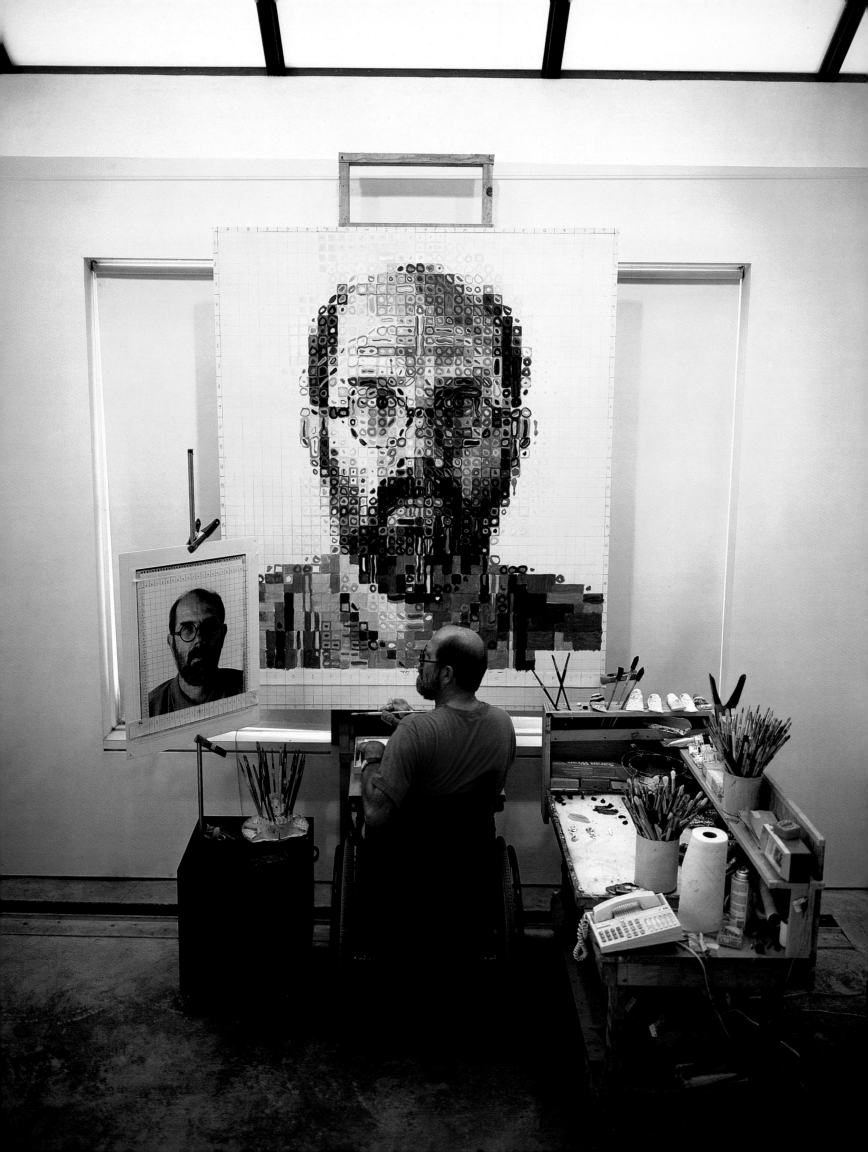

# CHUCK CLOSE: ANGLES OF REFRACTION

ROBERT STORR

The faces are familiar. We are on a first-name basis with them, or, rather, with the pictures in which they appear. The list of those names is long, but not that long. There are frequent repetitions, and a few duplications; that is unsurprising given the ordinary Americanness of most of them. Against their generally bright, clipped rhythms, the few truly foreign ones stand out even as the heads which they identify blend, melting-pot style, into the motley crowd. Scramble the names for a variety of sounds equal to the variety of faces they label: Stanley, Mark, Nat, Susan, John, Richard, Phil, Bob, Francesco, Keith, Sandy, Robert, Klaus, Dorothea, Frank, Joe, Janet, Bill, April, Lucas, Paul, Elizabeth, Cindy, Nancy, Leslie, Linda, Jud, Georgia, Fanny, Marge, Alex.

The exception to the titling of these pictures is "Self-Portrait," which is repeatedly attached to depictions of the changing visage of a balding, usually bearded man who is the author of the extended family portrait that is the subject of this exhibition. His name is Chuck. Or so it became after an editorial mishap that occurred when an early text on the painter initialed "C.C." on the manuscript—for Charles Close—appeared in print under the heading, "An Interview with Chuck Close."[1] This professional rechristening annoyed the artist, but the nickname stuck and for good reason. "Charles" is a fine name, but it does not roll off the tongue in the company of Phil, Bob, Joe, and Janet the way "Chuck" does. It is fitting, then, that the artist should take his place among his other subjects on a comparably informal footing.

The concept of informality applies only to the social ambiance Close and his cast of characters collectively inhabit. In all its permutations—paintings, watercolors, pastels, drawings, prints, photographs—the work itself could hardly be more formal. Whether staring straight at the viewer, partially turned away—this three-quarter view appears for the first time in *Self-Portrait* (1997; p. 201)—or in profile, Close's sitters are consistently posed in a manner that disallows any but the subtlest of individual inflections. At first glance the Polaroids the artist works from resemble a driver's license or passport photos. Patiently scrutinized in Close's manner, they could not be more different. Far denser visually as a

fig. 1. Chuck Close in his studio working on *Self-Portrait*, 1993

consequence of superior cameras and film, they are imposing in a way I.D. pictures can never be. Inherently grand in scale and aura even when the format is small and the features they record seem unremarkable, these "maquettes," as the artist calls them, are a primary product of his sensibility rather than a casually arrived at notational resource.

Invariably, Close places the faces he thus documents inside similarly proportioned rectangles with little if any room to spare. Cropping the image tight to the sides and top of the head and high on the shoulders eliminates body language and squeezes out background. The drama of the result lies in its stylized neutrality and extreme compression. Each picture is a kind of isolation chamber in which a contest has been staged between structure on the one hand—the rigid geometry of the picture plane, oftentimes graphically subdivided and re-iterated as a grid—and, on the other hand, the organic contours, masses, textures, and tints that compose a person's singular presence and are recomposed by the artist with a given system of marks that incrementally fills the space he has chosen.

In the three decades since 1968, when he made his first signature painting from a black-and-white self-portrait photograph (pp. 106, 107), Close's art has consisted of an ongoing experiment in synthesizing the absolute particular of the human form with the absolute requirements of his modern technique and his modernist format. Like any successful experiment, his is a demonstration of control, without which the results, intriguing as they might be as elaborations on the physiognomy of his subjects, would be valueless in terms of his primary concern, the anatomy of pictures. Within the implicit or explicit template from which he works, only the information his photographic source provides and his method of transcription imparts to us are permitted to enter our field of vision.

Critically speaking, Close's project has been carried forward in a correspondingly self-contained manner. For an oeuvre so well-reported on and widely known, this relative isolation constitutes a paradox, as if the artist's monolithic heads stood cluster by cluster, like so many statues on an art-historical Easter Island.

There are several reasons for this. To some degree the situation is due to Close's reluctance to have his work judged in conjunction with that of other artists whose premises and ambitions are fundamentally dissimilar to his own, despite the superficial points of comparison that caused them to be thrown together. When he first began to exhibit regularly in the early 1970s, he was quite outspoken in this regard, fending off the embrace of various movements or tendencies—mostly "Realist"—eager to count him as an ally or recruit. This reaction, Close now readily admits, borders on the Woody Allen syndrome—refusing to be a member of any club that would have you. Fundamentally, however, it was the sound, self-protective response of a young painter loath to see his still-evolving aesthetic identity swallowed whole by amorphous "isms."

Other camps have chosen to ignore him because, hewing to no aesthetic party line, Close, by virtue of his multimedia practice, bridges gaps some would prefer to keep wide apart. Thus the partisans of technologically oriented

modes of modernist or postmodernist art at war with studio traditions find it inconvenient that a painter who persists in the endeavor should also be the one who has analyzed the photomechanical image in such depth and detail. Rather than deal forthrightly with this anomaly, and so risk the revision of dogma Close's cross-fertilizing activities would require, the avowed disciples of Walter Benjamin and Roland Barthes pass over his work with barely a murmur.

Commonly, however, the limitations found in what *has* been written about Close's work stem from the fact that the artist himself makes such good copy. Even his surname lends itself to journalistic shortcuts through the actual complexity of the hall of mirrors he has created. A sampling of headlines and article titles tells the unfortunate tale: "Close-up," "Close, Closer, Closest," "Close Up Close," "Looking Closer at Chuck Close," "Close Quarters"—this for an article on his studio-house in a glossy "shelter" magazine—and, worst of all, variants on Steven Spielberg's eponymous science-fiction hit, "Close Encounters," and "Close Encountered." Compounding these puns are "Face to Face," "Face to Face with Faces," and more of the sort. The net effect of this wordplay is caricature, the jokey reduction of the artist's larger aims and accomplishment to their most rudimentary terms.

Another, more sympathetically intended simplification of Close's art consists of an excessive attention to issues of facture. In part this results from the layperson's understandable fascination with the "tricks" of the artistic conjuror's trade. The more nearly an image seems to replicate "nature" the more insistently people want to know the gimmick behind it. Professionals have their own curiosity about these matters. Close himself has asked whether or not at "a convention of magicians, the magicians see the illusion or the device" responsible for it.[2] He has effectively answered his own question as well—and in so doing encouraged the focus on technique—by discussing at length the possibilities made available to him by new media or by old but hitherto untried studio methods such as mezzotint. His enthusiasm is contagious, but too often prompts a largely procedural or descriptive treatment of the work. Evidently satisfied by Close's explanations, the authors of such articles have been content to paraphrase them while shying away from further consideration of the motives behind what the artist does or the context in which he works.

Then there is the man himself. Urbane and articulate, he has exerted a considerable magnetism on writers. As far back as 1977, critic Thomas Hess would comment, with a note of amicable frustration, "All the obvious things have been said about these paintings many times, and most of the words have come from the artist himself. A natural-born interviewee, he's as charming and chatty as his art is tough and mute."[3] Like any gifted conversationalist, Close has a stock of amusing as well as significant anecdotes to tell. Until recently, there was no unifying dramatic thread to these stories. A worker by habit if not by temperament, he has led a relatively quiet, purposeful life. Biography, in the sense of fateful events, is not the linchpin in his art. But character is.

Close's artistic makeup is the product of good luck intelligently exploited and true adversity ingeniously overcome. He was born into a lower middle class

family in the far Northwest—his father was a dedicated but unsuccessful inventor who died when the artist was eleven, and his mother a trained musician who nurtured her son's artistic leanings. As a boy, Close suffered from chronically poor health and severe learning disabilities, but by dint of effort, and a knack for finding his own solutions to problems he could not surmount in the prescribed manner, Close excelled in school. From modest beginnings he went on to win the support of his teachers at a local junior college, was among those selected in a national competition to attend the Yale Summer School of Music and Art, returned home to complete his B.A. at the University of Washington with high honors, was accepted by Yale University's graduate program, where he studied between 1962 and 1964, and on graduation was awarded a Fulbright scholarship to Vienna. Thus prepared, Close arrived in Manhattan's SoHo district in the late 1960s just as the downtown art scene was becoming the focus of attention, and his star rose steadily apace with the overall burgeoning of the New York art world.

His is an American success story of opportunity seized graciously but unequivocally. Then in the prime of his career, Close was struck again by illness. In December 1988, a congenitally weak blood vessel in his spinal column ruptured, paralyzing him from the neck down. And again, by force of will and mind, Close, having recovered partial movement, rebuilt his strength, reorganized his working process, and, detail by practical detail, adapted himself to his new condition, without compromising his overall artistic direction or ambition.

Close's arduous triumph over this sudden physical disaster is in keeping with his nature. If anyone can be said to be ready for such hardship, he was, despite its actual unexpectedness. Although compelling and often told—at times, it should again be said, at the expense of serious attention to his work— the story of Close's paralysis is less about the crisis that occurred than about how half a lifetime's rigorous focus and discipline made it possible for an evolving aesthetic inquiry to continue its gradual progress, almost uninterrupted, even as that same exceptional capacity for concentration was brought to bear in retraining an injured body to perform its creative functions.

True, there are things Close can no longer do, and must delegate to others or renounce. But the range of options remaining to him is far-reaching, and his ability to exploit their subtlest nuances is undiminished. Moreover, before he was crippled, Close had already moved toward a bolder, more painterly manner. The chromatic and compositional system of his recent paintings is not, therefore, an accommodation reached with the medium because of his handicap, but a choice made in the fullness of his artistic powers. This mid-career reorientation is further proof that for this artist at least, any restriction set—whether dictated by the ethos of modernist reductivism or by his long-standing determination to bend personal disability to good use—is an opportunity to make something distinctive and fresh.

For the reasons just referred to, Close's work occupies a respected but largely self-referential critical position. This grants him a certain privilege, to be sure, but also places him at a disadvantage by sidelining his contribution to

the broader discourse of contemporary art. One-person exhibitions and retrospectives exacerbate this effect. Customarily, a retrospective singles out the work of a given artist and examines the distinct stages and elements of his or her achievement in comparison to each other. In Close's case, however, the need is to break the habit of reading his work through the prism of its manifold physical dimensions and underscore instead its relations to other art.

In the brief sections that follow, I have attempted to spell out some of those connections while, in more general or speculative terms, indicating other avenues departing from or approaching Close's work. Insofar as the text is narrative, that narrative is one of working hypotheses arrived at by the artist within a particular context, and of applications accepted, rejected, or wholly invented. For Close, as for many of his contemporaries, traditional notions of inspiration and intuitive search are beside the point. Their faith in art's potential for new forms and fundamental changes in awareness is no less great than that of previous generations, but their manner of achieving those ends differs entirely from those of the past. Fundamentally, Close, and his peers, are decision-makers. The gamble they have taken is that the unique products of programmatic artistic choices will defy generalities and exceed any foreseeable results. In that spirit, using every means at his disposal, from photography to painting, to printmaking, to drawing, and back to photography, Close has spent the last thirty years pushing representation to its limits. In the process he has won his aesthetic wager many times over.

1.

Critics and historians writing about a painter or sculptor often anchor their analyses by citing the artist's influences. Far less attention is generally paid to the artist's overall education. This imbalance reflects intellectual habits formed around the idea that the vanguard artist is basically a free agent who establishes links to tradition through selective imitation of, and/or opposition to, the work of his or her predecessors. This way of accounting for artistic development fuses the old-fashioned models of self-apprenticeship and atelier training that generally applied from the mid-nineteenth through the mid-twentieth centuries.

By self-apprenticeship, on the one hand, I mean the emulation of a mature artist without direct instruction. This is what Vincent van Gogh did in his Dutch isolation, and what Arshile Gorky did in his American exile. In the privacy of their studios, virtually all budding artists do it to some degree, but very few nowadays do it in total solitude. By atelier training, on the other hand, I mean one thing that happens under several different auspices.

The pedagogical model that developed in Europe beginning in the late Renaissance with the founding in 1582 of the Accademia degli Incamminati by the youthful Carraccis—Lodovico, and his nephews, Agostino and Annibale— and saw its glory in France in the seventeenth, eighteenth, and early nineteenth centuries was predicated on the mentorship of a recognized master who set the standard for his pupils, rehearsed them in the appropriate skills, criticized their

performance, and prepared them for the competitions that would determine their careers. The Ecole des Beaux-Arts in Paris—which is still run along these essential lines—was the bastion of this system.

But by the 1840s and on into the 1950s, independent academies flourished, and often as the vehicle for propagating a single artist's ideas. Thus, for example, Fernand Léger's school attracted French artists, such as the young Louise Bourgeois, who attended in the late 1930s, as well as American artists who migrated to Paris just after World War II, such as Sam Francis, Richard Stankiewicz, Kenneth Noland, Jules Olitski, and Robert Colescott. Although organized to offer an alternative to the conservativism into which the Ecole des Beaux-Arts had fallen by the mid-nineteenth century, these private schools were, in some respects, a throwback to much older forms of training insofar as they were often based on the direct transmission of style and technique from teacher to student without any broader curriculum.

In their finest hour before they degenerated into regulators of style, the great academies of France had been centers of inquiry rather than of rote learning. Founded by young men, and open to practitioners of diverse opinions, the nascent French academy of the mid-seventeenth century began as a professional rallying ground and debating society with the aim of breaking the stultifying economic and aesthetic monopoly of the traditional craft guilds. Later, operating under the patronage of the State and the academy's aegis, the Ecole des Beaux-Arts was created to foster educational changes—based in part on the Carraccis' ideas regarding the direct study of nature as opposed to the reiteration of guild-sanctioned formal stereotypes. The prime objective of these changes was to raise the visual arts to the level of other cultural and intellectual disciplines as part of an overall Enlightenment coordination of the liberal arts. Although reviled as reactionary by early modernists for a rigid attachment to the neoclassicism with which it became synonymous by the mid-nineteenth century, the original French academy was, nevertheless, a progressive entity at its creation in 1648, and so it remained, in varying degrees, for almost two hundred years thereafter.[4]

Reviewing this past in even so cursory a manner changes one's optic in relation to postwar developments in American art. Increasingly, as modernism evolves, the common practice of damning certain forms of painting and sculpture with the epithet "academic," while praising others as "avant-garde," begs the qualifying and therefore crucial questions that should be asked. Usually the distinction made is between things that have the look of spontaneous invention and those that bear the clear marks of premeditation and applied skill. Realism, in this respect, is often dismissed as "academic" by advocates of novel styles, although Realism in its most radical variants was, in the nineteenth century, and remains today, a highly critical and "anti-academic" mode. (More on that subject in the third section of this essay.) Insufficient consideration is given to the virtues of ambitious academic art or art fundamentally indebted to the academic tradition in cases where the term is used strictly rather than pejoratively, as one should in discussing the works of the Carraccis,

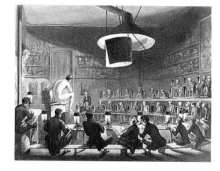

fig. 2. Thomas Rowlandson. *Drawing from life at the Royal Academy, Somerset House.* 1808. Etching and aquatint, hand colored, 9⅜ x 11¼" (23.8 x 28.6 cm). The Metropolitan Museum of Art, New York. Gift of Enid K. Rubin, 1979

Nicolas Poussin, Jacques-Louis David, Jean-Auguste-Dominique Ingres, or even of his most gifted disciple, Edgar Degas, who, parenthetically, was among the first to refer to photographs not only as a draftsman's *aide-mémoire* but also for their intrinsic properties of timing and framing.

Created in opposition to the vestiges of decadent nineteenth-century academies are the modernist academies. The Russian Revolution gave rise to a dynamic network of such institutions that briefly thrived with the support of the Communists until Stalin shut them down in the early 1930s. Revolutionary upheavals in Germany after World War I had much the same effect. Their most far-reaching consequence was the mandate given to Walter Gropius to reform the Weimar Art Academy, resulting in 1919 in his founding the Bauhaus, which, after being closed in 1932 under pressure from the Nazis, proceeded to extend its influence to the United States through the teaching of refugee students and professors.

Like Gropius, who pressed for a comprehensive reorganization of art education within the shell of the old system before moving on to create a wholly new school, Joseph Beuys spent his years as a professor in the 1960s and 1970s improvising an "anarcademy" within the confines of the existing Düsseldorf Art Academy. Staging his palace coup inside the walls of that nineteenth-century edifice, Beuys encouraged his students to experiment with conceptual art, assemblages, or other non-traditional forms in high studios designed and built for artists of previous generations who had used them to fashion vast public sculptures or paint huge pictorial "machines." Like their antecedents, moreover, these modernist schools were organized around definite principles, some of them grandly philosophical, others praxis-oriented, so that students entering them were inculcated with a clearly articulated rationale for making art while being drilled in the aesthetic grammar codified by their teachers.

Until the end of World War II, Americans were slow to appreciate this shift in paradigm, and to this day many in this country tend to speak disparagingly of the academy as if it still meant something inherently stale, "faux" classical, and "wannabe" European. The lore of Abstract Expressionism preserves this distinction in its celebration of a contentious confederation of artists at war with entrenched convention, of inspiration or improvisation versus intention and labor. And yet, at the speed that this myth seeped into the public consciousness, the mannerisms of Abstract Expressionism became the staple of art schools across the country. America's great indigenous contribution to modernism was "academic" in the negative sense of being imitated by lesser talents, almost as soon as it became an identifiable style.

In the meantime, new academies—ones that shared the original aims of the first great academies to establish art as a legitimate pursuit of cultured people— began to spring up everywhere. And many of them were truly unprecedented insofar as they were directly attached to the larger academic system of American colleges and universities. In this setting, the study of art became one more specialty among the many offerings of a general educational program, with the graduate divisions of these art departments approximating the profes-

sional schools in other fields. Regardless of their relative marginality in such places, art students began to routinely share in the broad-based social and intellectual life of the American campus—and in the career expectations of their scholarly peers.

These changes in artistic preparation brought about changes in professional conduct. The pure bohemian of expatriate or Greenwich Village legend was rapidly becoming an anachronism. Replacing him was "the artist as a man of the world," or so he was called by Allan Kaprow, former art-history student at Columbia University, sometime art critic, and the originator and theoretician of Happenings. Writing in 1964, Kaprow, in many respects an exemplar of his own idea, described this new persona in the following words: "The men and women of today's generation matured during and directly after World War II, rather than during the Depression. They are almost all college-educated, and are frequently married, with children. Many of them teach or have taught. On the street they are indistinguishable from the middle class from which they come and towards whose mores—practicality, security and self-advancement— they tend to gravitate."[5]

By no means did all of Kaprow's generation fit this prototype, and soon after he wrote the piece—published in *Art News*, the house organ of the Abstract Expressionist camp edited by Thomas Hess, who attacked the piece in a companion text called "The Artist as a Company Man"[6]—the exuberant sixties counterculture broke through the buttoned-down cool Kaprow had defined. But Kaprow's more basic point stood; the romantic notion of the artist as uncompromised outsider, dedicated only to his or her aesthetic calling, actively hostile to middle-class values, indifferent to middle-class comforts, and aloof from the mundane business and politics of culture was wrong-headed and self-defeating. Artistic success, Kaprow argued, could no longer be had at the cost of heroic failure in every other dimension of existence. On the contrary, the only guarantee that an idea would be recognized for its true worth was the efforts of its originator. Henceforth the artist was primarily responsible for every aspect of his or her life—from the production of art, to its interpretation, and its dissemination.

fig. 3. Paul Rudolph. Art and Architecture Building, Yale University, New Haven, Connecticut. 1963

In art schools, meanwhile, the ideology and the methods of Abstract Expressionism were under siege at the very point where they exercised their most enduring authority. Nowhere was this truer than at Yale University, perhaps *the* preeminent institutional training ground for artists in the United States during the past forty years. Yale was—and to a considerable extent continues to be— the epitome of the American university art department—the Academy within the Academy.

Presiding over Yale in the 1950s and 1960s in chronologically overlapping groups were a number of personalities whose ideas conflicted even when they did not. In one corner were the dedicated pedagogues such as Josef Albers and Bernard Chaet. Arguably the greatest artist-teacher of his era, Albers was a veteran of the original Bauhaus as well as of the American educational utopia, Black Mountain College. From 1950 to 1958 he was Dean of Yale's Department

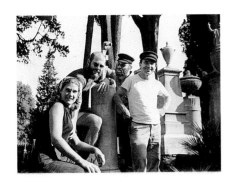

fig. 4. Nancy Graves, Chuck Close, Richard Serra, and Stephen Posen at the English Cemetery in Florence, Italy, 1964

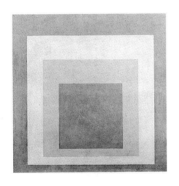

fig. 5. Josef Albers. *Homage to the Square: Two Whites Between Two Yellows.* 1958. Oil on composition board, 40 x 40" (101.6 x 101.6 cm). The Museum of Modern Art, New York. Mary Sisler Bequest

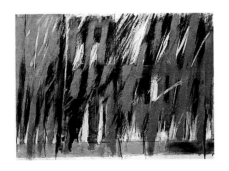

fig. 6. Jack Tworkov. *West 23rd Street.* 1963. Oil on canvas, 60⅛ x 80" (152.7 x 203.2 cm). The Museum of Modern Art, New York. Purchase

of Design, which encompassed painting, sculpture, and graphic arts. It was Albers, with his finely calibrated color schemas and austere serial painting, who posed the most outspoken challenge to the Abstract Expressionist faith in intuitive composition and exemplary creative suffering. And it was Albers who once dispatched a postcard to Harold Rosenberg, the New York School's premier existentialist critic, with the message, "Angst is dead."

In another corner stood the veteran Abstract Expressionists who taught full or part-time or who came as visiting critics, men such as Jack Tworkov, who headed the school from 1963 to 1969, Philip Guston, James Brooks, and even Willem de Kooning. The third pole of the educational triangle consisted of younger but already established artists who eschewed both gestural and systemic abstraction. Notable among them were the hard-edge abstract painter Al Held, the hard-edge figurative painter Alex Katz, and the hard-focus realist painter Philip Pearlstein.

Students entering Yale thus found themselves in the pull of several aesthetic force fields generated by the weekly encounter with full-time faculty, amplified by contact with a constant flow of visiting artists of diverse persuasions, and filtered through the shifting interests of fellow students. They were not, however, in an atelier or conservatory of the European type where allegiance to a single professor was required, but rather in a large liberal-arts institution where sampling multiple viewpoints and experimenting with any number of approaches were the norm. Though certain enthusiasms were widespread—in the early 1960s, according to Close, the favorites were Matisse and de Kooning—no one idea reigned supreme, and none went uncontested.

Having studied at the Yale Summer School in 1961, Close arrived as a first-year graduate student in 1962. Among the students in Close's class or in over-lapping classes were Rackstraw Downes, Janet Fish, Nancy Graves, Robert Mangold, Brice Marden, Don Nice, and Richard Serra. Expanding the scope by a decade on either side of Close's graduation date, one finds the names of Richard Anuszkiewicz, William Bailey, Robert Barry, Jonathan Borofsky, Victor Burgin, Ivan Chermayeff, Eva Hesse, Sylvia Mangold, Irving Petlin, Judy Pfaff, Howardena Pindell, Martin Puryear, Fred Sandback, Haim Steinbach, Gary Trudeau, Neil Welliver, and a host of others who have made significant careers.

Of course, attitudes toward the actual courses taught and critiques given vary among those listed in this roster, just as the pedagogical emphasis of those courses and critiques varied over the years according to the professor or visiting artist responsible. Albers's retirement in 1958 ended his direct involvement with the program, although several years later Richard Serra, a classmate of Close, worked with Albers to prepare the 1963 publication of Albers's widely influential theoretical workbook *Interaction of Color.* Tworkov, who took over in the middle of Close's stay, abandoned Albers's emphasis on core courses in basic design and perceptual problems, but held to the belief that rather than teach students how to be artists—an impossibility—or indoctrinate them in a particular aesthetic, Yale's goal was to expose students to as wide a range of competing ideas and potential choices as could be brought together under its roof.

"Just as there is no self except in relation to other selves," he said, "so there is no artist except in relation to other artists. The problem of identity for me is to work out my relation to the artists and art of my immediate environment."[7]

For his part, Bernard Chaet's approach to teaching drawing by direct observation, coupled with exercises employing the tools and mimicking the manner of great draftsmen from Dürer to Seurat, found differing degrees of sympathy and had correspondingly differing degrees of impact. But this method contributed to an overall climate, and reinforced certain student predispositions toward the past. The art-historical self-consciousness inherent in such an educational attitude is indirectly mirrored, for example, in the calligraphic drawings of Brice Marden—a respectful fusion of Rembrandt's reed-pen drawings, Philip Guston's ink drawings (with their nod to Rembrandt and van Gogh), and Chinese scroll painting—or in Marden's juxtapositions of pure architectonic geometries and collaged art postcards.[8]

By his own account Close was a "superstudent" in a situation wholly devoted to honing the talents of the best and the brightest of an ever-growing number of young artists-to-be.[9] Competition among them was fierce, and it encouraged reciprocal challenges, constant debate, and the rapid assimilation of large quantities of information available through magazines, books, and slides—more than any other before it, this generation of artists was raised on reproductions—as well as direct access to some of the most dynamic painters and sculptors then at work, and to all that the nearby New York galleries and museums had to offer. "At Yale we all learned to talk art before we could really make it," Close once remarked. "Not a bad skill actually. When you do get a great idea at least you can recognize it, articulate it, and exploit it."[10] With everything one needed and more in easy reach, and with the already acquired skills necessary to pursue any of the paths indicated by the styles that might, for a moment, seem promising, the open question remained, to what ultimate end does a gifted student apply himself or herself? How, in effect, does one take the fullest possible advantage of a well-structured academy and yet avoid becoming academic in the least sense of that adjective? That has been the quandary of the vast majority of aspiring American artists during the second half of this century, and it was Chuck Close's problem when he set out for New Haven in 1962.[11]

2.

Time and again in interviews Close comes back to this question. Occasionally the bravado of the young turk comes through. "I have made Hans Hofmanns easily as good as Hans Hofmann made Hans Hofmann's and sometimes better," he once said.[12] Boastful about his painterly knack on this occasion, on others he has been explicit about the predicament it put him in. "The first-generation abstract expressionists suffered and after that it was a system. We painted out of a system. We didn't have tortured, anguished, alcoholic people. We were art students, for Christ's sakes."[13] The issue was more fundamental than lifestyle, however. "I admired painters like Rothko, Pollock and Kline," Close once acknowledged. "But they nailed it down so well that I couldn't do anything but

fig. 7. Ad Reinhardt. *Abstract Painting, Red.* 1952. Oil on canvas, 108 x 40⅛" (274.3 x 101.9 cm). The Museum of Modern Art, New York. Gift of Mr. and Mrs. Gifford Phillips

weak impersonations of their work. . . . All my heroes were dead, and my work was incredibly eclectic."[14]

What earns rewards in school—Close's gestural paintings garnered the enthusiastic attention of at least one charter member of the first-generation Abstract Expressionists, Philip Guston—does not necessarily sustain momentum once outside it. Here, too, Close has been candid. "I could make any kind of art marks you wanted. . . . Once you know what art looks like it's not hard to make some of it. . . . And the dilemma that I found myself in after having gotten out of graduate school is [*sic*] enjoying making art but not liking what I made."[15]

A tug-of-war between authenticity of feeling while making a work and convincing form in the finished product had bedeviled artists since the myth of Pollock and de Kooning forging primordial images out of inchoate psychic matter and raw studio materials had first been propagated in the 1950s. It hardly mattered that this account misconstrued their methods, particularly those of de Kooning, who was, in his fashion, the most deliberate of artists. This fact notwithstanding, mystification of the creative act was steadily undermining the practical and imaginative freedoms Abstract Expressionism had won. Simultaneously, as Close had stated frankly, their aesthetic had become a "system" out of which others painted with ever greater familiarity and decreasing vitality.

Close was not alone in facing this challenge. A number of artists just making their presence felt around this time were gradually articulating an alternate model. At issue was a diametrical inversion of artistic process and identity. As an alternative to intuitive strategies which had become formulaic, these artists posited simple but severe strictures that stymied reflex gesture while bringing to light previously unexplored technical, compositional, and conceptual opportunities. The relevant texts articulating this shift follow logically, one upon the heels of the other.

fig. 8. Jasper Johns. *Souvenir 2*. 1964. Oil and collage on canvas with objects, 28¾ x 21″ (73 x 53.3 cm). The Estate of Victor and Sally Ganz

Ad Reinhardt in "25 Lines of Words on Art: Statement" of 1958:

11. PAINTING AS CENTRAL, FRONTAL, REGULAR, REPETITIVE.

18. BRUSHWORK THAT BRUSHES OUT BRUSHWORK.

20. THE STRICTEST FORMULA FOR THE FREEST ARTISTIC FREEDOM.

21. THE EASIEST ROUTINE TO THE DIFFICULTY.

23. THE EXTREMELY IMPERSONAL WAY FOR THE TRULY PERSONAL.

24. THE COMPLETEST CONTROL FOR THE PUREST SPONTANEITY.[16]

Jasper Johns, from his sketchbook of c. 1963–64:

Take an object

Do something to it

Do something else to it

"        "        "   "   "

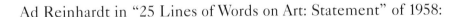

Take a canvas
Put a mark on it
Put another mark on it
"        "        "     "    "  17

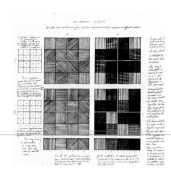

fig. 9. Sol LeWitt. *Wall Markings*. 1968.
Ink on paper, 16 x 16" (40.6 x 40.6 cm).
Whereabouts unknown

Sol LeWitt, from his "Paragraphs on Conceptual Art" of 1967: "I will refer to the kind of art in which I am involved as conceptual art. In conceptual art the idea or concept is the most important aspect of the work. When an artist uses a conceptual form of art, it means that all of the planning and decisions are made beforehand and the execution is a perfunctory affair. The idea becomes a machine that makes the art." 18

Richard Serra, from his "Verb List" of 1967–68:

| To roll | to sever |
|---------|----------|
| to crease | to drop |
| to fold | to remove |
| to store | to simplify |
| to bend | to differ |
| to shorten | to disarrange |
| to twist | to open |
| to dapple | to mix |
| to crumple | to splash |
| to shave | to knot |
| to tear | to spill |
| to chip | to droop |
| to split | to flow |
| to cut | to curve |
| | to life…19 |

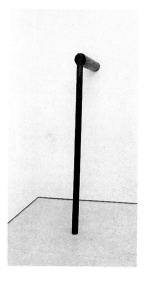

fig. 10. Richard Serra. *Close Pin Prop*. 1969.
Lead antimony, 90 x 6 x 100" (228.6 x
15.2 x 254 cm). Solomon R. Guggenheim
Museum, New York. Panza Collection, 1991

Perusal of artists' statements from the period uncovers further evidence of this reorientation toward art forms that were planned, dispassionate, impersonal, and materialistic. Each contribution enlarged the scope of resistance to the model of Abstract Expressionism, the importance of which nearly all of those involved candidly acknowledged. Opposition to this diffuse tendency toward programmatic art-making was strong. Some of its most dedicated adversaries were "mainstream" formalist critics, who, as an alternative, defended "Color Field" painting, the movement most obviously derivative of Abstract Expressionism. The watchwords of the formalist camp were "quality" and "taste."

Some of the younger systemic artists showed an affinity for individual Color Field painters—both Kenneth Noland's targets and Larry Poons's dot-matrix paintings (fig. 11) bear interesting comparison to Minimalism's more severe manifestations, while the stripe paintings of Princeton-educated Frank Stella (who has more or less explicitly laid claim to the role of a Carracci-like high academic artist) unilaterally linked these diverging groups. Yet "taste" as a criterion was anathema to virtually all.

fig. 11. Larry Poons. *Night on Cold Mountain*. 1962. Synthetic polymer paint and dye on canvas, 80 x 80" (203.2 x 203.2 cm). The Museum of Modern Art, New York. Larry Aldrich Foundation Fund

fig. 12. Frank Stella. *Sketch Les Indes Galantes*. 1962. Oil on canvas, 71⅝ x 71⅝" (181.9 x 181.9 cm). Walker Art Center, Minneapolis. Gift of the T. B. Walker Foundation, 1964

Taste, in the sense of informed discrimination and delectation, is a largely conservative attribute. When strongly possessed, not just strongly proclaimed, it is usually rooted in the frequent and exacting study of original works. In practice it is a mix of instinct, appetite, connoisseurship, and the ability to extrapolate from one class of things to another closely or remotely related one. Universal taste—that is, the ability to determine the best among objects of widely disparate traditions—is extremely rare, if not entirely hypothetical. More to the point, taste is seldom the most reliable indicator of the potential in new ideas—except if you admit the possibility of "taste" in generative concepts—especially insofar as the first statement of those ideas may intentionally defy prevailing conventions or may simply be so awkward as to be easily belittled or ignored.

Weaning himself from his own taste for painterly painting and the immediate pleasure he took in making it constituted Close's declaration of independence. As LeWitt stipulated in his 1969 "Sentences on Conceptual Art," "Banal ideas cannot be rescued by beautiful execution." LeWitt postulated other axioms that help explain the direction Close was then taking. "Successful art changes our understanding of the conventions by altering our perceptions," LeWitt wrote. Four crucial corollaries regarding facture amend this point. One: "The process is mechanical and should not be tampered with. It should run its course." Two: "If the artist changes his mind midway through the execution of the piece he compromises the result and repeats past results." Three: "The artist's will is secondary to the process he initiates from idea to completion. His willfulness may only be ego." Four: "There are many elements involved in a work of art. The most important are the most obvious."[20]

Two years before this text appeared, Close had already reached similar conclusions on his own. His breakthrough painting was a reclining figure based on the photograph of an acquaintance. Nearly ten feet high and just over twenty-one feet across, this "Cinemascope nude," as he has called it, was made in thin coats of black paint applied with brushes, sponges, rags, and spray guns to a flat white ground, and then textured or removed from it by erasers, razor blades, and an electric drill. The painting was never completed, but a second version was, and it shows a virtuoso touch throughout (fig. 13). Dissatisfied, however, by the unevenly distributed focal points in this otherwise consistently handled and Pollock-scaled "overall" painting—a large unblinking picture of a naked young woman does not draw equal attention the length of her whole body—Close resolved the next time to deal only with the head, greatly enlarged and seen full-face.

The primary merits of this subject were inherent interest, iconic fixity, and the subtle play of symmetrical formatting and asymmetrical features. With this subject in place, Close was at liberty to perfect his basic technique and then annex new ones as the necessity for further challenges arose. Abjuring the flourish of the brush that had become treacherously seductive second nature to him, he put aside oil paint in favor of water-based pigments and mechanical or other non-traditional applicators. Until it returned in the fingerprint works

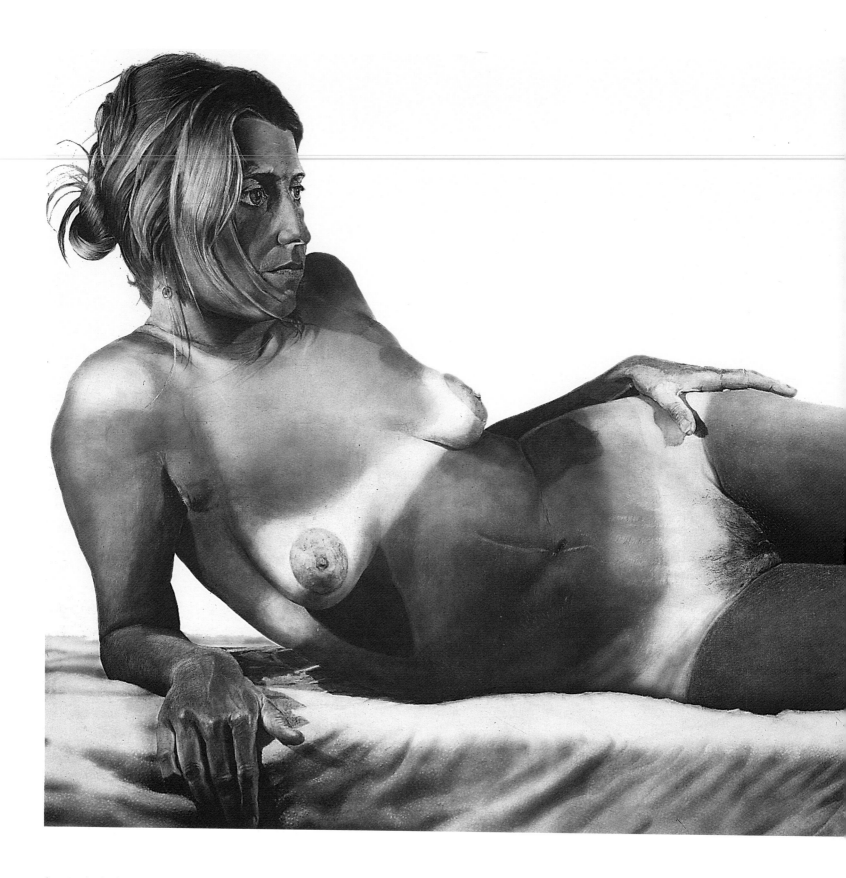

fig. 13. Chuck Close. *Big Nude.* 1967.
Acrylic on canvas, 9'9" x 21'1"
(297.2 x 642.6 cm). Collection Jon
and Mary Shirley

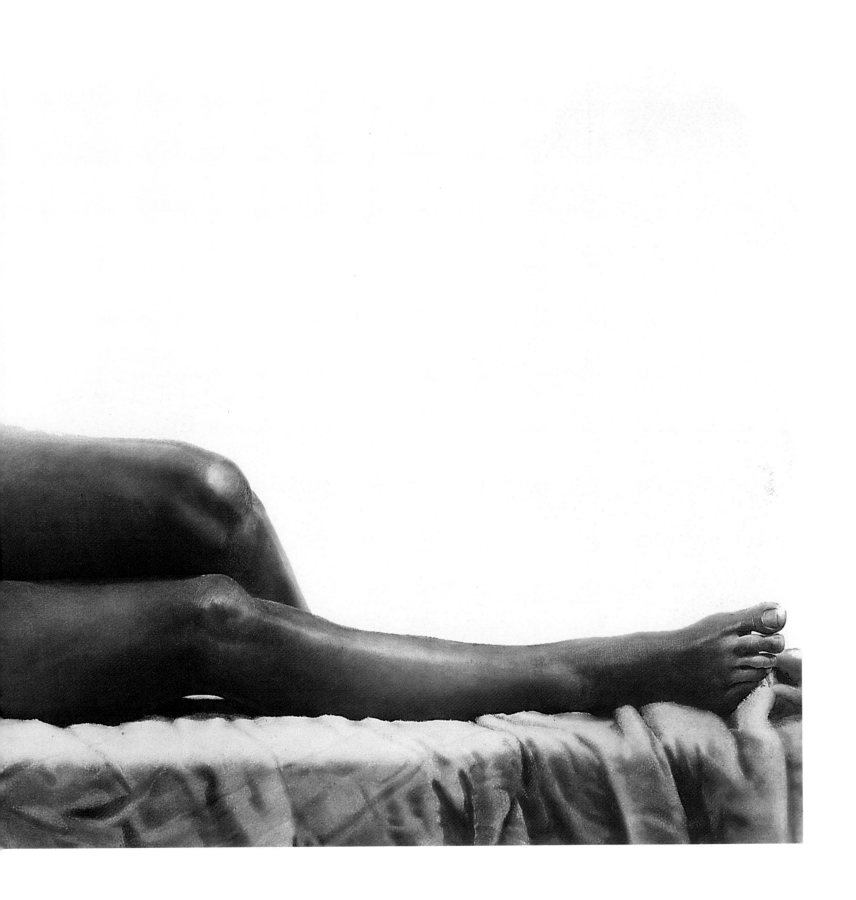

of the late 1970s, Close's hand entirely disappeared from his art. Since 1968, when he made his first self-portrait, Close's pictorial setup has, in essence, gone unchanged.

The artist's paradoxical determination to take command of his art only to surrender that command to a predetermined series of procedures can be quantified by the intensity of the labor to which he committed himself. Typically a painting made according to the rules he laid down for himself in the late 1960s and early 1970s would take four to seven months for a black-and-white canvas, twelve to fourteen months for one in color, slowing output to a crawl and delaying gratification to an hallucinatory point. Realizing this final effort required Close to repaint the entire image at least three times. Denying himself expressive gesture, he would build shapes and tonal variations within his working grid by repeated bursts of sprayed paint, going over and over an area he wished to elaborate but apportioning it the same amount of dilute pigment on each pass. "I wanted to make pieces in which each square inch was physically exactly the same…I wanted a stupid, inarticulate, uninteresting mark, that in and of itself could not be more interesting than the last mark or more beautiful than the next."[21]

To achieve the nuances that in sheer coatings of black acrylic distinguish stubble from wrinkled flesh, knitted fabric, shiny metal eyeglass frames, and all the other surfaces and textures in *Robert / 104,072* (1973–74; p. 129), Close had to "hit" the one hundred four thousand seventy-two squares of the grid an average of ten times. That adds up to over a million separate painting acts, completed day after regular workday for months on end. (The color pictures were composed of separate monochrome layers using only the primary hues employed in modern printing—cyan [a greenish-blue], magenta [reddish-purple], and yellow—which optically mixed when all the glazes were in place to create the full chromatic range of the completed work.)

Boring studio routine, alleviated only by the sound of music or television, was the accepted price for paintings that were truly unfamiliar and demanding. "I think it's a sense of professionalism," the artist once said. "I'm absolutely willing to do whatever's necessary to make something that I care about."[22] Thus, his solution to the problem posed by his own facility was to create difficulties, just as his solution to the problem of habit-forming style was to observe a habit-breaking regimen. Shedding his nebulous second-hand ideal of what an artist *was*, in exchange for finite ideas about what he as an intellectually and manually dexterous artist *could do*, Close effectively pitted his advanced academic training against his acquired academic taste.

Establishing new conventions is the task of the avant-garde. This means reordering art's content-bearing priorities and reconfiguring its formal variables. Turning the attitudes of the "superstudent" that he had been inside out, Close joined the ranks of the mid-1960s avant-garde, an amalgam of conceptual, minimal, and process-oriented artists. By virtue of a small number of initial decisions taken in conjunction and unwaveringly adhered to, he simultaneously aligned himself with Reinhardt's and Stella's emphasis on frontality,

fig. 14. Gerhard Richter. *Eight Student Nurses.* 1966. Oil on canvas, each 37¼ x 27½" (94.6 x 69.9 cm). Private collection, Cologne

Reinhardt's and LeWitt's faith in detachment and consistency, and Johns's and Serra's empirical conjugation of images and materials. Close, however, was the only "realist" in this company or in the larger community of interest they personify.

3.

From the outset Close shunned the "realist" rubric. "Realism is a word that came to us complete with baggage. I wasn't sure what it really meant," he once said, later explaining that "'New Realism' implies it is connected to old realism, and yet the old realist painters like Eakins and Hopper were not heroes of mine."[23] In fact, many of his former Yale classmates or near contemporaries had been or became "realists" in a sense that links up in some fashion with the American tradition to which Close referred; among them, Robert Berlind, Rackstraw Downes, Janet Fish, Sylvia Mangold, Michael Mazur, Stephen Posen, and Harriet Shorr. Thus Yale was—and to this day remains—a prime breeding ground for "new" realisms of various kinds, and in the early 1960s, despite his arm's-length response, Close was in the thick of it.

By 1968, the year Close painted his paradigm-setting *Big Self-Portrait* (p. 107), Realism was fast becoming a widespread and much-debated trend in the art world at large. Cresting in the mid-1970s, it was the focus of considerable gallery and museum attention. Perhaps the first important exhibition of its kind was "Realism Now," organized by art historian Linda Nochlin and her students at Vassar College in 1968. A year afterward, "Directions II: Aspects of a New Realism" was mounted at the Milwaukee Art Center, followed in 1970 by "22 Realists" at the Whitney Museum of American Art in New York. The latter exhibition included Close's *Frank* and *Phil* (both 1969; pp. 110 and 112). In 1972 the Sidney Janis Gallery tried to reframe the tendency as "Sharp-Focus Realism" and launch it as a successor to Pop art—thereby bringing down the wrath of Pop's irreconcilable enemies. Although Close did not participate in this first exhibition, a month later he showed *Susan* (1971; p. 116) in a second one entitled "Colossal Scale" that, quite literally, expanded on the point made by "Sharp-Focus Realism." Finally, preceded by a flurry of smaller gallery shows in Europe, contemporary American Realism went international in "Documenta 5," the massive critical exposition of current art that has taken place in Germany every five years since 1955. There too work by Close was seen—*Kent* (1970–71), *Susan* (1971), and *John* (1971–72; p. 117)—along with paintings by Richard Estes, Ralph Goings, Howard Kanovitz, and Malcolm Morley, and sculpture by Duane Hanson.

German affinity for cool figuration of this type extended to its own artists. Gerhard Richter, who tackled similar problems, also exhibited at "Documenta 5." The series of black-and-white canvases he presented portrayed the eight student nurses killed by Chicago mass-murderer Richard Speck (fig. 14). There are striking points of comparison between Close's project and Richter's in general, and equally striking contrasts in the way they actually work. Like Close, Richter takes his photographic sources as his subject. He does not turn

to them to paint what they depict—that is, he does not rely on them as artists since the mid-nineteenth century have done to study nature and so perfect an illusion of it—he paints the highly selective reality of the photograph itself. Yet, while Close piled on visual data in his "Documenta" paintings, Richter removed it with the swipe of soft brushes. Close's detachment in the presence of the individuals he described pore by pore was clinical; Richter's, in evoking little-known victims of a famous crime, was evocative and alienating, and almost Warholian in his death-haunted impassiveness. In both cases, however, the German art world's enthusiastic reception of such work harkens back to the *Neue Sachlichkeit*, or New Objectivity, of the 1920s and 1930s, and a pre-existing responsiveness to representational art of the least sentimental and most graphic variety.

Close's wariness about being called a "realist" resulted from the ambiguity of the term, that ambiguity being readily apparent from the ill-matched group of artists who participated in the group shows previously cited. As a whole, little seemed to unite them other than being figurative at a time when formalist abstraction still held critical and market dominion. Linda Nochlin, a scholar of nineteenth-century naturalism, pushed this distinction further in two important articles published in *Art in America* in 1973. Titled "The Realist Criminal and the Abstract Law," these essays argued that while abstraction claimed to pare visual phenomenon down to their essentials, realism sought to come to terms with the relational complexity of things seen. Thus Nochlin wrote: "For Modernism, we may take it that abstraction is the law and that realism is the criminal. Abstract art in this century, and antirealism generally, purges art of its gross impurities, its tawdry accessibility, its general inclination toward what Rosalind Krauss has called the 'documentary' mode."[24]

These purgative claims are not just those of high modernist abstraction, however. In the last century, Nochlin went on to demonstrate, neoclassicism was credited with similarly exalted aims, and "mere" realism was the whipping boy or dialectical counterweight then as well. Whereas realism occupied itself with the ordinary, classicism celebrated the ideal:

> Realism has always been criticized by its adversaries for its lack of selectivity, its inability to distill from the random plenitude of experience the generalized harmony of plastic relations, as though this were a flaw rather than the *whole point of realist strategy* [Nochlin's italics]. . . . To ask why realist art continues to be considered inferior to nonrealist art is really to raise questions of a far more general nature: Is the universal more valuable than the particular? Is the permanent better than the transient? Is the generalized superior to the detailed? Or more recently: Why is the flat better than the three-dimensional? Why is truth to the nature of the material more important than truth to nature or experience? Why are the demands of the medium more pressing than the demands of visual accuracy? Why is purity better than impurity?[25]

Although it had a long, complicated, and impressive heritage prior to Nochlin's piece, contemporary Realism lacked a comprehensive theory to

fig. 15. Fairfield Porter. *The Screen Porch.* 1964. Oil on canvas, 79½ x 79½" (201.9 x 201.9 cm). Whitney Museum of American Art, New York. Lawrence H. Bloedel Bequest

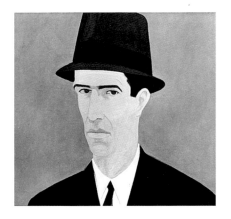

fig. 16. Alex Katz. *Passing.* 1962–63. Oil on canvas, 71¾ x 79⅝" (182.2 x 202.2 cm). The Museum of Modern Art, New York. Gift of the Louis and Bessie Adler Foundation, Inc., Seymour M. Klein, President

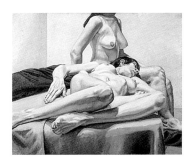

fig. 17. Philip Pearlstein. *Two Female Models in the Studio.* 1967. Oil on canvas, 50⅛ x 60¼" (127.3 x 153 cm). The Museum of Modern Art, New York. Gift of Mr. and Mrs. Stephen B. Booke

challenge the modernist theses of Clement Greenberg and his formalist allies. Part of Close's particular discomfort no doubt owed to the fact that he had more in common with certain formalist artists—through shared use of the grid, interest in materials, relative "flatness" of the picture plane, etc.—than he did with the majority of his realist colleagues.

Most problematic for Close were those who saw expressionistic figuration as a stylistic means to moral ends, the depiction of suffering and protest against its causes. Defining this existentialist current, the 1959 exhibition "New Images of Man" at The Museum of Modern Art gathered together artists as different as Francis Bacon and Rico Lebrun (who had taught at Yale), and, on the less dramatic side, Alberto Giacometti and Richard Diebenkorn.

Close categorically rejected this direction. "I have very little sympathy or interest in the figurative art being shown today," he told Cindy Nemser in 1970. "Don't get me wrong. I don't dislike the notion of figurative art . . . However, I think it is useless to try and revive figurative art by pumping it full of outworn humanist notions."[26] One need not be contemptuous of "humanism" or dismissive of the artists mentioned above to appreciate the thrust of Close's statement. The weakness he perceived in work modeled on such precedents had as much to do with its stylistic fundamentals as with its content per se, in particular their correlation with Abstract Expressionism made explicit in The Museum of Modern Art show by the co-opted presence of de Kooning and Pollock.

Of course, none of the artists represented in that exhibition were realist in any useful sense of the term. By 1960 impatience with accommodations made to Abstract Expressionism had prompted a small number of genuine realists to address the unresolved questions of painterly figuration. Fairfield Porter, choosing the decorous if not decorative painter Edouard Vuillard as his role model over the form-giving Paul Cézanne—with sidelong glances at his friend de Kooning—developed a lively but modest style of intimist realism, a kind of American Scene painting where the view was always good and the sociology Proustian rather than political.

More radical were the examples set by Philip Pearlstein and Alex Katz. Although close to Porter's circle, Katz simplified the pictorial devices he shared with the older artist—silhouetted shapes minimally modeled or edged by drawing and block color inflected by chromatic notations together reaching a sometimes cartoon-like abbreviation of form. These he broadened to billboard scale in the interests of an expansive realism alert to the changing fashions of his subjects and competitive with full-blown New York School abstraction and the brashest of the new Pop art. Braving charges of "coldness" that would soon be leveled at Close, Pearlstein devoted himself to studio nudes, limning his wan urban sitters with an unflinching attention to every visible detail of their nakedness but without any signs of affect (fig. 17). Anticipating Nochlin's article by a decade, Pearlstein's 1962 manifesto "Figure Paintings Today Are Not Made in Heaven" took issue with modernist orthodoxy on several points. In particular he rejected the variable viewpoint of Cézanne and its fracturing of pictorial volumes, and the corresponding mannerism of the broken stroke, mainly derived

from Pollock, de Kooning, and Giacometti, which led artists to privilege gestural gropings for phantom images over definitively stating observed reality.[27]

Close did not study with either Katz or Pearlstein when all three were at Yale, but their basic orientation once he had become a "realist" overlapped at several points. What separated Close from the other two was the camera. Katz seems simply to have had no interest in photography as a tool or paradigm, though cinematic cropping is a pronounced aspect of his pictorial syntax. Pearlstein, sometimes mistaken for a Photorealist, went out of his way to deny the need of technological assistance. "It never occurred to me that people would work from photos—because I never had any difficulty drawing or painting," he told Robert Hughes in 1972.[28]

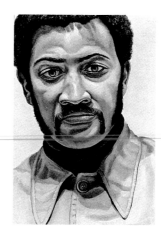

fig. 18. Philip Pearlstein. *Norman Loftis.* 1974. Oil on canvas, 24 x 16" (61 x 40.6 cm). The Metropolitan Museum of Art, New York. Gift of Norman Loftis, 1981

Close had no such difficulty either. Nor, in the beginning, did he have any interest in photography for its own sake. Instead, he used photography to intensify the level of seeing, to collapse depth and telescope the distance between the eye of the artist—and the viewer—and the model. "Photography is a means to an end," he explained.[29] Its virtue was omniscient indifference. "The camera is not aware of what it is looking at. It just gets it all down."[30] For Close, photography's role, therefore, was both instrumental and, in an unusual sense, editorial, unusual in that he counted on the glut of visual data it provided to counteract the natural physiologically and psychologically determined screening patterns of the direct vision.

fig. 19. Richard Estes. *Double Self-Portrait.* 1976. Oil on canvas, 24 x 36" (61 x 91.4 cm). The Museum of Modern Art, New York. Mr. and Mrs. Stuart M. Speiser Fund

If use of the camera set him apart from Pearlstein and Katz, it was not enough of a bond to the Photorealists to make Close at ease among them. With good reason. Whatever the distinct merits of their paintings, the work of Robert Bechtle, Richard Estes, Ralph Goings, Robert Cottingham, and their peers relied on photography for verisimilitude and a certain homogeneous graphic "look," but stopped short of any serious scrutiny of the convergence of the two media. For the rest, their concerns were almost entirely with the vernacular iconography of mid-century America, with cars, trucks, motorcycles, commercial signage, and suburban housing.

Those who attacked Photorealism as a naturalist variant on Pop were basically right about the affiliation even if they were wrong about the intentions of both Pop and Photorealism. (Trying to catch the tide with his "Sharp-Focus Realism" show, Sidney Janis, as previously mentioned, had seen this clearly.) Conservatives such as Hilton Kramer viewed both tendencies as the chic celebration of the worst in mass culture. Less rigid minds—Lawrence Alloway for Pop, to which he gave the name, and William Seitz for Photorealism—saw precisely the opposite, a critical ambivalence toward postwar prosperity, that ambivalence being partially expressed in both cases by an element of nostalgia characterized by the artists' abiding fascination with pre-boom movie stars, marquees, diners, advertising, consumer goods, and the like. In that regard, Photorealism as a movement looked "backward" in technique and, to a degree, in subject matter even as it was being promoted as the next "new" thing.

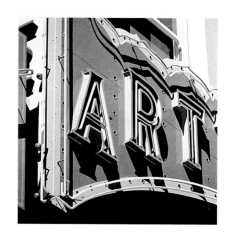

fig. 20. Robert Cottingham. *Art.* 1971. Oil on canvas, 78 x 78" (198.1 x 198.1 cm). Private collection

Close's oversized and optically supercharged *anti*-naturalist paintings had little in common with those of Bechtle, Estes, Goings, and company. Their

correspondences with those of Malcolm Morley are more substantial. Made in 1965, Morley's first Photorealist paintings—and they were perhaps the first paintings made anywhere in this country that fully fit the description—were of ocean liners and tourist spots directly transcribed from postcards and travel brochures. Crisp, bright, and, for the most part, devoid of obvious irony or extra high-art flourishes, they were painted upside down, and top to bottom on a gridded canvas, with each square being completed before the next in line was started. Around the image, or to the side, Morley left a monochrome margin, to emphasize its status as a picture of a picture. In *Race Track (South Africa)* (1970; fig. 21) he took things a step further and superimposed a large red X, canceling the *trompe l'oeil* effect of the central area and, not so incidentally, casting his vote against apartheid and its "race" record.

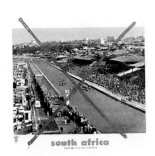

fig. 21. Malcolm Morley. *Race Track (South Africa).* 1970. Acrylic on canvas, 70 x 88½" (175 x 220 cm). Museum of Contemporary Art/ Ludwig Museum Budapest

The first Photorealist painting by Richter—about whom I have briefly spoken before—dates from still earlier, 1962. It is a grisaille depiction of a modern design table brushed over with splayed strokes and scraped at with a palette knife. The image as a whole is of the simultaneous making and unmaking of an illusion. Roughly contemporaneous paintings such as the *Coffin Bearers* (1962) rely on similar effects. Soon Richter expanded his range of devices to include irregular croppings which created margins like those in Morley's paintings but also referred to the margins and captions of the source photo, that usually came from a magazine. (Andy Warhol had worked in this way as early as 1960.) In some pictures Richter would draw in the contours of a photo image, but refrain from filling in the volumes. In others he would paint a series of photo-mat pictures on a canvas to remind one of the mechanical intervention in each snapshot. (Johns had collaged a strip of this type onto a painting as early as 1955, and Warhol started silk-screening such low-grade portrait images around 1964.) And in still others he would superimpose short confetti-like marks that floated between the viewer and the face in the frame. Finally, beginning in 1963, in what has remained his practice ever since, Richter took to smearing and blending images, initially in a kind of *moiré* effect and later in alternately streaky or consistent soft-focus blur.

Richter's works of this kind depart from those of mainstream Photorealism as markedly as Close's do. Oddly enough, postmodernist critics keen to champion artists who analyze and complicate the dialogue between painting and photography have fastened on Richter—and properly so—but have virtually ignored Close.[31] In practice, both artists proved themselves master "deconstructionists" long before that term was coined. Richter quite literally began by reducing painting to a *tabula rasa*, while Close banished gesture for an uninflected pictorial factualness equivalent to what the French semiotician Roland Barthes described as writing at "degree zero." Under these conditions, Close effectively removed himself as the author of the picture in order to remain as the agency of a picture in the process of structuring itself. (In the 1960s LeWitt started to produce drawings which, in a similar spirit, consisted of instructions for their own creation. Dorothea Rockburne's "Drawing Which Makes Itself" series of 1973 further elaborated this idea of the "autonomously" generated work of art.)

Thereby committing themselves to the erasure of conventional artistic identity, Close and Richter likewise took their distance from the authenticity of the images they painted. If a photograph partially reproduces nature while fundamentally altering it, and a painting, drawing, or print partially reproduces the photograph in one or more variants while deviating from the source, to what extent can one judge the truthfulness of any single item in this chain or establish a meaningful aesthetic priority based on the faithfulness to an original? Filtering actuality through several media in sequence, a Close or a Richter defies any such constructs. Yet undermining antiquated hierarchies is not the same thing as abolishing all distinctions among the remaining categories, much less foreclosing on any one of them in the name of progress. Contrary, therefore, to the imperatives set by partisans of the anti-painting strain of postmodernism, both Richter and Close have maintained a high regard for the traditions of image-creation they have devoted themselves to re-examining, of which painting always has been and still is the central component.

The fundamental difference between them resides in this, meanwhile: where Richter loosens painting's ties to reality and leaves them visibly undone, Close tends to reconstitute a fresh image out of the one he has procedurally dismantled that is as vivid as that with which he started, if not more so, but in a different fashion. This tendency appears to have convinced some people to look at him as "just" a realist rather than as a hands-on critic of realism's assumptions and techniques. Furthermore, while Richter has tackled a wide variety of painterly modes—the realist aspect of his production being complemented by minimal, monochrome, hard-edge, color systems, and gestural abstractions—Close has stuck to one basic image and format.

Close's tight focus translates into breadth of other sorts. For a given source photograph, there may be, and frequently are, multiple incarnations; in addition to paintings on canvas or paper, they might include drawings in various media and according to various mark-making systems, and prints in one or more techniques. While artists commonly proceed more or less directly from one image to the next, Close circles around each of his and never fully abandons any—a 1960s photograph of the painter was, for example, the basis of a 1988 spit-bite aquatint (p. 70). In each phase he displays the artifice in use. Thus, for example, instead of employing the grid merely to build a more cohesive pictorial whole, as artists from the Renaissance on down did when they turned to perspective and related proportional diagrams, Close implicitly acknowledges, if not explicitly shows, the grid in the final product. Always he is the magician who in performing a trick makes certain that the sleight of hand responsible for it is a conscious factor in the experience of the spectator.

Thus Close is not merely being label-shy when he says, "The word realist gives me problems too, because in a way I am not really trying to make something real.... The only way that I can accomplish what I want is to understand not the reality of what I am dealing with, but the artificiality of what it is."[32] Compare Close's repeated rejection of the "realist" label and his final emphasis on the word "artificiality" with Robert Ryman's insistence that he *is* a realist.

Ryman's work—reduced to the paint (predominately white) and the material properties of the surface on which he paints—merits the label inasmuch as every visible quality or detail of his paintings is there to be seen for itself and so exists on equal sensory terms with the wall on which the painting hangs and all other impinging dimensions of the surrounding room. Ryman does not ask that you look into or through his paintings in order to enter some other pictorial realm, but rather that you look *at* the paintings in the actual circumstances you find yourself in but, in all likelihood, only partially perceive.

Explaining how he prepared his canvases, Close once joked that given the fifteen coats of sanded gesso he puts on before making his first art mark, "If I were Bob Ryman I'd be done already."[33] He wouldn't be, of course, but seen less from Close's jesting perspective than from Ryman's aesthetically materialist one, each drawn or painted layer Close adds from that point on may be regarded in the same terms as primer, regardless of the fact that they coalesce into a head. A century ago Maurice Denis wrote, "It is well to remember that a picture—before being a battle horse, a nude woman, or some anecdote—is essentially a plane surface covered with colors assembled in a certain order."[34] Denis's seminal definition of painting is the basis of Ryman's "realism," as it is of the "realist" quotient of all modernist art in which the constituent elements of any made thing take precedence over whatever it may depict.

That dialectic describes the underlying conceptual as well as perceptual tension running throughout Close's work, a tension created when fidelity to the particularity of observed phenomenon that Nochlin names as the defining characteristic of pictorial realism and attention to the particularity of formal and material incident in the work that Ryman sees as the basis of non-pictorial realism are equally and simultaneously manifest. That duality provides the key for resolving the conflict of nomenclature that inhibits discussion of Close's art. His work *is* realist but in the two distinct ways just outlined. Its realism consists not only of subject matter and representational codes, but of the objectivity with which those codes and their abstract substrata are laid bare by its facture. By that token, Close perfectly fits the description of the modernist painter advanced by Clement Greenberg almost forty years ago. "The essence of Modernism lies, as I see it, in the use of characteristic methods of a discipline to criticize the discipline itself, not in order to subvert it but in order to entrench it more firmly in its area of competence."[35]

Undoubtedly Greenberg would have balked at admitting a picture-maker like Close into the high formalist enclave; nonetheless, that is where he belongs. It is the second half of Greenberg's law that tips the scales in his favor. For Close has clearly no desire to subvert his discipline. Rather, by shunning narrative, symbol, and all other considerations of or references to things outside the frame, he has pressed ahead "to entrench it [or rather each, in turn, of the many pictorial disciplines Close practices] more firmly in its area of competence."[36]

4.

Portraiture, as a genre, bears the stigma of mixed motives. Historically, portraits have predominantly been work for hire, which in virtually every instance dictates that the task of the artist, whatever his or her independent creative objectives may be, is to make the sitter look good or resemble some prescribed image. The art of commissioned portraits is, therefore, as much a matter of social and psychological manipulation as it is of aesthetic considerations, and rarely has it reached its peak without indulgence on the part of the subject. Velázquez's likenesses of Philip IV of Spain are great and ennobling, but they do not flatter his oddly shaped Hapsburg profile. Goya's *The Family of Charles IV*, though not an overt caricature, makes it clear that there was a dynasty ripe for overthrow.

These are exceptions to the rule. The master portraitist of the past—be it Bernini in marble or Ingres in pencil or oil—knew how to finesse the jowls of a Cardinal Scipione Borghese or a Monsieur Bertin (fig. 24), and improve, with a commanding pose, the weak features of Francesco d'Este or Sir Fleetwood Broughton Reynolds Pellew. Hals gave his not always prepossessing sitters the benefit of fashion and the attractive energy of his brush so that a dazzling lace cuff would mercifully upstage teacup ears, protruding lip, and a long nose. Rembrandt bathed the often doughy faces of his paying customers in lustrous tones and shadows that lent these otherwise bland burghers an air of Baroque mystery.

There are, of course, many portraits made without such compromising expectations. Often they are of the artists' family and friends, or of the artists themselves. Modern portraiture that rates as aesthetically worthy in its own right is generally of this type. (Among the first paintings to make a significant impact on Close was one of van Gogh's more Impressionist self-portraits, which he saw in 1959 in Seattle; fig. 22)

Outside of photography, however, comparatively little of such work is, in any strict sense, "realist." Like other traditional genres—still life, landscape, narrative tableaux—modern portraiture became a laboratory for stylistic experimentation and the form-altering analysis of personality or milieu. Picasso thus fractured the planes of David-Henry Kahnweiler's visage, and warped those of Marie-Thérèse Walter. Matisse, meanwhile, could note the brow, mouth, hair, and facial contour of a model in fewer than a dozen pen strokes, only to rephrase them in the next drawing in such a manner that an equal number of quite different strokes morphed into a likeness of the same woman. While Matisse used line sparingly, Giacometti eroded his images by compulsive graphic corrections, so that pursuit of an exact rendering of what he saw eternally postponed its definitive realization. For his part, Francis Bacon, taking off from Picasso and the Surrealists, kneaded flesh like a soft rubber eraser, making faces that in various states of ecstasy or distress made faces back at him and at the public.

With these and similar examples in mind, Close's statement "I tried to purge my work of as much of the baggage of traditional portrait painting as I could" is both provocative and logical.[37] First, Close has never painted a

fig. 22. Cover of a catalogue for the van Gogh exhibition at the Seattle Art Museum, 1959

fig. 23. Alberto Giacometti. *The Artist's Mother.* 1950. Oil on canvas, 35⅜ x 24" (89.9 x 61 cm). The Museum of Modern Art, New York. Acquired through the Lillie P. Bliss Bequest

fig. 24. Jean-Auguste-Dominique Ingres. *Louis Bertin*. 1832. Oil on canvas, 46 x 37½" (116.8 x 95.3 cm). Musée du Louvre, Paris

fig. 25. Chuck Close. *Untitled (Bill Clinton)*. 1996. Iris archival on Somerset Velvet Radiant, 30 x 24" (76.2 x 61 cm). Edition: 125. Courtesy Ronald Feldman Fine Arts, New York

commissioned portrait; the only occasion on which he has bent this self-imposed prohibition was to photograph President Bill Clinton in 1996 (fig. 25). Nor, to date, are the major portraits he has painted in the hands of their subjects; there again photographs and one small canvas are the only exception. Hence, the sensibilities of the sitters—who surrender their faces to him without recourse—are not an issue. In Close's case, the contract which exists between the painter and the model is almost entirely on the painter's terms.

Second, although he has subjected his heads to all kinds of formal stresses—including breaking them into Cubist-derived facets and patching them together with *fauve*, Matissean color—Close has remained voluntarily bound by the unchanging lineaments and basic surface "information" in his photo-maquettes. Stylization is governed by procedures of analysis and transposition, not by preconceived or impromptu expressive purposes. As to the liberties taken by Bacon—one of his least favorite painters—Close's impatience with cliché intended to speak to "the human condition" declares itself. "I consider myself a humanist, but why must all humanists deal with blind people, or bloated dead bodies, or man's inhumanity to man? Why can't we reflect on less dramatic or less primitive situations? I'm interested in approaching the subject flat-footedly, very unemotionally. Lack of highly charged emotion doesn't mean no emotion. It means that I'm not cranking it up for its maximal emotional impact."[38]

In posing his subject, Close sets consistent photographic parameters: the proximity of the camera; the shallow depth of field and its consequent blurring of traits nearest to the lens—the nose—and at furthest remove from it—stray hairs at the sides and top of the head. For the rest, it is a come-as-you-are party. In the early years, when he relied exclusively on family members or friends, many of them still unknown artists, Close's models for the most part presented themselves in everyday clothes and demeanor.

Two in particular went the other way. The Martin Scorcese-like thug in *Richard* (1969; p. 111) is the sculptor Richard Serra, who, pugnacious as he was and is, was never so much the street-hardened "wise guy" as he appears in Close's painting. "That's exactly the way Richard wanted to look," Close recalls, "tough, dumb, and ugly. Those were the adjectives he used."[39] *Joe* (1969; p. 109)—the painter Joe Zucker—contrived the opposite, but no more appealing, image of a clerk, engineer, or accountant, with business shirt and tie, Brill-creamed hair, and nerdy glasses. Zucker's invention was a matter of costuming, Serra's of aggravated "attitude." In neither case, however, did Close cue or kibitz these impersonations. Meanwhile, the dazed and even slightly demented look of *Nancy* (1968; p. 108)—the late painter and sculptor, Nancy Graves—is more the product of the camera's way of freezing transitional expressions than it is descriptive of her, in fact, very practical personality. The squashed, asymmetrical rigidity of *Keith* (1970; p. 113), *Keith/Mezzotint* (1972; p. 121), and related drawings is the straightforward depiction of the sculptor Keith Hollingworth's facial paralysis rather than a pictorial distortion as it might seem, especially in the mezzotint. Occasionally, though, Close's way of holding a large-scale mirror

up to someone has provoked permanent changes in his or her appearance. For example, the sleek, voluptuary face, with its matinee-idol mustache that looks out in *Klaus / Watercolor* (1976; p. 132), caused the sitter—Bykert Gallery co-founder and Close's first dealer, Klaus Kertess—to shave.

Thus, the idiosyncratic miens of *Richard, Joe, Keith, Nancy,* or *Klaus* that make these early paintings so arresting may be fictions, photographic accidents, or quirks of nature; but they are, in any case, beyond the artist's control except at the stage of choosing which among several possible photographic images to paint. The same holds true of later paintings. The Svengali-like gaze of *Lucas* (1986–87; p. 171) is a demonstration of the theatricality upon which multimedia wizard Lucas Samaras has based his own work (fig. 26); in *Lucas II* (1987; p. 170) Close rendered the Greek Samaras in an atypical radiating grid, lending the painting the aspect of a Byzantine mosaic of Christ Pantocrator but for Samaras's patently demonic intensity. (A version of the later work, titled *Lucas / Rug,* was made in 1993, and Close once suggested that, used as a carpet, with Lucas staring upward from the vortex, it would make an interesting place for a dalliance.) Conceptual photographer and filmmaker Cindy Sherman, of *Cindy* (1988; p. 168), is also a past master at making herself over (fig. 27), and for her portrait followed the tack taken by Zucker, hiding herself behind heavy librarian glasses, and affecting an out-of-fashion bobby-soxers ponytail. Like Samaras and Sherman, Francesco Clemente (*Francesco I* 1987–88; p. 169), Alex Katz (*Alex* 1987; *Alex II* 1989; and *Alex* 1991; pp. 166, 174, 177), William Wegman (*Bill II* 1991; p. 182), Lorna Simpson (*Lorna* 1995; p. 186), and Paul Cadmus (*Paul* 1994 and *Paul III* 1996; pp. 196, 197) have frequently used their own image in their work (fig. 28). For their part, Elizabeth Murray (*Elizabeth* 1989; p. 175), John Chamberlain (*John* 1992; p. 184), Roy Lichtenstein (*Roy II* 1994; p. 189), Robert Rauschenberg (*Robert* 1997; p. 198), and a majority of the famous artists on whom Close has concentrated in recent years are all experienced confronting the camera.

What in the original photo-maquette appears as a small glint in the eye, or the twist of a smile, or the deadpan lack of a smile, vastly enlarged in the final painting and fleshed out in the finest details of lashes, crow's-feet, whiskers, and skin grain, or as so many circles and ellipses of saturated color, may acquire grotesque vividness, becoming a glassy leer, a menacing grimace, or a comic rictus. Thus, the parted lips and edgy set of *Alex*'s jaw verge, at eight by seven feet, on a snarl, while the elastic, zigzagging loops that chart the benign countenance of *Bill II* lend it a clownish quality, as revealing of Wegman's temperament as Katz's expression is of his combative character. Capturing a likeness, or documenting one, as is perhaps the better description of Close's practice, means seizing upon essentials. Exaggerating those essentials, even without explicit editorial intent, borders on caricature. A meaty nose of normal proportions is a meaty nose; the same nose the size of a small child is monstrous.

This is particularly true in the early large-format black-and-white continuous tone paintings such as *Keith, Nancy, Richard,* and *Joe,* and to a lesser extent in the continuous tone color paintings such as *Susan* (1971; p. 116), *John* (1971–72;

fig. 26. Lucas Samaras. *Photo Transformation.* October 28, 1973. SX70 Polaroid, 3 x 3" (7.6 x 7.6 cm). Courtesy the artist

fig. 27. Cindy Sherman. *Untitled Film Still #56.* 1980. Gelatin-silver print, 6³⁄₈ x 9⁷⁄₁₆" (16.2 x 24 cm). The Museum of Modern Art, New York. Purchase

fig. 28. Francesco Clemente. *I.* 1982. Watercolor on paper, 14 x 20" (35.6 x 50.8 cm). Private collection

p. 117), *Linda* (1975–76; p. 131), and *Mark* (1978–79; p. 141). Everything about these faces, from misshapen features to the smallest blemish or lapse in grooming, is recorded, inspected millimeter by millimeter by the artist, and blown up to giant scale. Detached and meticulous attention explains the intrusiveness of Close's gaze rather than unkindness. Nevertheless, the effect, especially in chill tones of gray, can be simultaneously mesmerizing and off-putting if not positively repulsive. Thus Robert Hughes could overcome his original stylistic distaste for "Photorealism" and write, in defense of an aesthetically higher order of discomfort, "Close's works are among the most troubling icons of American art in the '70s. . . . Faces would look like this to a louse, if lice could scan them."[40]

Even Close himself felt this curious alchemy of unrestricted intimacy transformed into distance when he said of his unkempt *Big Self-Portrait* of 1967–68 (p. 107), "I often found myself referring to it as 'him.'"[41] Under such extreme circumstances, objectivity may subvert subjectivity even in a work's author. His was the alienation one feels on seeing a snapshot taken in an unguarded moment or hearing one's voice recorded on tape, but, of course, it is that experience writ large or with the volume turned all the way up.

Robert Israel indicated a corresponding type of displacement in speaking of his 1970 portrait. "It was very difficult for me to see it as a whole," he told *New York Times* critic Grace Glueck.[42] In fact, while working on the full-scale canvases, Close rarely backs up to appraise the overall picture, as painters normally do. The photo-maquette guarantees the coherence of the images while the artist works, but, as he paints, he sees it only in pieces. This incremental, hard-by-the-surface approach gives the completed heads a sense of precarious integrity even when they are fully described, as in the continuous tone paintings of the late 1960s and early 1970s. The viewer is also drawn toward details that require stepping up to the canvas to the point that other details move to the periphery of vision and begin to lose clarity along with the overall coherence of the image. When the features of a face are atomized into paint bursts, dots, crossbars, fingerprints, or the hook-rug weave of color circles and lozenges that Close has employed since the mid-1980s, that instability increases to the verge of dissolution, calling into question the perceptual threshold at which image recognition is achieved or lost.[43]

Matisse's sequential ink drawings previously cited pose this problem in one way. Close's technique poses it in another. And so does the computer. Close recalls with still noticeable dismay that the month of his third one-person exhibition at Bykert in 1973—and at a time when he was making his first overtly gridded works such as *Keith / Three-Drawing Set* (the 1973 antecedent to *Keith / Six Drawings Series* of 1979), *Bob I / 154, Bob II / 616, Bob III / 2,464, Bob IV / 9,856,* and the painting *Robert / 104,072* (p. 129)—*Scientific American* published a cover article by a biomedical engineer, Leon D. Harmon, on "The Recognition of Faces" (fig. 29). The idea that technology had overtaken him, or might be thought to have made his efforts redundant, greatly upset Close. (Remember that the numbers after the titles of the previously mentioned works represent the number of units in the handmade and hand-filled grid in each work.)

Concentrating on the problem of the minimum quantity of information necessary for a computer-screened picture of a person to be identifiable, the gist of Harmon's research did overlap with Close's concerns to some degree. But Close is not a perceptual psychologist—his concerns are formally synthetic rather than narrowly cognitive, imaginative rather than neurological—nor is he merely doing at an artisanal level what a machine could do as well and faster. Aesthetically, no machine can compete with the nuanced decision-making of the skilled artist, nor technologically can it produce a comparably high optical definition—at least not in 1973. When a computer scans, squares-off, and synthesizes the information in a photograph, that process involves not just mathematical reduction but qualitative degeneration of that information. At best what it delivers is a carefully edited but graphically impoverished copy. What is true of the relation between Close's photo-maquettes and the final paintings is true of all his production. Translating visual data from the source to a new medium and surface, the artist does not just mimic or summarize what he began with. He enhances the specific characteristics of each pictorial element as restated in its new terms. What one sees, therefore, is not a facsimile or digested version of the "real" thing but another "real" thing, complete unto itself. The test of this is the equivalent carrying power of a small drawing and a large painting seen from across a room (for example, *Mark*, pp. 138, 141). Unquestionably the latter is brighter and in sharper focus, but each exerts a long-distance pull and, studied closely, each satisfies in its own fashion.

Having spent the first decade of his career in disciplined rebellion against his facility and penchant for painterly effects, starting in the late 1970s, Close shifted gears gradually and then decisively. As noted before, the hand—banished from his pictures since 1966—returned in 1978 as fingerprints. First inserted into grids and later applied without graphic armature, Close's identifying mark thus bodied forth the faces in his "identity-photos." Some of these drawings have the soft, diffuse quality of a Degas monotype. Others possess an uncanny physicality, as if Close had peeled a layer of his own skin and shaped the image in its folds and textures. Grand and delicate at the same time, *Fanny/Fingerpainting* (1985; p. 161) is flesh made with flesh, as is *Leslie/Fingerpainting* (1985–86; p. 157). The fact that Fanny was the artist's mother-in-law and Leslie is his wife imbues the relation between the artist and his pictorial surrogate with a literally palpable tenderness.

Beginning with *Stanley* (1980; p. 149), Close resumed oil painting for the first time since 1966. Seven years later, after further work with fingerprints and some experiments in photography for its own sake—the images were greatly enlarged flowers and over life-size male and female nudes—Close turned his attention wholeheartedly to the medium. The early eighties was a period in which expressionist or bravura painting seemed pitted against various conceptual and photographic modes of art-making that had developed in the previous decade, and critics frequently championed one type of artist over his or her supposed opposite. In the context of this struggle between resurgent studio tradition and up-to-date modes of "mechanical reproduction," conceptual or

fig. 29. Cover of *Scientific American*, November 1973, which depicts an optically generated photocopy of George Washington taken from a Gilbert Stuart painting. The image was used to illustrate an article by Leon D. Harmon entitled "The Recognition of Faces"

flatness of the canvas and the separateness of piecemeal units of work, soon pushed forward to become a more integral aspect of the images. And when this happened, it became evident how Close's purposes also involved, far more than the apparently one-off stunt of painting big blowups, a prolonged meditation on the basic nature of making a picture, as embodied in the give-and-take between the autonomy of abstract marks and the overall force of resemblance and recognition. The working process was revealed as an odd variant on assembly-line logic: parceling the task into a grid of separate but repetitious units allowed the artist to (in his words) "sneak up on" the image by a series of indirect advances, working alternatively and idiosyncratically on different zones or different component layers of the whole, constantly delaying concentration on the end result, and/or constantly shifting that eventual goal (and subsequent steps toward it) in relation to the piecework done. In this way the faces have never been only "givens" simply copied; covertly in the early work, but obviously later, they are composite fabrications whose particularities are also "found" within the process of their making.

Getting there, for Close—as long as it is by a properly demanding and detoured route—has always been much more than half the fun. In this regard, as Leslie Close once remarked, the whole early career can be seen as advancing by serial self-frustrations, with the artist recurrently devising variations—altered scale, new mediums, reconceived units of work—intended to re-impose further impediments, and deny the facility gained in one technique in favor of the difficulty of pursuing a new one. Reluctantly at first, then with pleasure for the unexpected fertilities of collaboration, Close has also experimented with ceding control over parts of printmaking's reproductive processes. From all these strategies for delay or indirection, the resultant same-but-different blend of the unchanging and the restlessly altered, of the self-constraining and the self-challenging, has moved Close's work by zigs and zags along its road. This has imposed on his whole career the working principles of a single image, whereby the major constraints are locked down, the primary focus is on the particular action at hand, and the bargain is that in this way the big picture will ultimately take care of itself.

In a fate of high and bitter irony, after almost twenty years of foiling virtuosity in these fashions, Close then had its manual components taken from him in late 1988; the sudden collapse of a vein, starving his spine of blood, severely impaired neurological control of his legs, arms, and most especially his hands. Few of us will even want to imagine the process by which he pulled his way back from this near-total paralysis to be able to paint again. When he did, with no motor force in his fingers and a brush strapped to his wrist, he found himself permanently shut off from certain options of precise dexterity—but thereby (again in Leslie's observation) paradoxically liberated. The lushest, most vivid—and, yes, the most virtuosic—paintings of his career have followed since, as he has allowed himself once more to reenter, in maturity, the land of sumptuous color and de Kooningesque handling from which he had mercilessly banished himself as a young turk.

The crucial turning point in this regard took place in 1986, when Close resumed painting in oil after a long hiatus. A brief experiment with brush and oils around 1980 had been abandoned as he resolved—following his 1980–81 retrospective exhibition—to start in new directions by dropping the grid matrix which had been at the base of his process and much of his imagery. There then ensued a period of wandering in the wilderness, in prolonged experimentation with more free-form fabrications, by fingerprints and with irregular wads of paper slurry, that yielded some arresting individual works but no firm, sustained new path. In the end, around 1985, Close saw that he could achieve the new complexity and freedom he wanted by resubmitting his work to the rule of the grid, only now in terms of sharply enlarged and sometimes tilted (or initially even circular, fanned-out) matrixes which demanded more intensive, inventive, and discontinuous parcels of work in their more obtrusive boxes. The resultant canvases, shown at Pace Gallery in autumn 1988, just prior to Close's physical disaster, injected stinging new life into what had seemed a formula with dwindling returns. Though the base methodology was in some senses a return to 1970s roots, the way the vibrantly multihued tesserae asserted sensuality over logic made these canvases seem fully consonant with the general resurgence of painterly painting in the 1980s and miles away from the Seurat-like fields of relatively uniform dot-stipplings done five years earlier. These pictures opened the way for all that would follow after the artist resumed working in 1989.

By the late eighties, the photographic look which had been so central to Close's early work seemed less and less of an issue. In this perhaps, he belongs to what might be seen as a much broader shift in aesthetics that began in the late seventies, as art which made an issue of photography's particular syntaxes (grain, blur, etc.) and its direct relation to external facts gave way to the less self-conscious use of the medium as a tool or vehicle, often for showing constructed fantasies. Close now uses a large-format Polaroid that offers him an exquisite level of detailed information, incomparably more lavish in its range than the grainier snaps of the early years; yet virtually no photo effect (focus blur, halation, etc.) nor any surface information (pores or blemishes or wrinkles) is now translated to the canvas. Instead, as the paintings' grids have become steadily larger, each box has come to contain a more complex subworld of colors and shapes, vividly teeming with a variegated organicism largely removed from any specific correlation with local descriptive features. As a result, these recent pictures can seem to have less to do with the processes of photography than with those of thought itself: by treading more boldly along the edge of incoherence, they visibly play up the way in which our neural networks form a complex, uniquely specific whole—in this case, an identity, a likeness—from the synchronous firings of dissimilar, fractiously disconnected units. And again at this maximally abstract extreme, as much as in the first blowups, it might be argued that the dialogue between separate monads and overall swarms, or discrete particulars and dominant wholes, has been a theme that has pervaded Close's work from its most basic levels of working method, through its formal structures, to its larger spheres of possible meaning.

Yet these are also portraits in a more traditional sense, and perhaps never more so than in the past few years. The altered scenario of the 1988 show involved as well a new cast of characters, shifted away from the earlier anonymity of family and friends toward more publicly recognizable fellow artists. To the already established scaffolding of a personal, idiosyncratic pantheon of figurative artists (such as *Mark* [Greenwold], first portrayed in 1973, or *Joe* [Zucker], first painted in 1969; p. 109) were added not only longtime art-world figures such as *Lucas* (Samaras; pp. 170, 171) but also eighties newcomers *Francesco* (Clemente) and *Cindy* (Sherman). Close has said that, after an early 1980s period of disaffection and frustration with New York City, he came to the realization that his prime source of sustenance in the metropolis, and reason for remaining there, lay in its community of artists. He then resolved to image this consoling republic of the spirit by portraying those for whose work or careers—however tangential to, or different from, his own—he felt a personal affinity or admiration. That shift has shaped his work since; his paintings of the nineties have (along with returns to the changing faces of himself and his family, and reconsiderations of previous subject photos) steadily expanded through a new roster of well-known artists, beginning with Elizabeth Murray in 1989 (p. 175) and including Eric Fischl, April Gornik, Joel Shapiro, John Chamberlain, William Wegman, Lorna Simpson, Dorothea Rockburne, Roy Lichtenstein, and Paul Cadmus (pp. 182–84, 186, 188, 189, 196), among others.

Where the early faces formed a lineup of homogeneously unknown outsiders, this club of art-magazine familiars is both more exclusively circumscribed by trade and achievement and more diversely constituted by age, race, and orientation—an ideal polity redefined, no longer as a proximate coterie of contenders, but as a dispersed mosaic of common cause, explicitly contemporary in its constitution. Richard Serra and Nancy Graves were each about thirty when Close painted them in the late 1960s (pp. 108, 111), and Clemente and Sherman were in their mid-thirties when they stepped before his camera a decade and a half later (pp. 168, 169). But by then Close himself was approaching fifty, and the Reagan-era art world from which he now selected was as far from first-blush postminimalism as Michael Jackson's moonwalk was from Neil Armstrong. In particular, for those who know their work, Clemente's musky erotic narcissism and Sherman's media-based theater of self-disguise suggest how much the idea of the artist's identity, or of individual identity in a larger social sphere, had changed since the epoch of earthworks and oil crises. We might look, then, to find this shift written on the faces of Close's subjects. As the framing of the latest pictures bears in still closer on those faces, though, the sitters become more and more dematerialized and uncertain, and the "resolving distance" (the length we need to retreat from the canvas before the image begins to cohere more seamlessly) gets exponentially longer. We seem closer to them, and they further from us. Yet equally paradoxically, as the surface of these pictures has become maximally active, a new sense of figurative "depth," or personal interiority, seems to become more and more evident. We are reminded that Close, the artist of a waning photographic or emerging

cybernetic epoch, also admires the Byzantine mosaics in Ravenna. There, too, surface opulence and disembodied volumes become the vehicles for a heightened, albeit ineffable, sense of inhabiting spirit, absent from the more earthily particularized individualities of a previous style.

With the "resolving distance" of almost thirty years, we can now recognize how the look of Close's early heads—their palette, their scale, their method—carries a freight of associations that link them to their time and society. No matter how far back we physically step from these more recent pictures, we remain too immersed in the era they distill to bring into focus such possible extended meanings. But one marker of Close's shifted relationship to his work and to his subjects clearly lies in the way the defiantly extroverted anonymity of the first heads has given way to its inverse, a greater sense of reserved private individuality in the later portraits of more public individuals. This seems especially evident in the often timeworn countenances of the longtime veterans he has increasingly sought out, and it is nowhere more telling than in his most recent confrontations of himself. We may, of course, be reading into an image like the 1997 self-portrait, but then the picture precisely invites and allows that, while the spit-in-your-face posturing of its 1968 counterpart deflects any such probing. That brash son of the sixties was an unknown out to make a mark, while the Chuck Close of the nineties is internationally celebrated, a member of boards, juries, and honor societies, and a recipient of countless achievement awards. Now in his late fifties, he is on the threshhold of the latest and largest of a string of retrospectives. To replace the confrontational public address of the early picture, his current image proffers a different kind of boldness, which is inherent less in a theatrics of demeanor than in acts of painting, and which yields an altogether deeper and more elusive sense of personal presence (figs. 3, 4). This canvas and its lustrous recent companions ratchet up the tensions between surface and depth, and between abstraction and image, in a way that generates hard-to-define but compelling comminglings: of outfront bravado and inner reserve; of newfound freedoms and more obvious compulsions; of radical edge and conservative ease; and of indulgent pleasure and sadly dissolving disquiet. In ways not yet fully articulable, these are faces and paintings distinctly of our time; in other ways immediately recognized, they constitute some of the richest and most rewarding moments in an ever-consistent, but still now surprising, career.

NOTE

1. The choice of first-name-only titles reinforced that running-together of specific particularity and blank anonymity. (All the early sitters "pose as" themselves, with the odd but presciently proto-Sherman exception of Joe Zucker, who coiffed and costumed himself in another, imagined identity.)

fig. 3. *Big Self-Portrait* (detail). 1967–68

fig. 4. *Self-Portrait* (detail). 1997

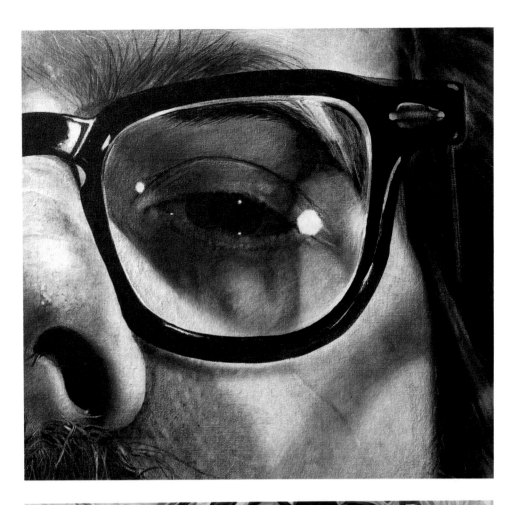

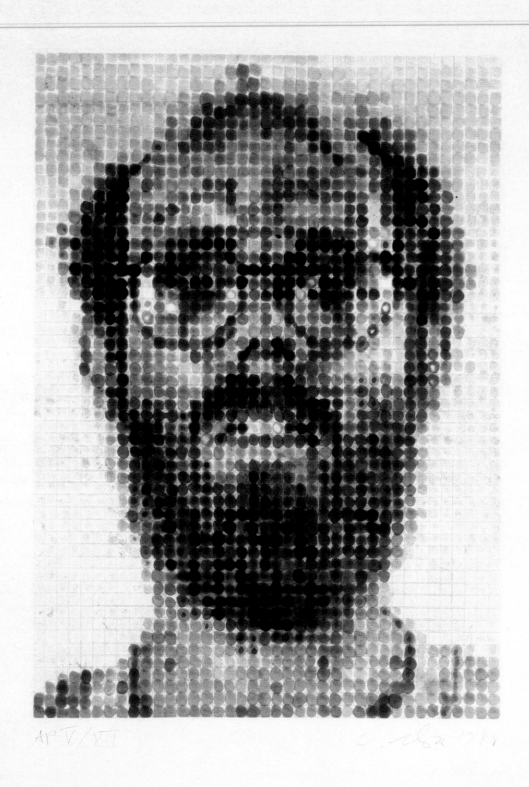

AP V/XII                                        [signature] '74

# CHANGING EXPRESSIONS: PRINTMAKING

DEBORAH WYE

"Resistance and edge are the key, keeping you off balance ...
it's not knowing what you're going to do, and having to solve a new problem."[1]

Technique has always been the "resistance" of printmaking. It can baffle artists, at times intimidating them to the extent that they avoid making prints altogether. It can put viewers off as well. Instead of appreciating a print for its aesthetic value, they may first question how it was made. In these instances, technique acts as a negative, an obstacle to, rather than a source of, new expression and meaning. Chuck Close's approach to printmaking encompasses technique's positive potential. He regards it as an opportunity, a means to expand both his artistic vision and its expressive range. Moreover, since the technical side of contemporary printmaking usually demands close interaction between artist, printer, and publisher, technique has forced Close to collaborate. Collaboration has become yet another factor in the overall strategy he establishes for each print project.

### Technique as System

The various print techniques offer Close the opportunity to devise new conceptual systems, which are at the heart of his artistic achievement. For him, creating an artwork—a painting, a drawing, or a print—means isolating visual problems that need solving. Rather than depending upon a romantic notion of artistic inspiration, Close formulates a plan that can be broken down into manageable parts. These small increments, pieced together day by day, eventually constitute a whole. The path along the way provides large and small pleasures, as well as a variety of new subproblems that in turn need breaking down. Ideas for future projects are a further outcome.

Close's belief in the fullness of both what can reside in individual increments of his plan, and in the relationships between them, becomes clear when he describes his experience of seeing ancient floor mosaics in Rome. "I roll into a room and the mosaic spreads out, but I only see one end of it.

fig. 1. *Self-Portrait*. 1988. Spit-bite aquatint, 20½ x 15¾" (52.1 x 40 cm). Publisher: Pace Editions, New York. Printer: Aldo Crommelynck, New York. Edition: 50

Still, I can tell within a few inches whether or not I am going to be interested in that mosaic.... I can already see the quality of the judgments."

In discussing his practice of formulating plans and creating systems, Close uses words like "comforting" and "liberating." The viewer, in turn, when absorbing the elements of a Close composition, can take similar "comfort" and also feel a sense of discovery. The daily routine Close has established, his observation of every detail of his artistic process, and his ability to glean so much from seemingly so little are inspiring when one relates the ebb and flow of one's own daily activities to his steady progress in the studio. With the example of Close's art, such routines can be seen as sources of meaning and richness. In this regard he has said: "Don't you think that's why people like diaries?" To him these personal memorabilia imply "patterns" and "habits" and are "little incremental connections and insights ... woven together." A Close artwork is a kind of diary of everyday activities and decisions. This orderly procedure also serves another function: it provides an energizing "friction" against Close's natural inclinations. He describes himself as "a nervous wreck ... very lazy and distracted ... a slob—all of which would seem to guarantee that I would make anything but what I make."

Printmaking, with its arcane techniques, distinctive tools and equipment, workshop settings with master printers, and specialized publishers, encompasses a whole range of elements that can cause such friction. Close has harnessed the resulting energy into making nearly fifty editioned prints since 1972, as well as numerous related experimental proofs.[2] Prints take a long time to complete, and they have come to occupy a constant background or foreground position for him, as he continues to work in other mediums. "I always have a print project going," he says, "like soup on the back of the stove."

While all new mediums provide Close with fresh possibilities, printmaking does so to the extreme. Each technique—whether mezzotint, etching, spit-bite aquatint, woodcut, linoleum cut, lithography, or screenprint, as well as hand-made paper and woven fabric—initially seems impenetrable, but ultimately becomes a locus of inquiry and ideas. Yet, in 1972, when publisher Robert Feldman of Parasol Press asked Close to undertake his first print project, he was not eager to accept. As an art student in Yale University's graduate program, he had been an assistant to the distinguished printmaker Gabor Peterdi, and he knew enough to be wary. Close saw only obstacles that would keep him from his painting rather than possibilities that would fuel his creativity.

## Collaboration

The notion of the lone artist in his or her studio carving a simple woodblock image that can be transferred to paper by rubbing with a spoon is contrary to the practice of contemporary printmaking. Today's artists are usually invited by publishers to undertake print projects in specialized workshops with expert technicians. Close's primary publishing experiences have been with Parasol Press and, more recently, with Pace Editions. Specific master printers have also been fundamental to accomplishing his projects. His efforts with Kathan Brown

of Crown Point Press and the late Joseph Wilfer of the Spring Street Workshop have had defining influences on his understanding of printmaking.

To be a successful print publisher takes ingenuity, interpersonal skills, and business acumen, along with a sophisticated knowledge of art. To a greater or lesser degree, the publisher is a creative force in each project, deciding which artists will be asked to participate, selecting master printers, shepherding a print through its development in the workshop, and establishing a mechanism for distribution and sales. Financially, he or she takes the risk of investing initial resources, and then shares in the ultimate profits. According to Close, Robert Feldman is "unique within print publishing," an opinion widely held in the field. Of particular note is his encouragement of printmaking by other artists from Close's generation who work in minimalist and conceptual modes such as Mel Bochner, Robert Mangold, Sol LeWitt, Brice Marden, and Robert Ryman. Feldman has also been a champion of intaglio techniques (engraving, etching, drypoint, aquatint, and mezzotint). When he began publishing in the 1970s, the use of intaglio had been eclipsed by the success of lithography and screenprint.

Close remembers Feldman's approach as a "no-risk proposition" financially, an important consideration for a young painter whose labor-intensive process led to a small production output. Feldman assured the artist that he would be compensated for his time on a print regardless of the outcome. The publisher also agreed to underwrite whatever costs might be necessary—and, indeed, a new press and extended experimentation by the printers were required in Close's case. "Bob never questioned what I was doing," remembers Close, even though this first project, *Keith/Mezzotint* (1972; fig. 3 and p. 121), yielded an edition of only ten impressions. "He was not limited by someone's preconceived notion of what prints should look like, and he never worried about whether things were salable." But Close actually marvels at what Feldman accomplishes with his own brand of salesmanship when "customers are convinced to buy prints, sight unseen, over the telephone." Of course, Close notes, everyone involved in a project "ends up with a great sense of obligation to him because he's so reasonable."

All of Feldman's formidable skills and an enormous amount of patience on the part of the printers must have been required to create Close's monumental *Keith/Mezzotint*, a piece that has become a milestone in the history of contemporary printmaking. *Keith/Mezzotint* was created in collaboration with master printer Kathan Brown of Crown Point Press in Oakland, California, who is known especially for her expertise in etching. But expertise was something that Close, at this early stage in his printmaking career, wanted to subvert. In a perverse gesture consciously designed to confound the printer, Close chose the long-out-of-favor and laborious technique of mezzotint and, given the conventions of printmaking, decided on an unusually large scale (see fig. 2). He did not want to relinquish substantial control to printers who had more knowledge than he had. By forcing them to learn a seldom-used technique, he put them on an equal footing. As he says, "It became on-the-job training for everyone."

Brown remembers the two-month tenure of Close in her shop while working on the *Keith / Mezzotint* project: "Every day he would come to the press, settle down, and work methodically, square by square, using a burnisher against the roughened plate surface ... At first, it was difficult for Close to imagine how a mark he made would print, and we pulled proofs every hour or so."[3] But, during this daily ritual, Close found ways to accommodate the demands of the arduous technique on its own terms, while also learning how to relate to his collaborators. There were many technical differences between the way he painted and the making of a mezzotint. As often happens when finding solutions for one medium, new methods emerged that could be added to his repertoire in general. In mezzotint, the artist proceeded from dark to light, that is, the pitted plate was burnished to create areas that would not hold ink and would therefore read as light when printed. This was the opposite of applying black paint to a white canvas. Also, since repeated trial printings at early stages were necessary to keep the artist abreast of his progress, the plate wore down in areas around the mouth, where he had scraped and burnished first. Close liked the patchy effect in the final image. It made his actions more visible, something that had not happened in his work up to that point. Similarly, a visible record of parts of his gridded guide also remained and, from then on, he used the grid openly as a structural element in all mediums.

Before the execution of *Keith / Mezzotint*, Close's monumental paintings had the seamless look of very large photographs. This "was the first piece where I allowed myself to deal with the increments as individual units which would not ultimately get pushed together to make a cohesive whole," he has said.[4] It was the first time, then, that his conceptual framework remained evident and that the formal aspect of the work was in obvious dialogue with the portrait subject. But portraiture had never been the primary subject of Close's art. His subject actually embraced both the figure depicted and the act of its depiction, both the end and the means of his art.

Kathan Brown would eventually evolve from being a contract printer for publishers like Robert Feldman to becoming one of the most respected publishers herself, under the Crown Point Press imprint. Unlike Feldman, who is not a printer and uses any of a number of shops for specific projects, Brown follows the model of the workshop-publisher, a common phenomenon in the

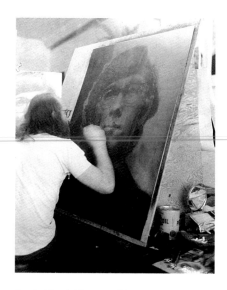

fig. 2. Chuck Close working on *Keith / Mezzotint* at Crown Point Press

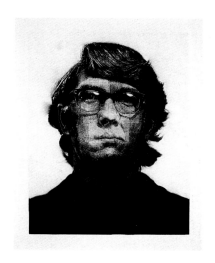

fig. 3. *Keith / Mezzotint*. 1972.
Mezzotint, 51 x 41½" (129.6 x 105.4 cm).
Publisher: Parasol Press, New York.
Printer: Crown Point Press, Oakland.
Edition: 10

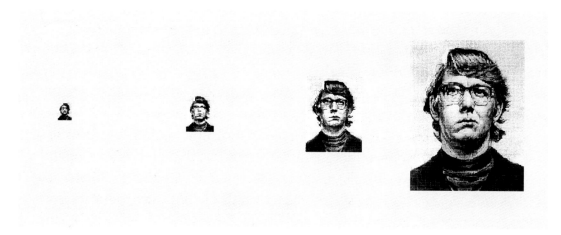

fig. 4. *Keith / Four Times*. 1975.
Lithograph, 30 x 80" (76.2 x 203.2 cm).
Publisher: Parasol Press, New York.
Printer: Landfall Press, Chicago.
Edition: 50

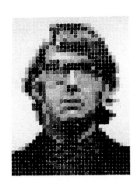

fig. 5. *Keith II*. 1981.
Handmade paper, 35 x 26½" (88.9 x 67.3 cm). Publisher: Pace Editions, New York. Printer: Joseph Wilfer at Dieu Donné Papermill, New York. Edition: 20

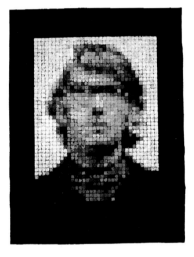

fig. 6. *Keith III*. 1981.
Handmade paper, 35 x 26½" (88.9 x 67.3 cm). Publisher: Pace Editions, New York. Printer: Joseph Wilfer at Dieu Donné Papermill, New York. Edition: 20

contemporary print field. Since the late 1950s, such establishments as the well-known Universal Limited Art Editions, Gemini G.E.L., and Landfall Press have encouraged generations of painters and sculptors to become significant printmakers. For Close, the Crown Point Press workshop has its own "attitudinal" tenor. He partly attributes this to a California ambiance of laid-back, unhurried manners, but Brown's personal style is also a factor. "The whole place would grind to a halt at noon while Kathan made some wonderful meal that was all macrobiotic or something . . . and everybody would sit and eat and drink too much wine. . . . There was always *mañana* to continue the project. It was so totally different from making prints anywhere else."

After the extraordinary results of *Keith/Mezzotint*, Crown Point Press provided another very memorable encounter with printmaking for Close. The creation of the woodcut *Leslie* (1986; p. 158) was undertaken as part of a project established by Brown to give American artists exposure to the traditional manner of Japanese woodblock printing.[5] In this centuries-old method, Japanese artisans cut blocks following a highly complex and refined procedure that utilized an artist's watercolor as a guide. With very thin, colored inks made from pigment and water, the printer then built up layers of translucent washes to approximate the watercolor model, conferring with the artist at various points along the way. Prints made in this fashion often resemble watercolors rather than the woodcuts with which Westerners are familiar. Feeling that they might more precisely be considered high-quality reproductions of watercolors than original woodblock prints, some collectors and curators were troubled by them. The involvement of the Japanese artisans was also thought to be too great.[6] Such questions of "originality" had plagued the print field in the late 1950s and early 1960s, when workshop printing with expert technicians began to take hold in America. But collaboration to one degree or another has been the underlying principle behind most modern printmaking, since artists themselves have not had the necessary skills to undertake it on their own. In American printshops, printers now often come from the ranks of university-trained art students, with hands-on experience in well-equipped facilities.

Although workshop-printing customs initially made Close uneasy, the Crown Point Press Japan project, in which he relinquished more control to technicians than ever before, also gave him his fullest understanding of the dynamics of productive collaboration. Still, he remains surprised at the controversy surrounding the project since, to him, its working procedures were not so dissimilar from those found in most printshops. Other artists involved in the Crown Point Press Japan project agree.

When asked about his memories of that time, Close recalls the wonderful trip to Kyoto and the lovely gardens and temples that became part of the total experience when he took breaks from meeting with the printer. This response is exactly what Brown hoped for, saying that "part of the point of our Japan program was taking artists to Japan."[7] The interaction with the traditional artisans was also unique. Close has described the cultural manners required in these encounters. Engaging Hidekatsu Takada, a Japanese-American Crown

Point Press printer, as translator, Close on one occasion asked simply that a color green be made lighter. The translator talked at great length to the printer, and Close wondered what exactly required such an extended discussion. Takada later explained that it was necessary first to praise the printer in many ways. "You are a miracle worker," he would say. "What you have done is beyond the wildest imagination. It is extraordinary and wonderful. However, in the interest of intellectual curiosity, not that it would be any better than what you've already done, but only to see what else might happen, the artist would be interested in seeing what it might look like if it weren't so green."

Such encounters gave Close "a whole other notion of what dialogue really means." His description sums it up: "You present the thing you want to do. They wrest control away from you, and they work on it. Now the project is theirs. Then you come back in and realize that you've got to get control again. So you wrest control back and reestablish your part in the piece. But then it goes back to them again. It's yours, then it's theirs, and then it's yours again. That's what collaboration really means." The Japanese printer for the Crown Point Press project, Tadashi Toda, also gained new insights from the Americans. "As I have worked with the artists, I have realized that my understanding of woodblock printing has been completely explored and expanded, and I accept that as a gift. The artist and printer become one, and two energies are engaged to make one print."[8]

Close believes these encounters influenced all his future relationships with printers. "I think it made me think differently about printers from then on. While the care and feeding of the artist is always thought about, we don't always think of the care and feeding of the printer." He points out that this lesson has taken on new importance now that he is handicapped and depends even more on other people's help in the execution of a print project.

Collaboration came to its greatest realization for Close in his projects with the late master printer Joseph Wilfer (1943–1995). As is often the case in printmaking, Wilfer had to cajole Close into agreeing to work with him. At first, Close outlined all sorts of likely problems as reasons for his hesitation, but Wilfer simply went away and returned with solutions. Finally, he convinced Close to try to create handmade paper editions. "Eventually it got to the point where he would not take no for an answer, so we just started doing some stuff," says Close. He was so pleased with the results that he subsequently convinced his publisher, Richard Solomon of Pace Editions, to have other artists take advantage of Wilfer's skills. Wilfer became master printer of the Spring Street Workshop for Pace Editions, and offered a wide range of printing options there. Close describes Wilfer as "the single greatest problem-solving mind I've ever worked with. He never panicked. I would always get really crazy and hysterical and nervous and Joe would remain calm." Eventually he oversaw, or "mother henned," all of Close's editioned projects, even when other printers and shops were involved. He came up with "thousands of ideas ... he kept things going. We learned from the processes and saw other possibilities. . . . That was my dialogue with Joe," says Close.

Publisher Richard Solomon would eventually form a partnership with another great printer, the renowned French master Aldo Crommelynck, who set up a workshop for intaglio printing in New York. Crommelynck is celebrated for his collaborations with such artists as Georges Braque, Joan Miró, and, especially, Picasso. A "modest, private, laconic man, a master craftsman trained in the classical nineteenth-century French tradition of intaglio printmaking,"[9] Crommelynck garnered particular fame for his ability to achieve glowing tonal gradations of aquatint. The spit-bite variation of aquatint afforded Close's compositions new expressive possibilities, and the ongoing dialogue between artist and printer had a character all its own.

Close portrays Crommelynck as "very tradition-bound. When you work with him, you adjust and adapt...you almost have to sign on to his system... and that becomes very interesting. He is as steady as a rock...doing it his way ...and doing it right. It's like the making of a fine wine." From Crommelynck's point of view, collaboration with each new artist provides new ways to test his "printerly prowess."[10] Since the spit-bite aquatint technique requires actual saliva as an ingredient to create the free flow of acid onto the plate, Close decided he wanted the spit for his print to be Crommelynck's "very French, very Gauloise-tempered spit," not his own. If there is a certain look to the spit-bite *Self-Portrait* (1988; figs. 1 and 14), Close believes it may be that special ingredient.

As noted earlier, collaboration took on new importance with Close's physical handicap in 1988. The limitations that came from this tragedy might have been insurmountable to many, but in this circumstance, the system-making impulse so fundamental to Close's art served him well. Although he had already learned to mold the inherent rules of individual printing techniques to his liking, and had found a way to flourish within the parameters of collaboration, his new limitations obviously required additional sets of solutions.

*Alex/Reduction Print* (1993; p. 179), a linoleum cut that eventually was finished as a screenprint, tested Close's ingenuity.[11] He chose a huge block, despite the fact that he no longer had the manual capabilities to carve it himself. As with the Japanese project, he relinquished that responsibility, becoming a kind of director rather than the leading man. A team of six or seven assistants was engaged to carve the block from Close's felt-tip markings. When Close noticed that each carver had a distinct cutting style, some making very loose strokes, others being finicky, he decided that certain areas of the composition would be best handled by a specific worker, and he made assignments accordingly. He then realized that individual "hands" were recognizable in those areas. His response was to devise a system in which the block would be rotated among the cutters at ten-minute intervals. These kinds of solutions allowed Close not to "cross whole ways of working off my list of possibilities." He conceived new methods to accomplish what he needed.

## Sitters

The sitters in Close's portraits also become collaborators in his artistic enter-
prise. "I have often thought about them as a family, or my family...my other
family," he has said. This family is made up of approximately sixty different
people depicted in paintings, drawings, and prints. Those from a smaller sub-
group have continually had their images recycled. The earliest *Phil*, for example,
was done in 1969 in acrylic (p. 112), while the latest is a spit-bite aquatint from
1995 (fig. 10); of the more than twenty existing "*Phils*," many are in printed or
other editioned versions (for examples see figs. 7–10). And while Close has said
that he does not notify Glass each time he uses his photograph to create a new
piece, he does tend to "apologize" each time they see each other. This photo-
graph remains compelling for Close for formal reasons. The silhouette of Phil
Glass's hair—his "Medusa-like head" as Close refers to it—remains an inventive
challenge as it is translated into new mediums. Other photographs have a hold
on him in ways he cannot articulate.

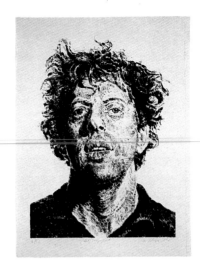

fig. 7. *Phil/Fingerprint*. 1981.
Lithograph, 50 x 38" (127 x 96.6 cm).
Publisher: Pace Editions, New York.
Printer: Vermillion Editions, Minneapolis.
Edition: 36

It is well known that Close uses friends, family members, and personal
acquaintances as his sitters but does not accept portrait commissions. While he
has been tempted at times to do so, such as when a friend might request it,
he maintains his original prohibition against this practice, concluding that ex-
ceptions would lead to confusion about the intent he has for his art. Moreover,
Close believes that if he knew the sitter would ultimately own the work, it
would affect and alter his feelings during the entire creative process. In fact,
none of his sitters (other than his two daughters) own paintings of themselves.
"People lend me their image in an act of tremendous generosity and with a
great deal of guts," Close says. While he has tried over the years to give Glass
a "*Phil*," Glass has always declined. When the artist finally convinced him to
accept, Glass gave the piece to a member of his family. "Everyone has the same
dread...they have a lot of trouble with their images and aren't comfortable
hanging them around the house. They would prefer to have one of someone
else." Some people have even declined the invitation to be subjects, preferring
not to be scrutinized in this way. "I've asked over and over, hoping they'll
change their mind but, for one reason or another, they don't want their image
out there, or they don't want me to do their image," Close has remarked.

While portraiture was not the initial impulse for Close's art, it has undeniably
captured his attention. "Recently, I've realized that when I go to a museum,
the works I stand in front of for any protracted period of time are almost always
portraits. So there must be something there that's more compelling to me than
I ever thought was the case."[12] He constantly shoots portrait photographs and
has accumulated many more subjects than he has ultimately chosen to portray.
Sometimes he has photographed someone with only a vague interest, and the
results have made him immediately want to work with that image; at other
times he is very anxious to have a certain person "enter that family of images"
but the face just doesn't seem right as a photograph. There is actually no corre-
lation between his personal closeness to a subject, his desire to do his or her
portrait, and whether or not he ends up doing it.

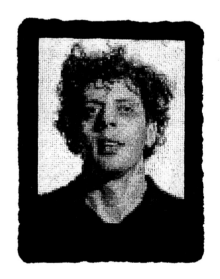

fig. 8. *Phil III*. 1982.
Handmade paper, 69 x 54" (175.3 x
137.2 cm). Publisher: Pace Editions,
New York. Printer: Joseph Wilfer, New
York. Edition: 15

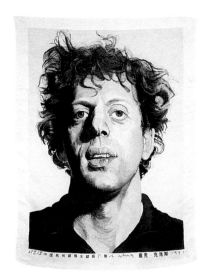

fig. 9. *Phil.* 1991.
Woven silk tapestry, 49 x 37" (124.5 x 94 cm). Publisher: the artist. Fabricator: Rugal Art and Craft Silk Carpet Factory, Jiansu, China. Edition: 50

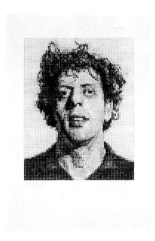

fig. 10. *Phil.* 1995.
Spit-bite aquatint, 28¼ x 19¾" (71.8 x 50.2 cm). Publisher: Pace Editions, New York. Printer: Spring Street Workshop, New York. Edition: 60

When the same sitter appears in different mediums, certain elements in Close's approach become clear, revealing the various creative systems he has devised for each. While some methods reflect his general stylistic evolution, others seem tied to the demands of the particular technique. Each technique requires a procedure with its own internal order, which inevitably affects the interpretation of the sitter's "character," even when it is the same sitter who is depicted. But while personal characterization, as such, is a primary factor in conventional portraiture, for Close it seems to be a by-product of other concerns and may or may not provide insight into the actual personality of the sitter. It is the artistic means themselves that demand attention, even while the confrontational, close-up poses make his sitters impossible to ignore. Means and ends form a new kind of symbiotic wholeness in Close's art.

When grouped according to sitter, Close's prints offer a clear opportunity to focus on the effects of technique as shaped by the artist. He has said: "It's an entirely different way of thinking and looking from technique to technique. You cannot go directly to what you want, you have to go some odd, eccentric route to get there. The route you take is a large part of the experience for the artist, and vicariously for the viewer." In the end, prints in each technique have "a different spirit because of that engagement." Close has compared working with the same sitters in different techniques to translating ideas into different languages, with the same subtle nuances of meaning and syntax required. Interpretations then change further as the viewer becomes a partner in what Close characterizes as the "performance" enacted in the use of each technique.

Six different sitters in a variety of printmaking techniques are reproduced here to illustrate these points (figs. 1–16, and pp. 158–59, 172–73, and 178–79). Among them is a self-portrait. Close's own face has always been a readily available subject, and over the years he has created over thirty self-portraits in a wide variety of mediums. He has also had the opportunity to rephotograph himself, and different photographs have been used as starting points. One might interpret this use of his own face as a means of ongoing psychological self-analysis, but Close states that he has not knowingly used his image for such probing. What he notices about himself is not on the level of emotional insight, but on the level of physical appearance. He sees himself aging; as he puts it, "I watch my hair disappear."

"I almost wish I had decided that, say, all prints were going to be self-portraits, or something like that. Just so that for that entire body of work, one constant would always be there." But, he adds, "that probably would have been nauseating...that many Chuck Closes." However, a comparison of the "Self-Portrait" prints provides a telling series of distinct relationships between depicted subject and working process, with the tension between the two giving each work part of its vitality (figs. 1, 11–16). The huge screenprint (1995; fig. 15) offers a world composed of layered, flat strokes and shapes, each with varying opacity. Here, the part of the grid that fills the background is complex and active in itself, as, of course, is the section devoted to the figure; individual components of both background and foreground become enveloping when one stands near

this large-scale print. Nevertheless, the size and boldness of the figure allow its own presence to assert itself.

The activeness of the background grid, in effect an environment of art surrounding and at times competing with the sitter, is found to some degree in all the *Self-Portrait* prints shown here, with the exception of the linoleum cut (1997; fig. 16). There the focus is solely on the head and its placement on the sheet which, due to its size and probable eye-level hanging height, confront the viewer almost as a mirror. The layering of muted colors creates an inner glow counteracting the eerie effect of the hundreds of tiny, rounded shapes that, together, assemble the face and call attention to the laborious carving required.

Neither the screenprint nor the linoleum-cut version of "Self-Portrait," however, conveys the somewhat friendly demeanor of the face in the etching on white paper (1977; fig. 11), or the vulnerability in the small, spit-bite aquatint (1988; fig. 14). The initial photographs used are contributing factors, but perhaps the subtle texture of the paper surfaces and the warm glow of their whiteness, both as margins and throughout the compositions, play an integral role in making these images seem accessible. The fragility of the slightly raised, diagonally etched lines, and the soft, fuzzy daubs and tonally varied circles of spit-bite are also factors. This humanizing quality is even more striking in the handmade paper version of *Self-Portrait*, in which the gridded squares have lost their rigidity through the manipulation of pulp and mold themselves around facial features to create seemingly fleshy contours (1982; fig. 13). In contrast, the etched *Self-Portrait* printed in white ink on black paper (1978; fig. 12) bears an air of artificiality with a ghost-like pall that conjures up the look of faces on a black-and-white television screen.

In addition to the technical requirements of each process, note should also be taken of the role of Close's stylistic development when examining differences between individual prints. In some cases, the prints and the paintings executed in roughly the same time period are similar in appearance, but in other cases, they provide a stark contrast to one another. He has said that he occasionally chooses to engage himself in ways that are consciously contrary to the mode he is currently working in simply because he feels a need to "revisit" issues from a previous period. "Sometimes a print technique can be a relief from what you are doing; or sometimes it extends what you are doing." For example, *Alex / Reduction Print* (1993; p. 179) represented a return to the photographic visual effects of the continuous tone paintings he had done many years before, even though the print was executed at a time when his contemporaneous paintings were filled with an expressionist array of "dots," "dough-nuts," and other shapes.

### Functions of Printmaking

It is clear that the methodology of printmaking is grist for Close's conceptional mill and that it serves to further his artistic aims. But his artworks created in multiple editions also fulfill another function—a social function that provides more viewers with access to his art. Close points out that his slow rate of

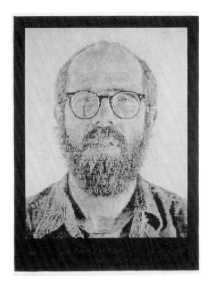

fig. 12. *Self-Portrait / White Ink*. 1978.
Etching, aquatint, and engraving, 53 x 41"
(136.7 x 104.1 cm). Publisher: the artist.
Printer: Crown Point Press, Oakland.
Edition: 35

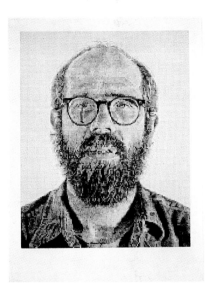

fig. 11. *Self-Portrait*. 1977.
Etching, 53⅞ x 40¾" (136.9 x 103.5 cm).
Publisher: the artist. Printer: Crown Point
Press, Oakland. Edition: 35

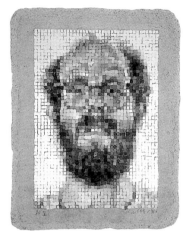

fig. 13. *Self-Portrait / Manipulated*. 1982.
Handmade paper, 39 x 29" (99.1 x 73.7 cm).
Publisher: Pace Editions, New York.
Printer: Joseph Wilfer, New York.
Edition: 25

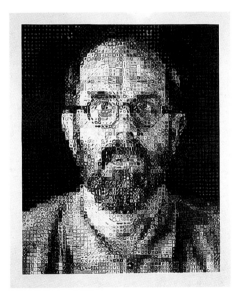

fig. 15. *Self-Portrait*. 1995.
Screenprint, 64½ x 54" (163.8 x 137.2 cm).
Publisher: Pace Editions, New York.
Printer: Brand X Editions, New York.
Edition: 50

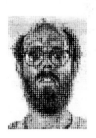

fig. 14. *Self-Portrait*. 1988.
Spit-bite aquatint, 20½ x 15¾"
(52.1 x 40 cm). Publisher: Pace Editions,
New York. Printer: Aldo Crommelynck,
New York. Edition: 50

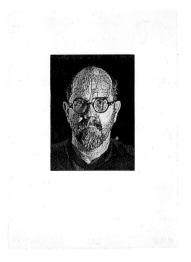

fig. 16. *S. P. #I*. 1997. Linoleum cut,
24 x 18" (61 x 45.7 cm). Publisher: Pace
Editions, New York. Printer: Spring Street
Workshop, New York. Edition: 70

production has determined his total oeuvre at only about sixty or seventy paintings. While rarity was never his intention, very few people or institutions can own an example. He very much likes the fact that his printed and other editioned works make his art more available. "I really believe in access— in people standing or sitting in front of these objects. That is the essential experience."

Close knows that most people experience art through reproduction. "Yet, if you don't have the physicality of the piece, you've got only the barest sort of notion of what the work is really about." Printmaking provides the opportunity to have his art collected. "But I knew early on that I wasn't interested in a reproductive method of printmaking. I didn't want prints to be some throw-away, signed, posterized reproductions that stood for me and my work. I was committed to making things that engaged me in the same way, with the same interest in process, the same intensity, the same commitment of time, and whatever else is required with the unique works."

Since the creation of systems is Close's basic working method, those required by printmaking—with the inherent rules and regulations of technique and the various collaborative partners needed—have proved fruitful for him, becoming assets rather than liabilities. His notion of art, embedded in a modernist tradition based on art's formal elements, involves pictorial problem-solving. The subsequent processes he utilizes as solutions become ends in themselves. In his most successful pieces, an engagement with the viewer is created that shifts almost imperceptibly between these artistic building blocks and the sitters they depict, with neither dominating the other.

The origins of Close's system-building stem from his desire to get away from clichéd artiness, a tendency he says that he naturally fell into when his dependence on spontaneous inspiration as a generating force opened up every conceivable option to him. To combat his own facility, he began to set up seemingly self-limiting procedures, which ultimately were anything but limiting. The obstacles inherent in printmaking processes led to even more possibilities for him. Their special language eventually enriched his way of approaching not only prints but his art in general. As Close puts it: "The thing that is the constant surprise is how my multiple work informs my unique work, and how the unique work then changes the prints. It's a real conversation back and forth. It just keeps going."

NOTES

1. All quotations from the artist are taken from two interviews with the author in June and July 1997.

2. For documentation on Close print projects from 1972 to 1988, see *Chuck Close Editions: A Catalogue Raisonné and Exhibition*, exhibition catalogue (Youngstown, Ohio: The Butler Institute of American Art, 1989), with text by Jim Pernotto.

3. Kathan Brown, *Ink, Paper, Metal, Wood: Painters and Sculptors at Crown Point Press* (San Francisco: Chronicle Books, 1996), 88.

4. Michael Shapiro, "Changing Variables: Chuck Close & His Prints," *Print Collector's Newsletter* 9, no. 3 (July–August 1978): 70.

5. For a thorough discussion of the Japanese woodcut project of Crown Point Press, see Brown, *Ink, Paper, Metal, Wood*, 176–203.

6. See Kathan Brown, "To the Editors," *Print Collector's Newsletter* 16, no. 2 (May–June 1985): 53, and "Collaboration East & West: A Discussion," *Print Collector's Newsletter* 16, no. 6 (January–February 1986): 196–205.

7. Brown, *Ink, Paper, Metal, Wood*, 181.

8. Ibid., 196.

9. Adam D. Weinberg, *Aldo Crommelynck: Master Printer with American Artists*, exhibition catalogue (New York: Whitney Museum of American Art at Equitable Center, 1988), 2.

10. Ibid., 15.

11. For a detailed description of the making of *Alex/Reduction Print*, see *A Print Project by Chuck Close*, exhibition brochure (New York: The Museum of Modern Art, 1993), with text by Andrea Feldman.

12. Chuck Close, "Artist's Statement," in *Artist's Choice: Chuck Close, Head-On: The Modern Portrait*, exhibition brochure (New York: The Museum of Modern Art, 1991), 2.

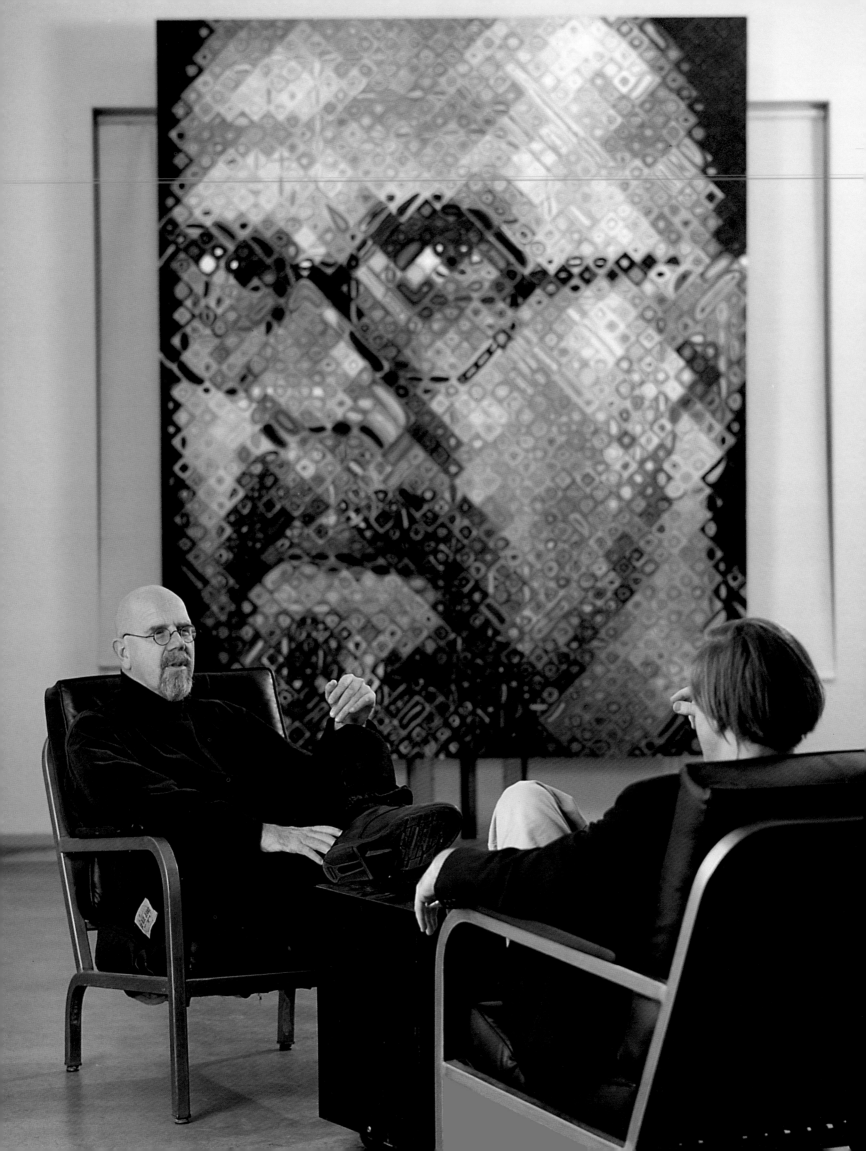

# INTERVIEW WITH CHUCK CLOSE

ROBERT STORR

This interview was conducted in April 1997.

**Robert Storr:** To begin, I wonder if you could describe what the art world was like when you first entered the scene here in New York.

**Chuck Close:** The art world was a pretty comfortable place for me when I came to New York because so many friends of mine from graduate school were already here or came at the same time. So I had a sort of built-in support system. We all helped each other. I helped Richard Serra make all his early lead Prop pieces when he just needed bodies to push the material around. You know it was a much smaller art world than it is now. We used to do every gallery in New York comfortably in an afternoon or a day. You started on 86th Street and ended on 57th Street, and you could see virtually everything that was contemporary in New York. It was a very exciting time.

I moved here in 1967 and it was politically such an interesting time in the world and in America. Everything seemed to change around '68. It was a kind of watershed moment. A lot of things seemed to be up for grabs or were being redefined. It was a very pluralistic art world. People did not like the seventies because of its lack of focus and the fact that there weren't art stars in the same way that there were in the sixties and eighties. But that very unfocused quality that many people disliked really made it a very healthy scene. So many different things were going on at once. Nothing predominated; there wasn't one thing that was the right thing to be doing and everyone else hopelessly lost. The emphasis was on finding a material or a way to work. Everyone could back themselves into their own particular idiosyncratic corner, work out of those issues, follow them wherever they went, and not really have to worry too much about where the art world was at that moment. It was, I think, a great time for artists, even though everyone else hated it, because it was not neatly digested, packaged, presented. As a generation, those of us who came up in the late sixties and early seventies have had a wonderful opportunity to mature. Many artists from the sixties and eighties peaked early and then went on a slow and steady decline. That's partially because of their superstar status, they had to develop in the white-hot glare of the spotlight attention. But if you look at my generation, including many people I went to school with like Richard Serra and Nancy Graves, Brice Marden, Bob Mangold, and Sylvia Mangold and people like that—and others, Joel Shapiro, Elizabeth Murray, they all have been able to keep working. And they're still finding another way to skin the cat thirty years later.

fig. 1. Chuck Close and Robert Storr in conversation, 1997

**RS:** American society was in a pretty fair state of chaos at that point in the late 1960s and early 1970s. Could you talk a little bit about the relation—the balance or imbalance—between the focus you and your contemporaries sought in the studio, and the traumatic events taking place outside it.

**CC:** I think everything changed in 1968 with Martin Luther King's assassination. I remember walking south on Greene Street, where we lived, the day that King was shot. In 1968 SoHo was as deserted as it could possibly be. You never saw anyone at night. There was a man walking toward me and when the light caught his face, I could see him. He was black and he looked at me. And for the first time in my life, I felt like someone hated me just because I was white, and I was guilty and felt guilty. It really seemed to change everything. That kind of tremendous social pressure may have driven people both out of the studio and back into the studio. I think the studio served as a refuge from what was going on, the chaos in the outside world. You just felt like the world was spinning out of control, and everybody that you believed in and everybody you supported from Malcolm X to the Kennedys to Martin Luther King were wiped off the face of the earth. So, it was an odd time but a very fertile time.

fig. 2. Elizabeth Murray. *Painters Progress.* 1981. Oil on canvas in 19 parts, overall: 116 x 93" (294.6 x 236.2 cm). The Museum of Modern Art, New York. Acquired through the Bernhill Fund and gift of Agnes Gund

**RS:** How did you regard the leading artistic figures of that moment? Did you see them as opening the way for you, or were you in some sense in rebellion against them? In this connection I am reminded of the fact that you have just completed a painting of Robert Rauschenberg, who was among the most protean and influential artists of the early 1960s when you were starting out. His declaration of independence from the previous generation—that of Abstract Expressionist—consisted in part of obtaining a drawing from Willem de Kooning and erasing it. Were you inspired by a comparable desire to kill your aesthetic fathers, at least ritually?

**CC:** Well, you know, our generation was the first fully educated generation—everybody went to graduate school. We were academy-trained modernists, academy-trained Abstract Expressionists, or whatever. So there wasn't the need to kill the aesthetic father as much as debate with him. I do remember there were times when artists took on particular heroes, people who had been incredibly important. I remember when I was helping Richard Serra make the one ton Prop and he said, "Let's get Carl Andre up off the floor," because he had these four plates laying on the floor, and he was conscious, after having put things against the wall, that he was reinventing for himself walk-around sculpture which occupied the middle of the room. So there was certainly awareness of taking on heroes but in a very serious way and with respect.

fig. 3. Robert Rauschenberg. *Erased de Kooning Drawing.* Traces of ink and crayon on paper, with mat and label hand-lettered in ink, in gold-leafed frame, 25¼ x 21¾ x ½" (64.1 x 55.2 x 1.3 cm). Collection the artist

**RS:** Who or what were your models when you painted the first paintings that you felt you could fully lay claim to? Did you have historical precedents consciously in mind?

**CC:** The first heads. You know I didn't call them portraits, I referred to them as heads. I denied any tradition of portraiture. In fact, I wasn't very interested in that. I had one person criticize me for not being interested in the past—not having an art book in my library of anything before 1945. That's not altogether true but I certainly was interested in postwar American art.

**RS:** I remember Alex Katz once saying something to the effect that when he began experimenting with large-format head and figure compositions in the early 1960s, he set about it with the ambition of making a representational painting that would hold the wall the way a gestural abstraction by Franz Kline did.

**CC:** I was very aware of certain people who kicked the door open for an intelligent, forward-looking kind of figuration that was not "retardataire," not reactionary, that wasn't trying to breathe new life into shopworn nineteenth-century notions of figuration and portraiture. Certainly Alex was one of those people and so was Philip Pearlstein. Alex, for just making images larger than life and making things that were

still paintings that hung on the wall competing with other paintings, but also happened to have an image on it. And, of course, [Andy] Warhol. We don't think of Warhol as a figurative painter essentially but that's a role that he offered, and the fact that he was working from photographs was important. I wanted to do something very different from the gesture of making an image with one silk-screen squeegee stroke, and I certainly didn't want to make movie stars. He really nailed all of that down. But Warhol was extremely important for me in terms of building an image that was also a painting.

**RS:** Did Warhol's way of being an artist have a bearing at that time on your thinking about how to go about things? I don't so much mean on the style or technique of what you were doing in the studio as on your ideas about how an artist should conduct himself or herself in the world.

**CC:** Certainly his life in the art world was different from mine and remained different from mine because he was surrounded by a huge cast of characters who helped him make everything. Even though I have many assistants, I still make art the old-fashioned way, one stroke at a time, all by myself. But I did marvel at the way he ran his career, and it was an interesting kind of object lesson in trying to take control in a world that was totally out of control.

The other aspect of that precursor thing was, of course, as opposed to the University of Washington, where I studied art and had to try and glean information from art magazines and reproductions with a magnifying glass—which may be why I made so many black-and-white paintings because I thought all art was black and white since I had to look at color paintings in black-and-white reproductions in my formative years—was that when I did go to Yale there was a chance to meet famous artists, artists who were mentioned in books. And also to have that whole art-world thing sort of demystified, because you see that they're just like other people. So my notion of what it was to be an artist in New York was largely formed by my experiences at Yale and studying with people like Jack Tworkov and Al Held who talked about what it was like to have the life in New York as an artist. Al especially really talked about how to survive. "Listen, you don't need to take a teaching job. You can move to New York. You can put up Sheetrock. You can find a way. This is how you live. You live in loft. It costs this much." And it was really wonderful in terms of taking the scariness out of being an artist. But it was also interesting to see these people up close and personal and to realize the very real problems that they had. I remember one day going with Jack Tworkov and Philip Guston to the Old Heidelberg Bar—just the two of them and me—and they really got into their cups. I watched these two heroes, these two people who were in art books and who had had retrospectives at the Whitney. And Jack said, "God, I haven't sold a painting in three years." And Guston said, "I haven't sold a painting in four years." It was an interesting lesson for a young art student, to think about what it was to have a career, what it was to sustain yourself.

**RS:** The Abstract Expressionists did some serious drinking to be sure, but in the process they did some serious talking too, not just about personal or career issues. There were ongoing debates about what art was or should be, in which Guston in particular took a big part. That makes me wonder what the bar and studio conversations were like for your generation. Among your peers what were the aesthetic or conceptual flash points during the 1960s and 1970s?

**CC:** Well, one thing you may have noticed in conversations with all of us who had gone to Yale is that we all sort of sound alike. And I think that's because we learned to talk art before we learned to make it. It was absolutely essential that you be able to defend your ideas. We were used to all-night sessions, screaming at each other, throwing paintbrushes at each other, smashing furniture over issues in art before we ever got

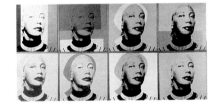

fig. 4. Andy Warhol. *Lita Curtain Star*. 1966. Synthetic polymer paint silk-screened on canvas, overall: 55½" x 9' 3" (141 x 282 cm); eight panels, each 27 x 26⅞" (68.6 x 68.3 cm). The Museum of Modern Art, New York. Gift of Lita Hornick

here. It was something that was already part of what it was to be an artist. When we arrived in New York, that dialogue was also going on here. And the role of the watering hole was just as central as it was with the Cedar Bar for the Abstract Expressionists. For us there was Max's Kansas City, Remington's, the Spring Street Bar, a few other bars. You defined your allegiance by which area of the bar you sat in and who you wanted to spar with, because it was extremely argumentative. I remember, for instance, often sitting in the front of Max's Kansas City with Robert Smithson, Dorothea Rockburne, Mel Bochner, and Richard Serra. At the same time, Warhol and all those people would be sitting in the back room. And maybe Brice [Marden] would be back with [Robert] Rauschenberg. You would move freely throughout the scene and sit for a while at one set of tables and then go somewhere else, and the dialogue was very, very competitive, a competition of ideas. You couldn't get away with flippant comments—someone would demand that you back up what you said. You couldn't get by with a casual complement, the kind of social niceties of the art world where you say, "Nice show," or something like that. You really were pinned down in a way that often made it very uncomfortable but edgy and interesting.

**RS:** So where in general or in specific terms were those lines drawn? What kinds of questions seemed especially urgent? Take, for example, the much-contested status of painting. What was it like for a young artist—what was it like for *you*—to face the assumption, widespread by the mid-1960s, that painting had definitely lost its avant-garde preeminence vis-à-vis sculpture and new media, and in all probability, had run its course historically?

**CC:** I've been around long enough to have had painting be dead many times. I entered at the precise moment when painting seemed to be about as uninteresting an activity as you could possibly think of. Sculpture was really beginning to dominate. Or maybe you worked on the wall or nailed paper to the wall and then put oil on it and let it soak through, or used carbon and drew something that would transfer like Dorothea Rockburne did. People were really questioning what had been accepted by that generation just prior to [Frank] Stella and the Color Field painters. The supremacy of the art object was questioned, plus putting something that hung on the wall and had any kind of decorative quality—like a painting—was questioned even more. But I think there's no better time to make paintings than when people think painting is dead. It was a wonderful time to reassess personally many of those issues: "Why make the paintings in the first place?" "If you are going to make them, what makes the time in which you live different from other times?" "How will that lend any urgency to what you are doing?" "What is it like to make a representational painting after the invention of photography?" "Is photography something that can be used and used in a way different from the way Warhol used it?"

Unbeknownst to me, there were a number of people doing things that were photo-derived in the 1960s. Gerhard Richter was doing stuff in Germany, certain people were doing stuff on the West Coast. A lot of things were in the air, but I think the all-embracing interest in process was probably the common denominator that allowed someone like me to make a representational painting in the very reductive, minimal frame of mind that was in the air at the moment. You know: "Use the least amount of paint, show no artist's hand, try and get all of that virtuoso brushmanship out of there." Things like that came very much out of the idea that the way to liberate yourself from the conventions and traditions of the past was to find a material that didn't have historic usage and see what it would do. What does rubber do, what does lead do? You wouldn't have wanted to use bronze, you wouldn't have wanted to use any traditional art material when the idea was to find a process and go with it. It was about the

fig. 5. Mel Bochner. *Three Sets: Rotated Center.* 1966. Black felt-tip pen, blue ballpoint pen, graphite and colored pencils on graph paper, 16½ x 21½" (42 x 54.6 cm). The Estate of Victor and Sally Ganz

fig. 6. Dorothea Rockburne. *Neighborhood.* 1973. Wall drawing, pencil, and colored pencils with vellum, 13'4" x 8'4" (406.4 x 254 cm). The Museum of Modern Art, New York. Gift of J. Frederic Byers III

imposition of rigorous, self-imposed limitations that seemed to open doors, that seemed to make it possible to go someplace where a lot of other people weren't flocking at the same moment. But it was also just a way to keep from banging your head against a wall.

**RS:** You mentioned Stella. Was he a figure who was important to your thinking at all?

**CC:** Absolutely. I mean I remember when I first got to New York and started seeing objects that prior to that I had only seen in books, and the thing that really became a thrill was finding something that didn't look like art. There's that wonderful moment when you see something that just doesn't look like art, and you are both excited and outraged at the same time and think, "Wait a minute. You can't do this! Art has to have this and that and that, and this object doesn't have any of those qualities. What is going on here?" I felt that in 1964 when I walked into the Stable Gallery and saw what appeared to be a supermarket warehouse of S.O.S. or Brillo boxes stacked to the ceiling. It was Warhol's show. I felt wonderful, momentary outrage, yet I was totally won over by seeing something like that in an art gallery and seeing the limits and definitions of what art could be, having to be elastic enough to incorporate it. Certainly Stella had the same effect when he did the early Black paintings and then the Silver paintings that followed—questioning the rectangle and the thickness of the stretcher, aspects which I still use in my work to increase the kind of object status of the painting, make it something other than just a flat, framed thing on the wall. And Stella experimented with the boring repetition of the artist's mark by creating a methodical process and doing it over and over and over so that no nuance occurred from one side to the other. Your eye would start at the left side and move across the painting's surface. There wasn't any variation, any center of interest, or any of the things that used to be what people talked about in painting. It was just the same all over, like yard goods or wallpaper. All of these issues were really extremely important in terms of showing a way out of building a painting the way the Abstract Expressionists did.

**RS:** Stella also made frontality a central issue.

**CC:** Well, his working method is a wedding of that sense of alloverness with an aggressive, confrontational imagery. I took that alloverness from Stella, the lack of hierarchy, the fact that no area is more important than any other area, and no area is approached with a different attitude or even a different technique than any other area. I wanted to make a painting in which every square inch was made the same way, had the same attitude or whatever. And I wanted to apply that lack of hierarchy—or having a different approach area by area that occurred in those Stella paintings—to a representational image. I wanted to make something that was impersonal and personal, arm's-length and intimate, minimal and maximal, using the least amount of paint possible but providing the greatest amount of information possible. Showing no display of the artist's hand in terms of virtuoso brushmanship but employing unbelievable handwork, you know lots of labor. And I was always interested in the tension that comes from those dichotomies and those extremes. I always thought the best art was extreme whatever it was.

**RS:** In 1967 Lucy Lippard wrote a bellwether essay examining the change in sensibility between the expansive painterly styles of the 1950s and the more austere, procedural work of the 1960s coming out of minimal and conceptual artists such as Carl Andre, Donald Judd, and Sol LeWitt. In that text, entitled "Cult of the Direct and the Difficult," she took note of the premium placed by this new tendency on aggressive presence and the denial of sensuous pleasure. To a certain degree your early black-and-white heads fit this description, but in a broader sense your work complicates the issues she raised—and applied to primarily abstract work—by presenting a kind of

perceptual oxymoron, an image that is easy to identify—in a normal-sized gallery they virtually buttonhole the viewer—but difficult to read after all because of their visual density. Looking at those pictures imposes great demands on the public, but at the same time you made things extremely difficult for yourself in order to pull together the enormous quantity of information they contain into a coherent image. Were you sympathetic to that quest for difficulty or were you tacking off the prevailing winds to some extent in making pictures that were more accessible, at least initially, than their abstract counterparts?

**CC:** I think our whole generation tried to do that in some ways. I remember in 1968 or '69, Richard Serra was in my studio looking at my paintings, and we were talking about how you make decisions as an artist. He said something which I'll never forget: "Making decisions as an artist is the easiest thing in the world because the important thing to do is to separate yourself from everyone else. Certain decisions are more difficult than other decisions. Every time you come to a Y in the road, one way to go is more difficult than the other. So you automatically take the difficult road because everybody else is taking the easy road, and if you do that you will automatically put yourself out in some field all by yourself." Yes, I think we were definitely concerned with the notion of rigorousness, difficulty, or whatever. I remember sitting around with Joe Zucker once, and we were watching some sporting event in which the judges would hold up one card and give a score for what it was that the athlete had done, and then hold up a second card for degree of difficulty. And we thought critics ought to be doing the same thing. This is for what you accomplished but this is for the degree of difficulty.

**RS:** Critics do. [Laughter]

**CC:** But it's so hard to make decisions. It's so hard to put yourself in a position where you are reacting personally. I think problem-solving is greatly overstressed. The far more important thing is problem *creation*. If you ask yourself an interesting question, your answer will be personal. It will be interesting just because you put yourself in the position to think differently.

**RS:** As far as difficulty for the viewer is concerned, here you are at mid-career with a body of work that has received very broad acceptance. Of course, acceptance is not the same thing as understanding, but compared to Richard Serra, who is constantly doing battle against critics, the public, the State, virtually anybody who does not see eye-to-eye with him, your position seems on the whole less adversarial. Do you subscribe to the notion that new art, if it is any good, is by definition oppositional, or do you see things from another perspective?

**CC:** Well, I don't think it is necessarily remembered how outrageous my paintings seemed to people at the time in the sixties. They really did seem to get under the skin of a lot of people. They got under the skin of the so-called eyeball Realists who had made a kind of moral decision about the necessity of working straight from life. It's hard to believe but people thought I was the anti-Christ for working from photographs. But the thing that I think became very clear was that my work could be very easily misunderstood, which is what I think you are getting at. I made a number of conscious decisions, one of which was not to show my work in a gallery which showed representational imagery. There were a number of reasons. First of all, I didn't want to be someplace where people came predisposed toward figuration. I wasn't doing what I was doing because I was against abstraction. In fact, I was doing what I was doing because I loved all that other stuff so much I couldn't help but make weak imitations of other people's art, and I was trying to find something personal to do myself that was as different from that as possible. But I wanted other aspects of the work to be

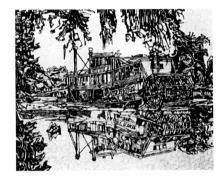

fig. 7. Joe Zucker. *Amy Hewes.* 1976. Acrylic, cotton, and rhoplex on canvas, overall: 8 x 10' (243.8 x 304.8 cm); two panels, each 4 x 10' (121.9 x 304.8 cm). The Marieluise Hessel Collection, on permanent loan to the Center for Curatorial Studies, Bard College, Annandale-on-Hudson, New York

seen. Whenever you have an image, you have the opportunity for people to get on board through that and perhaps not see other aspects at all. I seriously thought of and tried to convince Klaus Kertess, the director of the now legendary Bykert Gallery, to allow me to show one of my paintings upside-down. Not that I had painted it upside-down—Malcolm Morley actually painted upside-down, I didn't—but I thought I'll hang this sucker upside-down and then maybe people will see other aspects of the work.

**RS:** But then you would have been Georg Baselitz! Seriously though, what made you so reluctant for your work to be seen as exemplary of a general aesthetic shift, or yourself as a member of a larger group?

**CC:** No one likes to be pigeonholed. No artist likes to be labeled and no artist is ever comfortable with the group that he or she is lumped together with. We all want to be seen as individuals, and we all have to be respected for that which makes our work different from everybody else's, not the vague, shared, common denominators of some movement which we may or may not feel that we're part of. I stayed out of all those early Realist shows. I refused to participate not because I hated all that work but because I just wanted to be seen as an individual. I had different concerns, but if I then just threw it all into the pot and allowed someone to stir it up and make bad stew, those differences would be lost sight of.

**RS:** Given your refusal to join the Realist camp, who did you see as your natural allies or role models?

**CC:** For me, the two godfathers of my life as an artist really, from an earlier generation, were de Kooning, from whom I learned more about making painting than any other artist, and Ad Reinhardt. Ad did not influence the way I painted, but he influenced the way I thought. Nothing changed my mind more about how to make art than Reinhardt's writings. He made the choice not to do something a positive decision and showed how what seems to be negation ends up flipping around and opening doors and making all things possible. Certainly Sol LeWitt was another person who defined those issues and defined the moment as being one in which choices like that were everything. It was a matter of how you moved, how you kept from being stuck.

I've never had an "artist's block" in my entire career, never permitted myself to have one because I never waited for inspiration, I never waited for the clouds to part and lightning to strike because I just kept altering the variables. I always had something else that I wanted to do, something else I wanted to try, something I would throw out, something else I would put in. Well, it's no accident that I ended up with that freedom because the whole notion of inspiration and a masterpiece went out the window. The serial way of working in art meant that you just signed on and shipped out. You went wherever it went, and there wasn't going to be this ultimate or penultimate moment that summed everything up.

**RS:** It's telling that de Kooning rather than Jackson Pollock should have been in a sense your mentor even though Pollock's paintings emphasized certain formal properties of painting that are crucial to your work, such as alloverness, or the lack of compositional hierarchy as the eye travels across the picture plane.

**CC:** That's right. I recognize and appreciate Pollock's contribution but I don't love to stand in front of his work the way I love to stand in front of a de Kooning. And you know, there was no way to have Pollock enter your world. There wasn't much you could do that you should learn firsthand or steal from Pollock except the whole idea of being that kind of an artist, whereas de Kooning was much more useful. He was always useful to artists. I remember now a famous Clement Greenberg quote that really had urgency for me at the time that I started to paint the portraits that was quoted in de Kooning's *New York Times* obit. I had totally forgotten about it except that now I

remember the impact it had on me at the time. I wish I had the exact quote, but in essence Greenberg said, "The one thing you can't do in art anymore is make a portrait." And then de Kooning said, "Yeah. And you can't help but not make one," or something to that effect. I remember that as the gauntlet being thrown down by Greenberg. It's as if Greenberg had said, "This is the one thing you can't do." Then I thought, "Fuck 'em. I'm going to find a way to do it."

**RS:** You've talked about the methods you use to keep from getting stuck, and how you are never at a loss for new technical challenges, how you deliberately change your studio procedures so as to change the formal equations you work with. Given that systematic approach, I am curious to know what importance you place on the principle of "risk," which was much discussed during the 1950s and is from time to time revived as a primary aesthetic value? How do you judge your work in relation to the idea that an artist progresses by periodically breaking the mold, first the one which he or she inherits from tradition, and later the one the artist has created on his or her own?

**CC:** Well, again, I think an artist like Sol LeWitt is a great role model. He's kept moving, kept running the permutations in a thoughtful, intelligent way. Sol has always found a way to not only have people produce a lot of work for him but have the process continue to unfold in the most wonderful kind of way, even while he's not, in fact, actually making all of this stuff. And, I guess you have examples of people for whom there seems to be almost no elbow room, like a Robert Ryman. You might think, "God, thirty years later, he's still making white paintings," or that the range that he would be able to find within what seemed to be the box that he had put himself in was very narrow. In fact, he's had many exhibitions which point out exactly the opposite. And then there are exhibitions which show the reverse—where there is a great deal of change in a person's career but, in fact, they are the Johnny-One-Notes that someone like Ryman is accused of being. But he's not.

Then there are artists like Brice Marden, who has one career and then experiences a big rupture, and then has another career and then waits for another rupture. That seems pretty scary. So, I guess I tried to make what was going on in the studio, and how it felt, be the determining factor of how long I stayed with any particular thing. What I wanted to do was change the nature of the activity to keep myself engaged. You can, but I don't mean this superficially, which was certainly true of the so-called Photorealists. One year they would have a show with paintings of motorcycles and the next year of pick-up trucks and the next year of sedans, but regardless of the subject it was all shiny chrome and whatever, it didn't make much difference what the imagery was. The iconography changed but the paintings pretty much stayed the same.

I'm surprised that I'm still painting heads after all these years. If somebody had told me thirty years ago that I would still be painting heads, I would have laughed hysterically. I could have the look of change by painting still lifes and landscapes— and yet still have done the same damn painting over and over. What I wanted to do was alter my experience in the studio by changing the materials, changing the tools, changing the scale, changing the scale of the increment, using my body as a tool in the form of fingerprints, or spraying little stupid marks, or whatever the hell it was. And as each one of these things ran its course in terms of my own boredom and ease, then I would sort of naturally gravitate toward something else by altering other variables. I don't mind being bored on one level. I mean, I don't think it's an issue. People wouldn't say to a writer humped over a typewriter six months into a novel, "Are you having fun?" It just wouldn't come up. But we do have the idea that artists are play-

fig. 8. Brice Marden. *Avrutun.* 1971. Oil and wax on canvas, 72 x 36" (182.9 x 91.4 cm). The Museum of Modern Art, New York. Fractional gift of Werner and Elaine Dannheisser

fig. 9. Robert Ryman. *Untitled.* 1965. Oil on linen, 11¼ x 11⅛" (28.4 x 28.2 cm). The Museum of Modern Art, New York. Fractional gift of Werner and Elaine Dannheisser

ing; therefore, the play should be fun. I try to make things that I think are important or valuable, and I am perfectly willing to put the time into them.

**RS:** Could you describe the transition from the generally compressed and close valued work of the late 1970s and early 1980s to the paintings you are making now, in which the color is more varied and intense, the grid more open, and the stroke more visible?

**CC:** I had actually made the first oil paintings around 1980, that is, they were the first I had made since I was in graduate school. Those first paintings had quite a small grid. I think it was about a quarter of an inch or something like that, maybe a little bit bigger. So there was really no possibility to do much other than put one dot in each one of the squares. They were much more like the pastels that I made in and around the middle-to-late seventies and early eighties. But I wanted to make paintings that were allover. I wanted to be responsible for the whole field and to try and make something that was built out of incremental units, but I also wanted to get away from the grid. So, having made those initial couple of oil paintings, both of which had Stanley Rosen as the image, I started doing other things that abandoned the grid, although things were still incremental. I did pulp-paper pieces and fingerprint pieces where the fingerprint or a chunk of pulp paper became the unit. They were more randomly oriented. When I returned to oil painting, I decided that I would start to increase the increment. The reason I wanted to blow up the size of the increment and make each individual square larger was in order to find the color in context in the rectangle rather than making all the decisions out of context.

I still mix paint on a palette but when it went into the painting it was also going to mix physically because it was wet-into-wet, and it was going to optically mix with the other colors in that area as well. Using that as my methodology over the next several years, I would complete a series of paintings, then blow up the grid even larger to allow myself to stir more colors in and make the situation more complicated. Then I began to combine them and run them together with marks from adjacent squares.

**RS:** To what extent do you anticipate the final result? How are the first colors to go down determined, and how do you proceed from there?

**CC:** Well, the colors are not as arbitrary as one might think but more arbitrary than they look. That is, I will make the choice to put a color down as a kind of base decision so that I will have something to respond to. When I used to start with the same color in each square, the whole first part of the journey was the same. But now one square will begin as pink and one as blue and one as green and one as orange, so even if the next layer in that area is going in the same part of the spectrum, what is already underneath just makes it more interesting. So it's arbitrary in that for the beginning I'll just do something different from the square that I did before.... I don't want it to just be like peeling off the layers of an onion with all the color that's underneath of a certain nature and all the colors on top of another because then people can look at the painting and do amateur archaeology back through the strata.

I want to mix it up. Ultimately it allows me to be intuitive. The system is liberating in that when I used to allow myself to make paintings with any old color, I would use the same color combinations over and over again. I found myself much too much a creature of habit. One of the interesting things about working this way is what seems to be a kind of rigorously imposed system that might seem limiting or perhaps stifling in terms of the choices you can make. But it ends up allowing me to let my mind go blank and respond.

I try and make the decisions in three or four moves. When I mixed paint on a palette and tried to drop it in and get it on the first crack, that was the equivalent of shooting an arrow straight at a bull's-eye. You hope that you made the right decision,

and that it will hit the center in one action. Then, I thought, maybe I could look for some other kind of game, some other kind of process, and it occurred to me that it was possible to do something that's much more like golf. Golf is the only sport in which you move from general to specific in an ideal number of correcting moves. The first stroke is just out there, the second stroke corrects that, the third stroke corrects that. By then you are hopefully on the green, and you can try to place the ball in this very specific three-and-a-half-inch diameter circle that you couldn't even have seen from the tee. So, it was a different way of thinking about finding what you want, like walking through the landscape rather than going straight for something.

**RS:** We talked before about the example set for you by Alex Katz, and, with respect to what you've just said, there are some interesting parallels between your work and his, especially regarding his way of restricting himself to a finite number of marks or shapes in the depiction of any given form. He will allow himself one or two or three moves to bring a particular facet of a nose, ear, eye, or jowl into focus. You do it differently but the strategy is in some measure comparable, as are the graphic economy and crispness of the result.

**CC:** Well, his working method is interesting because he makes all his decisions early in little studies and then mixes large quantities of paint to agree with the little color studies and then puts it all on the canvas relatively directly. I always thought that the interesting thing about the way Alex made decisions is that he pushed everything to the edge. The whole center of an area will be flatly filled in with one color. But where the color planes meet, where the rubber meets the road, you can see what's happening on that edge. That, I think, comes out of Abstract Expressionism.

**RS:** Although Abstract Expressionism has exerted a powerful influence on your work as well as Katz's, it would seem that its influence has, on many levels, been negative or inside-out, a matter of your striving to achieve similar impact but arriving at that point by taking the opposite route technically.

**CC:** You know sometimes you do something to correct something that you think is an essential flaw in your nature. And if you do that, you have your own reasons to make things, not the art world's reasons. There were a number of issues that I discovered by myself when I was a junior Abstract Expressionist, one of which was that painting allover drove me crazy. You do something on the upper left-hand corner and that changes the way the lower right-hand corner looks, so you go down and you do that. And then what you just painted there falls off the canvas. I found myself applying first aid to paintings and saving little precious areas that I loved, but couldn't be ruthless enough to paint out anything so that when the whole painting was full of precious areas that I couldn't afford to paint out, I was done. The problem was that the painting wasn't conceived of as a whole; it never came together; it was just a series of fractured elements that I happened to like.

And then I had violent aesthetic mood swings. I would be wildly excited about the way it was going, and then I would just crash. It would be the most depressing thing in the world. I'd have a great start, and then the whole thing would end up in the toilet. Then I would try and save it, but I gradually realized that this is not a way of working that I was very well suited for. I needed something that was more positive as an experience, something you could add to every day and, if you keep doing it, eventually you get there.

There are other things about my nature that I didn't like. You know, I'm such a slob—how did I end up making these neat relatively tight paintings? Finally, it was a question of recognizing that I had a particular nature, that I was lazy and slobby and indecisive. I realized that to deal with your nature is also to construct a series of limita-

tions which just don't allow you to behave the way you most naturally want to behave. So, I found it incredibly liberating to work for a long time on something even though I'm impatient. I found it perfectly fine in the middle of squalor and half-eaten sandwiches and beer cans full of cigarette butts to sit in this mess and make very neat, precise paintings. It did not seem like such a dichotomy or such a denial of who I was. It seemed like I was taking care of who I was.

**RS:** Nevertheless, your recent paintings give license to some of the painterly impulses suppressed in your earlier work. Where gesture and color were previously subordinated to other aspects of the picture, now with elongation and nesting of strokes that tug away at the integrity of the likeness, they are plainly visible on the surface of the paintings. But it's not just de Kooning's spectra one sees. For example, the diamond-shaped lozenges you cluster to create the eyes of the sitter turn into tiny optical jitterbugging Mondrians.

**CC:** I think sometimes you can push something out of your painting, and then when you finally bring it back in you do it in a different way than if you'd never gotten rid of it in the first place. The fact that I had gotten rid of gesture—although I really didn't, I had just disguised gesture, controlled it in a certain way making those early paintings—but after I'd got drawing in that normal sense of the word out of the painting, by the time then when I dropped it back in the shape of hot dogs and lozenges and doughnuts and stuff like that, I had such a different reason to use it that I didn't fall into the same old habits. The same thing is true of color. I got color out completely and made black-and-white paintings, or I made color paintings with only red, yellow, and blue, but then when I came back to being able to use every color that I wanted, I ended up using a lot of the same color that I used in the fifties and sixties—a lot of de Kooningesque *Pink Angel* color, or areas that to me look very much like *Door to the River, Merritt Parkway*, or some of those early paintings I especially loved but I had such a different reason to use it. When it came back in, it's like quoting in such a way that the references would not make most people think about de Kooning or think about Abstract Expressionism. But for me it's very similar. Some of these images barely coalesce or coalesce in such a way that some people can't read them. I mean some people can't read the sex of the sitter, or whether they're young or old. Other people read them better. I think people who are used to decoding in a certain way seem to read the work better in the same way that people who are used to watching jump cuts in films don't have any trouble keeping up with flickering images. The MTV generation can watch something that's on the screen for a hundredth of a second and see everything. But you're right, I am celebrating the surface at the same time as I'm denying it. I love what you described as a kind of jitterbug and sort of as optical bounce. I love being able to put that into a representational painting. Just like I love putting color that I knew and loved in a very different kind of painting into representational paintings.

**RS:** The scanning patterns of the human eye are crucial to the formal logic and perceptual experience of the new paintings. When one confronts a canvas from a distance, head-on details tend to hold their place, but as you approach them and the eye moves left to right, those details start to become animated and shake loose.

**CC:** Well, in a way it's not unlike the way we look at people. When I look at you, I pick one eye to look at and then I sort of dance to the other one and back. A painting duplicates that gaze. You're looking at it, it's looking at you. I'm as interested in the distribution of marks on a flat surface and the articulation of that and the patterns and the beat that comes up as I am with the thing that ultimately gets depicted. My tendency is to see things formally, but I think some people when they read a poem or

fig. 10. Willem de Kooning. *Door to the River*. 1960. Oil on canvas, 80 x 70" (203.2 x 177.8 cm). Whitney Museum of American Art, New York. Purchase, with funds from the Friends of the Whitney Museum of American Art

novel or whatever, the narrative line is so important for them that they lose touch with the fact that it's actually built out of a series of words, and the words are pushed up against each other, and slowly an image is built. Other people like the way the words trip off the tongue and really get interested in the syntax and the physical experience of just forming words and making something out of them. I guess I always liked operating in the tension between those two extremes, where there are times when it's just the sheer joy of marks falling next to each other and then "oops" that it shifts into an image, and so that what was flat ends up spatial. It's that dichotomy shifting from one to the other that really interests me.

I think it happened in the early painting as well even though people think I was so much more concerned with process. But the new paintings are not freer than the old paintings. They look freer but they are a lot less free than they look. No painting ever got made without a process. No painting ever got made without some system. I always love it when viewers stand way back to see the whole image, then move to a middle distance where it's hard to see the whole thing, and then hopefully go right up to the painting and see that it is just a distribution of marks on a flat surface. One of the reasons why I was so uncomfortable with the idea of being a Realist is that I think I was as interested in artificiality always as I was in Realism. And it is that relationship of the artificial to image-building that I love about all the painters of the past.

**RS:** Technically, the early airbrush paintings demanded an extreme degree of close-up involvement, but the end product frequently struck one as remote. Starting with the fingerprint paintings, that impression changed dramatically, and the new works have an even more striking immediacy to them.

**CC:** Yes, there are a number of factors involved. I always enjoyed keeping an arm's-length distance from what I was doing, and if I am going to err on any side it's going to be on the side of remoteness. It's probably a part of my nature. A lot of people would like to read into the paintings changes that occurred because of what happened to me physically. To a certain extent, I think there is some truth in that. That is, I think that certain aspects of the work did change after I was in a wheelchair, and I had to figure out how to make paintings again. That can be attributed, at least partially, to being happy about being able to get back to work and having so many other things that I couldn't do that I really poured a lot more energy into those things that I had left. And painting was the one activity that brought me the most pleasure. There is a celebratory aspect to the paintings since I got back to work that may be a palpable change. But if you look at the show at Pace Gallery just before I went into the hospital [December 1988], you can see a kind of logical development toward what I'm doing now. I think that the work is probably not all that different from what I would have made anyway had I not had this event happen to me where I ended up having to strap the brushes to my hands and work in a wheelchair. That said, there are some other aspects to that which I only now am beginning to understand and appreciate eight years after having been in the hospital.

I went to the Met recently to look at some paintings, and I started with van Eyck and then Petrus Christus and then on into Holbein, and I realized that everything that I loved was little and tight—always the product of fine motor control. And I got so unbelievably depressed. It just hit me like a ton of bricks that I was never ever going to be able to make paintings again which were done with the wrist and fingers and done with that kind of fine motor control. Now, in all likelihood, I would never want to do it anyway, but I guess I hadn't thought about options truncated, doors closed, whole ways of working which were not available to me any more. And I think for the first time I experienced loss in terms of what options were closed to me. So, a very curious

thing happened. I continued on and looked at the Vermeers and all the other paintings that I love so much, and I got sadder and sadder. Normally I would be depressed for a half a day and then I would go right on to what I was doing. I stayed depressed for a long time. I really went with it, I was really grieving and I found myself just crying all the time.

So, the next Monday rolled around and I went to the studio. I was working on a painting and I really liked what I was doing, and I was enjoying these paintings a great deal, so I found myself painting away happy as can be, whistling. I was having such a good time and simultaneously I had tears streaming down my cheeks. I thought, "God, this is really interesting." I don't have to squelch the sense of loss in order to feel good, and I don't have to stop enjoying what I'm doing and finding value and pleasure in the kind of painting I am making now. It was really cathartic to realize that you could have both simultaneously and feel both. I mean, literally, I was whistling and smiling and the tears were rolling at the same time.

**RS:** What was the first painting you made during or after your rehabilitation?

**CC:** My wife, Leslie, had said to the occupational therapist that "you have got to find some way to get Chuck back to work." So we took a piece of shirt cardboard and I drew a primitive grid on it, and I stuck it straight up in a vise on the side of one of the tables in the hospital arts-and-crafts room. Then we got this brace that is normally made to hold a pencil, and we figured out some way to shove a brush into it. And we got some crummy acrylic paint—like four colors that you would never use in your wildest dreams—and I ended up lunging at this cardboard and trying to put a little daub of paint in the middle of each one of these squares. And I'd miss completely. My wife was there, and the physical therapist was there, the occupational therapist was there, and I said, "You see, I can't do it." But a little piece of me thought at the same time, "Well, maybe—maybe you can." So, the occupational therapist made a wheelchair-accessible easel for little paintings, and we found this hideous space on the ground floor of the Rusk Institute where they had bad art hanging from the clotheslines and half-finished baskets and, you know, like the worst burnt wood stuff you've ever seen. We set up this wheelchair-accessible easel and I started to paint. And Michael, my assistant, brought my paint and stuff down to this art-therapy room. At first, I didn't have enough strength to even mix the paint. I would tell him, "Mix some phalo green and some white; more white; a little yellow; no, not that yellow, the cadmium yellow medium; a little bit more." Finally when we got the brush loaded with the paint I wanted, we would slip it into my brushholder and I would drop it into the painting. My recollection now is that I was thrilled from the very first moment. I did a painting of Alex Katz, a small painting of Alex Katz, that I'd taken the photograph for long before I went into the hospital. The photograph itself was not particularly sad, but the resultant painting ended up expressing the kind of conflicting emotions that I was feeling myself (p. 174). I worked on that painting and started a second painting in the hospital, so that by the time I left I'd made like a painting and a half in the last few months.

**RS:** Beginning with the portraits of Francesco Clemente, Lucas Samaras, Alex Katz, and Cindy Sherman that you showed in your 1988 exhibition at Pace, you once again made artists your primary subject matter, as you had done in the late 1960s. Only this time most of them were very well known, whereas in the past you had avoided publicly familiar faces. Could you explain how and why this simultaneous return to your starting point and change of emphasis came about?

**CC:** Before I went in the hospital I had gone back to painting other artists. I was trying to figure out why I still lived in New York and why I put up with having my car towed,

or paying an exorbitant rent for a studio and all of that when I could just as well work somewhere else. And I realized the one thing that really mattered about being in New York—it allowed me to be close to the community of artists that I considered my other family. So I began to make paintings again of my colleagues and fellow artists as a kind of reaffirmation of the importance of these people to me. When I returned to painting artists, I decided not to just paint my best friends. I really wanted to make some paintings about people whom we know because they have made images of themselves. I wanted to paint pros, people who have posed themselves and are not just putty in your hands when they walk in to be photographed. Certainly this was true of Lucas, who manufactures a look that only lasts for one-hundredth of a second. He pumps himself up in front of the lens with this incredible intensity which dissipates the second the shutter is snapped. And then, of course, there was the question of how Cindy was going to present herself when she came to be photographed. I didn't even recognize her when she walked through the door. She had this sort of schoolmarmish look with glasses instead of her contacts. So, I got used to thinking about making images about fellow artists for whom I have a real sense of connectedness, not necessarily first and foremost a close personal friendship but some kind of connection that comes through the work. And I frequently used it as an excuse to get to know some people that I wished that I knew in an attempt to sort of establish a dialogue with another generation of people who were making images.

fig. 11. Roy Lichtenstein. *Mirror #10.* 1970. Oil and magna on canvas, 24" (61 cm) diameter. Collection PaineWebber Group Inc., New York

There always seemed to me to be a real pitfall in the nature of artists' friendships in that they tended to be of your generation, they tended to be based on certain common beliefs and shared attitudes. I really wanted to be around some kids and see what made them think there was something about this particular time that drove them to make art. I've gone generationally backwards, too, by painting Roy Lichtenstein, Robert Rauschenberg, and Paul Cadmus. Roy and Paul are part of my old-men-with-ponytails period.

**RS:** What do you think of the critical treatment you've received, particularly in the eighties? Were there themes that were not picked up on that you would have . . . ?

**CC:** You know my work was very much out of phase with a lot of the things that were going on in the eighties. But I didn't drop off of the radar. The best thing to do in that situation is just to keep going, and hopefully what you're doing bisects the needs that the art world has at that particular moment that allow them to recognize the inherent value of what it is that you're up to. It is only for a brief moment that your paths cross, and then if you are lucky somewhere later on your paths may cross again, and if you live long enough they might cross several times. You can't plan it, you can't orchestrate it so that you guarantee that your issues will be the issues the art world is looking for. I've always been extremely fortunate to have gotten attention, including critical attention. I think it would be especially whiny and unattractive of me to complain about the nature of the attention I got because I have received an inordinate amount. Far more than many people whose work I can think of which is as deserving of it as mine.

**RS:** Although you always worked picture by picture, have you ever thought of the cumulative body of work you have created as a composite portrait of the art world, a sociological or historical sampling of your milieu or a document of your time?

**CC:** I'm the last person probably to comment on that aspect of the work. I don't mean to suggest that I'm denying that. It's just not in my consciousness really. I know that there have been changes in hairstyles and fashion that are reflected in the pieces, and they're very much what I think about on some level. But in a larger sense, I'm not sure how to talk about the issue.

Some people wonder whether what I do is inspired by a computer and whether or not that kind of imaging is a part of what makes this work contemporary. I absolutely hate technology, and I'm computer illiterate, and I never use any labor-saving devices although I'm not convinced that a computer is a labor-saving device. I'm very much about slowing things down and making every decision myself. But, there's no question that life in the twentieth century is about imaging. It is about photography. It is about film. And it is about new digitalized things. There are layers of similarity, I suppose, that have to do with the way computer-generated imagery is made from scanning. I scan the photograph as well, and I break it down into incremental bits, and they can break it down into incremental bits. In fact, I have a *Scientific American* from 1973 that I saw on a newsstand the exact day that I was walking to my first dot drawing show at Bykert Gallery. Clearly, there are some similar issues, but I had no idea that it existed. It's not unusual, however, to have things occur within the same time frame without people knowing about it. The fact is that painters on the West Coast were working from photographs at the same time that painters in Europe were working from photographs. A lot of us sort of sprung up from the surface all at the same time without any knowledge of one another because those issues were in the air.

**RS:** Computer-generated images raised two issues. The first was purely technological: how a picture could be reduced to digital patterns. The second was perceptual and concerned the threshold at which all these bits of digital information could be read as an integrated whole or gestalt. There is, in effect, a visual continuum, and at a certain point the image becomes recognizable, while everything short of that point resembles an abstraction. You reconstitute the likenesses from fragments according to your own system, but have you ever considered interrupting the layering process at an early stage—three strokes instead of five, to use your golf analogy—and treating that more planar or "abstract" state as a finished painting?

**CC:** I don't know why that just feels so self-indulgent to me. You know people say they'd like to see me keep a painting unfinished. I would never leave it unfinished. That's why I take a photograph of it unfinished, so people can see what it looked like in progress, but I'm going to finish the damn thing. As a control freak, that's just who I am. I make finished, complete, consistent things. I would not leave a painting itself unfinished, except whatever one I happen to die in front or that I would be making at the point when I die. That one will be unfinished. For everything else, I sort of tie up all the loose ends. But I love the way these look, and I am keeping progressive proofs, and I would love to do an exhibition in which all the progressive proofs are laid out, but in the end I want it to be done.

**RS:** What I am asking is why is "done" defined in those terms always? Aesthetically aren't there other "dones"?

**CC:** There are other "dones" for other folks but "done" for me is done. It may be because of all the years that I spent as a junior Abstract Expressionist in which I never knew when anything was finished, and I went with my so-called taste and intuition and good sense of design and whatever. I felt so unequipped to make a painting that way. It's lack of doneness or overdoneness, where you go beyond what you should have done and wish you could back up: "If only I hadn't put that big orange stroke on top of everything." I think I wanted to find a way to work where that didn't happen. I get to the lower right-hand corner. It's done and it's clear and I know it. It relieves the anxiety and concern.

**RS:** How do you define a "failed" painting as distinct from a successful one? Do you make that judgment in the final stage after you have fully carried through your initial idea for the work, or does the decision come sooner in the course of its execution?

**CC:** I have failures, paintings which I abandoned and paintings that are a failure but I abandoned them relatively early in the process. I know that I don't like the way it's going. I don't like the coloration. I don't like the range of marks. I don't like the syntax. I don't like the conditions that are beginning to evolve. I don't like something about the size of the marks, the part to whole relationships. Things look stilted, things look contrived—and I would abandon the work a quarter of the way done, a third of the way done. I don't think I've ever abandoned one more than half or three-quarters of the way done. Everything that I've finished, I feel or I felt good about when I finished it. I don't always feel that way six months or a year or several years later, but at least at the time that I finished it I do. I guess it's something about craft. It's a way somebody constructs a book or a poem or whatever it is, there is a certain level of finish, a certain consistency. I wanted to be consistent. I wanted to feel like the same voice throughout, the same attitude throughout. The same guy finished the painting that started it. Those things are part of the painter's craft that matter a lot to me. I leave all that other stuff to other artists. One of the great things about being an artist, I think, is seeing what other people do. And, believe me, I see as much as I can of what other people do, and I always enjoy it. There's tremendous relief when I see something that I like that somebody else does because now I don't have to do that. Other people do these things much better than I do; it's more natural for them.

**RS:** In effect, then, each painting represents a kind of formal or procedural hypothesis which is tested by the act of painting. If the experiment doesn't confirm its premise and produce results, then it's a scratch.

**CC:** Then I go back and rewrite the theorem, alter the variables, figure out what I didn't like about it. With the paintings that I have abandoned, that's exactly what I've done. I get right back on the horse again. I don't think there was something wrong with the image I was working with, there was something wrong with my approach to it. I suppose some writers write all these unpublished novels. But if I were a novelist and didn't like a book I'd written, I'd probably write it again, and if I didn't like that, I'd probably write it again until I eventually got the thing that I wanted. And you know that kind of stubbornness and stick-to-itiveness, while I'm sure it's incredibly annoying for my family and friends, it got me where I am. I'm perfectly willing to put whatever it takes into a painting, however long it is—twelve or fourteen months—for a single image sometimes. I may never want to make another one again like it, but when I'm done I'm glad I did it.

**RS:** Do you know the great opera story about the American guy who goes to Italy to hear a famous tenor perform in his hometown? Well, after the showcase high-C aria there is wild applause, so the tenor returns to the stage and does an encore. More applause. So he does it again. And this continues for a while until the American leans over to the Italian guy next to him and says, "What's happening, why doesn't the audience let him get on with it?" And the Italian looks at him calmly and says, "We are going to keep him here until he sings it right."

**CC:** Well, I think there's an aspect of that to me as well.

**RS:** After you had made your first group of heads, did you look forward and anticipate where they were likely to lead you, or did you just proceed from one empirical experiment to the next without an overall project in mind?

**CC:** I'm either dumber than the average painter, which is a pretty scary thought, or maybe there's something about my learning disabilities or whatever that I am really of the moment. I don't think much about the past, and I really don't think about the future. I am surprised often that I'm still painting portraits at all to tell you the truth. I don't predict what I'm going to do. I don't plan ahead that much. It doesn't matter

where the whole art world is going. I've got my own little trajectory. I guess the thing about the way I work that is most important is that the things I make answer particular problems that I have posed for myself. They are my private solutions, and I get a hell of a kick out of it. It's one of the great things about the dialogue an artist has with his or her own work. It's you alone in the room. Now I have other people around me, but I still try and make the studio just me and the canvas. I see something that makes me do something. Then I realize that I did something I hadn't thought I was going to do, or I see some aspect of it that I didn't recognize before, or I start to take advantage of some accident that happened. It's really a conversation with the work, with the piece. I like the amount of change in my work, the progress and the development. It may be too slow for everybody else, or it may feel that I'm plowing the same ground endlessly, or as I've heard people say or critics write, "God, he's still making those god-damn heads," you know. Sometimes that one worries me. Sometimes I wonder if I'm not constipated or stuck. On the other hand, as long as the process feels rich enough and engaging enough, that dialogue can continue, I think, "Why mess with this?" This feels right. This is how it ought to feel to be an artist. Does that make any sense?

**RS:** That makes very good sense, in fact. Meanwhile, here we are on the verge of your retrospective at the Modern, and whether or not you ever looked forward in the past, you are now about to look backward on that past. Do you have any sense about what rounding up your work and presenting it as a whole will be like?

**CC:** Yes. This will bring work together that I haven't seen hanging together. You know whenever you work in really this long continuum, certain groups of work get brack-eted, and people tend to think of them as being one period about one thing. Gallery shows tend to do that. You make six or seven paintings and you have a show. So that work gets brackets put around it, and it gets pushed away somewhere in the back of your mind, and a catalogue gets written about it if you're lucky enough to be in a gallery that produces catalogues. Then there's that record of that chunk, and you go about making six or seven more things and that becomes another chunk. But really it's one long continuum. Normally you don't have the opportunity to select core samples of that long continuous process and make comparative judgments. That's the thing that makes a retrospective exhibition so instructive for an artist—and scary.

**RS:** What are you scared of?

**CC:** Well, that it will ultimately take all of that work, put one huge set of brackets around it, and then you're faced with the rest of your life. You say, "Well, now, that's prologue. It's time I got on with the rest of it." And then, of course, the biggest fear of all is that it won't add up to anything. "Is this something that a serious artist would spend thirty years doing?" "Was he fooling himself?" "How's it stack up against other bodies of work that you have seen in this same museum space?" I'm very aware of the hallowedness of those spaces, and what was just in there, and what was in there awhile ago, and what's going to follow it in there, and you wonder how it's going to stack up.

**RS:** Well, however nerve-racking the experience may temporarily be, the fact is that this is a mid-career show—an open parenthesis in the daily discipline of making things—not a fully punctuated summation. So you're right, this is a prologue; there is more to come.

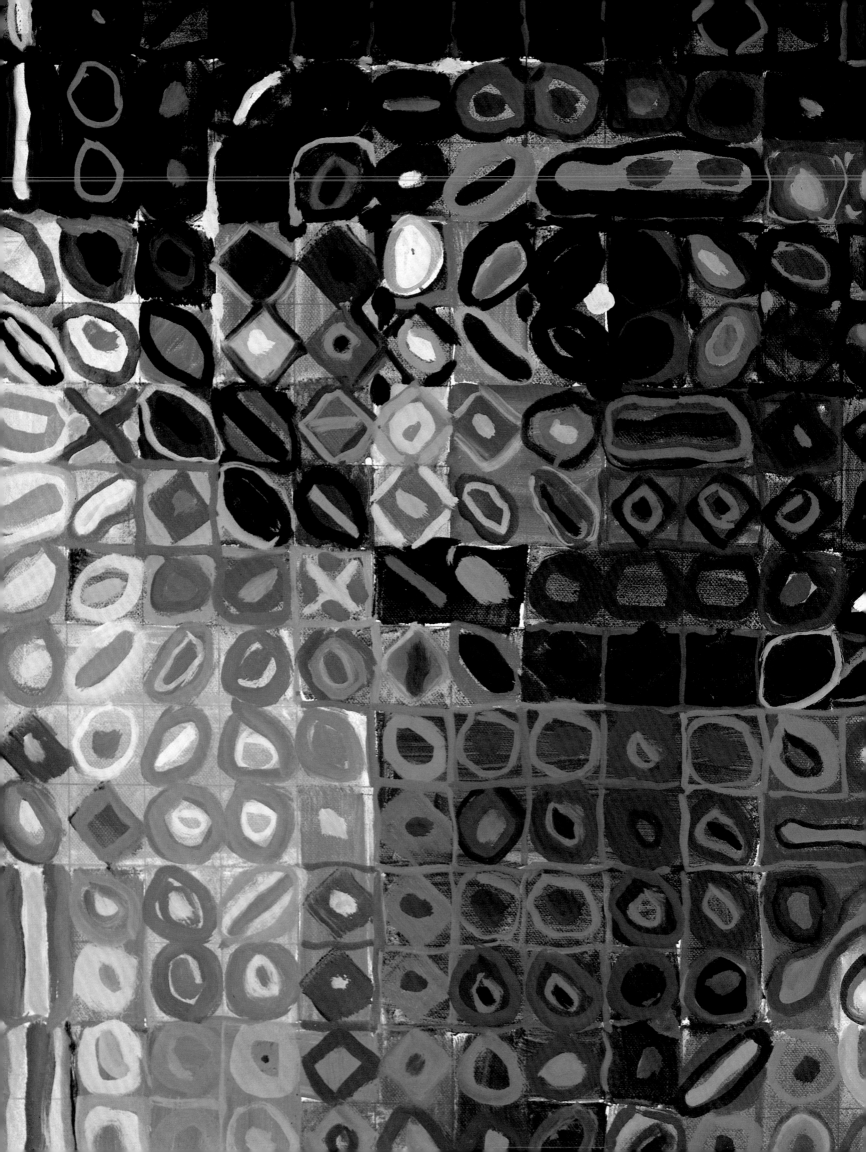

PLATES

*Self-Portrait.* 1968.
Pencil on paper, 29⅛ x 23″ (74 x 58.4 cm).
Collection Susan W. and Stephen D. Paine, Cambridge, Massachusetts

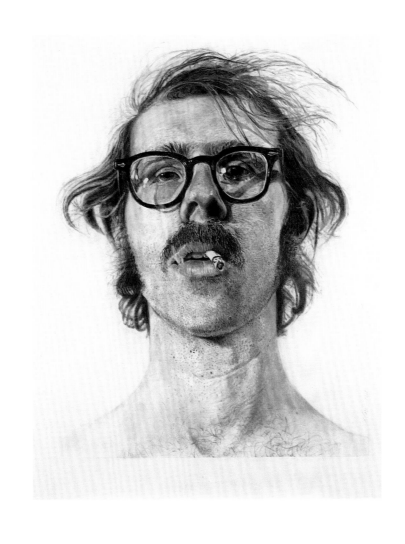

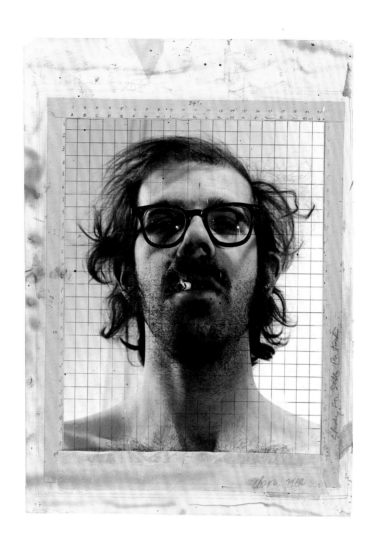

Study for *Self-Portrait*. Photographed 1967; dated 1968.
Photograph, pen and ink, pencil, masking tape, acrylic, wash, and blue
plastic strips on cardboard, 18⅝ x 13⅜" (47.3 x 34 cm).
The Museum of Modern Art, New York. Gift of Norman Dubrow

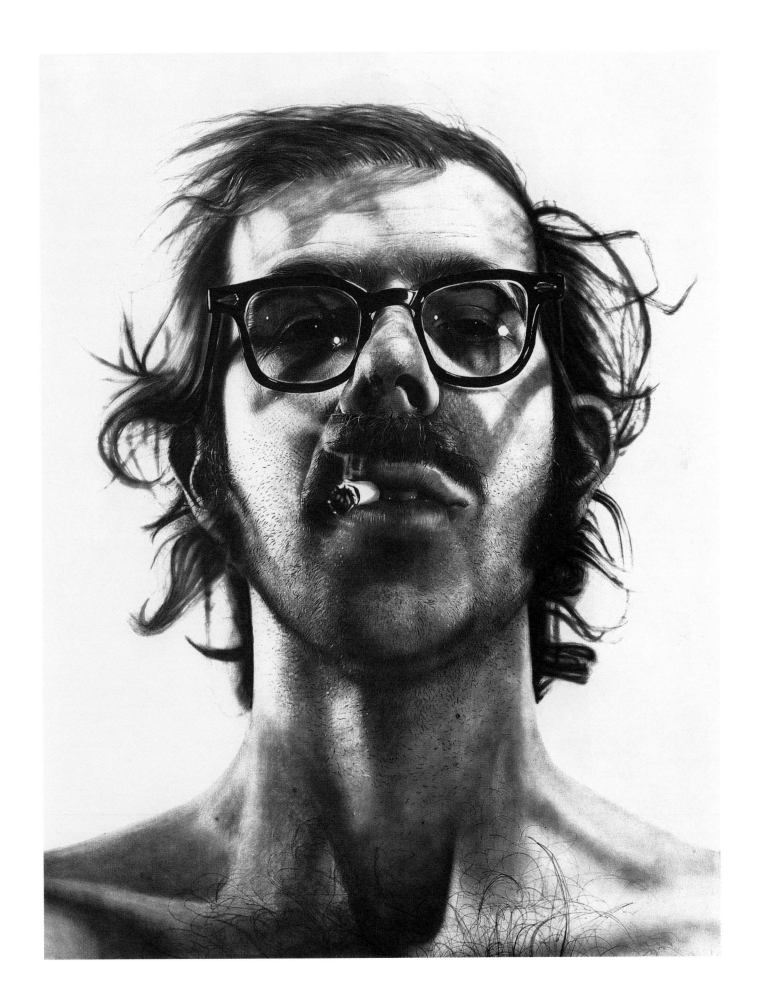

*Big Self-Portrait.* 1967–68.
Acrylic on canvas, 107½ x 83½" (273.1 x 212.1 cm).
Walker Art Center, Minneapolis. Art Center Acquisition Fund, 1969

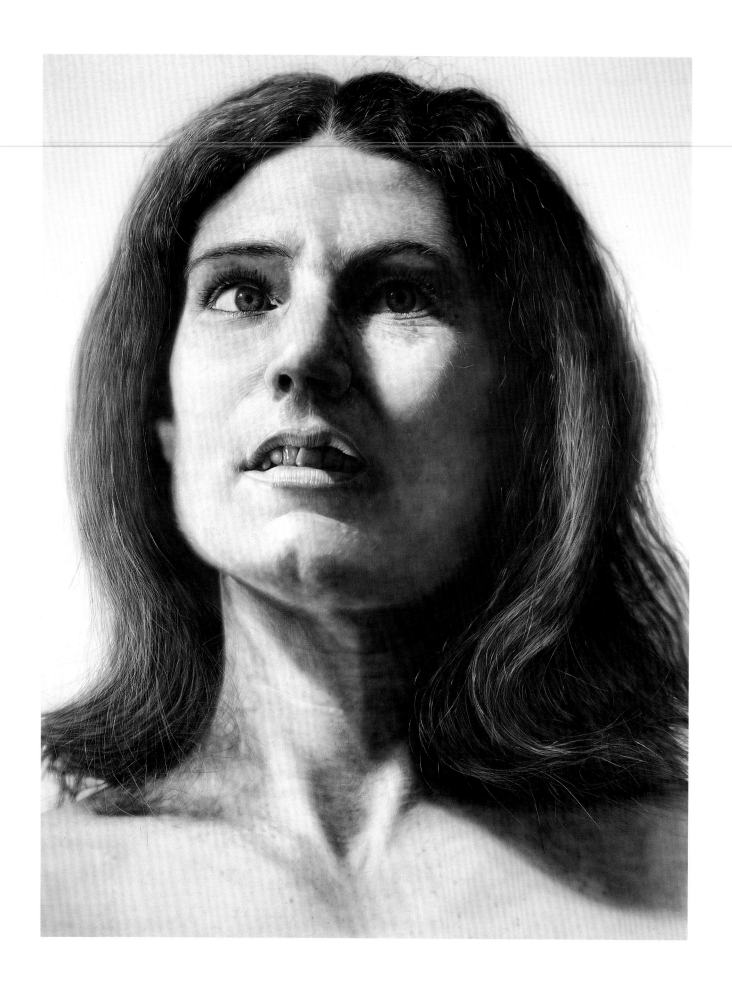

*Nancy.* 1968.
Acrylic on canvas, 108⅜ x 82¼″ (275.3 x 208.9 cm).
Milwaukee Art Museum. Gift of Herbert H. Kohl Charities, Inc.
(formerly HHK Foundation for Contemporary Art, Inc.)

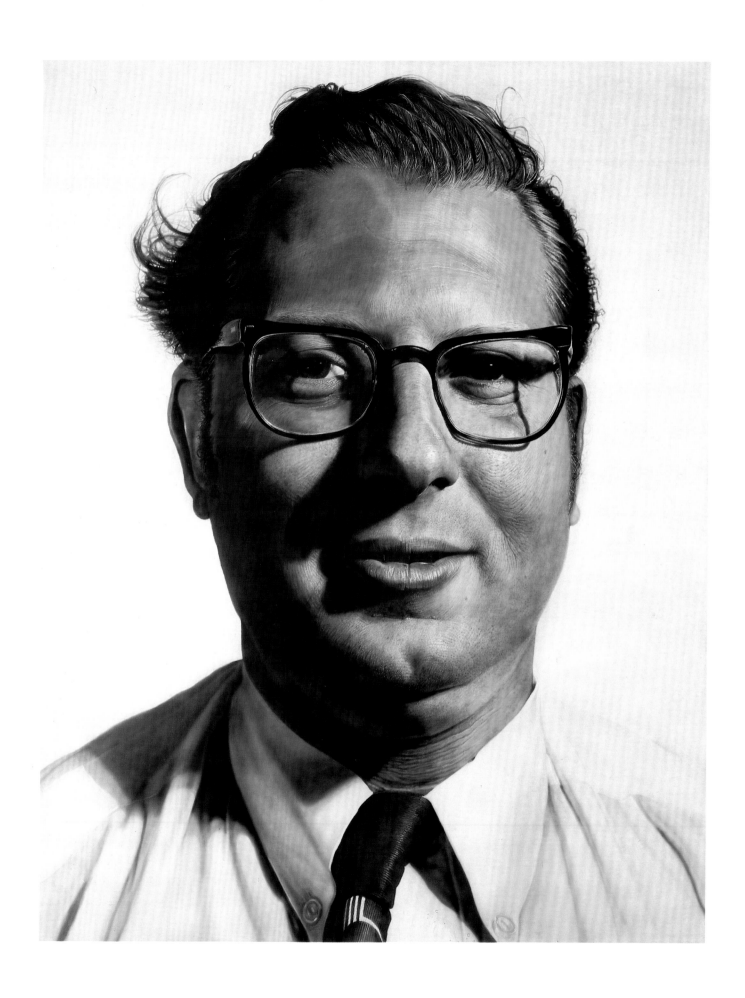

*Joe.* 1969.
Acrylic on canvas, 108 x 84″ (274.3 x 213.4 cm).
Osaka City Museum of Modern Art, Japan

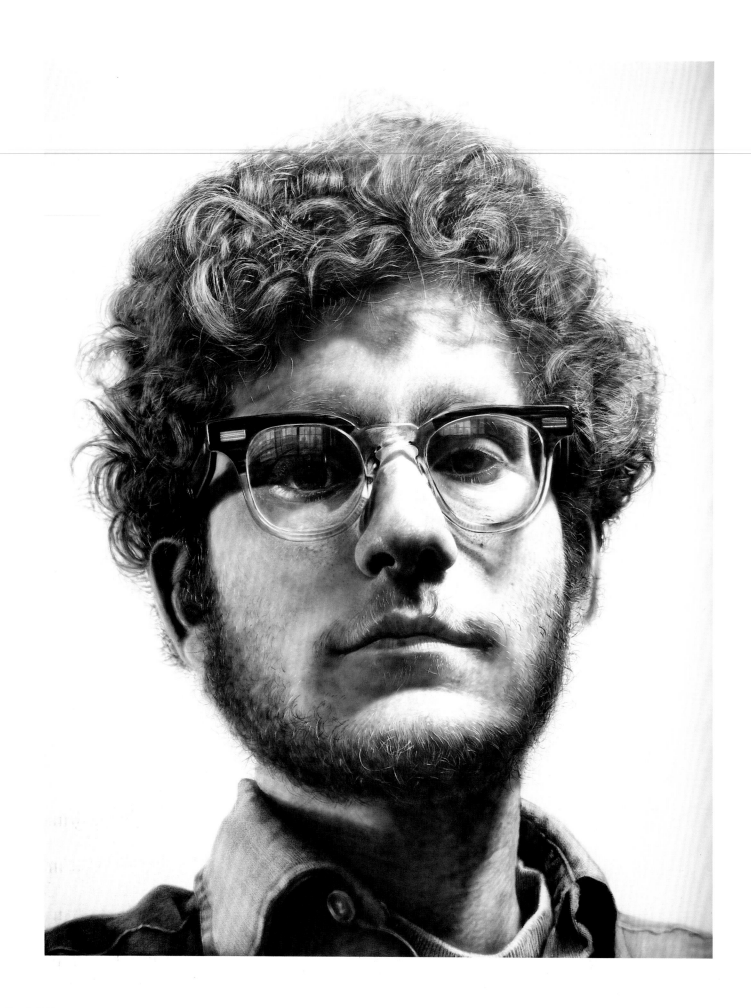

*Frank*. 1969.
Acrylic on canvas, 108 x 84" (274.3 x 213.4 cm).
The Minneapolis Institute of Arts. John R. Van Derlip Fund

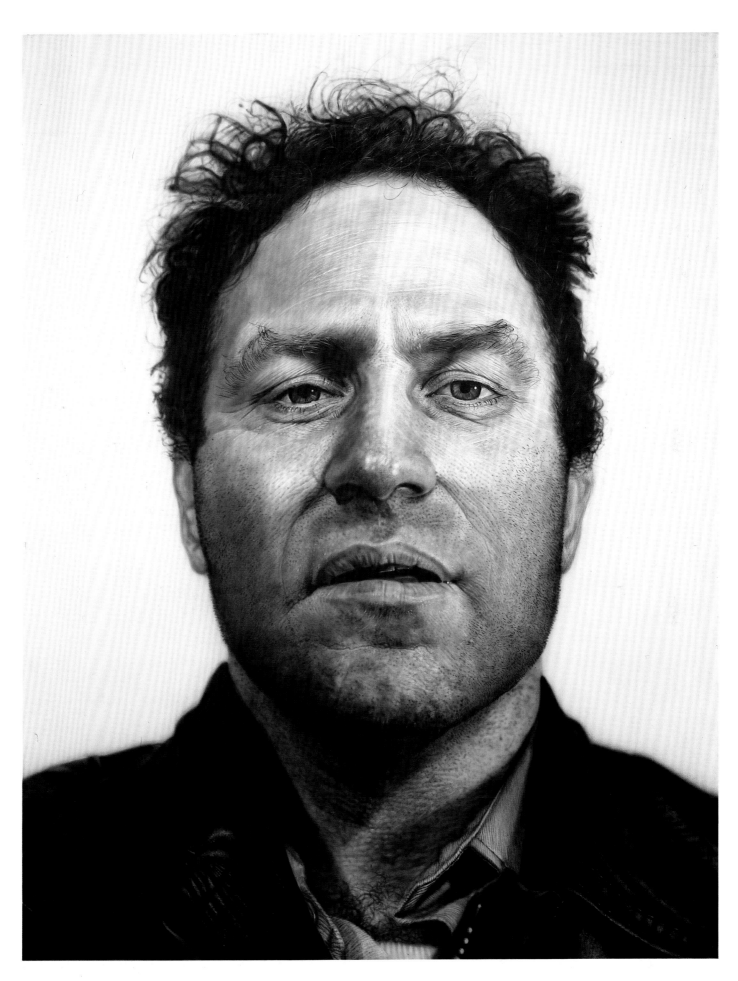

*Richard.* 1969.
Acrylic on canvas, 108 x 84″ (274.3 x 213.4 cm).
Ludwig Forum für Internationale Kunst, Aachen

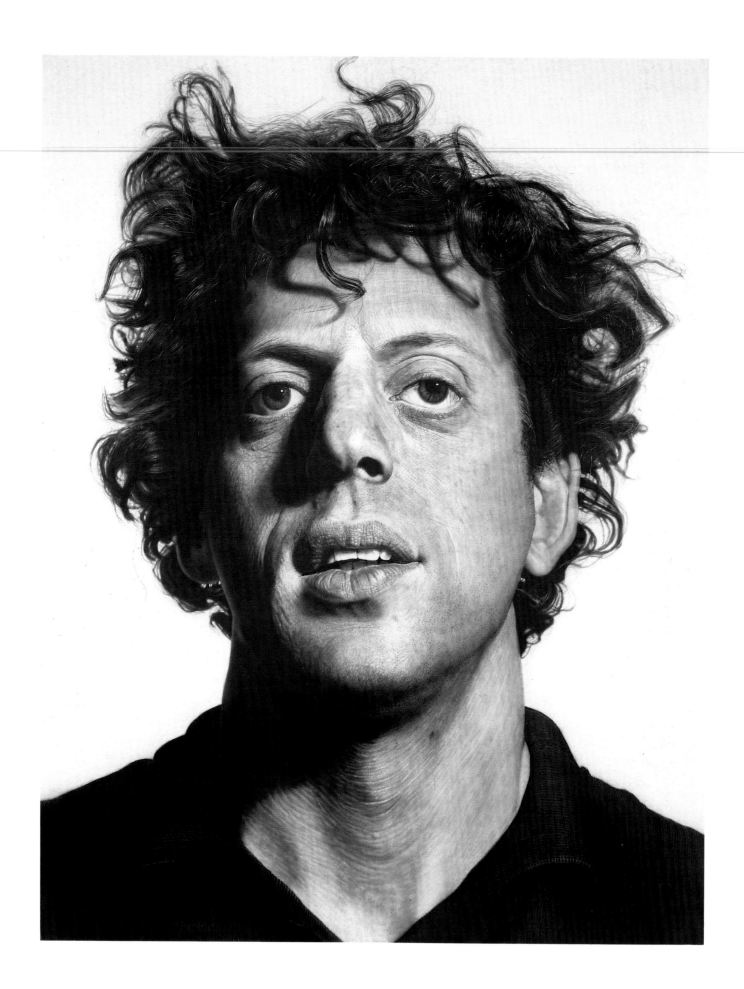

*Phil.* 1969.
Acrylic on canvas, 108 x 84″ (274.3 x 213.4 cm).
Whitney Museum of American Art, New York.
Purchase, with funds from Mrs. Robert M. Benjamin

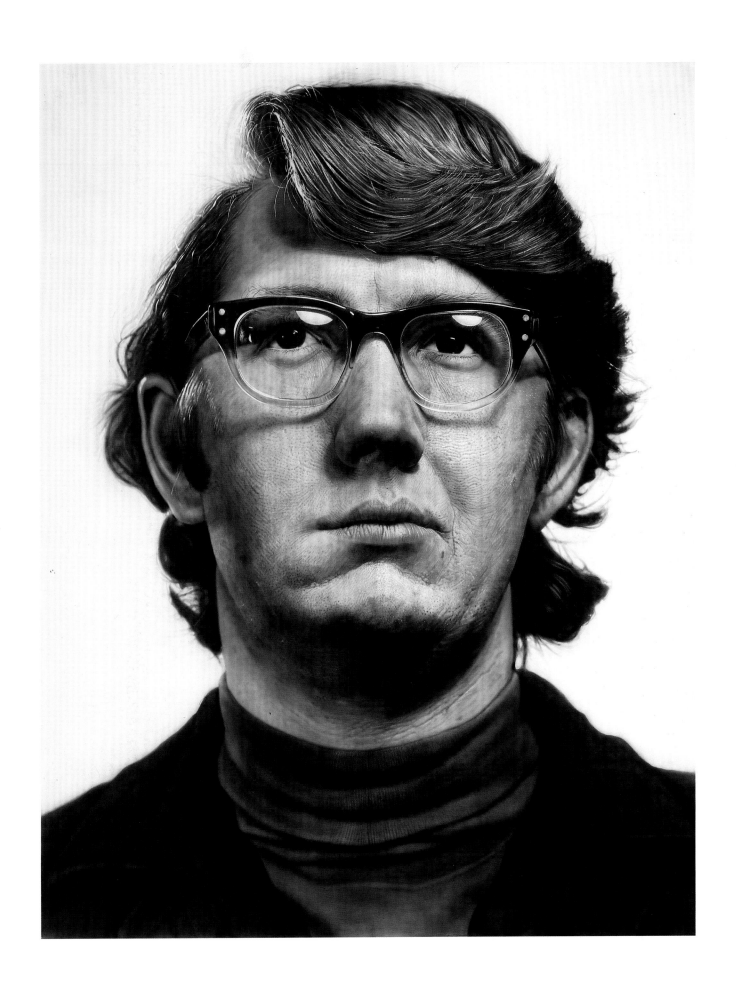

*Keith*. 1970.
Acrylic on canvas, 108¼ x 84″ (275 x 213.4 cm).
The Saint Louis Art Museum.
Purchased with funds given by the Shoenberg Foundation, Inc.

*Large Kent.* 1970.
Colored pencil and masking tape on paper,
35½ x 33½″ (90.2 x 85.1 cm).
Collection Ed Cauduro

Study for *Kent*. 1970.
Watercolor and pencil on paper, 30 x 22½″ (76.2 x 57.2 cm).
Allen Memorial Art Museum, Oberlin College, Ohio. Mrs. F. F. Prentiss Fund, 1971

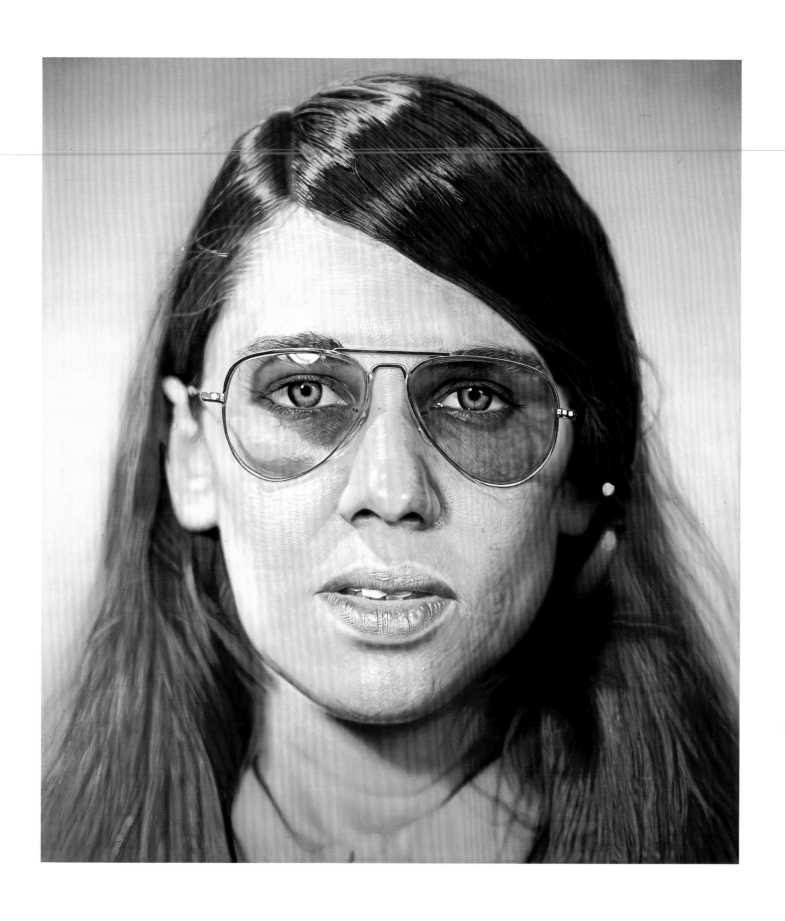

*Susan.* 1971.
Acrylic on canvas, 100 x 90″ (254 x 228.6 cm).
Morton G. Neumann Family Collection

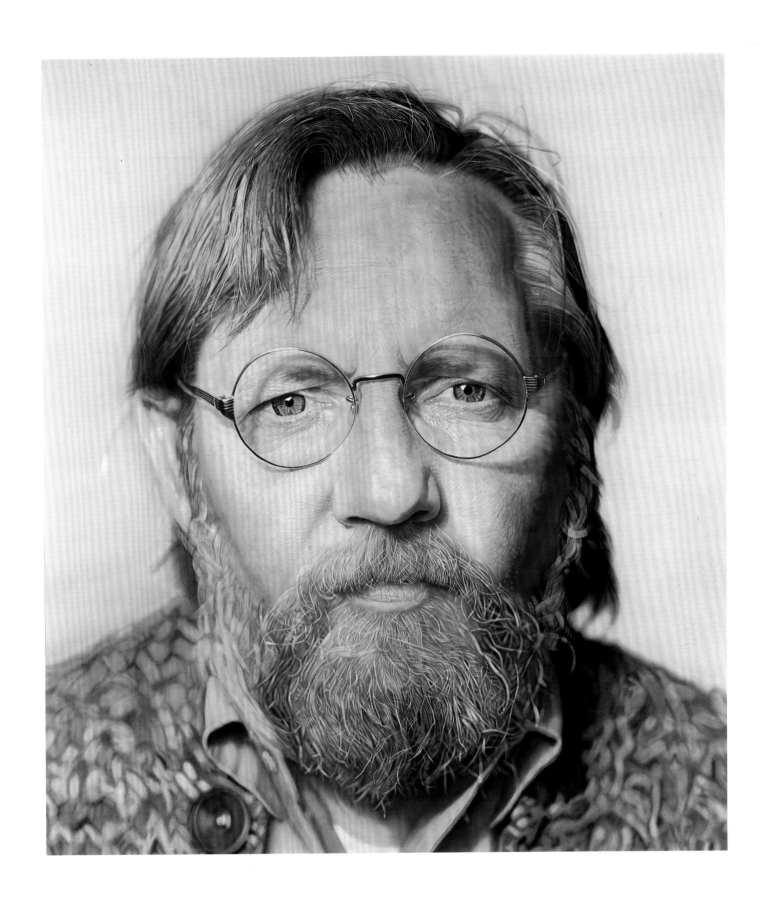

*John*. 1971–72.
Acrylic on canvas, 100 x 90" (254 x 228.6 cm).
Collection Mrs. Beatrice Cummings Mayer. On loan to The Art Institute of Chicago
from the Robert B. Mayer Memorial Loan Collection

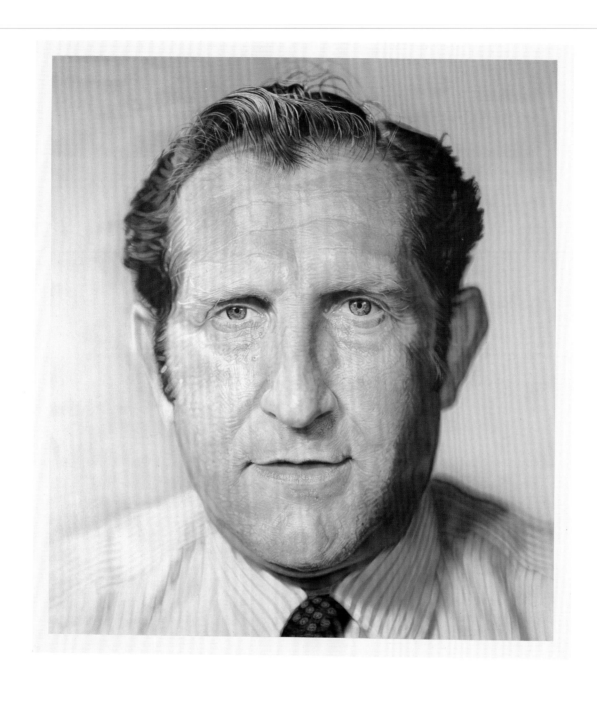

*Nat/Watercolor.* 1972.
Watercolor on paper mounted on canvas, 67 x 57″ (170.2 x 144.8 cm).
Museum of Contemporary Art/Ludwig Museum Budapest

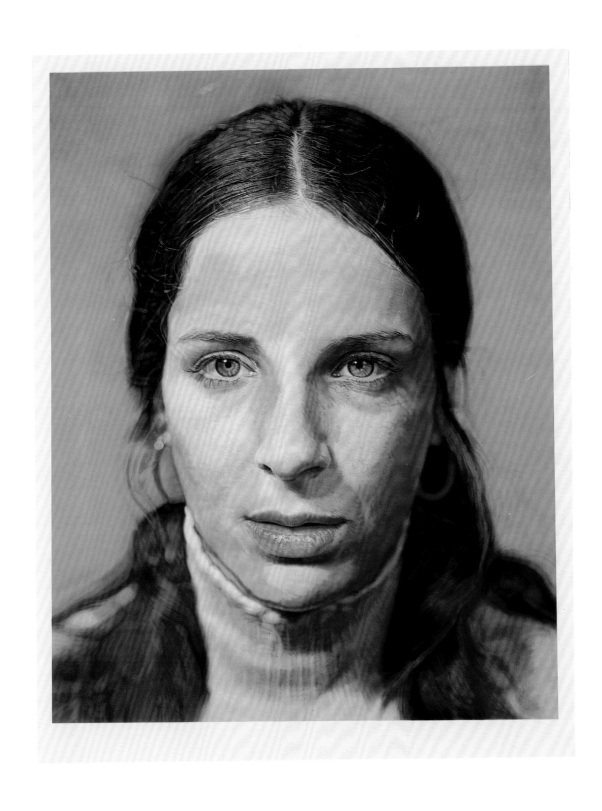

*Leslie/Watercolor.* 1972–73.
Watercolor on paper mounted on canvas, 72½ x 57″ (184.2 x 144.8 cm).
Private collection, New York

*Keith/Mezzotint.* 1972.
Mezzotint, 51 x 41½″ (129.5 x 105.4 cm).
The Museum of Modern Art, New York. John B. Turner Fund

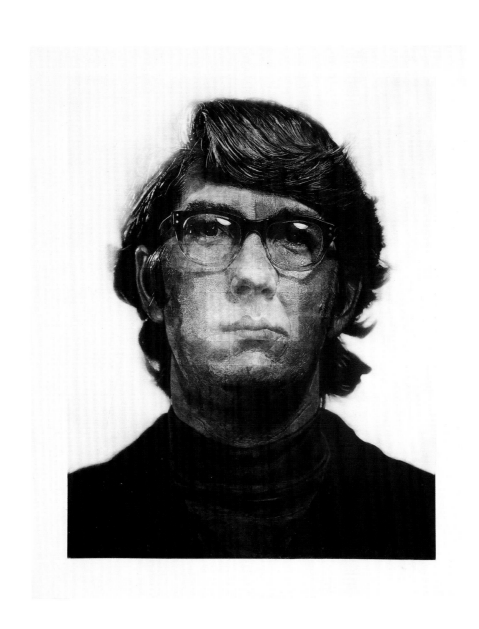

*Robert I / 154*. 1974.
Ink and pencil on paper, 30 x 22½″ (76.2 x 57.2 cm).
Wexner Center for the Arts, The Ohio State University.
Purchased in part with funds from The National Endowment for the Arts

*Robert II / 616*. 1974.
Ink and pencil on paper, 30 x 22½″ (76.2 x 57.2 cm).
Wexner Center for the Arts, The Ohio State University.
Purchased in part with funds from The National Endowment for the Arts

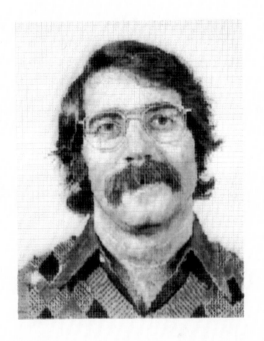

*Robert III / 2,464*. 1974.
Ink and pencil on paper, 30 x 22½" (76.2 x 57.2 cm).
Wexner Center for the Arts, The Ohio State University.
Purchased in part with funds from The National Endowment for the Arts

*Robert IV / 9,856*. 1974.
Ink and pencil on paper, 30 x 22½" (76.2 x 57.2 cm).
Wexner Center for the Arts, The Ohio State University.
Purchased in part with funds from The National Endowment for the Arts

*Fanny.* 1974.
Ink and pencil on paper, 30 x 22″ (76.2 x 55.9 cm).
Collection Leslie Close

*Marge R.* 1974.
Ink and pencil on paper, 30 x 22⅜″ (76.2 x 56.8 cm).
Collection Louis K. and Susan Pear Meisel.
Courtesy Louis K. Meisel Gallery, New York

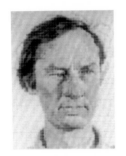

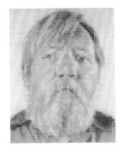

*Richard A.* 1974.
Ink and pencil on paper, 30 x 22″ (76.2 x 55.9 cm).
Collection Linda and Ronald F. Daitz. Courtesy Barbara Mathes Gallery

*John R.* 1974.
Ink and pencil on paper, 30 x 22″ (76.2 x 55.9 cm).
Collection C. Richard Belger, Kansas City, Missouri

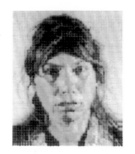 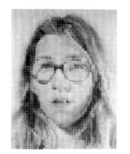

*Sandy B.* 1974.
Ink and pencil on paper, 30 x 22″ (76.2 x 55.9 cm).
Collection PieperPower

*Lisa P.* 1974.
Ink and pencil on paper, 30¼ x 22¼″ (76.8 x 56.5 cm).
Collection Louis K. and Susan Pear Meisel.
Courtesy Louis K. Meisel Gallery, New York

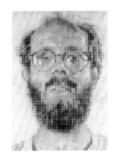

*Self-Portrait.* 1975.
Ink and pencil on paper, 30 x 22″ (76.2 x 55.9 cm).
Private collection, New York

*Robert / 104,072.* 1973–74.
Acrylic and ink with pencil on canvas, 108 x 84″ (274.3 x 213.4 cm).
The Museum of Modern Art, New York.
Gift of J. Frederic Byers III and promised gift of an anonymous donor

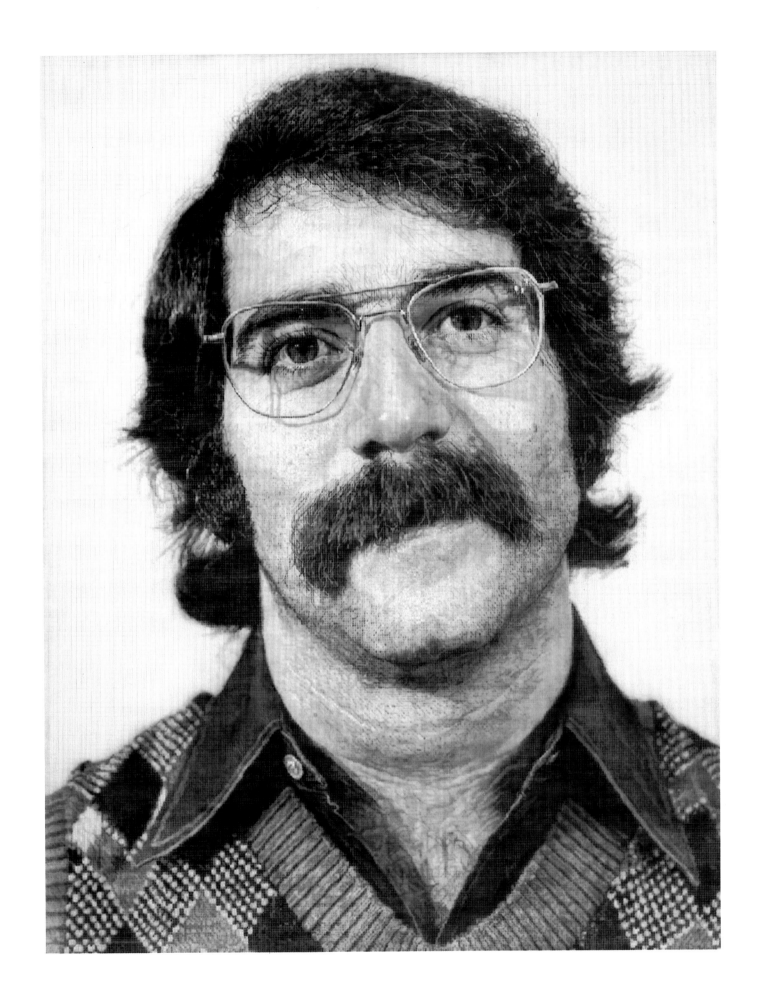

*Linda*. 1975–76.
Acrylic and pencil on canvas, 108 x 84″ (274.3 x 213.4 cm).
Akron Art Museum. Purchased with funds from an anonymous contribution,
an anonymous contribution in honor of Ruth C. Roush, and the Museum Acquisition Fund

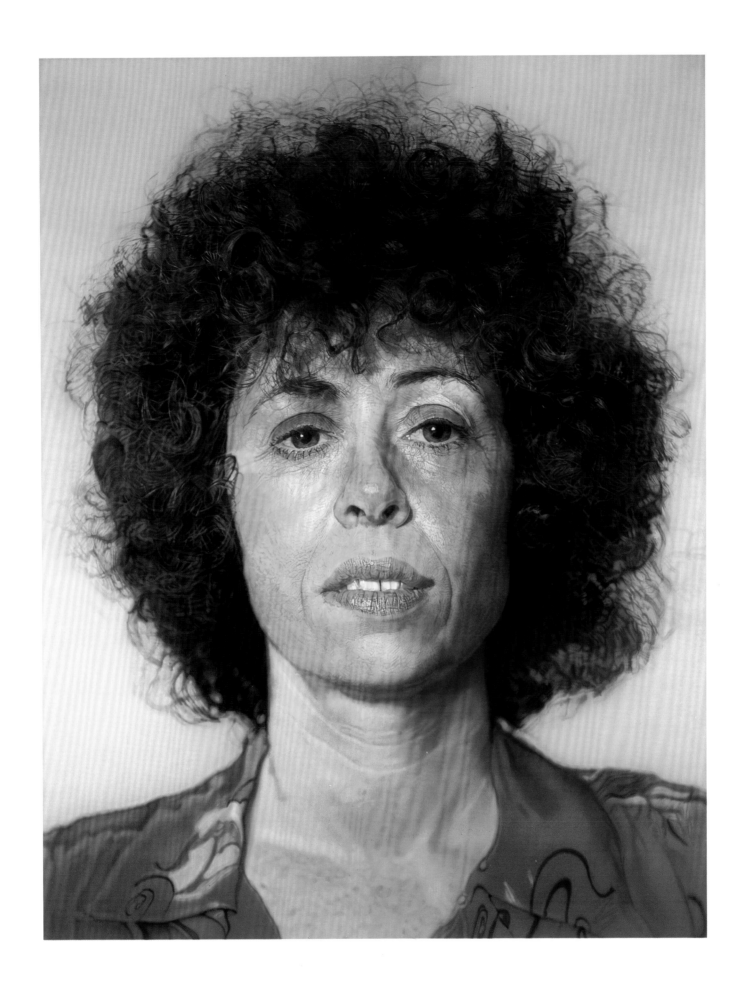

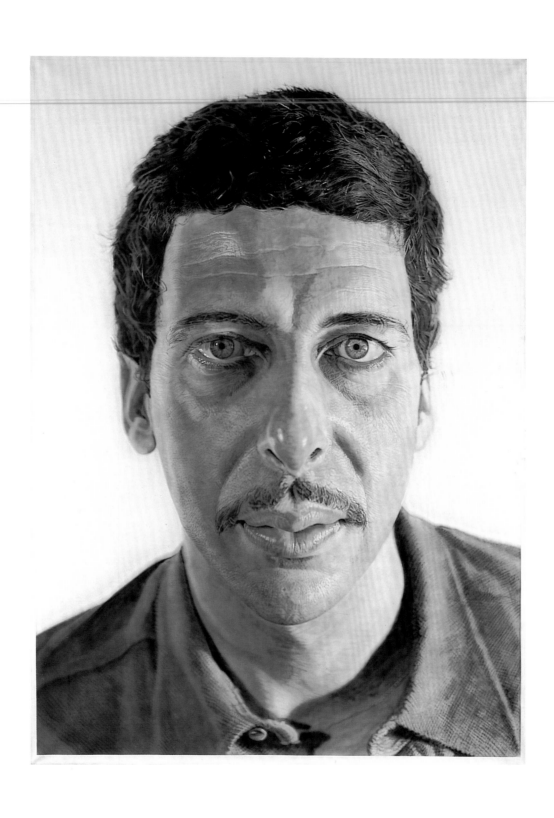

*Klaus/Watercolor.* 1976.
Watercolor on paper mounted on canvas, 80 x 58″ (203.2 x 147.3 cm).
Collection Sydney and Frances Lewis

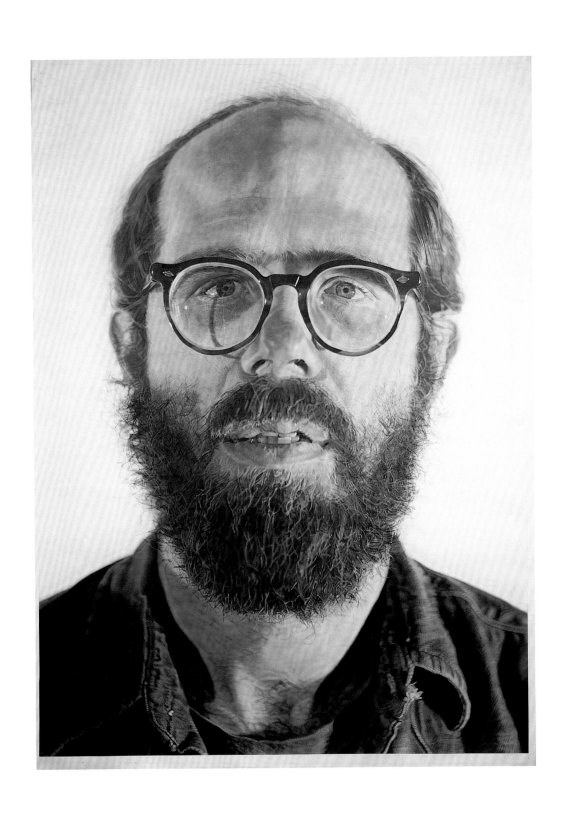

*Self-Portrait/Watercolor.* 1976–77.
Watercolor on paper mounted on canvas, 80½ x 59″ (204.5 x 149.9 cm).
Museum Moderner Kunst Stiftung Ludwig, Vienna

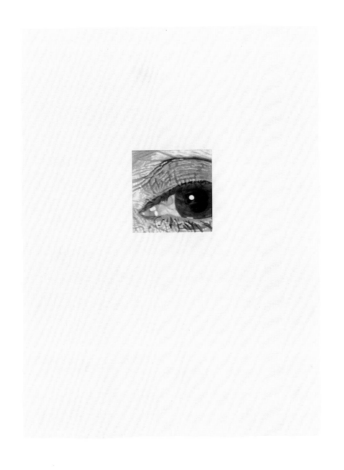

opposite, upper left:
*Linda/Eye Series I (Magenta)*. 1977.
Watercolor on paper, 30 x 22½″ (76.2 x 57.2 cm).
The Art Institute of Chicago. Gift of the Lannan Foundation

opposite, upper right:
*Linda/Eye Series II (Cyan)*. 1977.
Watercolor on paper, 30 x 22½″ (76.2 x 57.2 cm).
The Art Institute of Chicago. Gift of the Lannan Foundation

opposite, lower left:
*Linda/Eye Series III (Magenta and Cyan)*. 1977.
Watercolor on paper, 30 x 22½″ (76.2 x 57.2 cm).
The Art Institute of Chicago. Gift of the Lannan Foundation

opposite, lower right:
*Linda/Eye Series IV (Yellow)*. 1977.
Watercolor on paper, 30 x 22½″ (76.2 x 57.2 cm).
The Art Institute of Chicago. Gift of the Lannan Foundation

above:
*Linda/Eye Series V (Magenta, Cyan and Yellow)*. 1977.
Watercolor on paper, 30 x 22½″ (76.2 x 57.2 cm).
The Art Institute of Chicago. Gift of the Lannan Foundation

*Susan/Pastel.* 1977.
Pastel on watercolor-washed paper, 30 x 21¾″ (76.2 x 55.2 cm).
Collection Louis K. and Susan Pear Meisel. Courtesy Louis K. Meisel Gallery, New York

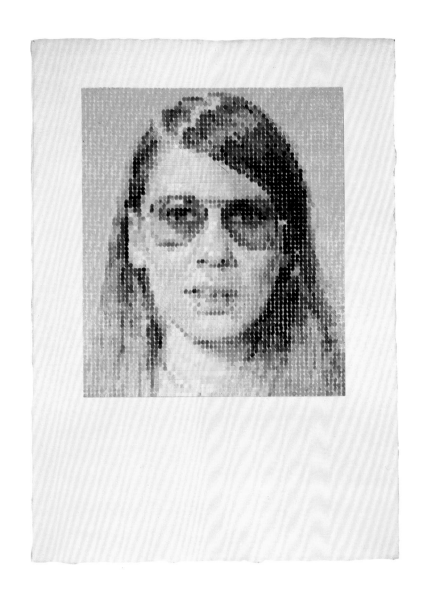

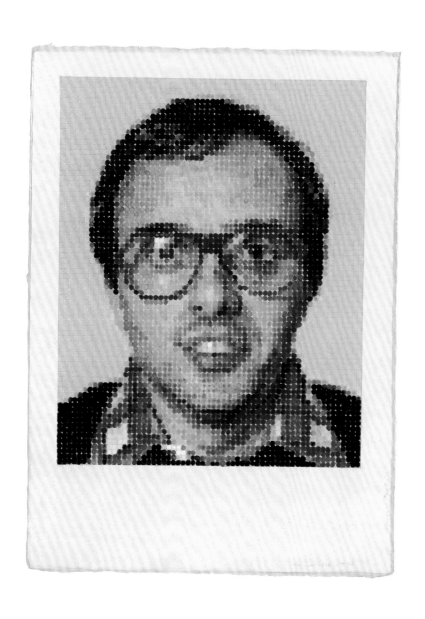

*Mark/Pastel/Small Version.* 1978.
Pastel on watercolor-washed paper, 30 x 22″ (76.2 x 55.9 cm).
Private collection

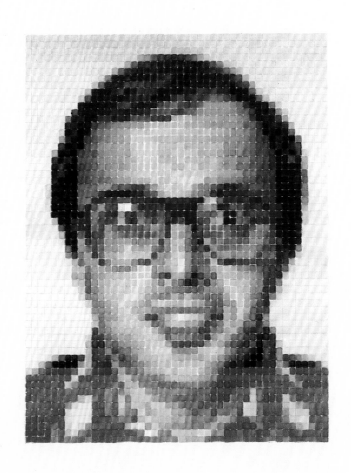

*Mark / Watercolor / Unfinished.* 1978.
Watercolor on paper, 53½ x 40½″ (135.9 x 102.9 cm).
Collection Sydney and Frances Lewis

*Mark.* 1978–79.
Acrylic on canvas, 108 x 84″ (274.3 x 213.4 cm).
Private collection, New York

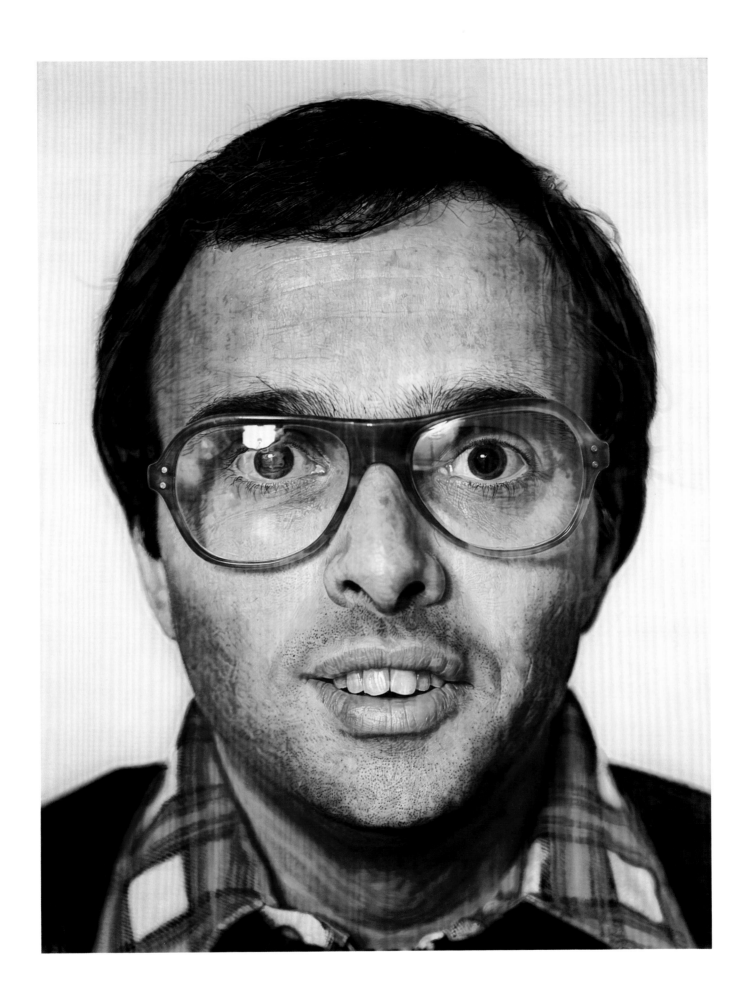

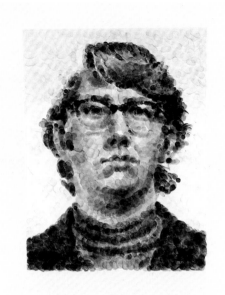 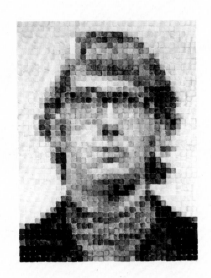 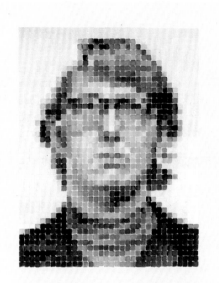

*Keith/Six Drawings Series: Keith/Random Fingerprint Version.* 1979.
Stamp-pad ink and pencil on paper, 30 x 22⅜″ (76.2 x 56.8 cm).
Reynolda House, Museum of American Art, Winston-Salem, North Carolina

*Keith/Six Drawings Series: Keith/Square Fingerprint Version.* 1979.
Stamp-pad ink and pencil on paper, 30 x 22¼″ (76.2 x 56.5 cm).
Reynolda House, Museum of American Art, Winston-Salem, North Carolina

*Keith/Six Drawings Series: Keith/Watercolor Version.* 1979.
Watercolor and pencil on paper, 29⅝ x 22⅛″ (75.2 x 56.2 cm).
Reynolda House, Museum of American Art, Winston-Salem, North Carolina

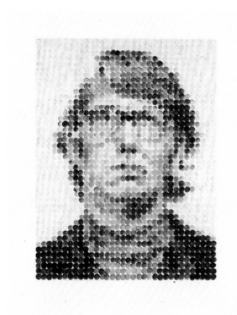

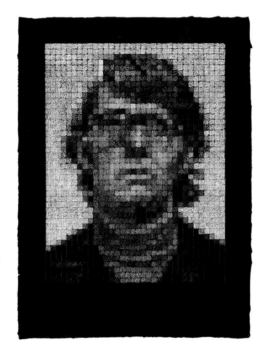

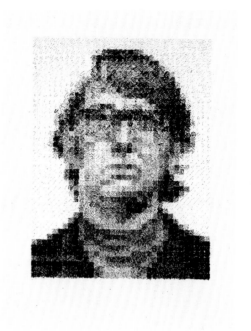

*Keith/Six Drawings Series: Keith/Round Fingerprint Version*. 1979.
Stamp-pad ink and pencil on paper, 30 x 22⅜″ (76.2 x 56.8 cm).
Reynolda House, Museum of American Art, Winston-Salem, North Carolina

*Keith/Six Drawings Series: Keith/White Conté Version*. 1979.
Conté crayon, pencil, and black gouache on paper, 29⅝ x 22″ (75.2 x 55.9 cm).
Reynolda House, Museum of American Art, Winston-Salem, North Carolina

*Keith/Six Drawings Series: Keith/Ink Stick Version*. 1979.
Ink and pencil on paper, 29⅝ x 22″ (75.2 x 55.9 cm).
Reynolda House, Museum of American Art, Winston-Salem, North Carolina

Study for *Keith/Six Drawings Series*. 1979.
Mixed media, 29⅝ x 22⅛″ (75.2 x 56.2 cm).
Reynolda House, Museum of American Art, North Carolina

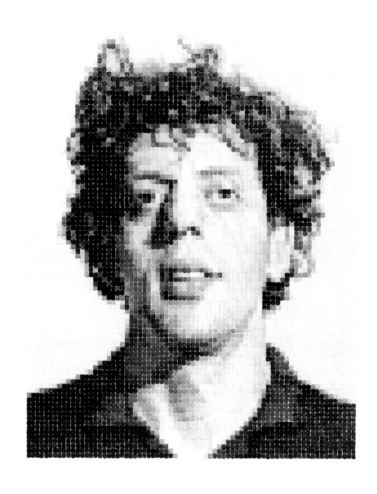

*Phil / Watercolor.* 1977.
Watercolor on paper, 58 x 40″ (147.3 x 101.6 cm).
Collection Mr. and Mrs. Julius E. Davis

144

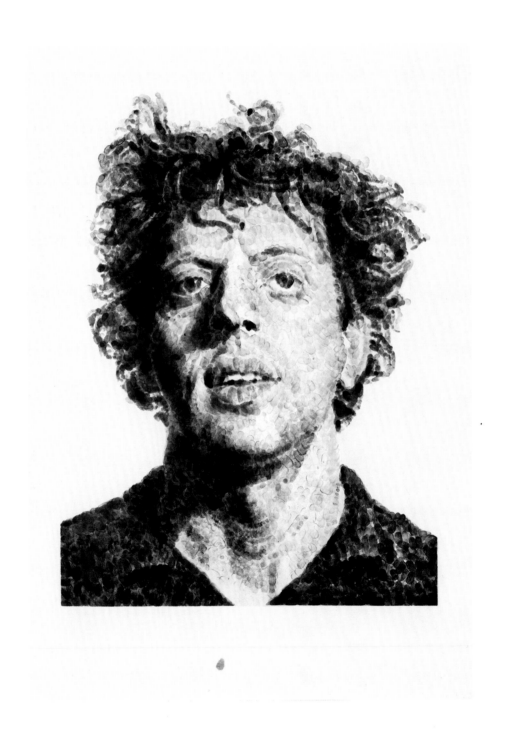

*Large Phil Fingerprint/Random.* 1979.
Stamp-pad ink on canvas, 58 x 41″ (147.3 x 104.1 cm).
Collection Robert H. Halff

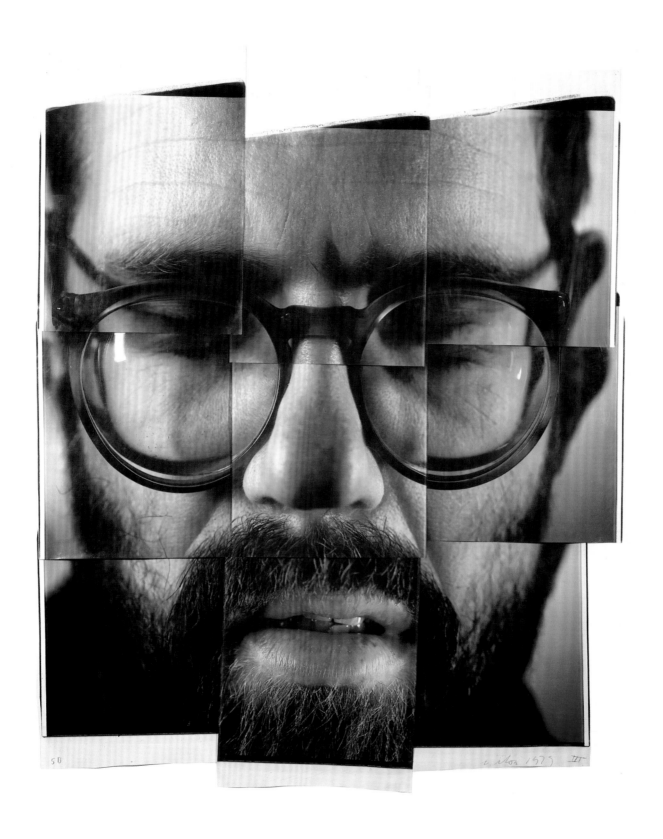

50                                                    6 Nov 1975  III

*Stanley.* 1980.
Oil on canvas, 55 x 42″ (139.7 x 106.7 cm).
Collection Mr. and Mrs. Charles Diker

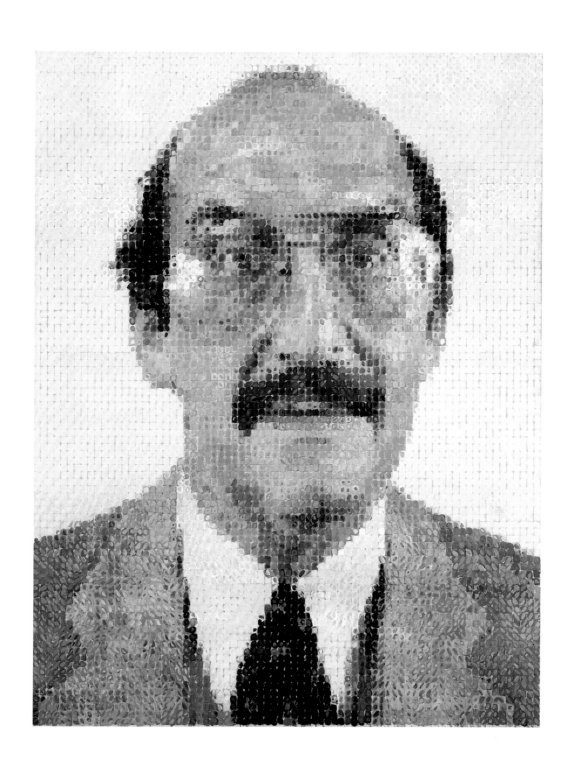

149

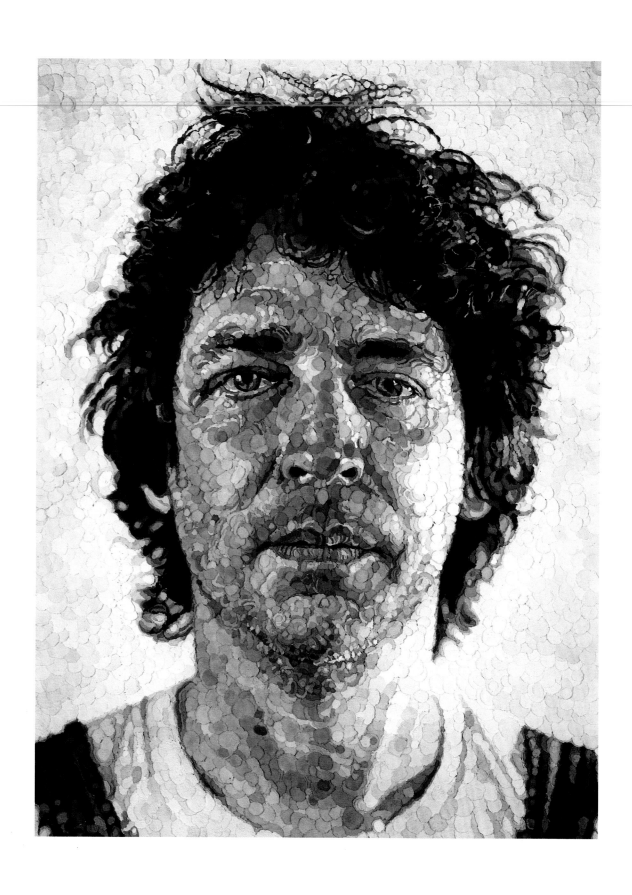

*Jud/Collage.* 1982.
Pulp paper collage on canvas, 96 x 72″ (243.8 x 182.9 cm).
Virginia Museum of Fine Arts, Richmond.
Gift of The Sydney and Frances Lewis Foundation

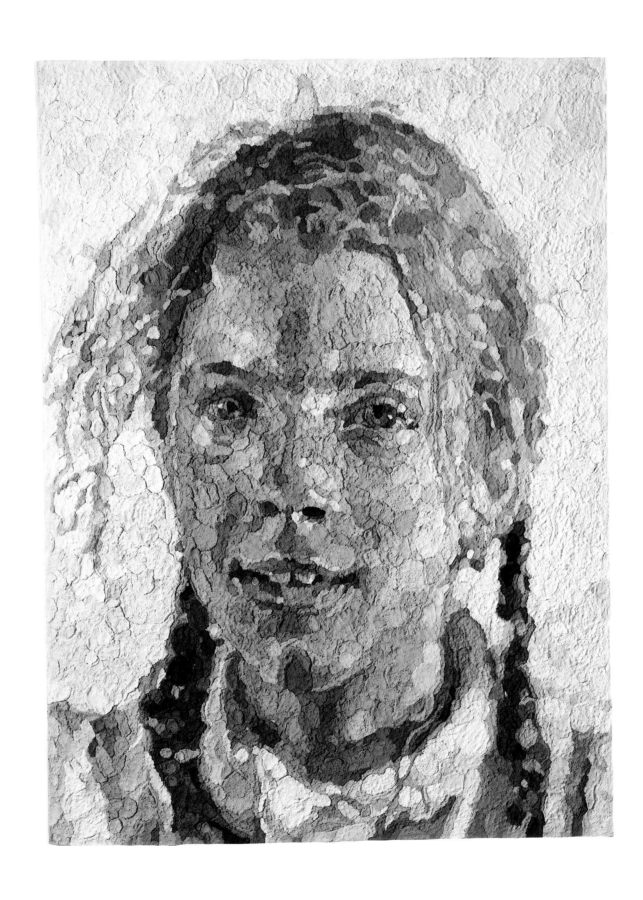

*Georgia*. 1985.
Wet pulp paper on canvas, 96 x 72″ (243.8 x 182.9 cm).
Private collection

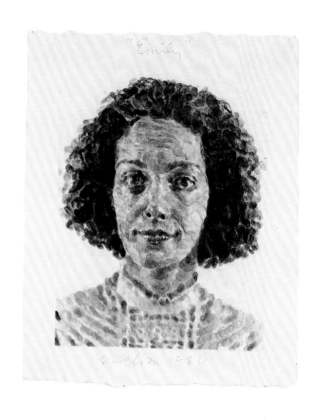

*Emily.* 1984.
Oil-based ink on paper, 19½ x 15½″ (49.5 x 39.4 cm).
Collection Joan and Stephen Feinsod, Boca Raton, Florida

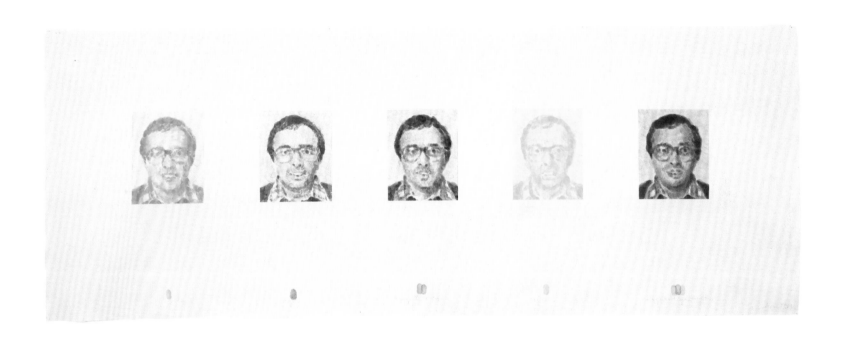

*Mark/Progression.* 1983.
Oil-based ink on paper, 30 x 80″ (76.2 x 203.2 cm).
Collection Arne and Milly Glimcher, New York

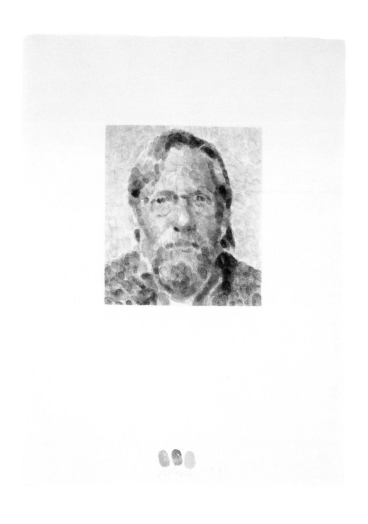

*John | Color Fingerprint.* 1983.
Oil-based ink on paper, 30 x 22½″ (76.2 x 57.2 cm).
Collection Mr. and Mrs. Hiroyuki Matsuo, Tokyo

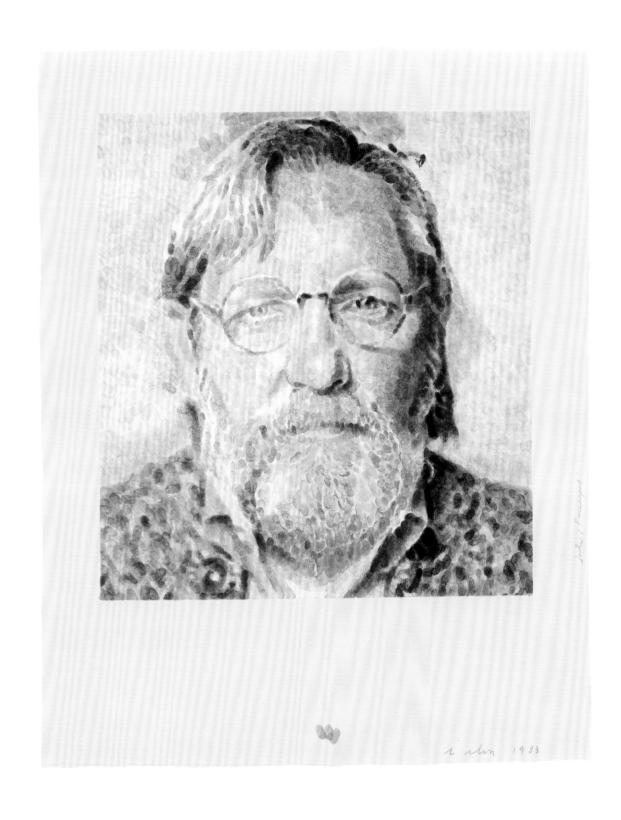

*John / Fingerprint.* 1984.
Oil-based ink on paper, 48 x 38″ (121.9 x 96.5 cm).
Private collection, New York

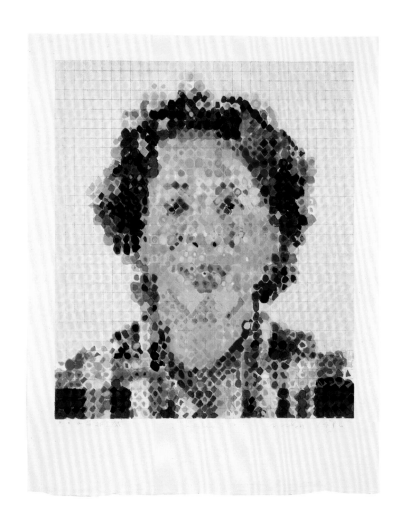

*Leslie/Watercolor II.* 1986.
Watercolor on paper, 30½ x 22¼″ (77.5 x 56.5 cm).
Collection James and Barbara Palmer

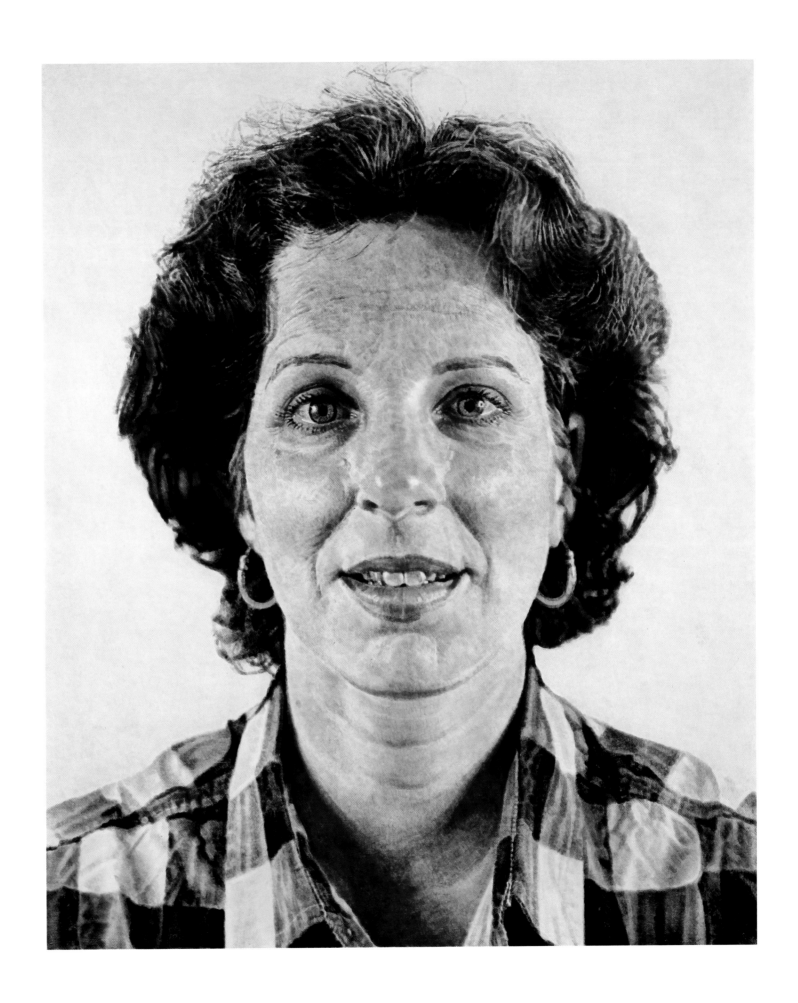

*Leslie/Fingerpainting*. 1985–86.
Oil-based ink on canvas, 102 x 84″ (259.1 x 213.4 cm).
Collection Michael and Judy Ovitz, Los Angeles

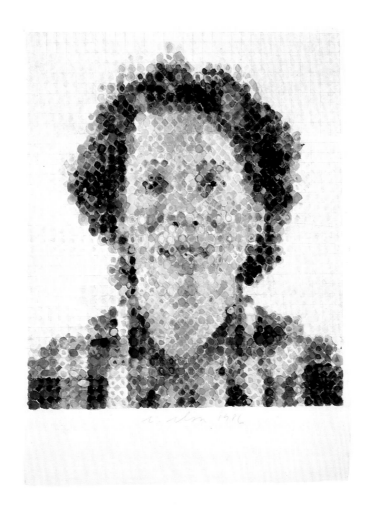

*Leslie*. 1986.
Woodcut, 32 x 25¼″ (81.3 x 64.1 cm).
Publisher: Crown Point Press, San Francisco.
Blocks cut by: Shunzo Matsuda.
Printer: Tadashi Toda, Kyoto. Edition: 150

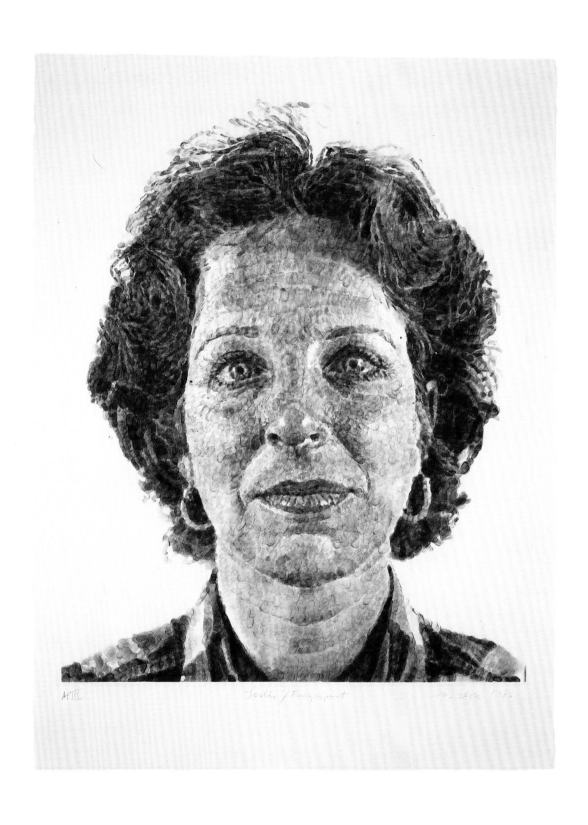

*Leslie / Fingerprint.* 1986.
Carbon transfer etching, 54½ x 40½″ (138.4 x 102.9 cm).
Publisher: Pace Editions, New York.
Printer: Graphicstudio, Tampa. Edition: 45

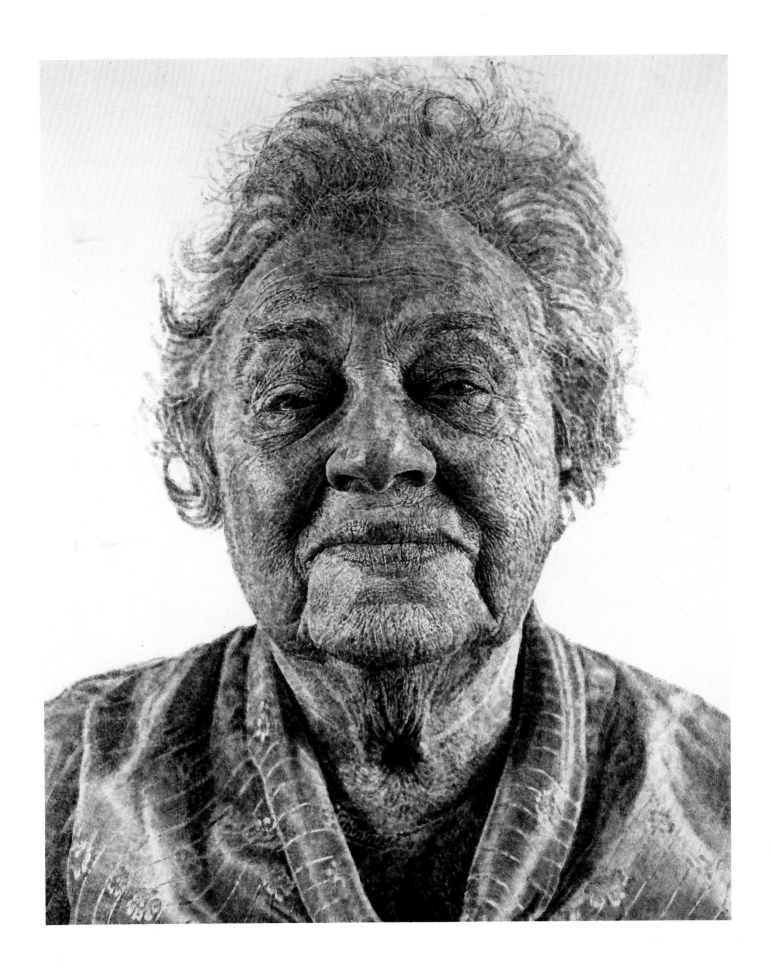

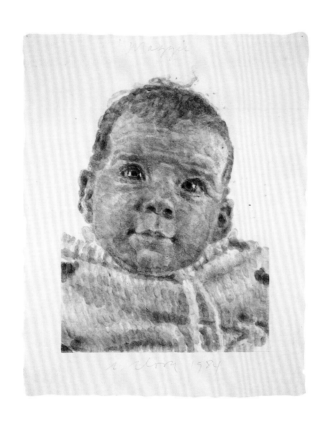

*Maggie.* 1984.
Oil-based ink on paper, 19⅛ x 15½″ (48.6 x 39.4 cm).
Collection Maggie Close

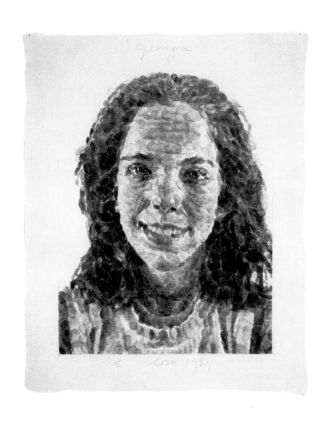

*Georgia.* 1984.
Oil-based ink on paper, 19½ x 15½″ (49.5 x 39.4 cm).
Collection Georgia Close

*Self-Portrait.* 1986.
Oil on canvas, 54¼ x 42¼″ (137.8 x 107.3 cm).
Collection David E. Smith

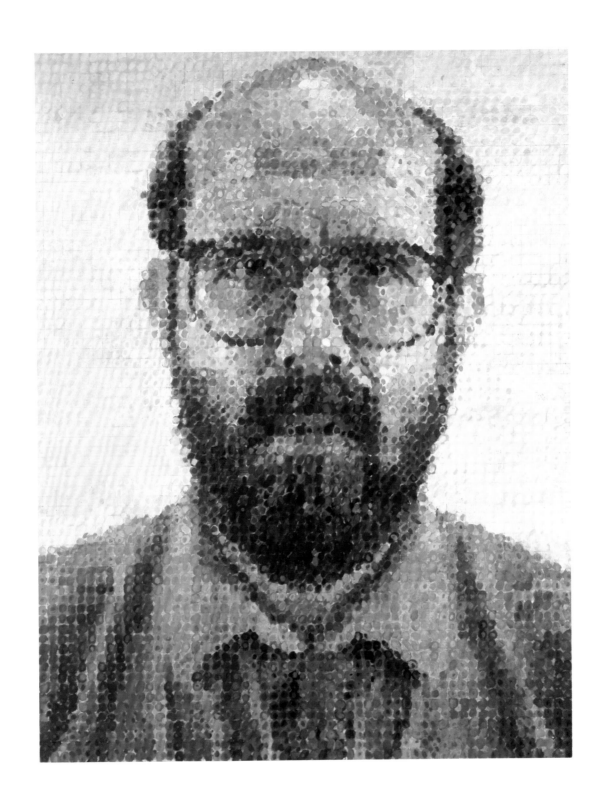

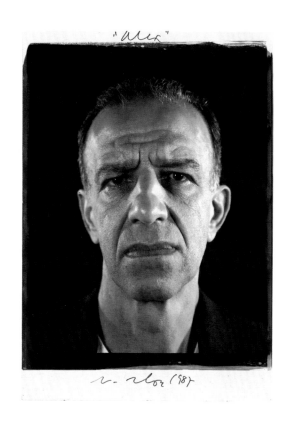

*Alex.* 1987.
Black-and-white Polaroid photograph mounted on aluminum,
32 x 21¾″ (81.3 x 55.3 cm).
Private collection, New York

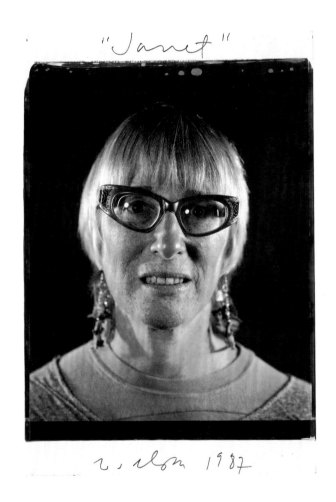

*Janet.* 1987.
Black-and-white Polaroid photograph mounted on aluminum,
32 x 21¾″ (81.3 x 55.2 cm).
Private collection, New York

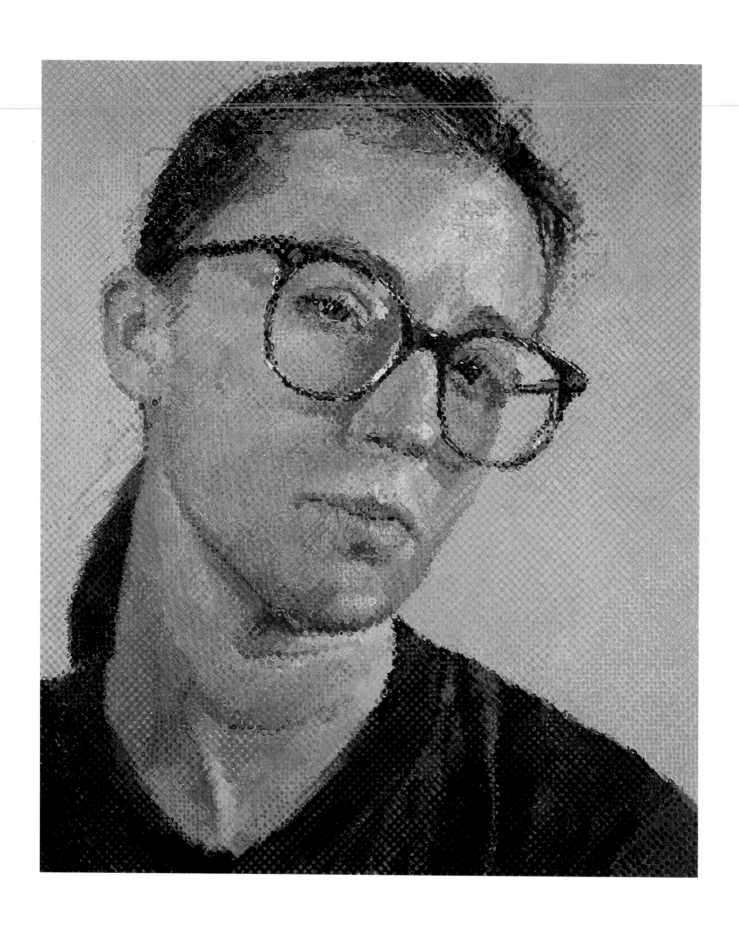

*Cindy.* 1988.
Oil on canvas, 102 x 84″ (259.1 x 213.4 cm).
Collection Oliver-Hoffman

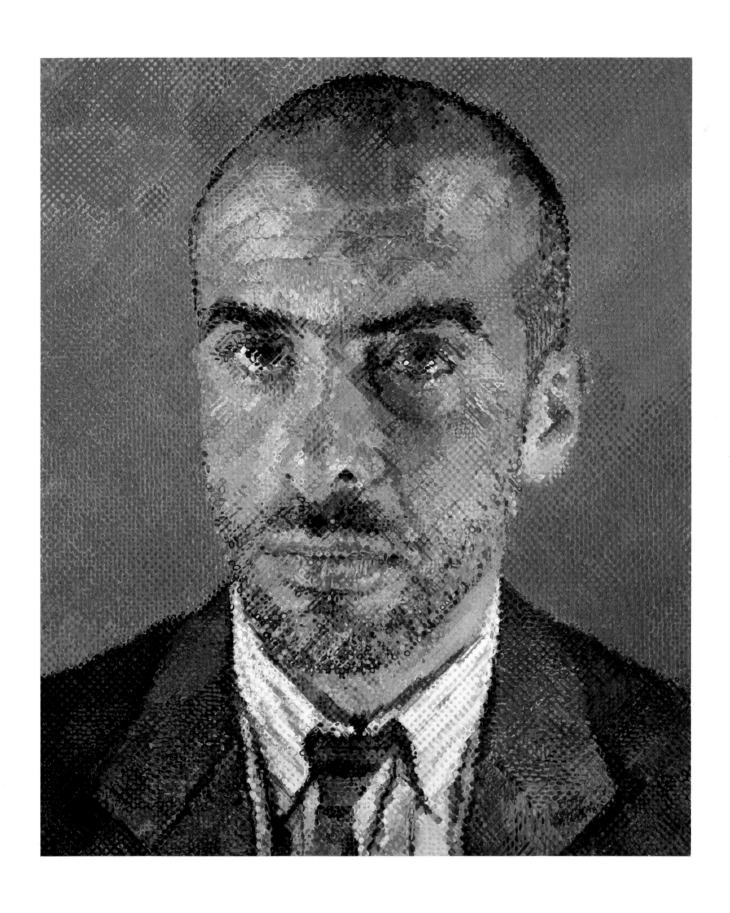

*Francesco I.* 1987–88.
Oil on canvas, 100 x 84″ (254 x 213.4 cm).
Collection Ron and Ann Pizzuti

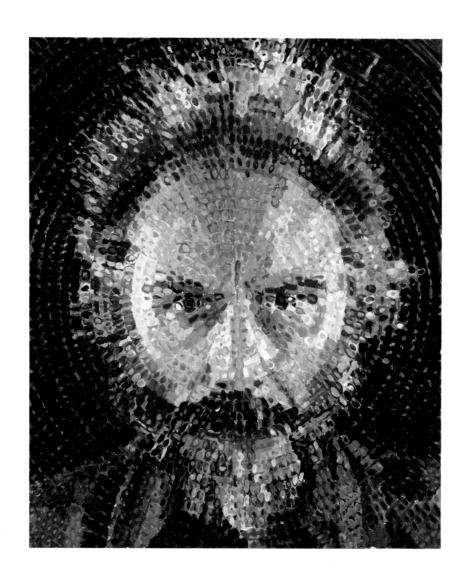

*Lucas II.* 1987.
Oil on canvas, 36 x 30″ (91.4 x 76.2 cm).
Collection Jon and Mary Shirley

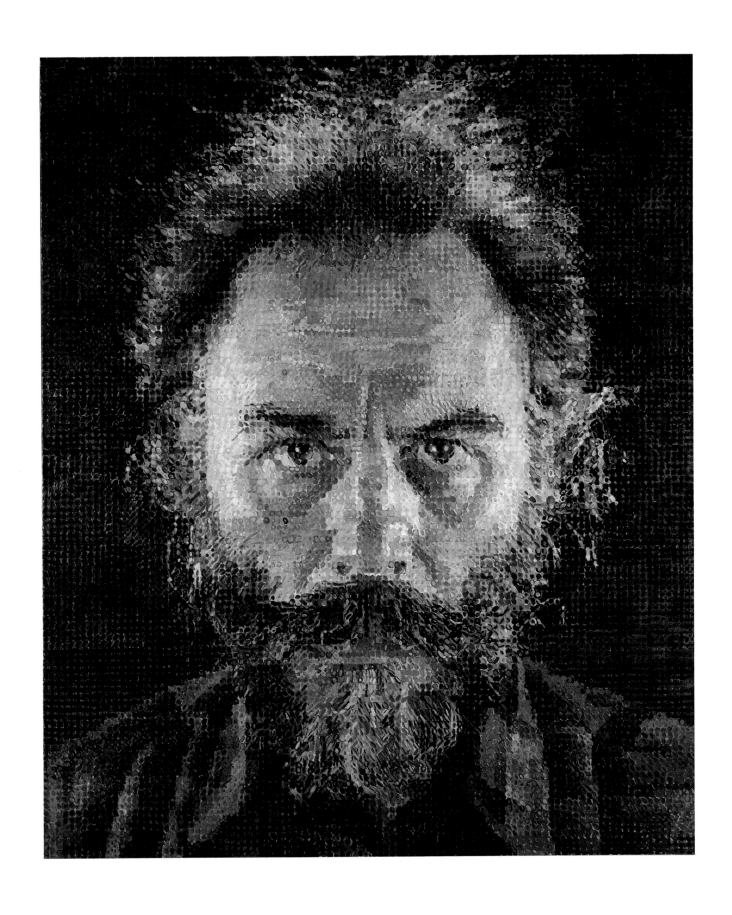

*Lucas.* 1986–87.
Oil on canvas, 100 x 84″ (254 x 213.4 cm).
The Metropolitan Museum of Art, New York.
Purchase, Lila Acheson Wallace Gift and Gift of Arnold and Milly Glimcher, 1987

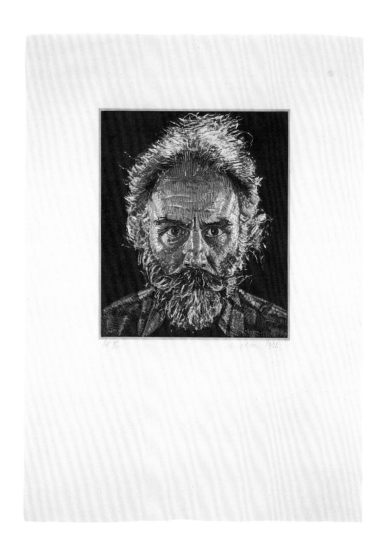

*Lucas.* 1988.
Linoleum cut, 31 x 22¼″ (78.7 x 57.2 cm).
Publisher: Pace Editions, New York.
Printer: Spring Street Workshop, New York. Edition: 50

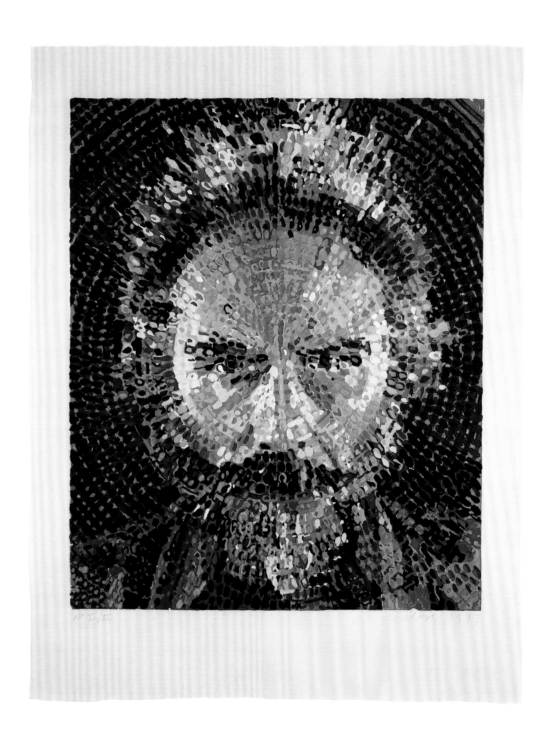

*Lucas/Woodcut.* 1993.
Woodcut with pochoir, 46¼ x 36″ (117.4 x 91.4 cm).
Publisher: Pace Editions, New York.
Printer: Karl Hecksher, New York. Edition: 50

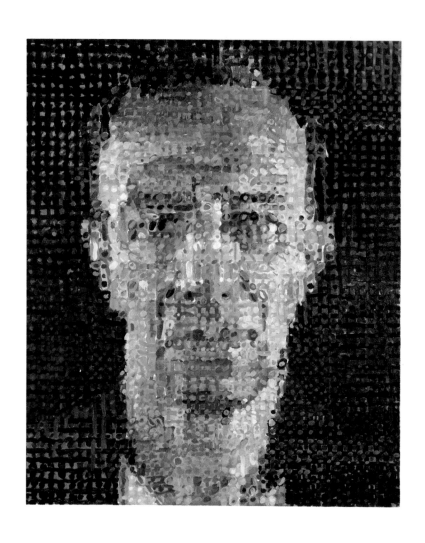

*Alex II.* 1989.
Oil on canvas, 36 x 30″ (91.4 x 76.2 cm).
Private collection, New York

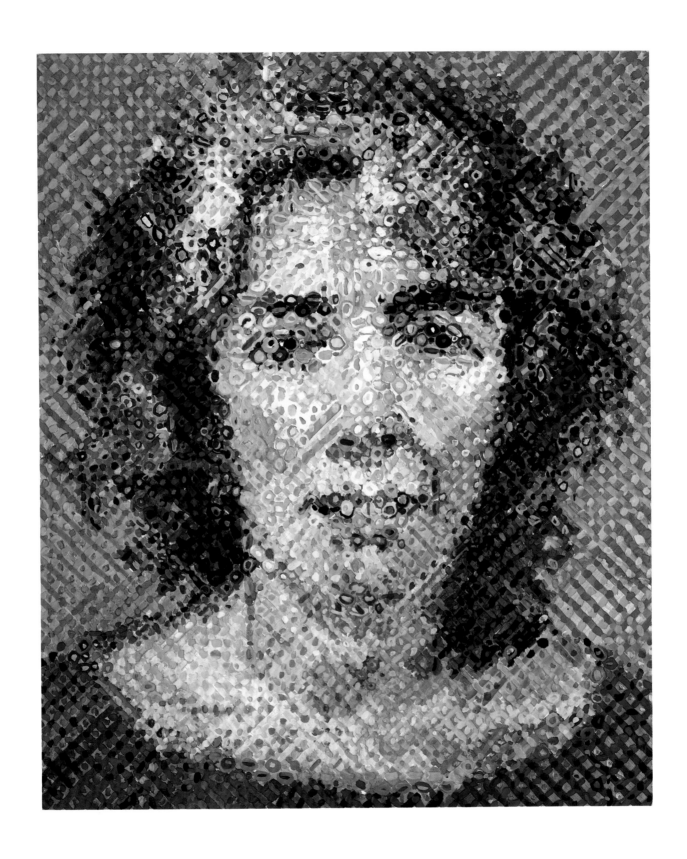

*Elizabeth.* 1989.
Oil on canvas, 72 x 60″ (182.9 x 152.4 cm).
The Museum of Modern Art, New York.
Fractional gift of an anonymous donor

*Alex*. 1991.
Oil on canvas, 100 x 84″ (254 x 213.4 cm).
The Art Institute of Chicago. Acquisition and Gift from the Lannan Foundation

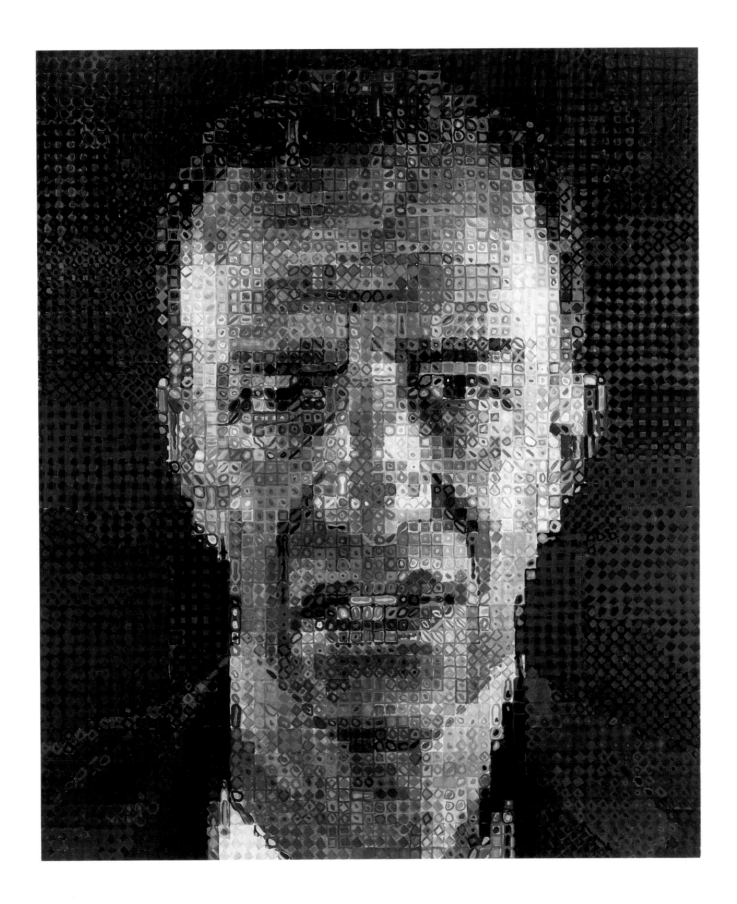

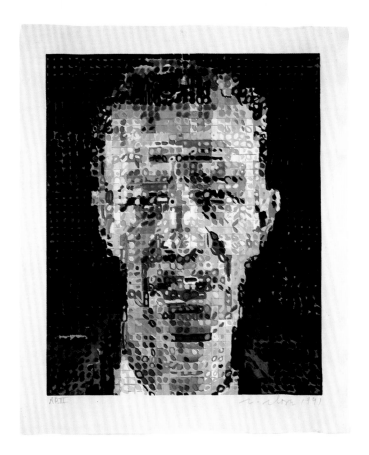 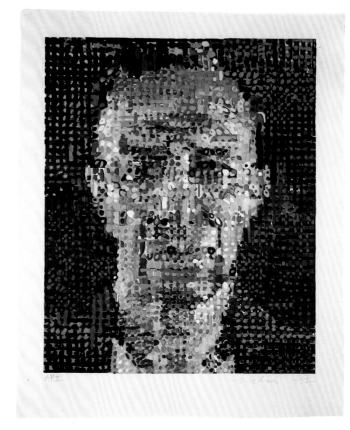

*Alex*. 1991.
Woodcut, 28 x 23¼″ (71.2 x 59.1 cm).
Publisher: Pace Editions, New York.
Printer: Ushio Shinohara, Malden, Massachusetts. Edition: 75

*Alex*. 1992.
Woodcut, 28 x 23″ (71.2 x 58.5 cm).
Publisher: Pace Editions, New York.
Printer: Ushio Shinohara, Malden, Massachusetts. Edition: 75

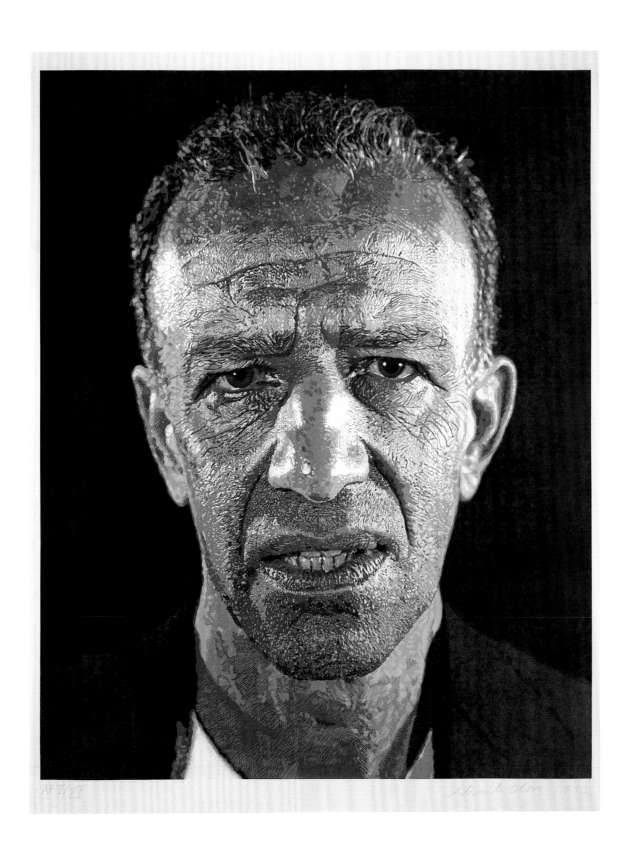

*Alex / Reduction Print*. 1993.
Screenprint, 79 x 60¼" (200.7 x 153.1 cm).
Publisher: Pace Editions, New York.
Printer: Brand X Editions, New York. Edition: 35

*Self-Portrait.* 1991.
Oil on canvas, 100 x 84″ (254 x 213.4 cm).
Collection PaineWebber Group Inc., New York

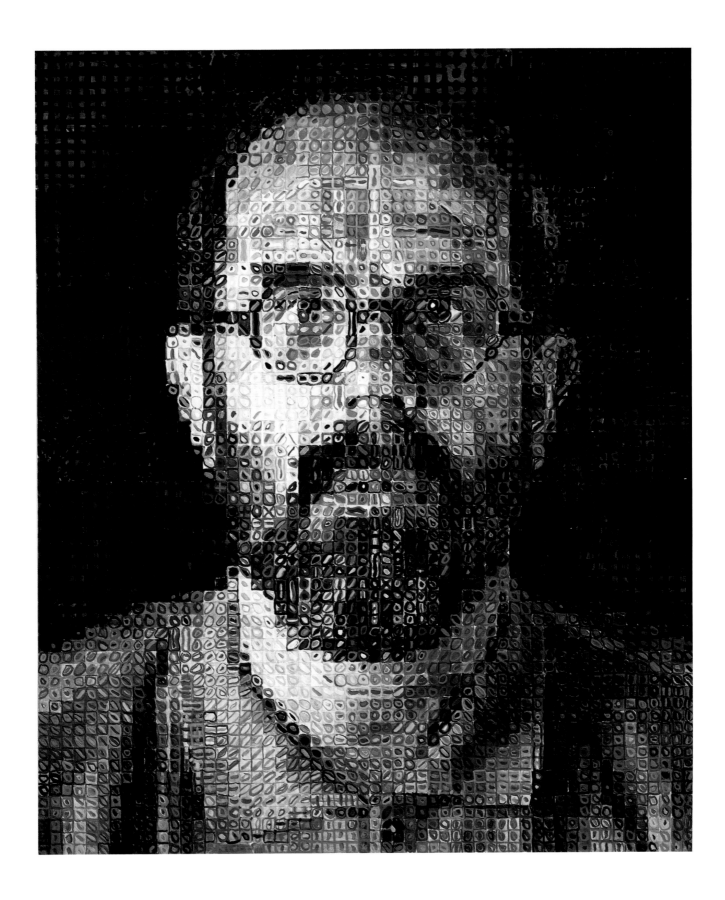

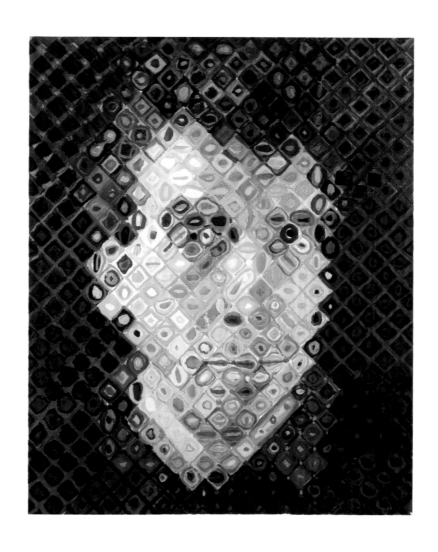

*Bill II.* 1991.
Oil on canvas, 36 x 30″ (91.4 x 76.2 cm).
Private collection, New York

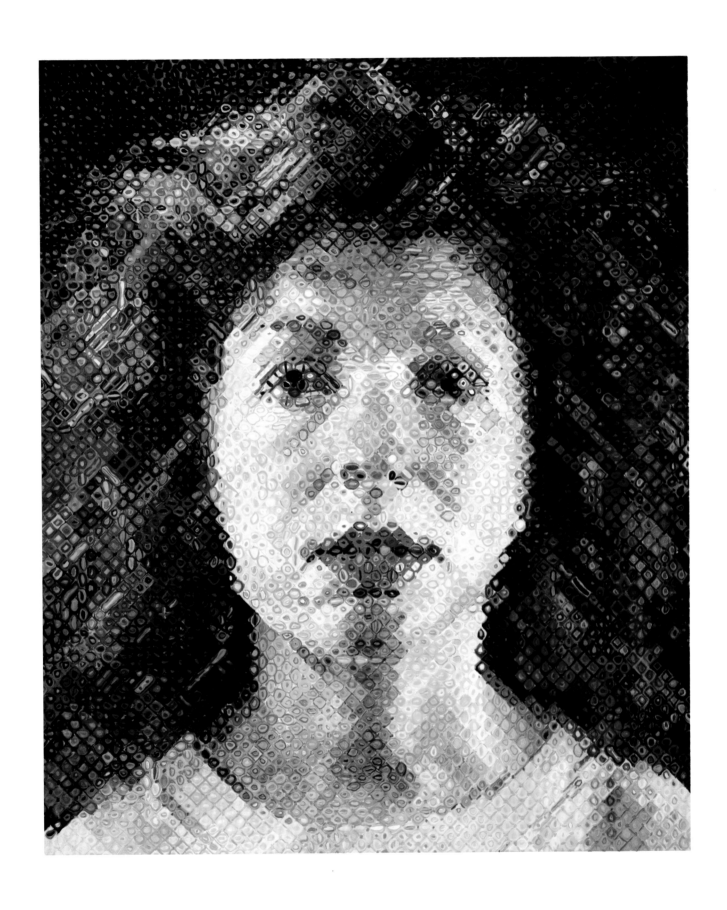

*April.* 1990–91.
Oil on canvas, 100 x 84″ (254 x 213.4 cm).
The Eli and Edythe L. Broad Collection, Los Angeles

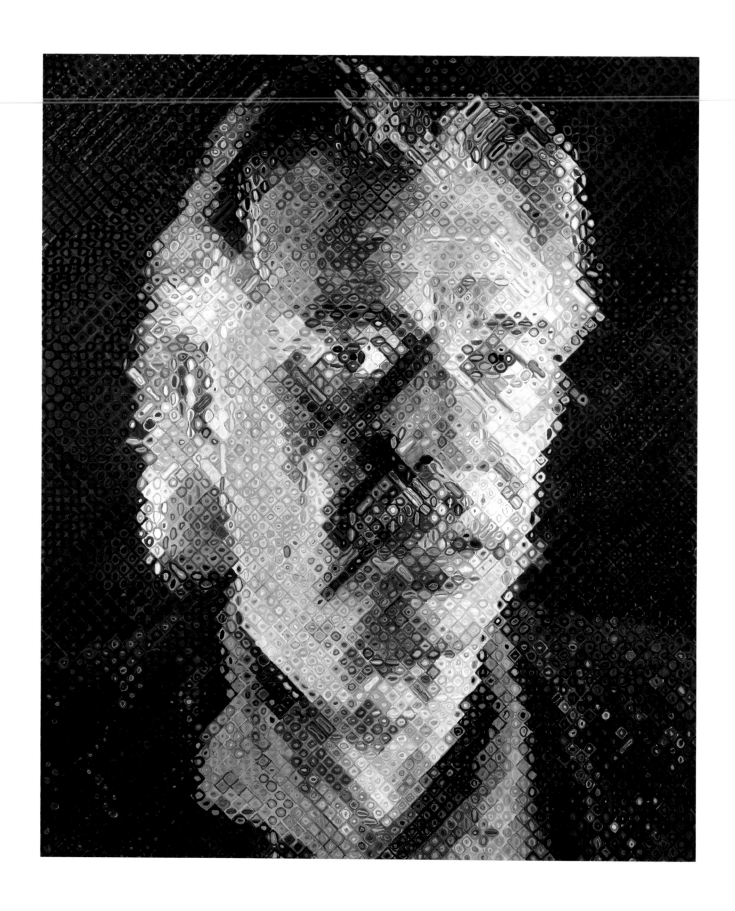

*John.* 1992.
Oil on canvas, 100 x 84″ (254 x 213.4 cm).
Collection Michael and Judy Ovitz, Los Angeles

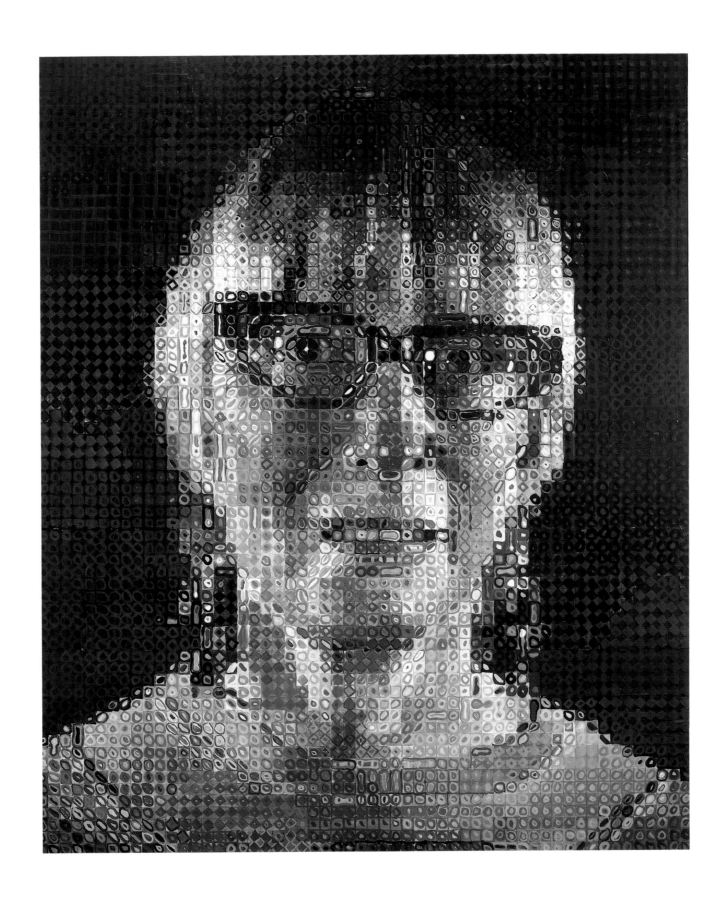

*Janet.* 1992.
Oil on canvas, 100 x 84″ (254 x 213.4 cm).
Albright-Knox Art Gallery, Buffalo, New York.
George B. and Jenny R. Mathews Fund, 1992

185

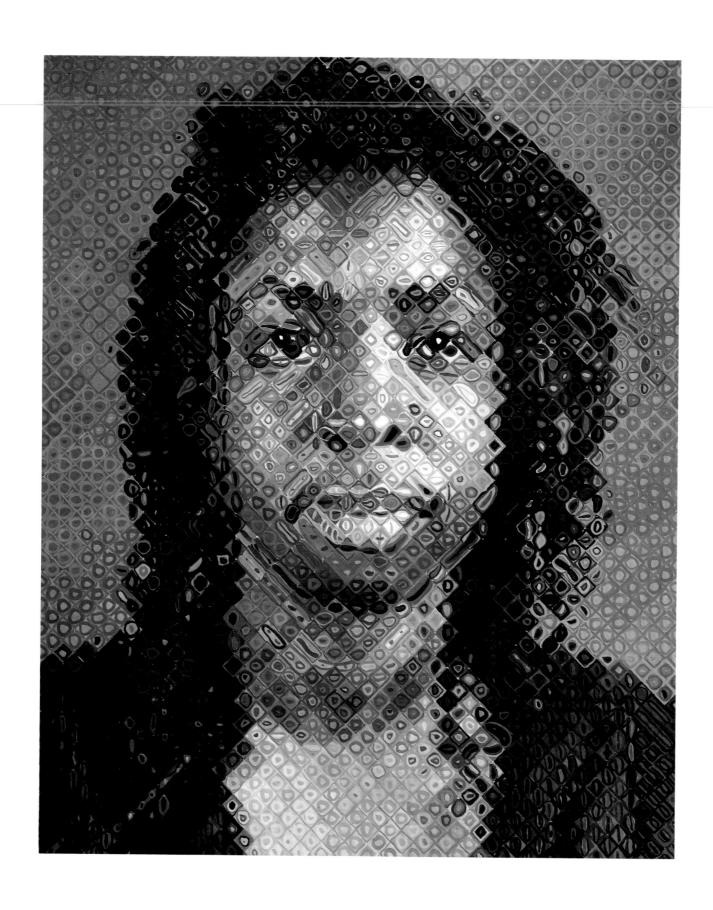

*Lorna.* 1995.
Oil on canvas, 102 x 84″ (259.1 x 213.4 cm).
Private collection, San Francisco

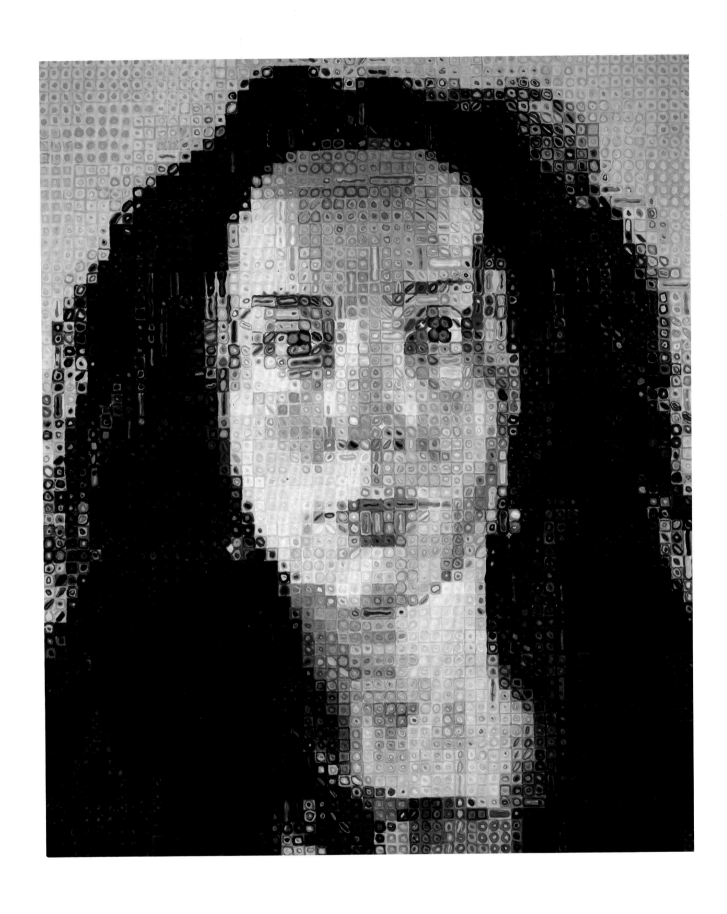

*Kiki.* 1993.
Oil on canvas, 100 x 84⅛″ (254 x 213.7 cm).
Walker Art Center, Minneapolis. Gift of Judy and Kenneth Dayton, 1994

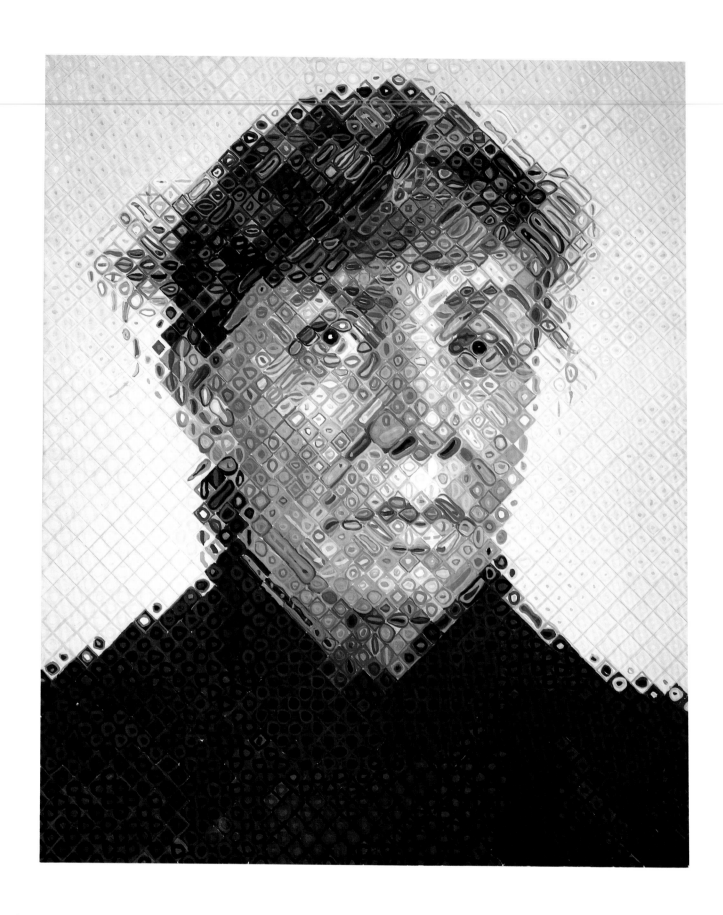

*Dorothea*. 1995.
Oil on canvas, 102 x 84″ (259.1 x 213.4 cm).
The Museum of Modern Art, New York.
Promised gift of Robert F. and Anna Marie Shapiro;
Vincent D'Aquila and Harry Soviak Bequest, Vassilis Cromwell Voglis Bequest,
and The Lauder Foundation Fund

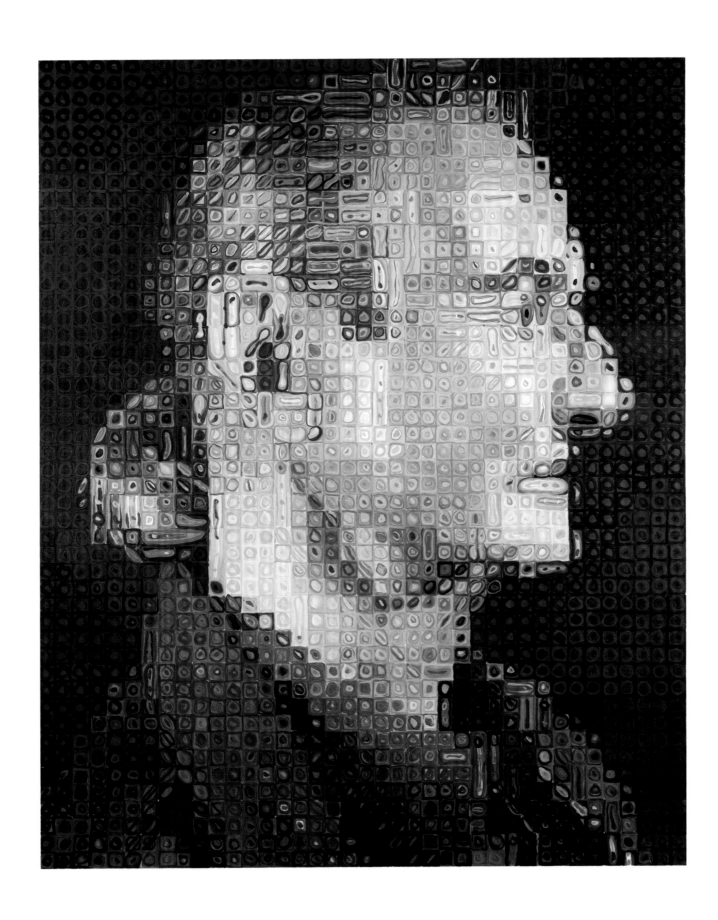

*Roy II*. 1994.
Oil on canvas, 102 x 84″ (259.1 x 213.4 cm).
Hirshhorn Museum and Sculpture Garden, Smithsonian Institution, Washington, D.C.
Regents Collections Acquisition Program with matching funds from the Joseph H.
Hirshhorn Purchase Fund, 1995

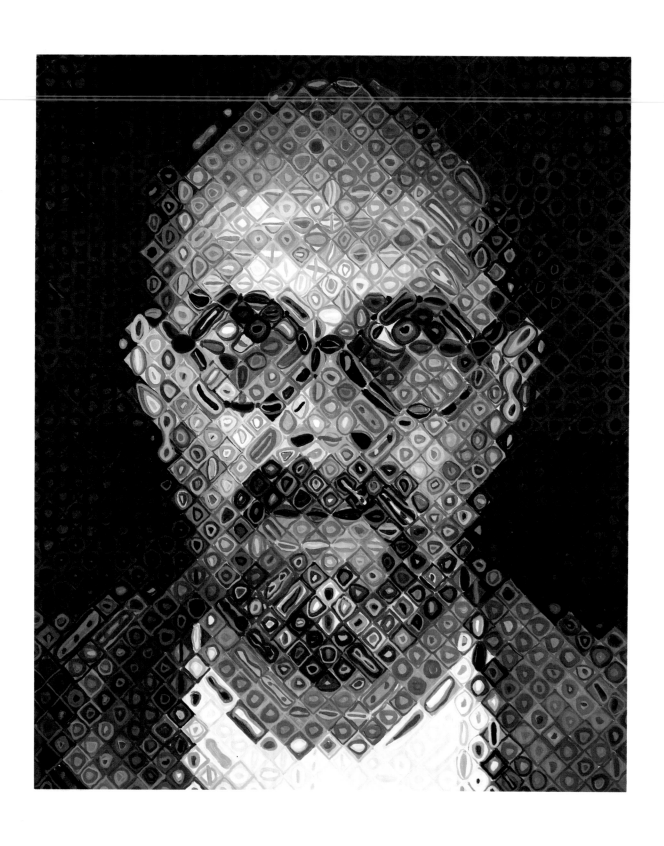

*Self-Portrait I.* 1995.
Oil on canvas, 72 x 60″ (182.9 x 152.4 cm).
Collection Jon and Mary Shirley

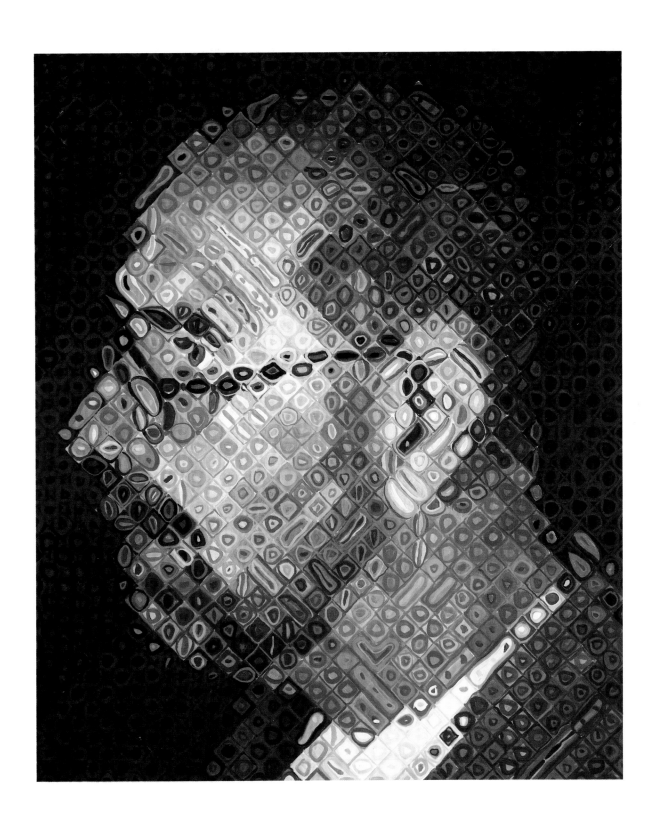

*Self-Portrait II.* 1995.
Oil on canvas, 72 x 60″ (182.9 x 152.4 cm).
Collection Wendy Finerman and Mark Canton

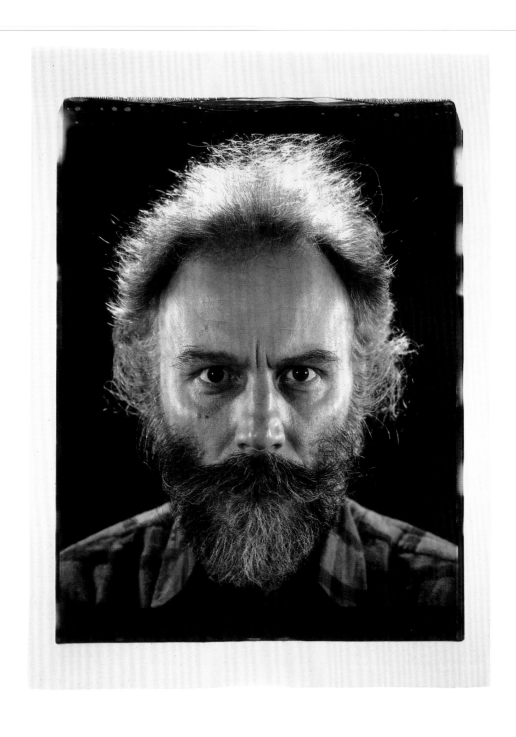

*Lucas.* 1996.
Four digital ink jet prints on Somerset paper, overall: 88 x 68⅛″ (223.5 x 173 cm).
Collection Arthur and Carol Goldberg

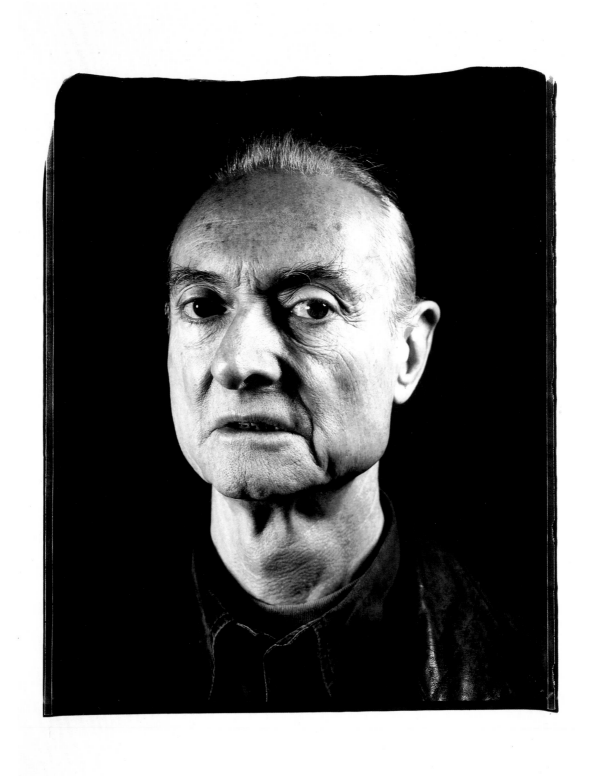

*Roy II*. 1996.
Four digital ink jet prints on Somerset paper, overall: 88 x 68⅛″ (223.5 x 173 cm).
Collection Arthur and Carol Goldberg

*Self-Portrait*. 1996.
Oil on canvas, 30 x 24″ (76.2 x 61 cm).
Private collection, New York

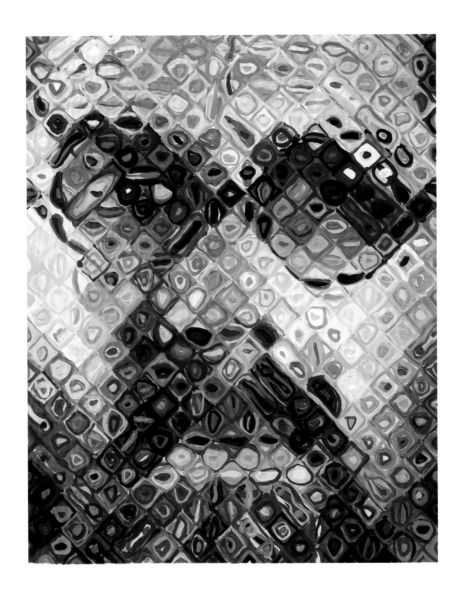

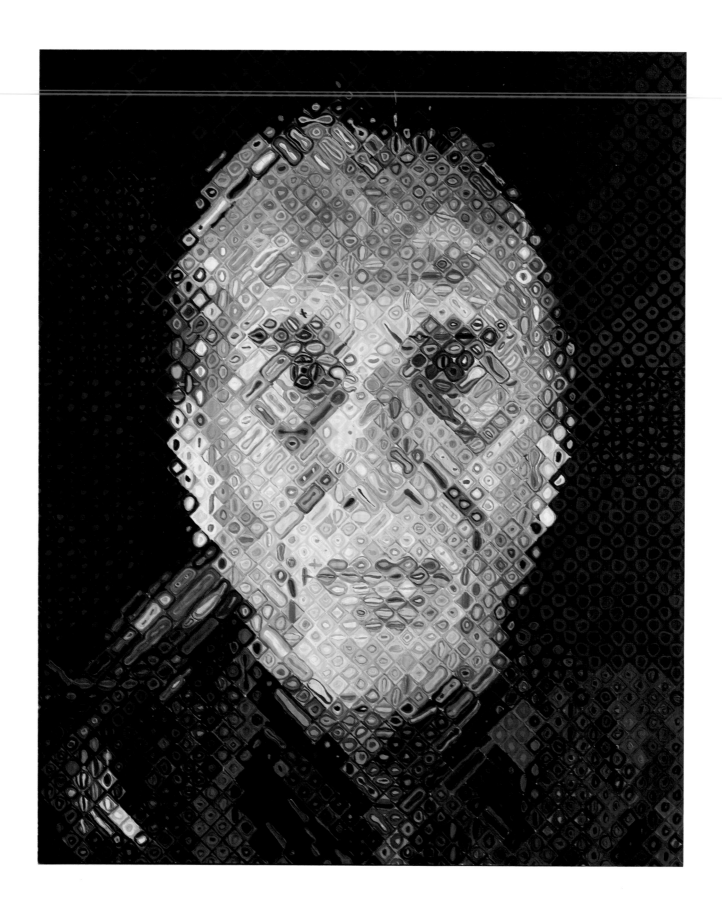

*Paul.* 1994.
Oil on canvas, 102 x 84″ (259.1 x 213.3 cm).
Philadelphia Museum of Art. Purchased with funds from the gift of
Mr. and Mrs. Cummins Catherwood, the Edith H. Bell Fund, and with funds
contributed by the Committee on Twentieth-Century Art

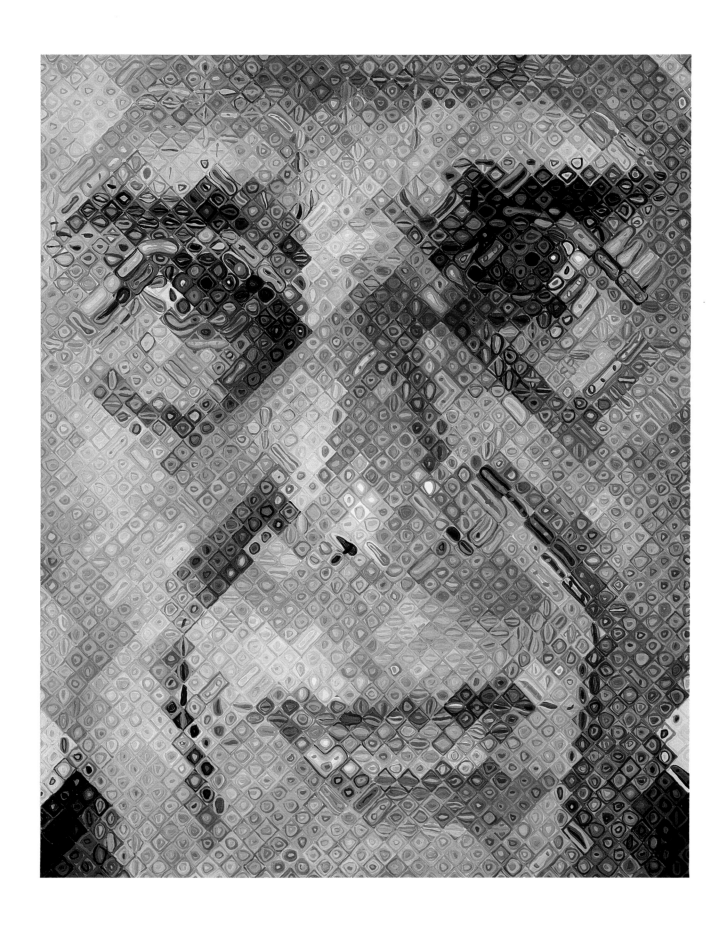

*Paul III.* 1996.
Oil on canvas, 102 x 84″ (259.1 x 213.4 cm).
The Cleveland Museum of Art. Mr. and Mrs. William H. Marlatt Fund, 1997

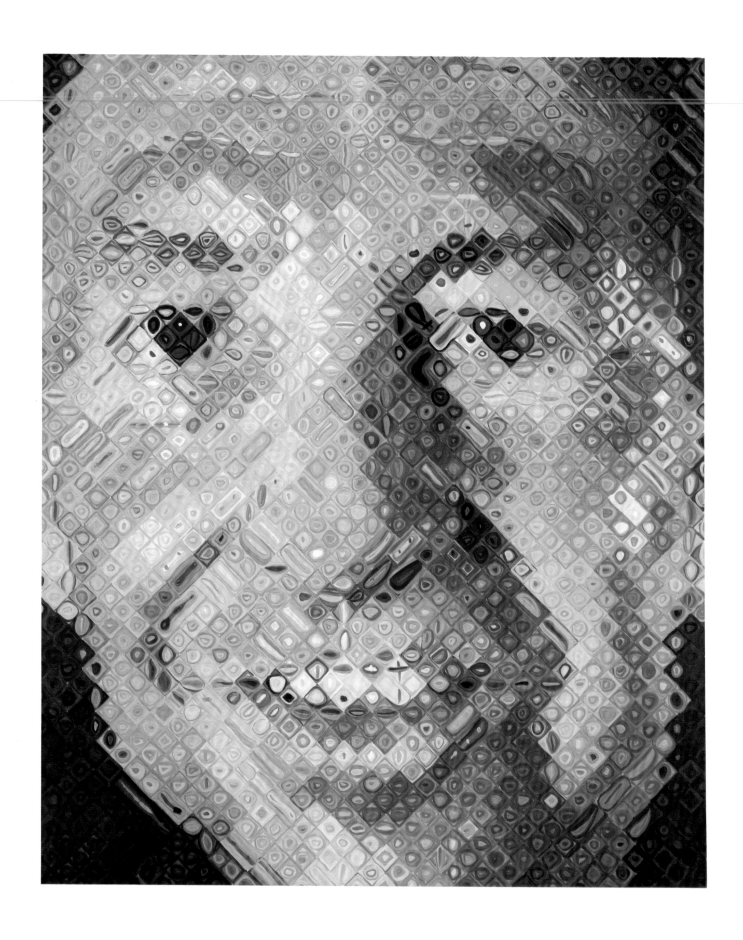

*Robert.* 1997.
Oil on canvas, 102 x 84″ (259.1 x 213.4 cm).
Collection Vicki and Kent Logan

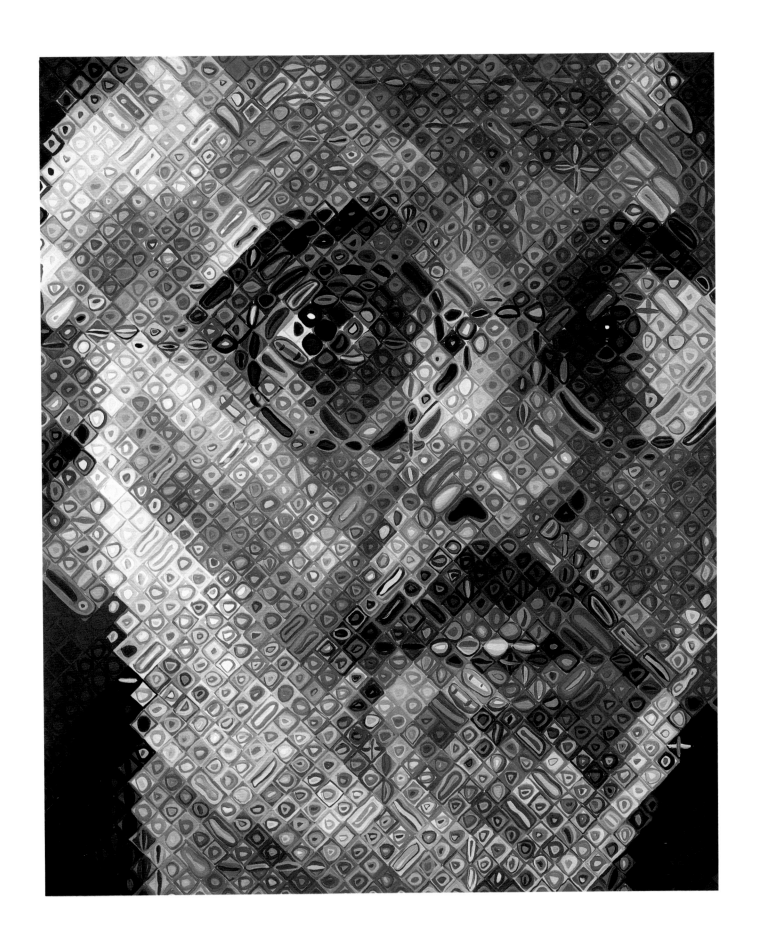

*Mark*. 1997.
Oil on canvas, 102 x 84″ (259.1 x 213.4 cm).
Private collection, New York

*Self-Portrait.* 1997.
Oil on canvas, 102 x 84″ (259.1 x 213.4 cm).
Private collection, New York

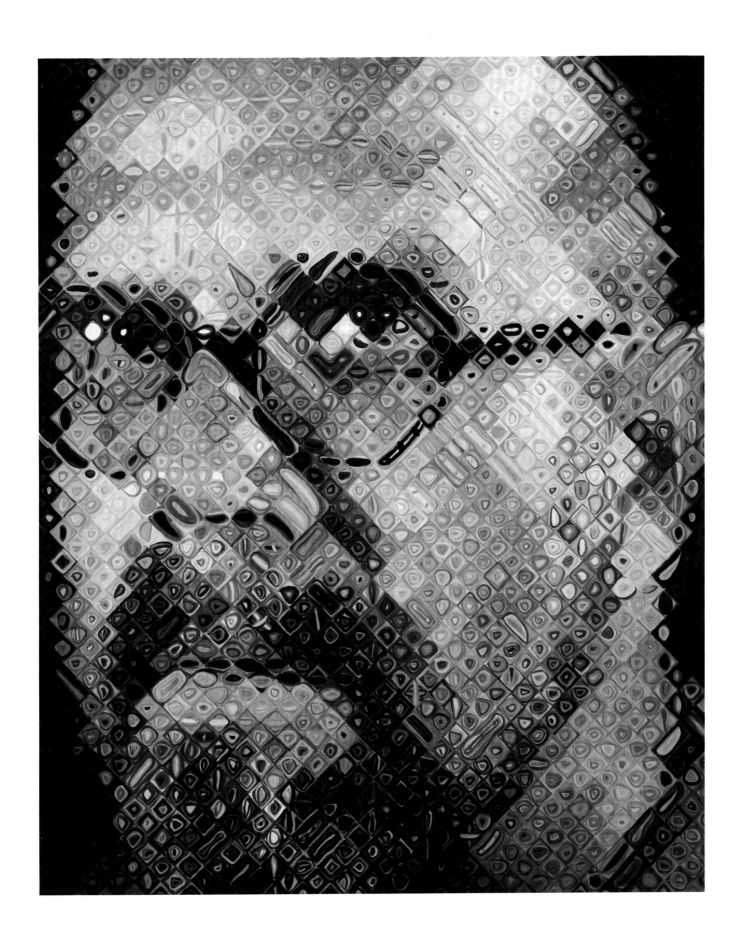

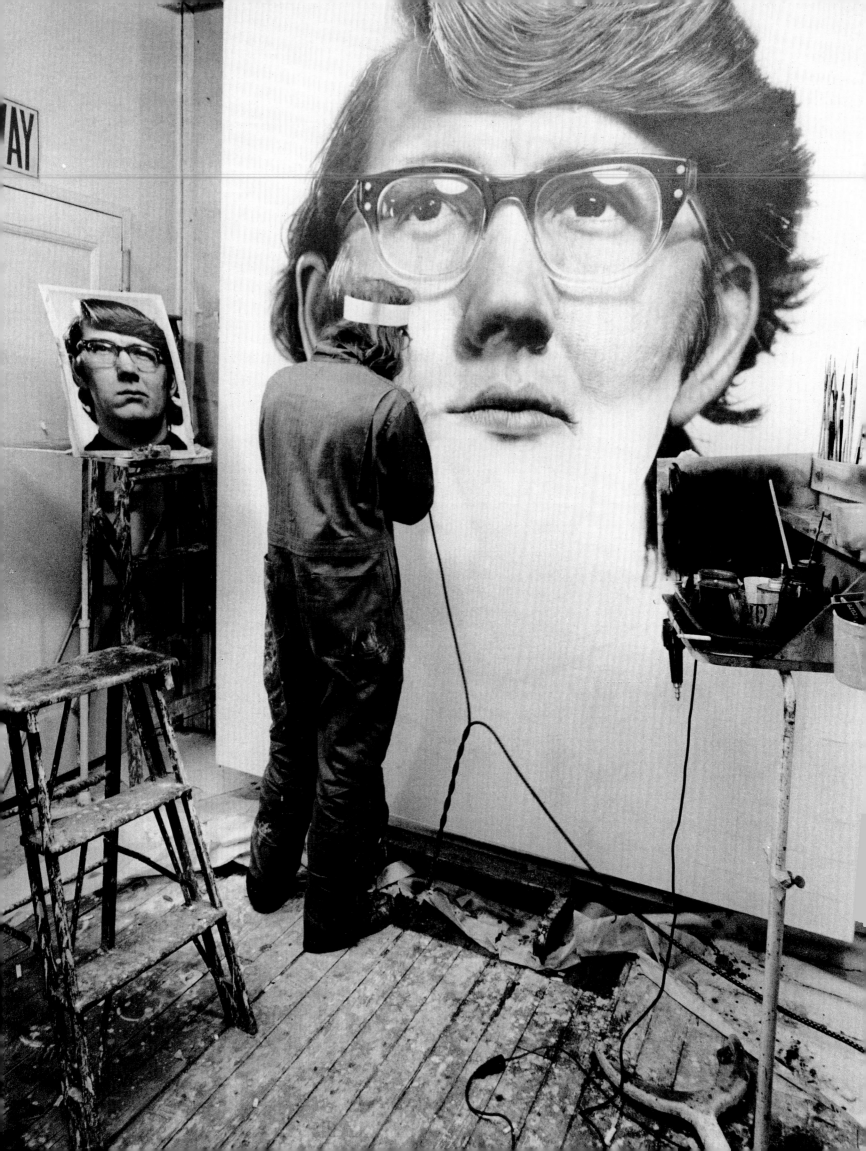

# CHRONOLOGY Compiled by Fereshteh Daftari

The chronology is largely based on information provided with exceptional generosity by the artist in written questionnaires and personal conversations held during June 1997. For the early years, Judd Tully's series of unpublished interviews conducted in 1987 for the Archives of American Art, Smithsonian Institution, served as a supplementary source. All quotations in italic type are statements by the artist and are derived from the above sources, unless otherwise indicated. The reader is referred to the exhibition history for a complete list of solo exhibitions and selected group exhibitions.

## 1940
July 5: Birth of Charles Thomas Close, at home, in Monroe, Washington. Only child of Leslie Durward Close (July 1, 1903–March 1, 1952), inventor, sheet-metal worker, and plumber, and Mildred Emma Wagner Close (October 30, 1913–December 30, 1980), a classically trained pianist who teaches at home until 1952.

December: Family moves to Everett, Washington, where his father begins working as a civil servant in the U.S. Army Air Corps. They live in Everett until 1945.

## 1945
Late fall: Father transfers to the U.S. Air Force at McCord Field in Tacoma, Washington, where he remains in civil service until his death in 1952.

Christmas: Receives an easel made by his father, who also makes him toys.

## 1946
About this time his parents give him artists' oil paints ordered from a Sears Roebuck catalogue.

Above: Chuck Close with his parents during a visit to his grandparents in Everett, Washington, c. 1947; left: Artist working with an airbrush on *Keith* in his Greene Street studio, 1970

## 1948
Begins taking instruction from a professional artist who teaches privately in her apartment. The training is academic. Studies anatomy and drawing from live models; paints still lifes and landscapes. Continues with private lessons until 1951.

## 1952
Spends several months of the year in bed with nephritis (a kidney disease).

March 1: Father dies.

Summer: Moves back to Everett. His mother takes a position as sales person at JC Penney department store and shortly thereafter enters civil service in the U.S. Air Force.

## 1953
Probably in 1953 his mother takes him on a visit to the Seattle Art Museum, where he sees a drip painting by Jackson Pollock on loan to the museum. *"I saw my first Jackson Pollock in the Seattle Art Museum. At first I was outraged by it. It didn't look like anything. It totally eluded whatever I thought that painting would look like. I remember feeling outraged, but later—probably even later the same day—I was dribbling paint all over my canvases."*

## 1955
Graduates from South Junior High School. Enters Everett High School. While there he designs, builds, and paints sets for school plays and illustrates yearbooks and literary magazines.

## 1958
Graduates from Everett High School. Intending to become a commercial artist, he enters Everett Junior College (now Everett Community College), which had an "excellent" art program. As an art major he studies drawing, design, painting, sculpture, commercial art, photography, ceramics, and jewelry.

## 1959
Visits "Vincent van Gogh: Paintings and Drawings," a retrospective exhibition of

155 paintings and drawings at the Seattle Art Museum, held from March 7 to April 19.

## 1960
Receives an A.A. (Associate of Arts) degree from Everett Junior College. Transfers to the University of Washington in Seattle.

Exhibits the oil painting *Nostalgia No. 2* (1960) at the "46th Annual Exhibition of Northwest Artists" at the Seattle Art Museum (November 9–December 4).

Reminiscing about his West Coast years he says: *"In art school you had late bohemian, pre-beatnik. Of course pre-hippie. Sort of beatnik . . . Growing up on the West Coast, we spent a lot of time in San Francisco . . . in North Beach . . . Kerouac and all those people were big. . . . In Seattle we used to go to poetry readings and heard music all the time. And a lot of jazz. Great jazz in California."*

## 1961
Early in the year he begins painting flags. *"I guess I had seen Jasper Johns . . . I got into a lot of trouble . . . I saw myself as railing against the establishment. To make art that offended."* Close cuts up the American flag and then sews it back together, in the shape of a mushroom cloud, for instance, and then paints over it. *"It was 'ban the bomb' kind of stuff . . . vaguely against military, against nuclear—the Korean War was over. We were in the heart of the Cold War."*

Summer: Visits New York for the first time before going to Norfolk, Connecticut, to attend Yale Summer School of Music and Art. In New York, finds that visits to museums and galleries are exhilarating to a *"kid from Seattle used to black and white reproductions."* In Norfolk, studies with Bernard Chaet, Richard Lytle, Philip Guston, Elmer Bischoff, Walter Rosenblum, and Walker Evans. Brice Marden, Vija Celmins, and David Novros are among his classmates. He takes photography, painting, drawing, and printmaking.

Fall: Returns to Seattle to finish his undergraduate work at the University of Washington.

At the end of the year exhibits flag painting at the "47th Annual Exhibition of Northwest Artists" at the Seattle Art Museum. *"Richard E. Fuller [ex*

**Artist dressed as a magician, c. 1946**

*officio Director of the museum] . . . came after the jury had awarded me third prize and I think a thousand dollars and threw the painting out of the show. Some of the jurors left in protest. But I was always interested in provoking."*

## 1962
"Art Since 1950," an exhibition organized by Sam Hunter for the Seattle World's Fair (April 21–October 21), is considered by Close to be a crucial event: *"[It was] one of the first opportunities we had in Seattle to see not only Hofmann, but de Kooning and Pollock and all those people, but also all the Europeans, because it was a very inclusive show."*

Receives B.A. in Art, *magna cum laude* from the University of Washington and wins highest honors.

Spring: Participates in a regional art exhibition, with Nathan Oliveira as juror, at Puyallup, near Tacoma, where again his flag painting infuriates the authorities. *"I had a painting in a show in Puyallup [and] . . . the American Legion literally came and chopped the door down."*

In the summer he applies to the Yale University School of Art and Architecture in New Haven and is accepted. Attends Yale from September 1962 to June 1964. Studies with Bernard Chaet, Gabor Peterdi, Jack Tworkov, Al Held, Esteban Vicente, and Enrico Donati, among others. (Alex Katz and Philip Pearlstein are also on the faculty but he does not study with them; later they become significant friends of his.)

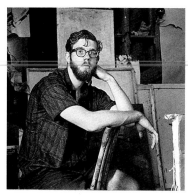

Artist in Norfolk, Connecticut, summer 1961

Artists who give critiques include Philip Guston, Isabel Bishop, Edwin Dickinson, and Walker Evans. Visiting artists and musicians include Robert Rauschenberg, Frank Stella, Richard Lindner, and Morton Feldman. Vincent Scully is one of several art historians with whom he studies. Among his classmates are Brice Marden, Rackstraw Downes, Newton Harrison, Don Nice, Jennifer Bartlett, Michael Craig-Martin, Richard Serra, Nancy Graves, Janet Fish, and Kent Floeter—the last four later portrayed by Close. While at Yale he makes *"pilgrimages to New York every couple of weeks."* He is mostly taken by Pop art, whereas his own work at the time is indebted to Willem de Kooning and Arshile Gorky.

### 1963
Receives B.F.A. with highest honors from Yale.

On a visit to New York purchases a lithograph by Roy Lichtenstein entitled *Crying Girl* (1963), about which he says, *"I remember I bought [a] Roy Lichtenstein…for [ten] dollars from Leo Castelli at Lichtenstein's first* [sic] *show. I brought it back to Yale and I was attacked unmercifully."* [1]

### 1964
June: Receives M.F.A. with highest honors from Yale.

Awarded Fulbright Hayes Grant to study work of Gustav Klimt and Egon Schiele in Vienna.

September: Begins one-year study at Akademie der Bildenden Künste, Vienna. Visits the Kunsthistorisches Museum on a daily basis and is especially struck by the work of Vermeer, Brueghel, Velázquez, and Arcimboldo. Travels widely in Europe, visiting

Germany, Greece, Italy, France, Switzerland, Czechoslovakia, Hungary, and Yugoslavia. Sees his Yale classmates Richard Serra and Nancy Graves in Paris and later in Florence, and Kent Floeter in Barcelona. In Paris he meets Philip Glass, whom he will photograph in 1968 or 1969 and then continue to recycle the image.

### 1965
June: Completes his one-year study at the Akademie.

September: After a brief stay in New York, leaves for Amherst, where he has been appointed instructor in the Department of Art at the University of Massachusetts. Continues teaching there until August of 1967. Befriends the painter John Roy and the sculptor Keith Hollingworth, two faculty members he will subsequently portray. Deborah Wye, now Chief Curator in the Department of Prints and Illustrated Books at The Museum of Modern Art, and Roberta Bernstein, currently Chair of the Art Department at the State University of New York in Albany, are two of the students at Amherst.

*Betsy Ross Revisited*, a flag painting from c. 1961

September: Meets his future wife, Leslie Rose, a student in his first drawing class.

About this time begins making painted constructions in shallow relief on plexiglass, which he eventually destroys. Also begins to work from found photographs and moves away from the kind of abstraction he had embarked on ever since his discovery of Pollock's painting in 1953 and from Pop-related expressionism (flag paintings).

### 1966
Starts working from photographs he takes himself. Shoots black-and-white photographs of a young woman, a secretary at the University, which he

uses as a basis for a reclining nude, a canvas he never completes and which is destroyed.

### 1967
In his first solo exhibition at the University of Massachusetts (January 8–February 1), he shows paintings, painted relief sculptures, and drawings based on photographs of record covers and magazine illustrations. *"The campus police came over there one night and took the show down."* Some of the work representing male nudity[2] results in a lawsuit, about which Close says, *"The ACLU and the AAUP defended me."* The court case is referred to as "Charles Close versus John W. Lederle [President of the University of Massachusetts] et al."

Late August or early September: Moves to New York City. His first studio is located in SoHo, at 27 Greene Street between Canal and Grand. Lives there until the spring of 1970.

September: Begins teaching position at the School of Visual Arts in New York, where he remains on the faculty until June 1971. Teaches photography, design, drawing, and painting. Serra, his classmate at Yale, is now his colleague. Acknowledges Vito Acconci and Joseph Kosuth as influential figures at the school.

Working from pieced-together photographs he had taken in Amherst, he paints the 21-foot-long *Big Nude* (pp. 34–35), which is first exhibited at the Staatliche Kunsthalle in Baden-Baden in 1994. With this work he purges his paintings of color. He uses a variety of techniques, including airbrush and traditional brushes, razor blade, and rags, to scratch, wipe out, and erase.

November: Begins work on the first of eight black-and-white airbrushed paintings of himself and friends he generically calls "heads." The first black-and-white head, *Big Self-Portrait* (p. 107), is completed in early 1968, the last one, *Keith* (p. 113), in April 1970. All eight works are painted in his Greene Street studio. These paintings are based on photographs he takes of his subjects, including himself. The subsequent stages of developing the film and printing the photographs are carried out in close collaboration with professional photographers.

Artist at Yale University, 1964

December 24: Marries Leslie Rose. She subsequently studies sculpture at Hunter College and later becomes a horticulturalist and landscape historian.

### 1968
Around this time, he periodically helps Richard Serra move his lead Prop pieces around. Besides Philip Glass, who is Serra's assistant, a whole circle of friends is engaged in helping Serra. They include Steve Reich, Michael Snow, Tony Shafrazi, the novelist Rudy Wurlitzer, Spalding Gray, the filmmaker Robert Fiore, and the musician and video artist Richard Landry. Close continues to assist Serra in the following year, especially with the 1969 *One Ton Prop (House of Cards)*. Regarding Serra's Props, Close recalls that one of them, until recently entitled *Clothes Pin Prop* (1969), was originally named after him *"Close Pin Prop"* (p. 32).

Paints *Nancy* (p. 108), the second in the black-and-white head series, which portrays the artist Nancy Graves, whom he had met at Yale and who in 1965 had married Richard Serra.

On the same day, in 1968 or 1969, he photographs the composer Philip Glass, the sculptor Richard Serra, and the opera designer Bob Israel. The photographs of Phil and Bob will be frequently recycled.

### 1969
Paints a portrait of Frank James (p. 110), a student at the School of Visual Arts, where Close is teaching.

Walker Art Center in Minneapolis acquires his 1967–68 *Big Self-Portrait* (p. 107) for $1,300 directly from the artist. This marks his first sale to a museum.

Joins Bykert Gallery (24 East 81st Street, New York), which is headed by Klaus Kertess. Wanting to disassociate himself from the burgeoning style of Photorealism, Close selects Bykert because of its devotion to abstraction. Brice Marden, David Novros, and Dorothea Rockburne are among the artists represented by the gallery.

First New York group show, "Lynda Benglis, Chuck Close, David Paul, Richard van Buren," takes place at the Bykert Gallery (May 20–June 20). *Frank* is exhibited. A review of the show, in which Close's work is reproduced, appears in the September issue of *Artforum*. *Frank* is acquired by the Minneapolis Institute of Arts, his second sale to a museum.

During the year, aside from *Frank* and *Richard* (Serra) (p. 111), he also paints two other friends, *Joe* (Zucker) (p. 109) and *Phil* (p. 112).

December 1: *Phil* enters the collection of the Whitney Museum of American Art.

December: First participation in the Whitney Annual (December 16, 1969–February 1, 1970), whose curators are Marcia Tucker and James Monte. Exhibits *Richard* (p. 111), which is acquired by the Ludwig Collection in Aachen.

### 1970
Cindy Nemser publishes "An Interview with Chuck Close" in the January issue of *Artforum* and "Presenting Charles Close" in the January–February issue of *Art in America*. The *Artforum* interview is the first time Charles Close is referred to as Chuck Close. The change is accidental. In his own words, "*A student of mine dropped off the photos that went along with the article, just wrote in the name 'Chuck' and that was that.*"[3]

February 10–March 29: Exhibits *Frank* (p. 110) and *Phil* (p. 112) at the Whitney's "22 Realists" exhibition, organized by James Monte. Close had declined twice before to participate in New Realist exhibitions.[4]

February 28–March 28: First of four solo shows at the Bykert Gallery in New York. Exhibits *Nancy* (p. 108), *Bob*—a portrait he had begun in 1969 and finished in 1970—and, most probably, *Joe* (1969).[5] Along with these paintings,

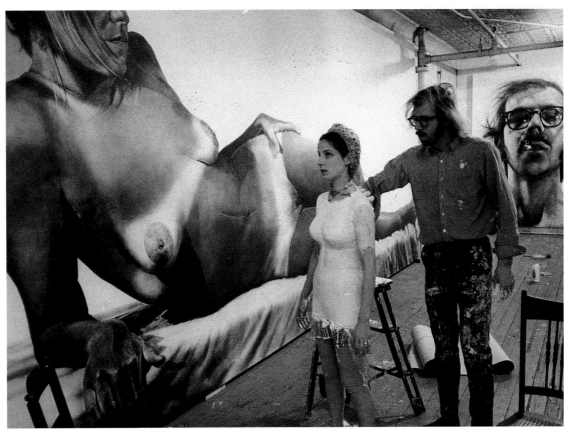

Artist applying plaster to his wife, Leslie, in his Greene Street studio, New York, 1968. At the left is the 21-foot-long *Big Nude* (1967); in the background the *Big Self-Portrait* (1967–68)

he also shows *Slow Pan for Bob*, a 16 mm black-and-white film made with the help of Richard Landry. The camera scans, in extreme close-up, the face of Bob Israel, which at no time is seen in its entirety.

March–April: For the first time his painting is seen abroad. *Richard*, which had entered the Ludwig Collection in 1969, is included in "Klischee und Antiklischee," the first exhibition at the Neue Galerie der Stadt Aachen in Aachen, Germany, a museum of contemporary art created under the patronage of Mr. and Mrs. Peter Ludwig.

April: Completes *Keith* (Hollingworth), the last of eight black-and-white portraits, in his Greene Street studio.

Spring: Moves to a loft at 101 Prince Street, where he works until 1974.

Summer: Teaches painting at the University of Washington in Seattle and meets the painter Mark Greenwold, who is also on the faculty. For the first time, he begins experimenting with the three-color process. The first works in this technique are two drawings and a watercolor of Kent Floeter. He thus

brings color back to his work in a technique of color separation derived from color printing. The first painting done with the three-color process is *Kent* (1970–71), executed in his Prince Street studio in New York.

Fall: Begins to teach painting at New York University, where he is on the faculty until spring 1973. Ross Bleckner is one of his students.

### 1971
Completes the portrait of Kent Floeter, begun in 1970, which is purchased by the Art Gallery of Ontario, Toronto. Using the same three-color process, he paints portraits of *Susan* (Austad) (p. 116), Joe Zucker's wife, and *Nat* (Rose), the artist's father-in-law. Working on these first three paintings he wears tinted cellophane filters over his glasses to see only the color he is spraying out of the airbrush.

Summer: Teaches at Yale Summer School of Music and Art in Norfolk, Conn.

September: First U.S. one-person museum exhibition, of nine recent works, opens at the Los Angeles County

Museum of Art (September 21–November 14). In the brochure, the artist explains his return to color and his method: "*The fewest number of colors needed to construct the full chromatic range of a color photograph is three: red (magenta), blue (cyanne), and yellow. The color is applied much the same way as in the black and white paintings, but now three colors have to be applied separately. This is done in layers—one color superimposed over another—with every area of the painting having some of all three colors present in varying densities. The relative percentage of each color controls the hue and its intensity. The relative density of the combined colors determines its value. There is no white paint used, and there is consequently no need for a palette as the paint is literally mixed on the canvas.*"[6]

On the occasion of his second solo exhibition at the Bykert Gallery (December 4, 1971–January 5, 1972), where he shows two works,[7] Hilton Kramer, in his first review of Close's work, characterizes him as "a particularly gruesome practitioner of this superrealism."[8] Less than a week later, Kramer writes another review in which he proclaims, "The kind of work Mr. Close produces is interesting only as evidence of the

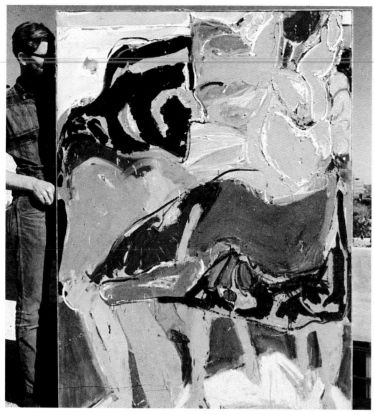

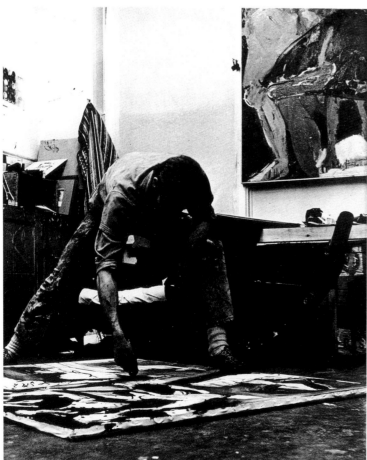

Top: *Seated Figure with Arms Raised* (c. 1963). This painting, which was lent by the artist to Everett Community College, was destroyed in a fire there in 1987; above: Artist in his studio at Yale University, c. 1964. On the wall behind is *Seated Figure with Arms Raised*

kind of rubbish that follows in the wake of every turn in the history of taste."[9]

## 1972

January: Participates in the Whitney Annual Exhibition (January 25–March 19) for the second time. Shows *Nat* of 1971.

February 5–March 19: Second solo exhibition in an American museum, at the Museum of Contemporary Art in Chicago. Shows eleven works.

Spring: Works in Oakland with Kathan Brown at Crown Point Press on *Keith/Mezzotint* (p. 121), in a printing technique rarely used by twentieth-century artists. This mezzotint and the 1970 black-and-white painting of Keith are based on the same photographic image. The edition of ten is published by Parasol Press. This is the first print he had made since college and the first piece to leave the grid exposed.

June 30–October 8: Participates in "Documenta 5" in Kassel, organized by Harald Szeemann. General theme of the exhibition revolves around the notion of "reality." Close shows three paintings, all executed in the three-color process: *John* (p. 117), *Kent*, and *Susan* (p. 116).

Summer: Teaches again at Yale Summer School of Music and Art along with his former teacher, Philip Guston.

Udo Kultermann publishes *New Realism*, the first monographic attempt to come to terms with the movement. Close is included.

## 1973

Early in the year, finishes *Leslie/Watercolor* (p. 119), the first portrait painting of his wife, which he had begun in the summer of 1972.

January 13–February 28: Exhibits for the first time at The Museum of Modern Art, New York, in "Projects: Chuck Close/Liliana Porter." *Keith/Mezzotint*, shown with its nineteen progressive proofs, is characterized in the press release as "Chuck Close's first major print, a portrait which is probably the largest mezzotint ever made." It had entered the Museum's collection in 1972.

July 15: Birth of his daughter, Georgia Molly.

[Fall]: Receives National Endowment for the Arts Fellowship grant.

Begins the airbrushed "dot" drawings, which he continues to make until 1978. The first one is titled *Keith/1,280*. The number, which is included in the titles of these works, refers to the number of squares in the grid. In a painstaking process, using an airbrush, he sprays a dot in each square an average of ten times, from left to right and top to bottom.

October 20–November 15: Third solo show at the Bykert Gallery, where dot drawings are exhibited.[10] Around the time of this show, Close is shocked to see a digitalized image of George Washington reproduced on the cover of the November issue of *Scientific American* (p. 48), which resembles his arduously airbrushed dots sprayed into gridded squares.

## 1974

February: William Dyckes publishes the article "The Photo as Subject: The Paintings and Drawings of Chuck Close," in *Arts Magazine*. This issue is devoted to Superrealism. The following June, an attack on Photorealism, exempting Close, is published by Robert Hughes in the same magazine. Hughes maintains, "If Photo-Realism's relation to photography is boringly simple, its potential as drawing is frequently null. All that remains is the technique."[11]

After fourteen months of work, he completes his largest dot drawing, of Robert Elson, Leslie's school friend. This work, *Robert/104,072* (p. 129), considered a painting since it is on canvas, enters The Museum of Modern Art's collection in June 1976.

Participates in numerous group exhibitions in the U.S. and abroad, including the Tokyo Biennale.

Moves from his Prince Street loft to 89 West Third Street. Stays there for the next ten years.

## 1975

February 22–April 6: Exhibits *Robert/104,072*[12] at the "34th Biennial of Contemporary American Painting," Corcoran Gallery of Art, Washington, D.C.

Executes lithographs at Landfall Press in Chicago. First lithograph is *Keith/Four Times* (p. 74).

Above: Artist in his Greene Street studio in 1970 with the black-and-white paintings of *Nancy* (1968), *Keith* (unfinished), *Joe* (1969), and *Bob* (1969–70). The image was used as the announcement to the artist's first solo exhibition at the Bykert Gallery;

Below: Chuck Close, Klaus Kertess, and two unidentified guests at the opening of "Three Realists: Close, Estes, Raffael," February 26, 1974, in Worcester, Massachusetts

April 5–24: Last of four solo exhibitions at the Bykert Gallery. Exhibits more than twenty drawings and the painting *Robert/104,072*, which had just been on view at the Corcoran. These dot drawings are then exhibited in a traveling show which opens at the Laguna Gloria Art Museum in Austin, Texas, in June.

Summer: Purchases a house in East Hampton, which he will retain until December 1985.

Returns to three-color process painting with *Linda* (p. 131), a portrait of the novelist Linda Rosenkrantz Finch.

Close is included in *Super Realism: A Critical Anthology*, edited by Gregory Battcock.

### 1976
Completes *Linda* (1975–76) after fourteen months of work.[13]

Portrays his dealer, Klaus Kertess (p. 132), who had left the Bykert Gallery the previous year. Bykert closes permanently in the summer.

Included in "Drawing Now, 1955–75," a traveling group exhibition, organized by Bernice Rose, at The Museum of Modern Art (January 21–March 21); in "Seventy-Second American Exhibition," at The Art Institute of Chicago (March 13–May 9), organized by A. James Speyer and Anne Rorimer; and in "Modern Portraits: The Self & Others" (October 20–November 28), with Kirk Varnedoe as curator, at Wildenstein in New York.

### 1977
February 19–April 3: Participates in the Whitney Biennial Exhibition. Shows the *Bob* series (1973), *Leslie/Watercolor* (1972–73), and *Robert/104,072* (1973–74).

Upon the invitation of Arnold Glimcher, Close joins The Pace Gallery, located at 32 East 57th Street in New York. In his first show (April 30–June 4), he exhibits *Linda* (p. 131), *Klaus* (p. 132), *Drawing for Phil/Rubber Stamp* (1976), *Self-Portrait* (p. 133), *Linda/Eye Series I–V* (pp. 134–35), *Twelve Heads x 1154 Dots* (1977), *Self-Portrait/6 x 1* (1977), *Self-Portrait/8 x 1* (1977), and *Klaus/8 x 1* (1977). He also exhibits *Linda/Pastel*, the first of the pastel series he begins working on in 1977. This exhibition prompts favorable reviews from Thomas B. Hess and Robert Hughes.[14]

June 24–October 10: "Documenta 6" in Kassel, organized by Klaus Honnef and Evelyn Weiss under the direction of Manfred Schneckenburger, marks Close's second participation in the Documenta exhibitions. Shows *Linda* (1975–76), *Linda/Eye Series I–V* (1977), and *Bob* series (1973).

Becomes intensely involved with etching, a printing technique he had studied with Gabor Peterdi at Yale. "*For two and a half months I drew on the plate in my own studio. Then I took it out to Crown Point Press in California where it was etched and printed very directly. It was the antithesis of the experience I had making the mezzotint, where I sat at the printers' for two or three months building an image, checking and adjusting it.*"[15]

### 1978
Begins "fingerprint" drawings by inking his finger and making impressions on the gridded surface of the paper. Differences in tonality result from the varying pressure of the hand. The first application of this technique occurs with the recycled image of Phil, *Phil/Fingerprint* (1978); the last, *Leslie*, dates from 1985.

December 16, 1978–January 20, 1979: *Mark Watercolor/Unfinished* (1978) is shown in "Grids: Format and Image in 20th Century Art," a group show at The Pace Gallery. Other artists shown include Eva Hesse, Sol LeWitt, Eadweard Muybridge, and Andy Warhol.

Begins portrait of *Mark* (p. 141), the last painting in the three-color process, which he finishes in 1979 after fourteen months of work. The first time he had portrayed Mark was in 1973, a dot

Artist at work on *Jud/Collage* (1982). The bowls contain pulp-paper chips

drawing of a gridded-off Polaroid that the subject had sent Close as a joke from Los Angeles.

### 1979
January 17–20: Spends time in Cambridge at the invitation of Kathy Halbreich, then the director of the Hayden Gallery at MIT, to explore the possibilities offered by the Polaroid Corporation's large format 20-by-24-inch camera. He photographs himself, Kathy Halbreich, Ray Johnson, Bob Feldman, Georgia, and Leslie, among others. The studio activities take place in the context of an informal exhibition titled "Focusing on Faces." Among the images is the *Self-Portrait/Composite/Nine Parts* (p. 147). These Polaroids are not meant to be studies for paintings or other works but, as Close said, *"It was the first time I considered myself a photographer."*[16]

February 14–April 1: Participates in the Whitney Biennial, where he shows *Self-Portrait/Pastel* (1977), *Mark/Pastel* (1977–78), and *Nat/Pastel* (1978).

April 18–June 11: Three-person exhibition titled "Copie Conforme?" at the Centre Georges Pompidou in Paris.

April 22–June 10: His photographs are included in an exhibition "The Altered Photograph: 24 Walls, 24 Curators," at P. S. 1, Long Island City, New York.

June 28–July 21: First European solo museum exhibition, of sixteen works, organized by Hermann Kern, opens in Munich at the Kunstraum München.

Executes *Keith/Six Drawings Series* (pp. 142–43) and publishes a book consisting of a complete and a detail illustration of each drawing. Included in the series are the last fingerprint drawings to display the grid; they fully illustrate the possibilities of variations within the restricted parameters of the technique.

### 1980
Begins portrait series using a 40-by-80-inch Polaroid, which he describes as

room-size, located at the Museum of Fine Arts in Boston. Among the first portraits are a self-portrait and a picture of Stanley Rosen, a salesman.

After *Mark* (1978–79), which was the last three-color process acrylic painting, Close takes up oil painting with a brush. His first oils are two versions of *Stanley* (small version, p. 149), based on Polaroid photographs he had taken with a 20-by-24-inch camera in 1979. The second, larger version is completed in 1981.

Executes fingerprint lithographs, with Vermillion Editions in Minneapolis. First such print is *Phil/Fingerprint* (p. 78).

September 28–November 16: Major retrospective, with 120 works, organized by Lisa Lyons and Martin Friedman, opens at the Walker Art Center, Minneapolis. The following year show travels to The Saint Louis Art Museum, the Museum of Contemporary Art, Chicago,

and to the Whitney Museum of American Art, New York.

December 30: Mother dies.

### 1981
February: Receives telephone call from a half-brother of whose existence he was unaware. This retired aerospace engineer, Martin Close, is his father's son from a previous marriage.

April 14–June 21: Whitney Museum of American Art is the last stop of his traveling retrospective. To this venue he lends the large, recently completed version of *Stanley*. The show is first reviewed by Hilton Kramer, who revises his earlier disparaging remarks about the artist and praises his development, especially in relation to *Stanley*. He writes, "The marriage of painting and photography that we see in the earlier works in this retrospective have [*sic*] now clearly been dissolved in an amicable divorce."[17] Several other critics join in the celebration of Close's oeuvre.

Among them are John Perreault,[18] Grace Glueck,[19] Kay Larson,[20] Amei Wallach,[21] and Robert Hughes, who writes: "Close has done more to redefine the limits of portraiture than any other painter of his generation."[22]

Begins pulp-paper editioned works with Joseph Wilfer, printer and paper-maker at Dieu Donné Papermill in New York, published by Pace Editions. Keith is the first subject executed in this medium in *Keith I–V* (see p. 75). The last pulp-paper edition is done in 1988.

### 1982

Begins pulp-paper collages on canvas, a series of unique paper pieces that were the result of accidents which occurred when working with pulp-paper editions. A portrait of the artist Jud Nelson, *Jud/Collage* (p. 150), marks the first of the series; *Phyllis/Collage*, a portrait of Phyllis Rosen, Stanley Rosen's wife, of 1983–84, the last.

Akron Art Museum acquires *Linda* (p. 131), a major painting from 1975–76.

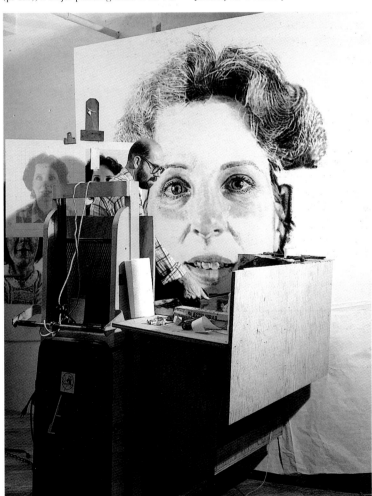

Artist at work c. 1985 on *Leslie/Fingerpainting* (1985–86)

### 1983

Begins fingerprinting in color, the first being *John/Color Fingerprint* (p. 154).

### 1984

January: Moves his residence to an Upper West Side apartment and his studio to 75 Spring Street.

March 24: Birth of his second daughter, Maggie Sarah, who is portrayed the same year in a fingerprint drawing (p. 162).

Begins applying the fingerprint technique to painting. *Georgia/Fingerpainting* is the first work in this technique; *Georgia/Fingerpainting/White Version* (1986) is the last.

Returns to Boston and for the first time uses a 40-by-80-inch Polaroid camera to photograph nudes. These works portray neither friends nor family but mostly professional dancers, the photographer Mark Morrisroe, and others.

### 1985

January 12–February 16: Exhibition

exclusively devoted to his color Polaroid prints made with a 40-by-80-inch camera takes place at Pace/MacGill Gallery, New York.

March 1–30: First exhibition of paintings in a commercial gallery outside of New York is held at the Fuji Television Gallery, Tokyo.

Executes "fingerprint" etchings at Graphicstudio, University of South Florida, Tampa. *Georgia/Fingerprint* etchings are the first.[23]

### 1986

January: Purchases a summer house in Bridgehampton, New York.

*Self-Portrait* (p. 165) is the third oil executed with a brush since the two versions of *Stanley* (1980–81), and the first painting in which a looser application of brushstroke is evident.

October 7–19: In Kyoto, works with the printer Tadashi Toda on woodblock carved by Shunzo Matsuda for Crown Point Press. *Leslie* is the artist's first color woodblock print (p. 158).

### 1987

September: Takes his first photographs of flowers.

*Chuck Close*, the first comprehensive monograph on the artist, by Lisa Lyons and Robert Storr, is published by Rizzoli Publications.

Begins a series of portraits of well-known artists such as Lucas Samaras, Alex Katz, Francesco Clemente, and Cindy Sherman. These will be exhibited the following year at The Pace Gallery.

### 1988

Works with Aldo Crommelynck in New York on spit-bite aquatints of *Self-Portrait* (p. 70) and *Arne* (Glimcher), his dealer.[24]

In September and October has three simultaneous exhibitions at Pace/MacGill Gallery, Pace Editions, and The Pace Gallery.

For the first time in his paintings uses the profile format for the portrait of Cindy Sherman, *Cindy II*. The only other profile he had made was a "fingerprint" drawing of the sculptor Jud Nelson, *Jud/Profile* (1981).

December 7: Six weeks after the closing of his shows, he is stricken with severe chest pain followed by an intense convulsion, which initially leaves him paralyzed from the neck down. He is diagnosed at the Tisch Hospital, at NYU medical center, as suffering from incomplete quadriplegia. Close refers to this episode as *"an event."*

### 1989

After spending six weeks in intensive care at the hospital, he is transferred to the Howard A. Rusk Institute, another part of the NYU medical complex, for rehabilitation. A portrait of Elizabeth Murray, which Close completely abandoned, and *Cindy II* were the last paintings made before his hospitalization. *Alex II* (p. 174) is the first painting he completes at the Institute. He then begins working on *Janet* (Fish), which he finishes in Bridgehampton. He leaves the hospital in July.[25]

### 1990

April 23: Receives the International Center of Photography Sixth Annual Infinity Award for Art for important use of photography in mixed media by a visual artist.

A new portrait of Elizabeth Murray (p. 175), executed in his Spring Street studio in 1989, is acquired by The Museum of Modern Art. This is the first sale after his hospitalization.

### 1991

January 10–March 19: Is curator of "Artist's Choice—Chuck Close: Head-On/The Modern Portrait," an exhibition of 159 portraits drawn mostly from the permanent collection of The Museum of Modern Art, New York. The show travels to the Lannan Foundation, Los Angeles.

April 2–June 30: "1991 Biennial" at the Whitney Museum of American Art. Exhibits *Judy* (Pfaff) (1989–90), *Bill* (William Wegman) (1990), and *April* (Gornik) (p. 183).

April 23: Receives 1991 Skowhegan Medal for Painting from Skowhegan School of Painting and Sculpture, Maine.

May 15: Receives Academy-Institute Award in Art from the American Academy and Institute of Arts and Letters, New York.

October 28: Testifies at Congressional hearing, conducted at the Brooklyn Museum, against stronger anti-obscenity restrictions on the National Endowment for the Arts.

November 2–December 7: First exhibition of twelve recent paintings executed after his illness takes place at The Pace Gallery. All the subjects are New York artists.

November 15: Receives Honorary Doctor of Fine Arts degree from the Art Institute of Boston.

### 1992
March: Moves his studio from Spring Street to the current site, 20 Bond Street, formerly a storefront. Instead of using a forklift as before, Close now installs a trapdoor in his studio that allows him to move his paintings on a motorized track.

May 20: Along with Elizabeth Murray and Martin Puryear is elected a member of the American Academy and Institute of Arts and Letters, New York.

### 1993
May 15: Receives Honorary Doctor of Humane Letters from Skidmore College, Saratoga Springs, N. Y.

June 13–October 10: Lends *Cindy II* to an exhibition organized by Christian Leigh, in collaboration with Pedro Almodóvar, during the "45th Venice Biennale."

Organizes a gallery of portraits, selected from the collection of The Metropolitan Museum of Art, for *Artforum*'s October issue.

Appears in the role of an artist named Andy in the film version of "Six Degrees of Separation," written by John Guare and directed by Fred Schepisi.

### 1994
April 10: A retrospective exhibition of thirty-nine works opens at the Staatliche Kunsthalle in Baden-Baden and travels to Munich. A catalogue is published with texts by Jochen Poetter, Helmut Friedel, Robert Storr, and Margrit Franziska Brehm.

May 22: Receives Honorary Doctor of Fine Arts from Colby College, Waterville, Maine.

### 1995
*Chuck Close: Life and Work, 1988–1995* by the playwright John Guare, the second monograph on the artist, is published by Thames and Hudson.

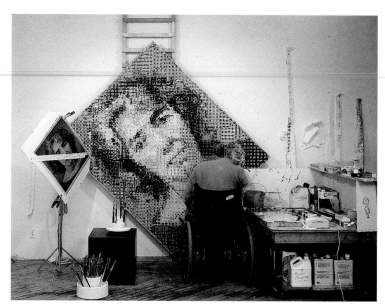

Artist at work on *Elizabeth* after his illness, October 1989

May 27: Receives Honorary Doctor of Fine Arts from the University of Massachusetts, Amherst, where he taught from 1965 to 1967.

June 10–October 15: "Identity and Alterity: Figures of the Body, 1895–1995," organized by Jean Clair, at the "46th Venice Biennale." *Fanny/Fingerpainting* (p. 161), a portrait of Fanny Leifer, and *Alex* (p. 177) are included.

November 5, 1995–February 18, 1996: Exhibits five works at "1995 Carnegie International" at the Carnegie Museum of Art, Pittsburgh.

### 1996
March 15–May 20: Resident artist at the American Academy in Rome.

May 27: Receives Honorary Doctor of Fine Arts from Yale University, New Haven, Connecticut.

Installation view of "Artist's Choice—Chuck Close: Head-On/The Modern Portrait," a show organized by Close at The Museum of Modern Art, New York, 1991

August 23: Photographs President Bill Clinton at the White House (see p. 45).

October 8: "A Salute to Chuck Close," a benefit dinner inaugurating an exhibition, is organized by the Archives of American Art, Smithsonian Institution, New York.

**1997**
February 14–May 11: "Birth of the Cool: American Painters from Georgia O'Keeffe to Christopher Wool," under the curatorship of Bice Curiger, opens in Hamburg and then travels to Zürich. Four paintings, *Bill* (1990), *Joel* (Shapiro) (1993), *Kiki* (Smith) (1993), and *John II* (1993), are included.

May 7–July 27: *Mark* (p. 141) is included in "Age of Modernism: Art in the 20th Century," an exhibition held at the Martin-Gropius-Bau in Berlin and organized by Christos M. Joachimides and Norman Rosenthal.

His photographs of Broadway actors appear in "Assignment: Times Square," *New York Times Magazine*, May 18, 1997.

June 7: Receives 1997 RISD Honorary Doctorate from the Rhode Island School of Design, Providence.

June 12: Receives Alumnus Summa Laude Dignatus, the highest award bestowed by the University of Washington, Seattle.

Chuck Close, Adele Chatfield-Taylor, Director of the American Academy in Rome, Donald Sutherland, Stockard Channing, and, in the back, John Guare, during the filming of "Six Degrees of Separation," New York, 1993

**Notes**
1. The lithograph of 1963 was probably in Lichtenstein's second show at Castelli (September 28–October 24, 1963) and not in the first, which took place in 1962. The amount Close paid for it was corrected from five dollars (as stated in the Judd Tully interview) to ten dollars after he read the present Chronology.
2. On the controversies generated by the exhibition and for the illustration of the painting of Bob Dylan, whose genitals were exposed, see *The Massachusetts Collegian* 95, no. 89 (January 16, 1967).
3. Barbaralee Diamonstein, "Chuck Close: 'I'm Some Kind of a Slow Motion Cornball,'" *ARTnews* 79, no. 6 (summer 1980): 114.
4. These shows were "Realism Now," a 1968 exhibition at Vassar College, and the 1969 "Directions II: Aspects of a New Realism," which opened at the Milwaukee Art Center.
5. Since the Bykert records are lost, it is difficult to pinpoint which works were exhibited in the first solo exhibitions. Reviews, such as one by John Perreault (*Village Voice* 15, no. 11, March 12, 1970, p. 18), mention only the number of works but not their titles. Close believes that *Joe* was included.
6. *Chuck Close: Recent Work*, Los Angeles County Museum of Art, September 21–November 14, 1971, n.p.
7. The critics refer to two works, one of a male, one of a female, without identifying them. The female subject was surely *Susan* because the painting was illustrated in Hilton Kramer's review, "Art Season: A New Realism Emerges," *New York Times*, December 21, 1971, p. 50.
8. Ibid.
9. Hilton Kramer, "Stealing the Modernist Fire," *New York Times*, December 26, 1971, sec. D, p. 25.
10. John Perreault, "A New Turn of the Screw: Drawings by Chuck Close," *Village Voice* 18, no. 44, November 1, 1973, p. 34.
11. Robert Hughes, "An Omnivorous and Literal Dependence," *Arts Magazine* 48, no. 9 (June 1974): 29.
12. In the exhibition catalogue for this show, the painting was erroneously titled *Richard*, which accounts for the inaccuracies in the exhibition reviews.
13. Barbara Cavaliere, "Arts Review: Chuck Close," *Arts Magazine* 52, no. 1 (September 1977): 22.
14. Thomas B. Hess, "Up Close with Richard and Philip and Nancy

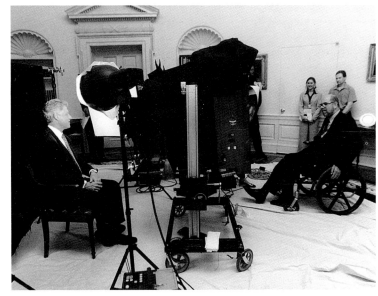

Close photographing President Bill Clinton at The White House, August 23, 1996

and Klaus," *New York* 10, no. 22 (May 30, 1977): 95; and Robert Hughes, "Blowing Up the Closeup," *Time* 109, no. 21 (May 23, 1977): 92. Close noted, *"The Hughes and the Hess reviews were the best I received,"* in Barbara Harshman, "An Interview with Chuck Close," *Arts Magazine* 52, no. 10 (June 1978): 145.
15. Michael Shapiro, "Changing Variables: Chuck Close & His Prints," *Print Collector's Newsletter* 9, no. 3 (July–August 1978): 69.
16. Lisa Lyons and Robert Storr, *Chuck Close* (New York: Rizzoli International Publications, 1987), p. 38.
17. Hilton Kramer, "Chuck Close's Break with Photography," *New York Times*, April 19, 1981, sec. D, p. 32.
18. John Perreault, "Encounters of the Close Kind," *Soho News*, April 29, 1981, p. 45.

19. Grace Glueck, "Artist Chuck Close: 'I Wanted to Make Images That Knock Your Socks Off,'" *New York Times*, June 10, 1981, sec. C, p. 26.
20. Kay Larson, "Art: Chuck Close," *New York* 14, no. 19 (May 1981): 74.
21. Amei Wallach, "Looking Closer at Chuck Close," Part 2. *Newsday*, April 19, 1981, pp. 17–18.
22. Robert Hughes, "Close, Closer, Closest," *Time* 117, no. 17 (April 27, 1981): 60.
23. *Chuck Close Editions: A Catalogue Raisonné and Exhibition* (Youngstown, Ohio: The Butler Institute of American Art, 1989), cat. nos. 38–41.
24. Ibid., cat. no. 52.
25. For an account of Close's illness, see John Guare, *Chuck Close: Life and Work, 1988–1995* (New York: Thames and Hudson, 1995).

Artist in 1994 holding a brush in front of *John II* (1993)

# BIBLIOGRAPHY

## Interviews and Artist's Statements

**1970**

Nemser, Cindy. "An Interview with Chuck Close." *Artforum* 8, no. 5 (January 1970): 51–55.

**1972**

Chase, Linda, and Ted McBurnett. "The Photo Realists: 12 Interviews." *Art in America* 60, no. 6 (November–December 1972): 76–77.

Kurtz, Bruce. "Documenta 6: A Critical Preview." *Arts Magazine* 46, no. 8 (summer 1972): 41.

**1975**

Henry, Gerrit. "The Artist and The Face: A Modern American Sampling." *Art in America* 63, no. 1 (January–February 1975): 41.

**1976**

"The Art of Portraiture in the Words of Four New York Artists." *New York Times*, October 31, 1976, sec. D, p. 29.

**1977**

Glueck, Grace. "The 20th Century Artists Most Admired By Other Artists." *ARTnews* 76, no. 9 (November 1977): 78–103.

**1978**

Harshman, Barbara. "An Interview with Chuck Close." *Arts Magazine* 52, no. 10 (June 1978): 142–45.

Shapiro, Michael. "Changing Variables: Chuck Close & His Prints." *Print Collector's Newsletter* 9, no. 3 (July–August 1978): 69–73.

**1979**

Diamonstein, Barbaralee. "Chuck Close." In *Inside New York's Art World*, pp. 68–80. New York: Rizzoli International Publications, 1979.

"Kinds of Realism." *Allan Frumkin Gallery Newsletter*, no. 7 (winter 1979): 1–8.

**1981**

Close, Chuck. "Excellence: The Pursuit, The Commitment, The Achievement." Dallas, Texas: The LTV Corporation, 1981.

**1982**

DeLoach, Douglass. "Up Close: An Interview with Chuck Close." *Art Papers* 6, no. 2 (March–April 1982): 2–3.

**1983**

Cottingham, Jane. "An Interview with Chuck Close." *American Artist* 47, no. 490 (May 1983): 62–67, 102–05.

**1984**

[Sandback, Amy, and Ingrid Sischy]. "A Progression by Chuck Close: Who's Afraid of Photography?" *Artforum* 22, no. 9 (May 1984): 54–55.

**1986**

Close, Chuck. "New York in the Eighties: A Symposium." *New Criterion*, special issue (summer 1986): 12–14.

"Dialogue: Arnold Glimcher with Chuck Close." In *Chuck Close: Recent Work*, n. p. New York: The Pace Gallery, 1986.

**1987**

Close, Chuck. "New York Studio Events." *Independent Curators Incorporated Newsletter* 2, no. 3 (fall 1987): 2.

Smecchia, Muni de. "Artisti nel loro studio: Chuck Close." *Vogue Italia*, no. 446 (April 1987): 144–47, 201, 204.

Tully, Judd. Unpublished interview with Chuck Close, May 14, 27; June 5; September 30, 1987. Archives of American Art, Smithsonian Institution, New York.

**1990**

Close, Chuck. "Transcending Prejudice; An Inside Look at Peer Review." *Vantage Point* (spring 1990): 14–15; reprinted in *The Grantsmanship Center Whole Nonprofit Catalog* (fall–winter 1990): 29.

**1991**

*Artist's Choice—Chuck Close: Head On / The Modern Portrait*. New York: The Museum of Modern Art, 1991. Foreword by Kirk Varnedoe and Artist's Statement by Chuck Close.

"Interview with Chuck Close: Access for Artists with Disabilities." *FYI* 7, no. 1 (spring 1991): 1.

"Statement of Chuck Close, Painter." In *Effect of Last Year's NEA Reauthorization Process. Hearing before the Government Activities and Transportation Subcommittee of the Commission on Government Operations, House of Representatives, One Hundred Second Congress, October 28, 1991*, pp. 9–12. Washington, D.C.: U. S. Government Printing Office, 1993.

Watson, Simon. "A Conversation Between Simon Watson, Dennis Kardon, and Chuck Close." *Balcon* (Madrid), 1991, pp. 156–60.

**1992**

Close, Chuck. "Artist Pages: *Janet*." *American Art* 6, no. 2 (spring 1992): 58–59.

————. "Chuck Close: *Self-Portrait, Composite, Sixteen Parts, 1987*." *Aperture*, no. 129 (fall 1992): 24–25.

Götz, Stephan. "Chuck Close." In *American Artists In Their New York Studios: Conversations about the Creation of Contemporary Art*, pp. 35–37. Cambridge, Massachusetts: Center for Conservation and Technical Studies, Harvard University Art Museums, and Stuttgart: Daco-Verlag Günter Bläse, 1992.

**1993**

Close, Chuck. "He Called Me Chuck." *Artforum* 32, no. 1 (September 1993): 122–23.

Smith, Jean Kennedy, and George Plimpton. "Chuck Close." In *Chronicles of Courage*, pp. 14–28. New York: Random House, 1993.

Van Wyck, Bronson. "Interview: Chuck Close." *Yale Literary Magazine* 5, nos. 2–3 (autumn–spring 1993–94): 44–49.

**1994**

Close, Chuck. "Interview with Kiki Smith." *Bomb*, no. 49 (fall 1994): 38–45.

Diamonstein, Barbaralee. "Chuck Close." In *Inside the Art World: Conversations with Barbaralee Diamonstein*, pp. 46–52. New York: Rizzoli, 1994.

Gardner, Paul. "Light, Canvas, Action: When Artists Go to the Movies." *ARTnews* 93, no. 10 (December 1994): 129.

**1995**

Close, Chuck. "Golf War," in "Returned to Sender, Remembering Ray Johnson." *Artforum* 33, no. 8 (April 1995): 73, 111.

Dellinger, Jade R. "Chuck Close." *Printmaking Today* 4, no. 1 (spring 1995): 13–14.

"A Tribute to Ray Johnson." *Coagula Art Journal*, no. 18 (1995): 34–36.

**1996**

"Telephone Interview with Chuck Close: January 8, 1996." In *Fractured Fairy Tales: Art in the Age of Categorical Disintegration*, pp. 81–84. Exhibition catalogue. Durham, North Carolina: Duke University Museum, April 12–May 25, 1996.

"Vija Celmins Interviewed by Chuck Close, 1992." In *Between Artists: Twelve Contemporary American Artists Interview Twelve Contemporary American Artists*, pp. 17–44. Los Angeles: A.R.T. Press, 1996. Introduction by Dave Hickey.

**1997**

Temkin, Ann, intro. *Chuck Close / Paul Cadmus: In Dialogue*. Philadelphia: Philadelphia Museum of Art, 1997.

**1998**

Bartmann, William, ed. *Chuck Close: Conversations in the Studio*. To be published in January 1998.

## Articles and Reviews

**1969**

Nemser, Cindy. "Reviews in the Galleries." *Arts Magazine* 43, no. 8 (summer 1969): 58.

Wasserman, Emily. "Group Show/Bykert Gallery." *Art Forum* 8, no. 1 (September 1969): 69.

**1970**

Davis, Douglas. "Art: Return of the Real." *Newsweek* 75, no. 8 (February 23, 1970): 105.

Marandel, J. Patrice. "New York." *Art International* 14, no. 5 (May 20, 1970): 86.

Nemser, Cindy. "Presenting Charles Close." *Art in America* 58, no. 1 (January–February 1970): 98–101.

Perreault, John. "Art: Get Back." *Village Voice* 15, no. 8, February 19, 1970, pp. 14–15, 17.

————. "Dining In." *Village Voice* 15, no. 11, March 12, 1970, pp. 16, 18.

Ratcliff, Carter. "New York" (review of "22 Realists" exhibition at the Whitney Museum). *Art International* 14, no. 4 (April 1970): 67–71.

Spear, Athena. "Reflections on Close, Cooper and Jenny: 'Three Young Americans at Oberlin.'" *Arts Magazine* 44, no. 7 (May 1970): 44–47.

**1971**

Kramer, Hilton. "Art Season: A New Realism Emerges." *New York Times*, December 21, 1971, p. 50.

————. "Stealing the Modernist Fire." *New York Times*, December 26, 1971, sec. D, p. 25.

Seldis, Henry J. "Art Review: Chuck Close Work Shown." *Los Angeles Times*, October 4, 1971, sec. 4, p. 4.

Szeemann, Harald. "Documenta 5: Entretien avec Harald Szeemann." *L'Art vivant*, no. 25 (November 1971): 4–7.

**1972**

Ammann, Jean-Christophe. "Realismus." *Flash Art*, nos. 32–34 (May–July 1972): 50-52.

Davis, Douglas. "Nosing Out Reality." *Newsweek* 80, no. 7 (August 14, 1972): 58.

Dyckes, William. "A One-Print Show by Chuck Close at MoMA." *Arts Magazine* 47, no. 3 (December 1972/ January 1973): 73.

Elderfield, John. "The Whitney Annual." *Art in America* 60, no. 3 (May–June 1972): 27–29.

Hahn, Otto. "La nouvelle coqueluche: L'hyperréalisme." *L'Express*, no. 1112, October 30–November 5, 1972, p. 102.

Hughes, Robert. "The Realist as Corn God." *Time* 99, no. 5 (January 31, 1972): 50–55.

Nakov, Andrei B. "Sharp Focus Realism: Le retour de l'image." *XX Siècle* 37, no. 38 (June 1972): 166–68.

Nemser, Cindy. "The Close Up Vision—Representational Art—Part II." *Arts Magazine* 46, no. 7 (May 1972): 44–48.

Pozzi, Lucio. "I Super Realisti USA." *Bolaffi Arte* 3, no. 18 (March 1972): 54–61.

Rose, Barbara. "Real, Realer, Realist." *New York* 5, no. 5 (January 31, 1972): 50.

Seitz, William C. "The Real and the Artificial: Painting of the New Environment." *Art in America* 60, no. 6 (November/December 1972): 58–72.

**1973**

Brunelle, Al. "Reviews: Chuck Close at MoMA." *ARTnews* 72, no. 4 (April 1973): 73.

Canaday, John. "Art: Chuck Close [Bykert]." *New York Times*, October 27, 1973, p. 27.

Davis, Douglas. "Art Without Limits." *Newsweek* 82, no. 26 (December 24, 1973): 68–74.

Levin, Kim. "The Newest Realism: A Synthetic Slice of Life." *Opus International*, nos. 44–45 (June 1973): 28–37.

Mellow, James. R. "Largest Mezzotint by Close Shown." *New York Times*, January 13, 1973, p. 25.

Melville, Robert. "The Photograph as Subject." *Architectural Review* 153, no. 915 (May 1973): 329–33.

Nochlin, Linda. "The Realist Criminal and the Abstract Law." Part 1. *Art in America* 61, no. 5 (September–October 1973): 54-61. Part 2. no. 6 (November–December 1973): 96–103.

Perreault, John. "A New Turn of the Screw: Drawings by Chuck Close." *Village Voice* 18, no. 44, November 1, 1973, p. 34.

Restany, Pierre. "Sharp Focus: La Continuité réaliste d'une vision Américaine." *Domus*, no. 525 (August 1973): 9–13.

Stitelman, Paul. "New York Galleries: Chuck Close [at] Bykert." *Arts Magazine* 48, no. 3 (December 1973): 60.

**1974**

Coleman, A. D. "From Today Painting is Dead." *Camera 35*, 18, no. 5 (July 1974): 34, 36–37, 78.

Dyckes, William. "The Photo as Subject: The Paintings and Drawings of Chuck Close." *Arts Magazine* 48, no. 5 (February 1974): 28–33. Reprinted in Battcock, Gregory, ed., *Super Realism: A Critical Anthology.* New York, 1975.

Hughes, Robert. "An Omnivorous and Literal Dependence." *Arts Magazine* 48, no. 9 (June 1974): 25–29.

**1975**

Bourdon, David. "American Painting Regains Its Vital Signs." *Village Voice* 20, no. 11, March 17, 1975, p. 88.

deAk, Edit. "Photographic Realism." *Art-Rite/Painting*, no. 9 (spring 1975): 14–15.

Derfner, Phyllis. "New York: Chuck Close." *Art International* 19, no. 6 (June 15, 1975): 67.

Henry, Gerrit. "Artist and the Face: A Modern American Sampling." *Art in America* 63, no. 1 (January–February 1975): 34–41.

Kramer, Hilton. "Art: Chuck Close [Bykert]." *New York Times*, April 26, 1975, p. 19.

Wallach, Amei. "Portrait Painting is Alive and Well." Part 2. *Newsday*, January 26, 1975, pp. 16–17.

Zimmer, William. "Art Reviews: Chuck Close [Bykert]." *Arts Magazine* 49, no. 10 (June 1975): 8.

**1976**

Chase, Linda. "Photo-Realism: Post-Modernist Illusionism." *Art International* 20, nos. 3–4 (March–April 1976): 14–27.

Kramer, Hilton. "Art: The Fascination of Portraits." *New York Times*, October 22, 1976, sec. C, p. 15.

**1977**

Bourdon, David. "Time Means Nothing to a Realist." *Village Voice* 22, no. 20, May 16, 1977, p. 75.

Cavaliere, Barbara. "Art Reviews: Chuck Close." *Arts Magazine* 52, no. 1 (September 1977): 22.

Ffrench-Frazier, Nina. "New York Reviews: Chuck Close." *ARTnews* 76, no. 8 (October 1977): 130.

Hess, Thomas B. "Up Close with Richard and Philip and Nancy and Klaus." *New York* 10, no. 22 (May 30, 1977): 95–97.

Hughes, Robert. "Blowing Up the Closeup." *Time* 109, no. 21 (May 23, 1977): 92.

Russell, John. "Art: Big Heads By Chuck Close." *New York Times*, May 6, 1977, sec. C, p. 19.

Stevens, Mark. "Close Up Close." *Newsweek* 89, no. 21 (May 23, 1977): 68.

**1978**

Levin, Kim. "Chuck Close: Decoding the Image." *Arts Magazine* 52, no. 10 (June 1978): 146–49. Reprinted in *Chuck Close: Recent Work*, exhibition catalogue, The Pace Gallery, New York, October 26–November 24, 1979, and in *Copie Conforme?* exhibition catalogue, Centre Georges Pompidou, Musée National d'Art Moderne, Paris, April 18–June 11, 1979.

Ratcliff, Carter. "Making it in the Art World: A Climber's Guide." *New York* 2, no. 48 (November 27, 1978): 61–67.

**1979**

Close, Chuck. "Phil: Six Images." *The Paris Review* 21, no. 75 (spring 1979): 107–14.

Harshman, Barbara. "Grids." *Arts Magazine* 53, no. 6 (February 1979): 4.

Kramer, Hilton. "Chuck Close—In Flight from the Realist Impulse." *New York Times*, November 4, 1979, pp. 33, 36.

Perreault, John. "Post-Photorealism." *Soho Weekly News*, November 22, 1979, p. 19.

Schmidt, Doris. "Malerei—wie gedruckt. Zur ersten europäischen Ausstellung von Chuck Close im Kunstraum München." *Süddeutsche Zeitung*, no. 157, July 11, 1979.

**1980**

Cavaliere, Barbara. "Art Reviews: Chuck Close" (review of Pace Gallery exhibition, October 26–November 24, 1979). *Arts Magazine* 54, no. 6 (February 1980): 33.

Diamonstein, Barbaralee. "Chuck Close: 'I'm Some Kind of a Slow Motion Cornball.'" *ARTnews* 79, no. 6 (summer 1980): 112–16.

Kertess, Klaus. "Figuring It Out." *Artforum* 119, no. 3 (November 1980): 30–35.

Simon, Joan. "Close Encounters." *Art In America* 68, no. 2 (February 1980): 81–83.

**1981**

Appelo, Tim. "Too Close for Comfort." *Pacific Northwest* 15, no. 9 (December 1981): 32–34.

Artner, Alan G. "Close Encounters at the MCA: No Longer Radical or Realistic." *Chicago Tribune*, February 15, 1981, sec. 6, p. 13.

Bourdon, David. "Art. Chuck Close: Portraits. The Saint Louis Art Museum." *Vogue* 171, no. 1 (January 1981): 27, 30.

Casademont, Joan. "'Close Portraits' Whitney Museum of American Art." *Artforum* 20, no. 2 (October 1981): 74

Glueck, Grace. "Artist Chuck Close: 'I Wanted to Make Images That Knock Your Socks Off!'" *New York Times*, June 10, 1981, sec. C, p. 26.

Hughes, Robert. "Close, Closer, Closest." *Time* 117, no. 17 (April 27, 1981): 60.

Kramer, Hilton. "Portraiture: The Living Art." *Bazaar*, no. 3232 (March 1981): 14, 26, 28.

_____ . "Chuck Close's Break with Photography." *New York Times*, April 19, 1981, sec. D, pp. 29, 32.

Larson, Kay. "Art: Chuck Close." *New York* 14, no. 19 (May 11, 1981): 74–75.

_____ . "Dead End Realism." *New York* 14, no. 42 (October 26, 1981): 94–95.

Levin, Kim, and Fred W. McDarrah. "Close-Ups." *Village Voice* 26, no. 17, April 22–28, 1981, pp. 64–65.

Perreault, John. "Encounters of the Close Kind." *Soho News*, April 29, 1981, p. 45.

Schjeldahl, Peter. "Realism on the Comeback Trail." *Village Voice* 26, no. 46, November 11–17, 1981, p. 77.

Wallach, Amei. "Looking Closer at Chuck Close." Part 2. *Newsday*, April 19, 1981, pp. 17–18.

Wilson, William. "The Chilly Charms of Close." Part 6. *Los Angeles Times*, June 8, 1981, pp. 1, 5.

**1982**
Ackerman, Jennifer. "Aggressive Image, Painterly Gestures: Looking at Some Close-Ups." *Yale Alumni Magazine and Journal* 45, no. 8 (May 1982): 42–45.

**1983**
Baker, Kenneth. "Leaving His Finger-prints." *Christian Science Monitor*, August 12, 1983, p. 20.

Danoff, I. Michael. "Chuck Close's Linda." *Arts Magazine* 57, no. 5 (January 1983): 110–11.

Larson, Kay. "Art: Chuck Close [Pace]." *New York* 16, no. 12 (March 21, 1983): 59–60.

Moritz, Charles, ed. "Chuck Close." In *Current Biography* 44, no. 7 (July 1983), pp. 9–12.

Raynor, Vivien. "Art: Chuck Close With Friends as Models." *New York Times*, March 4, 1983, sec. C, p. 24.

**1985**
Grundberg, Andy. "Chuck Close at Pace/MacGill." *Art in America* 73, no. 5 (May 1985): 174–75.

Hagen, Charles. "Chuck Close, Pace/ MacGill." *Artforum* 23, no. 8 (April 1985): 96–97.

**1986**
Close, Chuck. "New York in the Eighties: A Symposium." *New Criterion*, special issue (summer 1986): 12–14.

Grundberg, Andy. "A Big Show That's About Something Larger Than Size." *New York Times*, February 23, 1986, p. 35.

Poirier, Maurice. "Chuck Close, Pace." *ARTnews* 85, no. 5 (May 1986): 127.

Raynor, Vivien. "Chuck Close at Pace." *New York Times*, February 28, 1986, sec. C, p. 21.

**1987**
Johnson, Ken. "Photographs by Chuck Close." *Arts Magazine* 61, no. 9 (May 1987): 20–23.

Pradel, Jean-Louis. "Jean-Olivier Hucleux, Chuck Close: Les réalités improbables." *Art Press*, no. 120 (December 1987): 34–37.

Steiner, Wendy. "Postmodernist Portraits." *Art Journal* 46, no. 3 (fall 1987): 173–77.

**1988**
Grundberg, Andy. "Blurring the Lines-Dots?—Between Camera and Brush." *New York Times*, October 16, 1988, p. 35.

Kimmelman, Michael. "Chuck Close [at] Pace Gallery." *New York Times*, October 7, 1988, sec. C, p. 30.

Lewis, Jo Ann. "Chuck Close's True Grid." *Washington Post*, November 5, 1988, sec. C, p. 2.

Lyon, Christopher. "Chuck Close [at] Pace [and] Pace/MacGill." *ARTnews* 87, no. 10 (December 1988): 143, 145.

**1989**
Nesbitt, Lois. "Chuck Close [at] Pace Gallery [and] Pace Prints." *Artforum* 27, no. 5 (January 1989): 110.

Westfall, Stephen. "Chuck Close." *Flash Art*, no. 144 (January–February 1989): 119.

**1990**
Speiser, Irene. "Gesprach mit Chuck Close: Eine Welt intimer Einzelheiten." *Photographie*, no. 9 (September 1990): 50–52.

**1991**
Johnson, Ken. "Chuck Close at MoMA." *Art in America* 79, no. 5 (May 1991): 167–68.

Kimmelman, Michael. "Chuck Close Browses and Assembles an Exhibition." *New York Times*, January 18, 1991, sec. C, p. 32.

Knight, Christopher. "Face to Face With Faces in 'Head-On.'" *Los Angeles Times*, June 26, 1991, sec. F, pp. 1, 5.

Larson, Kay. "Close Encounter." *New York* 24, no. 47 (December 2, 1991): 148–49.

Newhall, Edith. "Close to the Edge." *New York* 24, no. 15 (April 15, 1991): 38–46.

Schjeldahl, Peter. "Those Eyes…Head On/The Modern Portrait." *Village Voice*, February 5, 1991, p. 85.

Smith, Roberta. "In Portraits on a Grand Scale, Chuck Close Moves On." *New York Times*, November 8, 1991, sec. C, p. 24.

Wallach, Amei. "Close Encounters at MoMA." Part 2. *Newsday*, January 27, 1991, p. 17.

———. "The Will To Paint." Part 2. *New York Newsday*, April 21, 1991, pp. 4–5, 18.

———. "How Can You Tell A Franz Gertsch From A Chuck Close?" *Parkett*, no. 28 (June 1991): 44–46.

Wise, Kelly. "Vibrant Selection of Close's Work." *Boston Globe*, December 4, 1991, p. 46.

**1992**
Ament, Deloris Tarzan. "He Lost his Hands, but not his Art." *Seattle Times/ Seattle Post-Intelligencer*, October 4, 1992, sec. L, p. 8.

"Artist Pages. Chuck Close: Janet." *American Art* 6, no. 2 (spring 1992): 58–59.

Auping, Michael. "Chuck Close: The Ironies of *Janet*," Albright-Knox Art Gallery, December calendar, 1992, pp. 1, 3.

Decter, Joshua. "New York in Review." *Arts Magazine* 66, no. 6 (February 1992): 78–79.

Gardner, Paul. "'Making the Impossible Possible.'" *ARTnews* 91, no. 5 (May 1992): 94–99.

Gopnik, Adam. "The Art World: Close-Up." *New Yorker* 68, no. 1 (February 24, 1992): 76–78.

Princenthal, Nancy. "Chuck Close at Pace." *Art in America* 80, no. 3 (March 1992): 114–15.

**1993**
Close, Chuck. "Face to Face: Portraits from the Collection of the Metropolitan Museum of Art," a project for *Artforum*. Text by Michael Auping. *Artforum* 32, no. 2 (October 1993): 66–71.

Danto, Arthur C. "Close Quarters." *Elle Decor* 4, no. 1 (February–March 1993): 98–107.

De Ferrari, Gabriella. "Close Encountered." *Mirabella* 5, no. 54 (November 1993): 78–80.

Glueck, Grace. "Habit-Forming Close-ups; Playpen-Style Post-Structuralism." *New York Observer*, November 22, 1993, p. 24.

Kimmelman, Michael. "Art in Review: Chuck Close." *New York Times*, November 5, 1993, sec. C, p. 31.

Malcolm, Daniel R. "Print Project by Chuck Close." *Print Collector's Newsletter* 24 (November–December 1993): 178.

Tanaka, Hiroko. "Chuck Close: An Artist of Wonder." *Asahi Shimbun Weekly AERA* (Japan), December 20, 1993, p. 46.

Wallach, Amei. "Close Builds to a Dazzling Solution." Part 2. *New York Newsday*, October 29, 1993, p. 87.

**1994**
Breyer, Heinrich. "Folgenreiche Kleinodien, Mittelalterliche Buch-malerei aus dem Kloster Seeon." *Feuilleton*, no. 160 (July 14, 1994): 12.

Gookin, Kirby. "Reviews: Chuck Close." *Artforum* 32, no. 7 (March 1994): 84–85.

Holert, Tom. "Malerei die Porträt-maschine—Vom Fotorealismus zu leuch-tenden Farbfeldern: Chuck Close." *Vogue* (Germany), no. 4 (April 1994): 108, 110.

Lingemann, Susanne. "Chuck Close: Porträts sind seine Romane." *Art* (Hamburg), no. 4 (April 1994): 54–63.

Meinhardt, Johannes. "Chuck Close." *Kunstforum International*, no. 127 (July–September 1994): 328–29.

Rosenblatt, Roger. "A Painter in a Wheelchair." *Men's Journal* 3, no. 2 (March 1994): 23–24.

Sonna, Birgit. "Chuck Close: Oszillation des Realen." *Kritik*, no. 3 (March 1994): 42–47.

Stein, Deidre. "Chuck Close: 'It's Always Nice to Have Resistance.'" *ARTnews* 93, no. 1 (January 1994): 95–96.

———. "Reviews: Chuck Close—Pace." *ARTnews* 93, no. 2 (February 1994): 135–36.

**1995**
Greene, David A. "Chuck Close at Pace Wildenstein." *Art Issues*, no. 40 (November–December 1995): 43.

Guare, John. "Close Encounters of an Incredible Kind." *Interview* 25, no. 11 (November 1995): 80–83.

Halle, Howard. "Close to You." *Time Out New York*, no. 12 (December 13–20, 1995): 22.

Kimmelman, Michael. "Art in Review: Chuck Close's Big Change." *New York Times*, December 8, 1995, sec. C, p. 28.

Landi, Ann. "The 50 Most Powerful People in the Art World." *ARTnews*, special issue (July 1995): 52–62.

Pagel, David. "Chuck Close at PaceWildenstein." *Art & Auction* 18, no. 2 (September 1995): 64, 66.

Yuskavage, Lisa. "Chuck Close." *Bomb*, no. 52 (summer 1995): 30–35.

**1996**
Angell, Roger. "Life Work." *New Yorker* 71, no. 44 (January 15, 1996): 48–49.

Artner, Alan G. "Work Ethic: Linking Chuck Close and Tom Friedman on the Basis of Effort." *Chicago Tribune*, May 3, 1996, sec. 7, p. 58.

Blair, Dike. "Chuck Close at PaceWildenstein." *Flash Art*, no. 187 (March–April 1996): 111.

Bloom, Amy. "A Face in the Crowd." *Vogue* 186, no. 12 (December 1996): 293–97.

Grabner, Michelle. "Chuck Close and Tom Friedman." *Frieze*, no. 30 (September–October 1996): 76–77.

Grynsztejn, Madeleine. "Affinities: Chuck Close and Tom Friedman." *Art Institute of Chicago Members' Magazine* (March–April 1996): 13–14.

Halle, Howard. "Chuck Close, 'Large-Scale Photographs.'" *Time Out New York*, no. 60 (November 14–21, 1996): 46.

Katz, Vincent. "Review of 'Chuck Close: Life and Work, 1988–1995' by John Guare." *Print Collector's Newsletter* 27, no. 2 (May–June 1996): 71.

"MoMA Gets Close." *ARTnews* 95, no. 3 (March 1996): 35.

Muchnic, Suzanne. "Chuck Close at PaceWildenstein, Beverly Hills." *ARTnews* 95, no. 1 (January 1996): 130–31.

Schjeldahl, Peter. "At Close Quarters." *Village Voice*, January 9, 1996, p. 67.

Tully, Judd. "To MoMA from Met." *Art & Auction* 18, no. 8 (March 1996): 25–26.

Vogel, Carol. "Chuck Close to Get a Show at the Modern." *New York Times*, January 31, 1996, sec. C, p. 11.

Wallis, Stephen. "Close to Home." *Art & Antiques* 19, no. 1 (January 1996): 80–81.

Wilk, Deborah. "Chuck Close, Tom Friedman." *New Art Examiner* 24, no. 1 (September 1996): 37–38.

**1997**
"Assignment: Times Square/A Special Photography Issue, REAL: Chuck Close Never out of Character." *New York Times Magazine*, May 18, 1997, pp. 81–85.

Decker, Andrew. "Conjuring Consensus." *ARTnews*: special issue titled "The Cutting Edge" (January 1997): 58–59, 64.

Kimmelman, Michael. "At the Met with Chuck Close: Sought or Imposed, Limits Can Take Flight." *New York Times*, July 25, 1997, sec. C, pp. 1, 23.

Landi, Ann. "The 50 Most Powerful People in the Art World." *ARTnews* 96, no. 1 (January 1997): 90–97.

MacAdam, Barbara A. "Vasari Diary: Close to Bill." *ARTnews* 96, no. 1 (January 1997): 29.

## Monographs and Exhibition Catalogues

**1971**
*Chuck Close: Recent Work*. Los Angeles: Los Angeles County Museum of Art, 1971. Text by Gail R. Scott

**1972**
*Chuck Close*. Chicago: Museum of Contemporary Art, 1972. Text by Dennis Adrian.

**1975**
*Chuck Close: Dot Drawings, 1973–1975*. Austin, Texas: Laguna Gloria Art Museum, 1975. Text by Christopher Finch.

**1977**
*Chuck Close: Recent Work*. New York: The Pace Gallery, 1977.

**1979**
*Chuck Close*. Munich: Kunstraum München, 1979. Text by Hermann Kern.

*Chuck Close: Recent Work*. New York: The Pace Gallery, 1979. Text by Kim Levin; reprint from *Arts Magazine*, June 1978.

Close, Chuck. *Keith/Six Drawings/1979*. New York: Lapp Princess Press, 1979.

**1980**
*Close Portraits*. Minneapolis: Walker Art Center, 1980. Texts by Martin Friedman and Lisa Lyons.

**1983**
*Chuck Close*. New York: The Pace Gallery, 1983. Text by John Perreault.

**1984**
*Chuck Close: Handmade Paper Editions*. Los Angeles: Herbert Palmer Gallery, 1984. Text by Richard H. Solomon.

**1985**
*Chuck Close: Works on Paper*. Houston: Contemporary Arts Museum, 1985. Text by Edmund P. Pillsbury.

*Exhibition of Chuck Close*. Tokyo: Fuji Television Gallery, 1985. Text by Lisa Lyons.

**1987**
*Chuck Close: Drawings 1974–1986*. New York: The Pace Gallery, 1987.

Lyons, Lisa, and Robert Storr. *Chuck Close*. New York: Rizzoli International Publications, 1987.

**1988**
*Chuck Close, New Paintings*. New York: The Pace Gallery, 1988. Text by Klaus Kertess.

**1989**
*Chuck Close*. Chicago: The Art Institute of Chicago in collaboration with The Friends of Photography, San Francisco. Chicago: The Art Institute of Chicago, 1989. Text by Colin Westerbeck.

*Chuck Close Editions: A Catalogue Raisonné and Exhibition*. Youngstown, Ohio: The Butler Institute of American Art, 1989. Introduction by Louis A. Zona and essay by Jim Pernotto.

**1991**
*Chuck Close: Recent Paintings*. New York: The Pace Gallery, 1991. Text by Peter Schjeldahl.

*Chuck Close: Up Close*. East Hampton, New York: Guild Hall of East Hampton, 1991. Foreword by Joy L. Gordon. Text by Colin Westerbeck.

**1993**
*Chuck Close: Recent Paintings*. New York: The Pace Gallery, 1993. Text by Arthur C. Danto.

**1994**
*Chuck Close: 8 peintures récentes*. Paris: Fondation Cartier pour l'Art Contemporain, 1994.

*Chuck Close: Retrospektive*. Baden-Baden: Staatliche Kunsthalle, and Stuttgart: Edition Cantz, 1994. Texts by Jochen Poetter, Helmut Friedel, Robert Storr, and Margrit Franziska Brehm.

**1995**
*Chuck Close: Recent Paintings*. [Beverly Hills and New York]: PaceWildenstein, 1995. Text by John Yau.

Guare, John. *Chuck Close: Life and Work, 1988–1995*. New York: Thames and Hudson in association with Yarrow Press, 1995.

**1996**
*Affinities: Chuck Close and Tom Friedman*. Chicago: The Art Institute of Chicago, 1996. Text by Madeleine Grynsztejn.

# EXHIBITION HISTORY

An asterisk (*) indicates that the exhibition had a catalogue.

## Solo Exhibitions

### 1967
Amherst, University of Massachusetts, Art Gallery. "Charles Close," January 8–February 1.

### 1970
New York, Bykert Gallery. "Chuck Close," February 28–March 28.

### 1971
*Los Angeles, Los Angeles County Museum of Art. "Chuck Close: Recent Work," September 21–November 14.

New York, Bykert Gallery. "Chuck Close: Recent Work," December 4, 1971–January 5, 1972.

### 1972
*Chicago, Museum of Contemporary Art. "Chuck Close," February 5–March 19.

### 1973
New York, The Museum of Modern Art. "Projects: Chuck Close/Liliana Porter," January 13–February 28.

Akron, Ohio, Akron Art Museum. "Chuck Close: Collector's Exhibition," March 31–May 6.

New York, Bykert Gallery. "Chuck Close: Recent Work," October 20–November 15.

### 1975
Charlotte, North Carolina, Mint Museum of Art. "Chuck Close: Keith," January 5–February 2. Traveled under different exhibition titles to the Ball State University Art Gallery, Muncie, Indiana, dates unconfirmed; Phoenix Art Museum, Phoenix, Arizona, June 1–29; The Minneapolis Institute of Arts, Minneapolis, July 18–August 31.

New York, Bykert Gallery. "Chuck Close," April 5–24.

*Austin, Texas, Laguna Gloria Art Museum. "Chuck Close: Dot Drawings, 1973–1975," June 17–July 20. Traveled to the Texas Gallery, Houston, July 22–August 16; Art Museum of South Texas, Corpus Christi, August 19–September 20; San Francisco Museum of Modern Art, San Francisco,

December 10, 1975–January 25, 1976; The Contemporary Arts Center, Cincinnati, Ohio, February 22–March 5, 1976.

Portland, Oregon, The Portland Center for the Visual Arts. "Chuck Close: Drawings and Paintings," September 26–October 26.

### 1976
Baltimore, Baltimore Museum of Art. "Chuck Close," April 6–May 30.

### 1977
*New York, The Pace Gallery. "Chuck Close: Recent Work," April 30–June 4.

Hartford, Wadsworth Atheneum. "Chuck Close, Matrix 35," November 1, 1977–January 29, 1978.

### 1979
Cambridge, Massachusetts, Hayden Gallery. "Focusing on Faces," January 17–20.

*Munich, Kunstraum München. "Chuck Close," June 28–July 21.

*New York, The Pace Gallery. "Chuck Close: Recent Work," October 26–November 24.

### 1980
*Minneapolis, Walker Art Center. "Close Portraits," September 28–November 16, 1980. Traveled to The Saint Louis Art Museum, Saint Louis, December 5, 1980–January 25, 1981; Museum of Contemporary Art, Chicago, February 6–March 29, 1981; Whitney Museum of American Art, New York, April 14–June 21, 1981.

### 1982
Berkeley, University Art Museum. "Chuck Close: Matrix/Berkeley 50," March 3–May 5.

Riverside, California Museum of Photography, University of California. "Chuck Close: Polaroid Portraits," May 14–July 31.

Chicago, Richard Gray Gallery. "Chuck Close: Paperworks," September–October 1982. Traveled to John Stoller Gallery, Minneapolis, October–November 1982; Jacksonville Art Museum, Jacksonville, Florida, December 10, 1982–January 19, 1983; Greenberg Gallery, Saint Louis, September–October 1983.

### 1983
*New York, The Pace Gallery. "Chuck Close," February 25–March 26.

### 1984
*Los Angeles, Herbert Palmer Gallery. "Chuck Close: Handmade Paper Editions," February 4–March 16. Traveled to Spokane Center of Art, Cheney, Washington, April 5–May 12; Milwaukee Art Museum, Milwaukee, June 1–September 30; Columbia Museum of Art, Columbia, South Carolina, November 18, 1984–January 13, 1985.

### 1985
New York, Pace/MacGill Gallery. "Chuck Close: Photographs," January 12–February 16.

*Houston, Contemporary Arts Museum. "Chuck Close: Works on Paper," February 9–April 21.

*Tokyo, Fuji Television Gallery. "Exhibition of Chuck Close," March 1–30.

San Francisco, Fraenkel Gallery. "Chuck Close: Large Scale Photographs," June 26–July 27.

### 1986
New York, Pace/MacGill Gallery. "Chuck Close: Maquettes," January 9–February 15.

New York, Pace Editions. "Chuck Close: New Etchings," February 21–March 22.

*New York, The Pace Gallery. "Chuck Close: Recent Work," February 21–March 22.

### 1987
New York, Pace/MacGill Gallery. "Chuck Close: Photographs," March 1–May 10.

Ridgefield, Connecticut, Aldrich Museum of Contemporary Art. "Chuck Close Photographs," March 1–May 10.

*New York, The Pace Gallery. "Chuck Close: Drawings 1974–1986," June 19–July 24.

New York, Pace/MacGill Gallery. "Chuck Close: Large Scale Self-Portraits," October 15–November 28.

### 1988
New York, Pace Editions. "Chuck Close: Prints and Photographs," September 23–October 22.

*New York, The Pace Gallery. "Chuck Close, New Paintings," September 23–October 22.

New York, Pace/MacGill Gallery. "Chuck Close: A Survey," September 23–October 22.

Washington, D.C., Fendrick Gallery. "Chuck Close: Photographs," November 1–December 3.

### 1989
*Chicago, The Art Institute of Chicago. "Chuck Close," February 4–April 16. Traveled to The Friends of Photography, Ansel Adams Center, San Francisco, November 8, 1989–January 7, 1990.

*Youngstown, Ohio, The Butler Institute of American Art. "Chuck Close Editions: A Catalogue Raisonné and Exhibition," September 17–November 26.

Ridgefield, Connecticut, Aldrich Museum of Contemporary Art. "Chuck Close: Works on Paper from the Collection of Sherry Hope Mallin," October 29, 1989–February 25, 1990.

### 1991
*East Hampton, New York, Guild Hall of East Hampton. "Chuck Close: Up Close," June 15–July 28.

Honolulu, The Contemporary Museum. "Chuck Close: Large Color Photographs," September 10–November 17.

*New York, The Pace Gallery. "Chuck Close: Recent Paintings," November 2–December 7.

### 1993
New York, Pace Editions. "Chuck Close Editions," March 20–30.

Richmond, Virginia Museum of Fine Arts. "Chuck Close: Portraits," July 21–October 31.

New York, The Museum of Modern Art. "A Print Project by Chuck Close," July 24–September 28.

*New York, The Pace Gallery. "Chuck Close: Recent Paintings," October 22–November 27.

### 1994
*Baden-Baden, Germany, Staatliche Kunsthalle. "Chuck Close: Retrospektive," April 10–June 22. Traveled to Lenbachhaus, Munich, July 13–September 11.

Taiwan, Kaohsiung Museum of Fine Arts. "Chuck Close: Visible and Invisible Portraits," June.

*Paris, Fondation Cartier pour l'art contemporain. "Chuck Close: 8 peintures récentes," September 24–October 23.

**1995**

New York, Pace Editions. "Chuck Close Recent Editions: Alex-Chuck-Lucas," March 10–April 13.

*Los Angeles, PaceWildenstein. "Chuck Close: Recent Paintings," September 28–October 28. Traveled to Pace Wildenstein, New York, December 2, 1995–January 6, 1996.

Los Angeles, Lannan Foundation. "Chuck Close: Alex/Reduction Block," September 30, 1995–January 7, 1996.

**1996**

*Chicago, The Art Institute of Chicago. "Affinities: Chuck Close and Tom Friedman," April 27–July 28.

New York, Archives of American Art, Smithsonian Institution. "Chuck Close: A Personal Portrait. Works and Papers," October 8, 1996–January 6, 1997.

New York, PaceWildenstein/MacGill. "Chuck Close: Large Scale Black and White Photographs," October 24–November 23.

**1997**

Los Angeles, PaceWildenstein. "Chuck Close: Large Scale Black and White Photographs," January 24–March 1.

**1998**

*New York, The Museum of Modern Art. "Chuck Close," February 26–May 26. Traveled to the Museum of Contemporary Art, Chicago, June 20–September 13; Hirshhorn Museum and Sculpture Garden, Smithsonian Institution, Washington, D.C., October 15, 1998–January 10, 1999; Seattle Art Museum, Seattle, February–May 1999.

## Group Exhibitions

**1969**

New York, Bykert Gallery. "Lynda Benglis, Chuck Close, David Paul, Richard van Buren," May 20–June 20.

*New York, Whitney Museum of American Art. "1969 Annual Exhibition of Contemporary American Paintings," December 16, 1969–February 1, 1970. Foreword by John I. H. Baur.

**1970**

*New York, Whitney Museum of American Art. "22 Realists," February 10–March 29. Text by James Monte.

*Aachen, Neue Galerie der Stadt Aachen. "Klischee und Antiklischee," March–April.

Oberlin, Ohio, Allen Memorial Art Museum. "Three Young Americans," April 17–May 12.

**1971**

*Düsseldorf, Städtische Kunsthalle. "Prospect '71: Projection," October 8–17. Texts by Konrad Fischer, Jürgen Harten, and Hans Strelow.

*Ontario, Art Gallery of Ontario. "Recent Vanguard Exhibition," December 18, 1971–January 9, 1972. Text by Dennis Young.

**1972**

*New York, Whitney Museum of American Art. "Annual Exhibition: Contemporary American Painting," January 25–March 19. Foreword by John I. H. Baur.

*New York, Sidney Janis Gallery. "Colossal Scale," March 9–April 1.

*Aachen, Neue Galerie der Stadt Aachen. "Kunst um 1970–Art Around 1970: Sammlung Ludwig in Aachen," June. Text by Wolfgang Becker.

*Kassel, Fridericianum. "Documenta 5," June 30–October 8. Text by Jean-Christophe Ammann.

*Paris, Galerie des Quatre Mouvements. "Hyperréalistes Américains," October 25–November 25. Texts by Udo Kultermann and Daniel Abadie.

*Stuttgart, Württembergischer Kunstverein. "Amerikanischer Fotorealismus," November 16–December 26. Traveled to Frankfurter Kunstverein, Frankfurt, January 6–February 18, 1973; Kunst und Museumsverein Wuppertal, February 25–April 8, 1973. Text by Uwe M. Schneede.

*New York, The New York Cultural Center. "Realism Now," December 6, 1972–January 7, 1973. Text by Mario Amaya.

**1973**

*Turin, Italy, Galleria Civica d'Arte Moderna. "Combattimento per un'immagine: fotografi e pittori," March–April. Texts by Daniela Palazzoli and Luigi Carluccio.

*London, Serpentine Gallery, The Arts Council. "Photo-Realism: Paintings, Sculpture and Prints from the Ludwig Collection and Others," April 4–May 6. Text by Lawrence Alloway.

*Paris, Galerie des Quatre Mouvements. "Grands Maîtres Hyperréalistes Américains," May 23–June 15. Traveled to 4e Salon International d'Art, Basel, June 20–25. Text by Salvador Dali.

*New York, Whitney Museum of American Art. "American Drawings 1963–1973," May 25–July 22. Text by Elke M. Solomon.

*Hannover, Germany, Kunstverein Hannover. "Kunst nach Wirklichkeit: Ein neuer Realismus in Amerika und in Europa," December 9, 1973–January 27, 1974. Text by Wolfgang Becker.

**1974**

*Helsinki, Finland, Ateneum, The Fine Arts Academy of Finland. "Ars '74," February 15–March 31. Traveled to Tampereen Nykytaiteen Museo, Tampere, Finland, April 10–May 12. Text by Salme Sarajas-Korte.

*Paris, Centre National d'Art Contemporain. "Hyperréalistes Américains, Réalistes Européens," February 15–March 25. Texts by Daniel Abadie and Wolfgang Becker; reprints of texts by Pierre Restany and Jean Clair.

*Worcester, Massachusetts, Worcester Art Museum. "Three Realists: Close, Estes, Raffael," February 27–April 7. Text by Leon Shulman.

*Tokyo, "11th Tokyo Biennale 1974," May 10–30. Text by Linda Chase.

*Rotterdam, Museum Boymans-van Beuningen. "Kijken naar de werkelijkheid," June 1–August 18. Text by Daniel Abadie.

*Utrecht, The Netherlands, Hedendaagse Kunst. "Amerikaans Fotorealisme: Grafiek," June 8–August 4. Traveled to Palais des Beaux–Arts, Brussels, Belgium, September–October. Texts by Wouter Kotte and Heinz Holtmann.

*Basel. "Art 5 '74," June 19–24.

New York, Whitney Museum of American Art, Downtown Branch. "New Portraits," November 7–December 12.

**1975**

*New York, Louis K. Meisel Gallery. "Watercolors and Drawings: American Realists," January 3–30. Text by Susan Pear Meisel.

*New York, Allan Frumkin Gallery. "Portrait Painting 1970–75," January 7–31. Text by G.W. Barette and Allan Frumkin.

*Washington, D.C., Corcoran Gallery of Art. "34th Biennial of Contemporary American Painting," February 22–April 6. Text by Roy Slade.

*Philadelphia, Institute of Contemporary Art, University of Pennsylvania. "Painting, Drawing and Sculpture of the 60's and 70's from the Dorothy and Herbert Vogel Collection," October 7–November 18. Traveled to The Contemporary Arts Center, Cincinnati, Ohio, December 17, 1975–February 15, 1976. Text by Suzanne Delehanty.

*Middletown, Connecticut, Davison Art Center, Wesleyan University. "Recent American Etching," October 10–November 23. Traveled to National Collection of Fine Arts, Smithsonian Institution, Washington, D.C., January 21–March 27, 1976. Text by Richard S. Field.

**1976**

*New York, The Museum of Modern Art. "Drawing Now, 1955–75," January 21–March 21. Traveled to Kunsthaus Zürich, October 9–November 14; Kunsthalle Baden-Baden, November 24, 1976–January 16, 1977; Graphische Sammlung Albertina, Vienna, January 28–March 6, 1977; Sonjia Henie-Niels Onstad Museum, Oslo, March 17–April 24, 1977; The Tel-Aviv Museum, Tel Aviv, May–June 1977. Text by Bernice Rose.

*Chicago, The Art Institute of Chicago. "Seventy-Second American Exhibition," March 13–May 9. Introduction by A. James Speyer. Text by Anne Rorimer.

*Tokyo, Seibu Museum of Art. "Three Decades of American Art Selected by the Whitney Museum of American Art," June 18–July 20. Text by Barbara Haskell.

New Orleans, Tulane University. "Drawing Today in New York," September 2–23. Traveled to Rice University, Houston, October 8–November 19; Southern Methodist University, Dallas, January 10–February 16, 1977; University of Texas at Austin, February 27–March 11, 1977; Oklahoma Arts Center, Oklahoma City, April 15–May 15, 1977; Dayton Art Institute, Dayton, June 3–August 21, 1977.

*Berlin, Nationalgalerie. "Amerikanischer Druckgraphik von 1945 bis heute," September 4–November 11. Traveled to Kunsthalle zu Kiel, Kiel, November 7–December 30. Book: *Amerikanische Kunst von 1945 bis heute:*

*Kunst der USA in europäischen Sammlungen*, edited by Dieter Honisch and Jens Christian Jensen.

*San Francisco, Daniel Weinberg Gallery. "Richard Artschwager, Chuck Close, Joe Zucker," September 14–October 22. Traveled to La Jolla Museum of Contemporary Art, November 5–December 5; Memorial Union Art Gallery, University of California at Davis, January 5–28, 1977. Preface by Richard Armstrong. Text by Catherine Kord.

*New York, Wildenstein. "Modern Portraits: The Self & Others," October 20–November 28. Organized by Columbia University. Text by J. Kirk T. Varnedoe.

New York, Whitney Museum of American Art. "American Master Drawings and Watercolors," November 23, 1976–January 23, 1977.

**1977**
*New York, Whitney Museum of American Art. "1977 Biennial Exhibition," February 19–April 3. Text by Barbara Haskell, Marcia Tucker, and Patterson Sims.

*Paris, Centre Georges Pompidou, Musée National d'Art Moderne. "Paris–New York," June 1–September 19. Text by K. G. Pontus Hultén et al.

*Kassel, Museum Fridericianum. "Documenta 6." June 24–October 10. Text by Manfred Schneckenburger.

*St. Paul, Minnesota Museum of Art. "American Drawings, 1927–1977," September 6–October 29. Text by Paul Cummings.

*Chicago, Museum of Contemporary Art. "A View of a Decade," September 10–November 10. Texts by Martin Friedman, Robert Pincus-Witten, and Peter Gay.

*Ann Arbor, University of Michigan Museum of Art. "Works from the Collection of Dorothy and Herbert Vogel," November 11, 1977–January 1, 1978. Text by Bret Waller.

[New York]. Organized by The Metropolitan Museum of Art. "Representations of America." Traveled to Pushkin Museum, Moscow, December 15, 1977–February 15, 1978; The Hermitage, Leningrad, March 15–May 15, 1978; Palace of Art, Minsk, June 15–August 15, 1978.

**1978**
*Philadelphia, Philadelphia Museum of Art. "Eight Artists," April 29–June 25. Text by Anne d'Harnoncourt.

*New York, Whitney Museum of American Art. "20th Century American Drawings: Five Years of Acquisitions," July 28–October 1, 1978. Text by Paul Cummings.

*Richmond, Anderson Gallery, Virginia Commonwealth University. "Late Twentieth-Century Art," [organized by] The Sydney and Frances Lewis Foundation, December 5, 1978–January 8, 1979. Text by Susan L. Butler.

*Buffalo, New York, Albright Knox Gallery. "American Painting of the 1970s," December 9, 1978–January 14, 1979. Traveled to Newport Harbor Art Museum, Newport Beach, California, February 3–March 18, 1979; The Oakland Museum, Oakland, California, April 10–May 20, 1979; Cincinnati Art Museum, Cincinnati, July 6–August 26, 1979; Art Museum of South Texas, Corpus Christi, September 9–October 21, 1979. Text by Linda L. Cathcart.

*New York, The Pace Gallery. "Grids: Format and Image in 20th Century Art," December 16, 1978–January 20, 1979. Traveled to Akron Art Institute, Akron, Ohio, March 24–May 6, 1979. Text by Rosalind Krauss.

**1979**
*New York. Whitney Museum of American Art. "1979 Biennial Exhibition," February 14–April 1. Texts/Preface by Tom Armstrong. Foreword by John G. Hanhardt, Barbara Haskell, Richard Marshall, Mark Segal, and Patterson Sims.

*Paris, Centre Georges Pompidou, Musée National d'Art Moderne. "Copie Conforme?" April 18–June 11. Reprint of interview by Linda Chase and Ted McBurnett from *Art in America*, November–December 1972, and reprint of text by Kim Levin from *Arts Magazine*, June 1978.

Long Island City, New York, P. S. 1. "The Altered Photograph: 24 Walls, 24 Curators," April 22–June 10.

*New York, Light Gallery. "20 x 24/Light," October 4–27. Traveled to Philadelphia College of Art, Philadelphia, April 1980. Texts by Peter MacGill, Gary Metz, and JoAnn Verburg.

New York, Whitney Museum of American Art, Downtown Branch.

"Artists by Artists," October 25–November 28.

**1980**
*New York, The Museum of Modern Art. "Printed Art: A View of Two Decades," February 13–April 1. Text by Riva Castleman.

*New York, Whitney Museum of American Art. "The Figurative Tradition and the Whitney Museum of American Art: Paintings and Sculpture from the Permanent Collection," June 25–September 28. Foreword by Tom Armstrong. Texts by Patricia Hills and Roberta K. Tarbell.

*Washington, D.C., National Gallery of Art. "The Morton G. Neumann Family Collection." August 31–December 31. Text on "Super Realism" by Trinkett Clark.

**1981**
*New Haven, Connecticut, Yale University Art Gallery. "20 Artists: Yale School of Art, 1950–1970." January 29–March 29. Text by Irving Sandler.

*[London]. Organized by The Arts Council of Great Britain. "Photographer as Printmaker: 140 Years of Photographic Printmaking." Traveled to Ferens Art Gallery, Hull, August 5–30; Museum and Art Gallery, Leicester, September 16–October 18; unconfirmed venue, October 28–November 28; The Cooper Gallery, Barnsley, December 19, 1981–January 17, 1982; The Photographer's Gallery, London, March 11–April 11, 1982. Text by Gerry Badger.

*Kalamazoo, Michigan. "Super Realism from the Morton G. Neumann Family Collection," September 1–November 1. Traveled to The Art Center, Inc., South Bend, Indiana, November 22, 1981–January 3, 1982; Springfield Art Museum, Springfield, Missouri, January 16, 1982–February 28, 1982; Dartmouth College Museum and Galleries, Hanover, New Hampshire, March 19–May 2, 1982; De Cordova Museum, Lincoln, Massachusetts, May 9–June 20, 1982; Des Moines Art Center, Des Moines, Iowa, July 6–August 15, 1982. Text by Linda Chase.

*Philadelphia, Pennsylvania Academy of the Fine Arts. "Contemporary American Realism Since 1960," September 18–December 13. Traveled to Virginia Museum of Fine Arts, Richmond, February 1–March 28, 1982; The Oakland Museum, Oakland, California, May 6–July 25, 1982; Gulbenkian Foundation,

Lisbon, September 10–October 24, 1982; Salas de Exposiciones de Bellas Artes, Madrid, November 17–December 27, 1982; Kunsthalle, Nuremberg, February 11–April 10, 1983. Text by Frank H. Goodyear, Jr.

New York, Solomon R. Guggenheim Museum. "Seven Photorealists from New York Collections," October 6–November 8.

*New York, Whitney Museum of American Art. "American Prints: Process and Proofs," November 25, 1981–January 24, 1982. Text by Judith Goldman.

**1982**
*Paris, Galerie Isy Brachot. "Photo-Réalisme: Dix ans après," January 13–March 6.

*Hannover, Germany, Kestner-Gesellschaft. "Momentbild: Künstlerphotographie," March 5–April 18. Text by Carl Haenlein.

Cambridge, Massachusetts, Hayden Gallery, Massachusetts Institute of Technology. "Great Big Drawings," April 3–May 2.

New York, Leo Castelli Gallery. "Black & White," December 29, 1982–February 9, 1983.

**1983**
Los Angeles, Los Angeles Center for Photographic Studies. "Photographic Visions by Martha Alf, Chuck Close, Robert Cumming, David Hockney, Robert Rauschenberg, Ed Ruscha," September 19–October 16.

*Los Angeles, The Museum of Contemporary Art. "The First Show: Painting and Sculpture from Eight Collections, 1940–1980," November 20, 1983–February 19, 1984. Texts by Julia Brown, K. G. Pontus Hultén, and Susan C. Larsen.

**1984**
*[New York]. Organized by the Whitney Museum of American Art. "American Art Since 1970: Painting, Sculpture, and Drawings from the Collection of the Whitney Museum of American Art." Traveled to La Jolla Museum of Contemporary Art, La Jolla, California, March 10–April 22; Museo Tamayo, Mexico City, May 17–July 29; North Carolina Museum of Art, Raleigh, September 29–November 25; Sheldon Memorial Art Gallery, University of Nebraska, Lincoln, January 12–March 3,

1985; Center for the Fine Arts, Miami, March 30–May 26, 1985. Text by Richard Marshall.

**1985**

*Lausanne, Musée Cantonal des Beaux-Arts. "L'Autoportrait à l'âge de la photographie: peintres et photographes en dialogue avec leur propre image," January 18–March 24. Traveled to Württembergischer Kunstverein, Stuttgart, April 11–June 9. Texts by Michel Tournier, Erika Billeter, Tilman Osterwold, William Hauptman, Philippe Junod, and Roger Marcel Mayou.

*San Francisco, San Francisco Museum of Modern Art. "American Realism: Twentieth Century Drawings and Watercolors from the Glenn C. Janss Collection," November 7, 1985–January 12, 1986. Traveled to De Cordova and Dana Museum and Park, Lincoln, Massachusetts, February 13–April 6, 1986; Archer M. Huntington Art Gallery, University of Texas, Austin, July 13–September 21, 1986; May and Leigh Block Gallery, Northwestern University, Evanston, Illinois, October 23–December 14, 1986; Williams College Museum of Art, Williamstown, Massachusetts, January 15–March 8, 1987; Akron Art Museum, Akron, Ohio, April 9–May 31, 1987; Madison Art Center, Madison, Wisconsin, July 26–September 20, 1987. Text by Alvin Martin.

New York, The Museum of Modern Art. "Self-Portrait: The Photographer's Persona, 1840–1985," November 7, 1985–January 7, 1986.

Cambridge, Massachusetts, Hayden Gallery, Massachusetts Institute of Technology. "Nude, Naked, Stripped," December 13, 1985–February 2, 1986.

**1986**

New York, The Queens Museum. "The Real Big Picture," January 17–March 19.

*New York, Whitney Museum of American Art at Philip Morris. "The Changing Likeness: Twentieth-Century Portrait Drawings, Selections from the Permanent Collection of the Whitney Museum of American Art," June 27–September 4. Text by Paul Cummings.

**1987**

*Sarasota, Florida, The John and Mable Ringling Museum of Art. "This is not a Photograph: Twenty Years of Large Scale Photography, 1966–1986," March 7–May 31. Traveled to Akron Art Museum, Akron, Ohio, October 31,

1987–January 10, 1988; The Chrysler Museum, Norfolk, Virginia, February 26–May 1, 1988. Texts by Joseph Jacobs and Marvin Heiferman.

*Washington, D.C., National Gallery of Art. "20th Century Drawings from the Whitney Museum of American Art," May 21–September 7. Traveled to The Cleveland Museum of Art, Cleveland, September 30–November 8; Achenbach Foundation, California Palace of the Legion of Honor, San Francisco, March 5–June 5, 1988; Arkansas Art Center, Little Rock, June 30–August 28, 1988; Whitney Museum of American Art, Fairfield County, Stamford, Connecticut, November 18, 1988–January 18, 1989; Whitney Museum of American Art at the Equitable Center, New York, February 3, 1989–April 1, 1989. Text by Paul Cummings.

*Los Angeles, Los Angeles County Museum of Art. "Photography and Art: Interactions Since 1946," June 4–August 30, 1987. Traveled to the Museum of Art, Fort Lauderdale, Florida, October 15, 1987–January 24, 1988; The Queens Museum, Flushing, New York, February 13–April 3, 1988; Des Moines Art Center, Iowa, May 6–June 26, 1988. Texts by Andy Grundberg and Kathleen McCarthy Gauss.

*New York, International Center of Photography/Midtown. "Portrayals," June 12–July 18. Traveled to Herron Gallery, Indianapolis Center for Contemporary Art, November 21–December 19. Texts by Charles Stainback and Carol Squiers.

**1988**

New York, Whitney Museum of American Art at the Equitable Center. "Aldo Crommelynck: Master Prints with American Artists," August 31–November 7, 1988.

*New York, Whitney Museum of American Art, Federal Reserve Plaza Branch. "Identity: Representations of the Self," December 14, 1988–February 10, 1989.

**1989**

New York, Studio School. "Field and Frame: Meyer Shapiro's Semiotics of Painting," April 7–May 13.

New York, Pat Hearn Gallery. "Robert Bechtle, Chuck Close, Robert Cottingham, Malcolm Morley, Sigmar Polke," September 16–October 7.

*New York, Whitney Museum of American Art. "Image World: Art and

Media Culture," November 8, 1989–February 18, 1990. Texts by Marvin Heiferman and Lisa Phillips with John G. Hanhardt.

**1990**

*Tokyo, Fuji Television Gallery. "The 20th Anniversary." April 2–26.

Boston, Museum of Fine Arts. "Figuring the Body," July 28–October 28.

**1991**

*New York, The Museum of Modern Art. "Artist's Choice–Chuck Close: Head On/The Modern Portrait," January 10–March 19. Traveled to the Lannan Foundation, Los Angeles, June 25–September 7. Foreword by Kirk Varnedoe and Artist's Statement by Chuck Close.

Humlebaek, Denmark, Louisiana Museum of Modern Art. "Louisiana: The New Graphics Wing," March 3–31.

New York, American Academy and Institute of Arts and Letters. "Academy-Institute Invitational Exhibition of Painting & Sculpture," March 5–30.

*New York, Whitney Museum of American Art. "1991 Biennial Exhibition," April 2–June 30. Texts by Richard Marshall, Richard Armstrong, Lisa Phillips, and John G. Hanhardt.

New York, American Academy and Institute of Arts and Letters. "Exhibition of Work by Newly Elected Members and Recipients of Honors and Awards," May 15–June 9.

New York, Robert Miller Gallery. "Portraits on Paper," June 25–August 2.

New York, Paula Cooper Gallery. "Vito Acconci, John Baldessari, Jennifer Bartlett, Chuck Close . . . ," September 7–28.

*[New York]. Organized by Independent Curators Incorporated. "Departures: Photography 1923–1990." Traveled to Iris and B. Gerald Cantor Art Gallery, College of the Holy Cross, Worcester, Massachusetts, September 12–October 20; Denver Art Museum, Denver, Colorado, January 25–March 22, 1992; Joslyn Art Museum, Omaha, Nebraska, April 9–May 31, 1992; Pittsburgh Center for the Arts, Pittsburgh, Pennsylvania, July 5–August 23, 1992; The Goldie Paley Gallery at Moore College of Art and Design, Philadelphia, Pennsylvania, September 5–October 11, 1992; Telfair Academy of Arts and Sciences, Inc.,

Savannah, Georgia, January 5–February 21, 1993. Texts by Edmund Yankov and Andy Grundberg.

*Miyagi, Japan, The Miyagi Museum of Art Sendai. "American Realism and Figurative Art: 1952–1990," November 1–December 23. Traveled to Sogo Museum of Art, Yokohama, January 29–February 16, 1992; Tokushima Modern Art Museum, Tokushima, February 22–March 29, 1992; The Museum of Modern Art, Shiga, April 4–May 17, 1992; Kochi Prefectural Museum of Folk Art, Kochi, May 23–June 17, 1992.

**1992**

*New York, KunstHalle. "Psycho," April 2–May 9. Texts by Christian Leigh, Octavio Zaya, Donald Kuspit, and Adrian Dannatt.

*Jouy-en-Josas, France, Fondation Cartier pour l'Art Contemporain. "A visage découvert," June 18–October 4. Text by Jean de Loisy.

*Nice, France, Musée d'Art Moderne et d'Art Contemporain. "Le Portrait dans l'art contemporain, 1945–1992," July 3–September 27. Preface by Gilbert Perlein. Texts by Claude Fournet, Hélène Depotte, Alain Buisine, Daniel Dobbels, and Gilbert Lascaux.

New York, Paul Kasmin Gallery. "The Language of Flowers," December 12, 1992–January 16, 1993.

**1993**

New York, Thread Waxing Space. "I Am The Enunciator," January 9–February 27.

*Miami, Center for the Fine Arts. "Photoplay: Works from the Chase Manhattan Collection," January 10–February 21. Traveled to Latin America from April 1993 to January 1995. Text by Lisa Phillips.

*Lyon, France, Espace Lyonnais d'Art Contemporain. "Autoportraits contemporains: Here's Looking at Me," January 29–April 30. Text by Bernard Brunon.

New York, Midtown Payson Gallery. "Paul Cadmus: The Artist as Subject," February 4–March 6.

Annandale-on-Hudson, New York, Richard and Marieluise Black Center for Curatorial Studies and Art in Contemporary Culture, Bard College. "Passions & Cultures: Selected Works from the Rivendell Collection, 1967–1991," April 4–December 22.

*New Haven, Connecticut, Yale University Art Gallery. "Yale Collects Yale," April 30–July 31. Edited by Sasha M. Newman and Lesley R. Baier with essay by Nicholas Fox Weber.

*New York, Jason McCoy, Inc. "Heads and Portraits: Drawings from Piero di Cosimo to Jasper Johns," May 6–June 12. Catalogue by Kate Ganz.

New York, The Museum of Modern Art. "A Print Project by Chuck Close," July 24–September 28.

*New York, The Drawing Center. "The Return of the Cadavre Exquis," November 6–December 18. Traveled to Corcoran Gallery of Art, Washington, D.C., February 5–April 10, 1994; The Santa Monica Museum of Art, July 7–September 5, 1994; Forum for Contemporary Art, Saint Louis, September 30–November 12, 1994; American Center, Paris, December 1994–January 1995. Texts by Ann Philbin, Ingrid Schaffner, Charles Simic, and Mary Ann Caws.

*London, National Portrait Gallery. "The Portrait Now," November 19, 1993–February 6, 1994. Text by Robin Gibson.

### 1994
*Washington, D.C., National Gallery of Art. "From Minimal to Conceptual Art: Works from the Dorothy and Herbert Vogel Collection," May 29–November 27. Texts by John T. Paoletti and Ruth E. Fine.

New York, Richard Anderson Gallery. "A Floor in a Building in Brooklyn," June 9–July 30. Curated by Chuck Close.

*Philadelphia, Institute of Contemporary Art, University of Pennsylvania. "Face-Off: The Portrait in Recent Art," September 9–October 30. Traveled to Joslyn Art Museum, Omaha, Nebraska, January 28–March 19, 1995; Weatherspoon Art Gallery, University of North Carolina, Greensboro, April 9–May 28, 1995. Texts by Melissa E. Feldman and Benjamin H. D. Buchloh.

### 1995
*Venice. "La Biennale di Venezia. 46 Esposizione Internazionale d'Arte. Identity and Alterity: Figures of the Body, 1895–1995," June 10–October 15. Texts by Jean Clair et al.

*Houston, Museum of Fine Arts. "Art Works: The PaineWebber Collection of Contemporary Masters," July 2–September 24. Traveled to Detroit

Institute of Arts, Detroit, October 28–December 31; Museum of Fine Arts, Boston, March 12–June 16, 1996; The Minneapolis Institute of Arts, Minneapolis, July 7–September 14, 1996; San Diego Museum of Art, San Diego, October 13, 1996–January 5, 1997; Miami Museum of Art, Miami, March 15–May 25, 1997; Carnegie Museum of Art, Pittsburgh, Pennsylvania, June 18–September 1, 1997. Book with texts by Jack D. Flam, Monique Beudert, and Jennifer Wells.

Cologne, Museum Ludwig. "Our Century," July 8–October 8.

*Southhampton, The Parrish Art Museum. "Face Value: American Portraits," July 22–September 3. Traveled to Wexner Center for the Arts, Ohio State University, Columbus, March 5–April 21, 1996. Foreword by Trudy C. Kramer. Texts by Donna De Salvo, Kenneth E. Silver, Maurice Berger, Max Kozloff, and Michele Wallace.

*Kwangju, South Korea. "Beyond the Borders: The First Kwangju International Biennale: International Exhibition of Contemporary Art." September 20–November 20.

Los Angeles, Lannan Foundation. "Facts and Figures: Selections from the Lannan Foundation Collection," October 22, 1995–February 26, 1996.

*Pittsburgh, Pennsylvania, Carnegie Museum of Art. "1995 Carnegie International," November 5, 1995–February 18, 1996. Text by Richard Armstrong.

### 1996
Taiwan, Kaohsiung Museum of Fine Arts. "Master Printers and Master Pieces," February 16–June 2.

*Rome, American Academy in Rome. "Annual Exhibition 1996," May 24–July 14. Text by Caroline Bruzelius.

*New York, The Museum of Modern Art. "Thinking Print: Books to Billboards, 1980–1995," June 19–September 10. Text by Deborah Wye.

Toledo, Ohio, The Toledo Museum of Art. "A Decade of Giving: The Apollo Society," September 8–December 1.

*Miami, Museum of Contemporary Art. "Painting into Photography/Photography into Painting," December 20, 1996–February 16, 1997. Text by Bonnie Clearwater.

### 1997
*Hamburg, Deichtorhallen. "Birth of the Cool: American Painters from Georgia O'Keeffe to Christopher Wool," February 14–May 11. Traveled to Kunsthaus Zürich, June 18–September 7. Texts by Bice Curiger et al.

*Berlin, Martin-Gropius-Bau. "Age of Modernism: Art in the 20th Century," May 7–July 27. Edited by Christos M. Joachimides and Norman Rosenthal.

# PHOTOGRAPH CREDITS

Photographs have been provided in most cases by the owners or custodians of the works, identified in the captions. Individual works of art appearing herein may be protected by copyright in the United States or elsewhere, and may thus not be reproduced in any form without the permission of the copyright owners. The following list applies to photographs or copyrights for which separate acknowledgments are due.

All works of Chuck Close © 1998 Chuck Close

Richard Ackley: p. 156; © 1998 The Josef and Anni Albers Foundation / Artists Rights Society (ARS), New York: p. 29 (fig. 5); Albright-Knox Art Gallery: photographs by Biff Heinrich, pp. 102-103, 185; Photograph © Allen Memorial Art Museum: photograph by John Seyfried, p. 115; David Allison, New York: pp. 8-9, 125 (left), 149; Myles Aronowitz: p. 211 (lower left); Photographs © 1996 The Art Institute of Chicago. All rights reserved. Photographs by Susan Einstein, pp. 134, 135, 177; Kathan Brown: p. 74 (fig. 2); Courtesy Christie's, Inc.: p. 31 (fig. 8), p. 88 (fig. 5); Andy Cohen: p. 152; Martha Cooper: p. 211 (lower right); Courtesy DC Moore Gallery, New York: p. 49 (fig. 31); D. James Dee: p. 45 (fig. 25); © 1998 Willem de Kooning Revocable Trust/Artists Rights Society (ARS), New York: p. 95 (fig. 10); Daniel B. Duffy Associates, Worcester, Mass: p. 207 (bottom); Courtesy André Emmerich Gallery, New York: p. 29 (fig. 6); © Richard Estes, courtesy, Marlborough Gallery, New York: p. 40 (fig. 19); Alberto Giacometti © 1998 Artists Rights Society (ARS), New York / ADAGP, Paris: p. 44 (fig. 24); Photograph © Anne Gold, Aachen: p. 111; Paula Goldman: p. 145; Courtesy Nancy Graves Foundation, New York: p. 29 (fig. 4); Richman Haire: p. 131; By permission of the Estate of Leon D. Harmon, courtesy, *Scientific American*, November 1973: p. 48 (fig. 29); Greg Heins, Boston: p. 105; Hirshhorn Museum and Sculpture Garden, Smithsonian Institution: photograph by Lee Stalsworth, pp. 14-15; Wayne Hollingworth: p. 207 (top); Bill Jacobson: pp. 183, 184, 187, 210 (bottom); © Jasper Johns / Licensed by VAGA, New York, N.Y.: p. 31 (fig. 8); © Alex Katz, *One Flight Up* 1968, courtesy Marlborough Gallery, New York: p. 49 (fig. 30); © Alex Katz, *Passing* 1962-63, courtesy Marlborough Gallery, New York: p. 39 (fig. 16); Courtesy Phyllis Kind Gallery: photograph by Jeffrey Gurecka, p. 49 (fig. 32); Courtesy Sol LeWitt © Sol LeWitt: p. 32 (fig. 9); © Roy Lichtenstein, photograph by

Dorothy Zeidman: p. 98 (fig 11); Dennis McWaters: pp. 132, 139; © 1998 Brice Marden / Artists Rights Society (ARS), New York: p. 92 (fig. 8); Photographs © 1991 Frederik Marsh: pp. 122, 123; Michael Marsland: p. 28 (fig. 3); Photograph © 1987 The Metropolitan Museum of Art, New York: p. 171; The Metropolitan Museum of Art, New York. All rights reserved: p. 26 (fig. 2), p. 40 (fig. 18); Kelly Mills, Lawrence, Kan.: p. 125 (right); Copyprint © 1997 The Museum of Modern Art, New York: p. 46 (fig. 27); Photographs © 1997 The Museum of Modern Art, New York: p. 29 (fig. 6), p. 39 (fig. 16), p. 40 (fig. 19), p. 44 (fig. 22); Photograph by David Allison, pp. 6-7; Photographs by Kate Keller, p. 30 (fig. 7), p. 39 (fig. 17), p. 86 (fig. 2), p. 88 (fig. 6), p. 92 (figs. 8, 9), p. 129; Photographs by Erik Landsberg, pp. 106, 121, 124 (right), 126 (right); Photograph by James Mathews, p. 33 (fig.11); Photographs by Mali Olatunji, p. 29 (fig. 5), p. 175; Photograph by Soichi Sunami, p. 44 (fig. 23); Photographs © 1997 Board of Trustees, National Gallery of Art, Washington, D.C.: photographs by Bob Grove, pp. 12-13, 161; Photograph © Osaka City Museum of Modern Art: p. 109; PaceWildenstein, New York: p. 46 (fig. 26), pp. 116, 117, 137, 138, 155, 165, 169, 204 (middle), 208, 210 (top); Photographs by Bill Jacobson, pp. 168, 170, 182; Photographs by Maggie L. Kundtz, p. 74 (fig. 3), p. 81 (figs. 11, 12), pp. 166, 167, 173; Photographs by Ellen Page Wilson, pp. 4-5, p. 20 (fig. 1), p. 60 (fig. 2), p. 69 (fig. 4), p. 70 (fig. 1), p. 74 (fig. 4), p. 75 (figs. 5, 6), p. 78 (figs. 7, 8), p. 79 (figs. 9, 10), p. 81 (figs. 13-16), pp. 84, 119, 124 (left), 127, 141, 153, 158, 159, 162, 163, 172, 174, 178, 179, 186, 188, 189, 190, 191, 195, 197, 198, 199, 201; PaceWildensteinMacGill, New York: p. 192. Photograph by Maggie L. Kundtz, p. 193; Douglas M. Parker: p. 157; Robert Pettus: pp. 2-3; © Robert Rauschenberg / Licensed by VAGA, New York, N.Y.: p. 86 (fig. 3); © 1998 Estate of Ad Reinhardt / Artists Rights Society (ARS), New York: p. 30 (fig. 7); Reynolda House, Museum of American Art, Winston-Salem, North

Carolina: photographs by Jackson Smith, pp. 142, 143; © Gerhard Richter, courtesy Marian Goodman, New York: pp. 36, 37 (fig. 14); © R.M.N., Agence Photographique: p. 45 (fig. 24); © 1998 Dorothea Rockburne / Artists Rights Society (ARS), New York: p. 88 (fig. 6); József Rosta: p. 41 (fig. 21), p. 118; Larry Sanders, Milwaukee: p. 126 (left); Courtesy Cindy Sherman and Metro Pictures: p. 46 (fig. 27); Photograph © 1997 Sotheby's, Inc.: p. 151; Photograph © Souma Photo Art: p. 154; © 1998 Frank Stella / Artists Rights Society (ARS), New York: p. 33 (fig. 12); Photograph © 1994 Virginia Museum of Fine Arts, photograph by Ron Jennings, p. 150; Photograph © 1997 Virginia Museum of Fine Arts, photograph by Katherine Wetzel, pp. 10-11; Christian Wachter: p. 133; © 1998 Andy Warhol Foundation for the Visual Arts / ARS, New York: p. 87 (fig. 4); The White House, official photograph: p. 211 (upper right); Photographs © 1997 Whitney Museum of American Art, New York: photographs by Geoffrey Clements, p. 39 (fig. 15), p. 95 (fig. 10), pp. 112, 147; Graydon Wood: p. 196.

# ACKNOWLEDGMENTS

First, I want to express my warmest thanks to Kirk Varnedoe, Chief Curator in the Department of Painting and Sculpture, who initiated this exhibition but was forced by illness to relinquish his leading part in its creation. Fortunately, his health has been restored, and he has been able to write a major text for the catalogue testifying to his deep commitment to Close's work. Once again I am in his debt. Deborah Wye, Chief Curator of Prints and Illustrated Books, has also had a long-standing involvement with the artist, and her curatorial contribution to this show as well as her critical essay have been a great boon. Fereshteh Daftari has labored tirelessly as my curatorial assistant throughout the past year. Among her many ably acquitted duties, she has authored the catalogue's chronology and edited its bibliography and exhibition history. Stacy Glass Goldstone has energetically seconded her in all aspects of this project. As always, my assistant, Carina Evangelista, has kept the world in order while I concentrated—a very tough job. In the Publications Department, Marc Sapir, Production Manager, and Joanne Greenspun, Editor, have faced hellish deadlines with skill and good humor, as has Jodi Hanson, Director of Graphics.

In Close's studio we have relied heavily on painter Michael Volonakis for information and practical interventions. Joe Letitia also assisted in many ways. At PaceWildenstein Gallery, Director Arne Glimcher and photo archivist Noelle Soper have helped greatly in obtaining loans and documenting the artist's work.

The realization of this exhibition in an unusually short period of time has depended upon the expertise and dedication of many other people both inside and outside the Museum. The list which follows is correspondingly long, but the fact of its being a list in no way diminishes my appreciation for the efforts made by all of those cited below. At The Museum of Modern Art my gratitude goes to Glenn D. Lowry, Director; Jennifer Russell, Deputy Director for Exhibitions and Collections Support; Linda Thomas, Coordinator of Exhibitions; Diane Farynyk, Registrar; Stefanii Ruta, Assistant Registrar; Patterson Sims, Deputy Director for Education and Research Support; Josiana Bianchi, Public Programs Coordinator; Michael Margitich, Deputy Director for Development; Rebecca Stokes, Manager, Campaign Services; Elisa Behnk, Marketing Manager; Mary Lou Strahlendorff, Assistant Director of Communications; and Ann Dugourd, Research Assistant in Communications; Jerry Neuner, Director of Exhibition Design and Production; Pete Omlor, Manager of Art Handling, and his team of Preparators; Andrew Davies, Production Manager; Harriet Bee, Managing Editor; Nancy Kranz, Manager, Promotion and Special Services; Alison Hahn, Hahn Smith Design; Mikki Carpenter, Director of Photographic Services and Permissions; Jeffrey Ryan, Senior Assistant, Photographic Archives; James Coddington, Chief Conservator; Stephen W. Clark, Assistant General Counsel; Madeleine Hensler, former Administrative Assistant; and intern Regine Rapp. Marion Cajori has also generously shared interview tapes and images from her film on the artist, and Bill Bartman gave free access to materials from his forthcoming book of conversations between Close and other artists.

To all lenders whose names appear on the following page as well as to those who wish to remain anonymous many thanks are owed for their willingness to surrender treasured works for the long period such retrospectives require.

Last but by no means least, I wish to thank Chuck Close. No show comes easily, even when it involves a collaboration between friends. In every aspect of this endeavor, Chuck has been willing if not eager to go the extra distance. His drive and unshakable good-naturedness under pressure are unique in my experience; his courage in adversity and absolute devotion to his work are unparalleled.

Robert Storr

# LENDERS TO THE EXHIBITION

Akron Art Museum

Albright-Knox Art Gallery, Buffalo,
   New York

Allen Memorial Art Museum,
   Oberlin College, Ohio

The Art Institute of Chicago

The Cleveland Museum of Art

Hirshhorn Museum and Sculpture Garden,
   Smithsonian Institution, Washington, D.C.

Ludwig Forum für Internationale Kunst,
   Aachen

The Metropolitan Museum of Art,
   New York

Milwaukee Art Museum

The Minneapolis Institute of Arts

Museum of Contemporary Art / Ludwig
   Museum Budapest

The Museum of Modern Art, New York

Museum Moderner Kunst Stiftung
   Ludwig, Vienna

National Gallery of Art, Washington, D.C.

Osaka City Museum of Modern Art

Philadelphia Museum of Art

Reynolda House, Museum of American Art,
   Winston-Salem, North Carolina

The Saint Louis Art Museum

Virginia Museum of Fine Arts, Richmond

Walker Art Center, Minneapolis

Wexner Center for the Arts, The Ohio
   State University

Whitney Museum of American Art,
   New York

Pace Editions, Inc., New York

PaineWebber Group Inc., New York

C. Richard Belger

The Eli and Edythe L. Broad Collection

Ed Cauduro

Georgia Close

Leslie Close

Maggie Close

Linda and Ronald F. Daitz

Mr. and Mrs. Julius E. Davis

Mr. and Mrs. Charles Diker

Joan and Stephen Feinsod

Wendy Finerman and Mark Canton

Arne and Milly Glimcher

Arthur and Carol Goldberg

Robert H. Halff

Sydney and Frances Lewis

Vicki and Kent Logan

Mr. and Mrs. Hiroyuki Matsuo

Mrs. Beatrice Cummings Mayer

Louis K. and Susan Pear Meisel

Morton G. Neumann Family Collection

Mr. and Mrs. Oliver-Hoffman

Michael and Judy Ovitz

Susan W. and Stephen D. Paine

James and Barbara Palmer

PieperPower

Ron and Ann Pizzuti

Jon and Mary Shirley

David E. Smith

Anonymous lenders